THE
CHINESE
SPIRIT
ROAD

ANN PALUDAN

The
Classical
Tradition of
Stone Tomb
Statuary

THE CHINESE SPIRIT ROAD

Yale University Press

New Haven & London

*Published with assistance from
the Getty Grant Program.*

Designed by Richard Hendel
and Sonia L. Scanlon
Set in Linotype Walbaum type
by Tseng Information Systems,
Inc., Durham, NC.
Printed in the United States of
America by Edwards Brothers,
Inc., Ann Arbor, Michigan.

The paper in this book meets
the guidelines for permanence
and durability of the
Committee on Production
Guidelines for Book Longevity
of the Council on Library
Resources.

10 9 8 7 6 5 4 3 2 1

Library of Congress Cataloging-in-Publication Data
Paludan, Ann, 1928–
 The Chinese spirit road : the classical tradition of stone
tomb statuary / Ann Paludan.
 p. cm.
 Includes bibliographical references and index..
 ISBN 0-300-04597-2
 1. Statues—China. 2. Monuments—China.
3. Sculpture, Chinese. 4. Humans in art. 5. Animals in
art. I. Title.
 NB1665.P35 1991
730'.952–dc20 90-2359

67799

For Janus

with love

CONTENTS

LIST OF TABLES AND CHARTS

TABLES

CHARTS (by Lucy Peck)

ACKNOWLEDGEMENTS

My first thanks are to the Chinese Ministry of Foreign Affairs. Without their active support this project could never have been realized. In particular I wish to thank Ambassador Wang Benzou, formerly director of the Western European section of the Ministry of Foreign Affairs, and Mme. Zhangying, former director of the Institute of Writers and Artists, for showing confidence in the idea when it was first raised and for their concrete help and encouragement through many years. Special thanks are due to Wu Quanda, who looked after me so well during my journeys in 1981 and 1983, and to Chinese diplomatic colleagues in Copenhagen, London, and Reykjavík.

I am most grateful to the Chinese Institute for Foreign Affairs and to its president, former Vice-Minister of Foreign Affairs Han Nianlong, whose kind invitation to my husband to revisit China in 1986 enabled me to visit sites which I would not otherwise have seen.

In Beijing, I wish to give special thanks to Dr. Wang Zhongshu and Xu Pingfang at the Institute of Archaeology, from whom I learned much and whose friendship I have greatly valued; Ma Jichuan, Sun Que, Jin Feng, Zang Ji, and Sheng Weiwei of the State Administrative Bureau for Museums and Archaeological Data; Prof. Fu Tianzhou, Prof. Jin Weinuo, Prof. Tang Chi, and Liu Xingzhen of the Central Institute of Fine Arts; the late Dr. Sheng Congwen; Wang Xu and Wang Yarong of the Section of Historical Costume of the Institute of History, Chinese Academy of Social Sciences; Dr. Wang Jianying of the Peoples' Educational Publishing House; Fu Xinian of the Beijing Institute of Construction; and Chinese friends in the Danish Embassy in Beijing.

Great thanks are due to many archaeologists in the provinces and in particular to Prof. Guo Husheng, Department of Architecture, Xiamen University; Luo Zongzhen, Nanjing Museum; Prof. Tong Enzheng, Sichuan University Museum, Chengdu; Wang Shiping, Shaanxi Provincial Museum, Xian. I also wish to thank Chao Qingyun of the Archaeological Institute at Zhengzhou; Deng Zeyuan of the Fengyang Cultural Bureau; Dong Ji Xian and Xu Wenbing from the Chongjing Museum, Sichuan; Fu Yongguei of the Gongxian Cultural Bureau; Yang Zainian of the Danyang Cultural Bureau; and Prof. Yuan Xioacun of the Institute of Fine Arts, Kunming.

Special thanks are due to Leifur Thorsteinsson for his generous help with my photographs through many years, and to Lucy Peck, who has once

again translated rough sketches into beautiful charts; to Jessica Rawson of the British Museum, Rose Kerr and Dr. Craig Clunas of the Victoria and Albert Museum, and Beth Mckillop and Dr. Francis Wood of the British Library for their advice and support; to Dr. K. C. Chang of Harvard University; Dr. Annette Juliano of Brooklyn College, New York; to Helen Espir; to Ambassador and Mrs. Thorning-Petersen, Ambassador and Mrs. Belling, Hanne Guldberg, and Birgitte Crawfurd from the Danish Embassy, Beijing.

I would also like to thank Sarah Allen, School of African and Oriental Studies, London University; Dr. Clayton Bredt, University of Queensland; John Cayley, British Library; Richard Dawkins, photographer; Ray Dawson, Oriental Institute, Oxford; Magali Fowler; Else Glahn, Needham Research Institute, Cambridge; Derek Gillman, Sainsbury Centre for Visual Arts, Norwich; Dyveke Helsted, Thorvaldsen Museum, Copenhagen; Dr. J. Hoare, Research Department, British Foreign Office; Mme Joly-Segalen; Andrew Li, Nanjing Institute of Technology; Dr. Thomas Lawton, Freer Gallery, Washington, D.C.; Colin Mackenzie, University of Durham; David McMullen, School of Oriental Studies, Cambridge; Margaret Medley; Dr. Edward Schafer, Department of Oriental Languages, University of California, Berkeley; Barry Till, Art Gallery of Greater Victoria; Shelagh Vainker, British Museum; the late Prof. Howard J. Wechsler, Center for East Asian and Pacific Studies, University of Illinois; and Wu Hung of Harvard University.

I wish to remember with thanks the encouragement I received from Sir John Addis, Professor Carrington-Goodrich, Dr. Lawrence Sickman, and Dr. Xia Nai.

I wish to thank the British Academy and the Marc Fitch Fund for generous help in the final stages of this book.

NOTE TO THE READER

References to the illustrations will be found in the margins of the text. The tables and charts are grouped together following page 231.

CHRONOLOGICAL TABLE

Shang	c. 1550–1027 B.C.	Northern Dynasties	386–581
Zhou	1027–221 B.C.	Northern Wei	386–534
Qin	221–206 B.C.	Eastern Wei	534–550
Western Han	206 B.C.–A.D. 24	Northern Qi	550–577
Eastern Han	25–221	Western Wei	535–556
Three Kingdoms	220–280	Northern Zhou	557–581
Western Jin	265–316	Sui	581–618
Eastern Jin	317–420	Tang	618–907
Southern Dynasties	420–589	Five Dynasties	907–960
Liu Song	420–479	Northern Song	960–1127
Southern Qi	479–502	Southern Song	1127–1279
Liang	502–557	Jin	1115–1234
Chen	557–589	Yuan	1271–1368
		Ming	1368–1644
		Qing	1644–1911
		Republic of China	1911–1949
		People's Republic of China	1949–

MAP OF CHINA

LIAONING

Shenyang

INNER
MONGOLIA

HEBEI

Ming Tombs

Peking

**Eastern
Tombs**

NINGXIA

Datong

**Western
Tombs**

GANSU

• **Mt. Qilian**

SHANXI

Huang He

SHANDONG

Qufu

Xinxiang

Longmen

Wei He

Xianyang

Luoyang

Yanshi

Xuzhou

Gongxian

Kaifeng
Zhengzhou

SHAANXI

Xian

Dengfeng **Song Mtns.**

Fengyang

*Lake
Hongse*

Han
Shui

HENAN

JIANGSU

Nanyang

Huai He

Guanxian

• **Mianyang**

SICHUAN

HUBEI

ANHUI

Danyang

Nanking

Shanghai

Chengdu

Dazu

Yangtze

Hangzhou

Lushan • **Ya-An**

Chongjing

ZHEJIANG

Changsha

JIANGXSI

HUNAN

FUJIAN

GUIZHOU

Guilin •

GUANGXI

TAIWAN

YUNNAN

Xi Jiang

GUANGDONG

Canton

■ Cities
• Tomb Sites

INTRODUCTION

This book is the result of a long search into the history of Chinese spirit road statuary. The spirit road—here understood as the above-ground avenue of stone figures and monuments lining the approach to an important tomb—is an essential element in Chinese tomb architecture; these carvings embody the classical non-Buddhist tradition of Chinese sculpture.

The earliest known spirit road statue, on the tomb of the Western Han general Huo Qubing, dates from 117 B.C.; some of the latest examples are from 1934, on the tomb of a direct descendant of Confucius in the Kong family graveyard at Qufu. The spirit road tradition was powerful and deep-seated; attempts to abolish it on grounds of undue extravagance always failed. When the alien Mongols rejected the custom, it was kept alive by their Chinese subjects. The spirit road custom spread throughout the empire and over its frontiers. Spirit roads were erected by the ruling families in Korea and Vietnam and by minority tribes such as the Western Xia in what is now Gansu. The result is an extraordinary collection of monumental statuary spanning two millenia and spread out all over China.

This statuary represents a strong and ancient branch of monumental sculpture, which predated and then coexisted with the better-known Buddhist sculptural tradition. It was based on ancient beliefs connected with ancestor worship and the importance of the tomb which were common to all ranks of society. The right to erect tomb statuary was limited to the upper ranks and became an instrument of state power, but in the long term preservation of these stone figures depended on the ordinary people. Indeed, perhaps the most extraordinary thing about these carvings is their endurance. Time and time again, during rebellions, civil wars, and changes of dynasty, cities with massive walls and gate towers, tombs with vast underground complexes and luxurious palaces have been destroyed, sometimes so effectively that only a bare outline of rammed earth remains, and yet the stone statues nearby have survived. Frequently you will find a complete alley of sculptures leading to a tomb of which nothing but a small mound remains. As late as the Cultural Revolution, the grave chamber of a newly discovered Ming tomb which had been flooded for three hundred years was destroyed whilst the adjacent alley of stone carvings was left untouched. Nothing goes to waste in China; in many regions stone is scarce and the statues could have been put to many uses. Their survival is due, not to chance, but to the

place which they occupy in the hearts of the people. A village which has a pair of stone animals is proud of the fact; frequently it takes its name from these beasts, and even today they are believed to bring good fortune. At the New Year paper cuttings of these figures are put in the window, and it is not uncommon to find a little red label on the forehead of a stone chimera with a plea for help in curing a sick child or getting a grandson. Between three and four thousand such statues have been recorded in recent years, and new discoveries are continually taking place.

Until recently, this great repository of material was largely ignored. There has been a tendency to assume that Buddhist sculpture replaced the indigenous tradition reflected in Han stone statuary; that after the arrival of Buddhism Chinese sculpture was synonymous with Buddhist sculpture. Even scholars with a positive approach deal with the great fifth- and sixth-century tomb statues of the Southern Dynasties as a late flowering of pre-Buddhist Han statuary; later examples of the classical tradition, such as the great spirit roads at Tang Qianling or the Ming Tombs outside Beijing, are dismissed in a few sentences, and Chinese sculpture as a whole is divided historically into pre-Buddhist and Buddhist.

There are various reasons for this. The most obvious is the question of accessibility. Much Buddhist sculpture is concentrated in a few dramatic sites such as Yungang, Longmen, and Dunhuang, each having a wealth of statuary; most of the rest is in temples which were accessible because they were in use. Tomb sculpture was by its nature scattered, and by far the larger part stands in isolated places far from any tourist or industrial centre. The basis for Western knowledge of Chinese monumental sculpture was laid by the great French archaeologists Edouard Chavannes and Victor Segalen. In the 1890s Chavannes set the pattern which Segalen was to follow of travelling in China in search of sites mentioned in local historical annals and of finding, recording, and photographing monuments in situ.[1] Between them they covered much of the then known Han statuary in Shandong, Henan, and Sichuan, the Southern Dynasties monuments in Jiangsu, and some of the Tang and Song imperial spirit roads. This field work was cut short by political disturbances inside China. In the warlord era which followed the 1914–1918 war, travel in China was difficult, and during the long Sino-Japanese War it was virtually impossible. After 1949 large areas of China remained closed to foreigners, and it is only recently that travel off the beaten track has become possible. Even today, however, few have the time or inclination to travel for three days to see a pair of statues unless they are convinced of their value in advance. The result is that knowledge of spirit road statuary has advanced little since the time of Chavannes and Segalen; their excellent photographs, still unsurpassed, have remained the main source material for modern scholars, and there has been a tendency

to assume that these great pioneers had seen all that there was to see. Chavannes had divided his subject matter into non-Buddhist and Buddhist, but because most of his non-Buddhist statuary preceded the introduction of Buddhism, his division was later amended to pre-Buddhist and Buddhist. This was misleading, for it led to the assumption that the strong classical tradition which existed before the arrival of Buddhism was superseded by it.

Another reason lay in the nature of the two traditions. Buddhist sculpture was based on a set of beliefs with which Westerners were acquainted and served a religious-artistic purpose which could be compared with the Indian art by which it was inspired. Buddhist art formed a satisfactory unit. It was possible to study its arrival, development, and decline and, by comparison with Indian art, to identify the different stages of sinicization. None of this applied to the classical tradition. The purposes of this sculpture were abstruse, reflecting an amorphous amalgam of ideas which had their roots in prehistory. The spirit road with its sculptures reflected a curious mixture of a belief in the supernatural and an affirmation of worldly power. The underlying concepts were tacitly accepted but never made explicit; they had no place in Confucian philosophy and were thus ignored in official chronicles. No single doctrine can be found which provides a key to their understanding; in striking contrast to the field of painting, there are no texts to refer to, no critique or written rules expounding the aims of such sculptures or providing standards by which to judge them.

Finally, there was the question of artistic appreciation. For different reasons neither the Chinese nor Westerners appreciated these monumental carvings as works of art. For the Chinese, such statuary fell outside the scope of art. For Westerners, applying aesthetic criteria largely derived from the Graeco-Roman sculptural tradition, these statues were found wanting. It was a short step to deciding that this branch of sculpture was negligible.

This book is an attempt to show the strength and persistence of the original classical tradition. It has become increasingly clear that the spirit road figures are of interest, not primarily as works of art, but as an integral part of the all-important funeral system. They are, in most cases, the only visible part of the great early mausolea to have survived more or less intact. Through them we can still, today, get some idea of past grandeur. The sheer number, size, and expense of imperial spirit road statuary, situated in the venerated imperial tomb complexes, proclaim their original importance. Recent Chinese research has shown the close links between state ritual and imperial tomb architecture, including the spirit road.[2] It is to be hoped that with time, further light will be thrown on the political and philosophical attitudes which led to the adoption of particular subjects in a spirit road. In the meantime, however, this form of sculpture has an intrinsic value for scholars in other branches of Chinese art. Much of it is dateable and can be

used to pinpoint the acceptance of new art motifs and decorative patterns. Costumes on the stone officials were always contemporary and carved with great attention to detail. These figures are three-dimensional examples of ceremonial court dress, and it is possible to trace changes in fashion by comparing earlier and later statues from the same dynasty. At the same time, the spirit road as a whole, in its form and content, can tell us much about the nature, beliefs, and aspirations of the dynasty which erected it.

This study is based on field work. During the last ten years I have travelled extensively in search of stone carvings placed on tombs. I have photographed the statues in detail, hoping in this way to update earlier records, to make information about these figures available to those who are unable to visit them in person, and perhaps to convey to others the unique charm of this form of statuary.

It is a study confined to non-Buddhist stone monumental sculptures placed above ground. Tomb figurines, stone statues found in tombs, and clay figures such as the extraordinary armies of Qin Shi Huangdi which were placed underground, are not included. Beginning with the Western Han statues on the grave of Huo Qubing, the book follows the development of the spirit road through successive dynasties until the fall of the empire in 1911. For the most part the pictures tell their own story. The text is intended mainly to give a background which may explain the principal changes.

Chinese and Western attitudes towards all the arts differ, but this is particularly true with regard to sculpture. To appreciate spirit road sculpture it is necessary to place it in context, to consider the aim of the sculptor and the criteria by which his work was judged. Before turning to the statues themselves, it may therefore be useful to take a brief look at the role of sculpture and sculptors in Chinese thought and society.

1

THE ROLE OF SCULPTURE AND SCULPTORS IN CHINA

For the Chinese, sculpture did not rank as art. The sculptor was a craftsman, not an artist; his work was judged on its ability to fulfill a definite purpose, not on any abstract idea of form or beauty. No independent theory of sculpture was ever expounded and there are no written doctrines to which it must conform. The conventions underlying Chinese sculpture are connected with both architecture and painting. For a categorization of sculptural techniques it is necessary to turn to the early twelfth-century architectural treatise *Ying zao fa shi*.[1] In so far as sculpture is considered as art at all, it is compared with painting, and when modern Chinese judge a statue they refer to the famous Six Principles for Painters.[2]

The links between Chinese monumental sculpture and architecture are obvious and close; indeed, the dividing line is often blurred and many stone monuments belong to both categories. The stone towers (*que*) placed in front of Han tombs were replicas of wooden towers used in contemporary architecture; their significance in the context of the tomb, however, depended on their sculptural decoration. The same is true of one of the triumphs of Ming sculpture—the great marble archway, or *pai lou*, in the Ming Tombs outside Beijing. The spirit road avenue, as such, played an architectural role. In Tang and Song spirit roads, for example, the avenue of tall stone figures, set in a framework of earthen towers, provided the visual link between two walled enclosures.

This close connection is not accidental. For the sculptor, as for the architect, the question of spatial relationships was paramount. A Chinese stone statue was always made for a particular purpose, which included being placed in a particular site. In this respect it was closer to European medi-aeval sculpture than to the free-standing statues produced in the Graeco-Roman and post-Renaissance Western traditions, which were mostly intended to be seen from every angle. The Chinese statue was not carved as an independent entity; it was not meant to be moved and the angle of observation was decisive. Just as in Chinese architecture a building cannot be judged in isolation but must be considered as part of the whole formed by the surrounding balustrades and courtyards, a Chinese stone statue must be seen as part of its architectural and natural setting. It is designed as part of a complex which includes not only other monuments, buildings, and 5

1. Spirit road leading to empress's tomb, Yong Zhaoling, c. 1063.

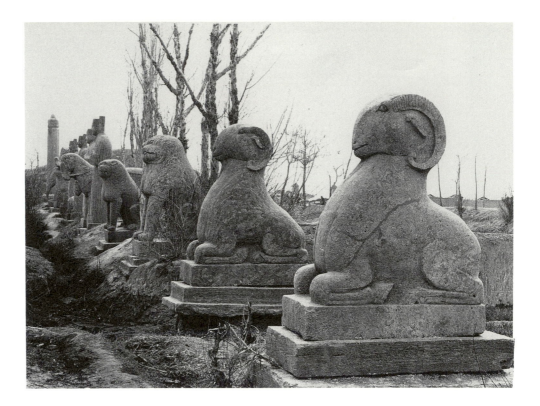

2. Fabulous beast, tomb of Qi Jingdi, Danyang, Jiangsu, 494. Height 2.4 m; length 2.9 m.

courtyards but also the surrounding landscape. In this way, the Chinese geomantic principles of *fengshui*, decisive in choice of site, exerted an influence on the size and orientation of a monumental statue. Proportions which look artificial in isolation are seen to be correct when the statue is viewed from the intended viewpoint and in the intended context.[3]

This is particularly clear with spirit road statues. These were placed in two parallel lines forming an alley leading to the tomb. They were viewed by those who came to the tomb to perform the memorial rites, that is to say, people walking in a ceremonial procession with eyes forward or possibly down. The main impact was thus received from the side. If the alley is narrow and the figures are placed close together, the observer will hardly notice them from the front. Hence the emphasis on the flanks of spirit road animals, which often give the impression of being two sides joined together rather than a figure carved in the round. This effect is deliberate. Only in this way can the artist create the right impression in the situation for which the statues have been carved. Where the spirit road is wide and long, the figures would be seen from at least three sides; in these cases the Chinese sculptor created statues which are equally impressive from every direction. The great stone beasts of the fifth- and sixth-century Southern Dynasties fall into this category. Standing over forty metres apart, their rounded, sinu-

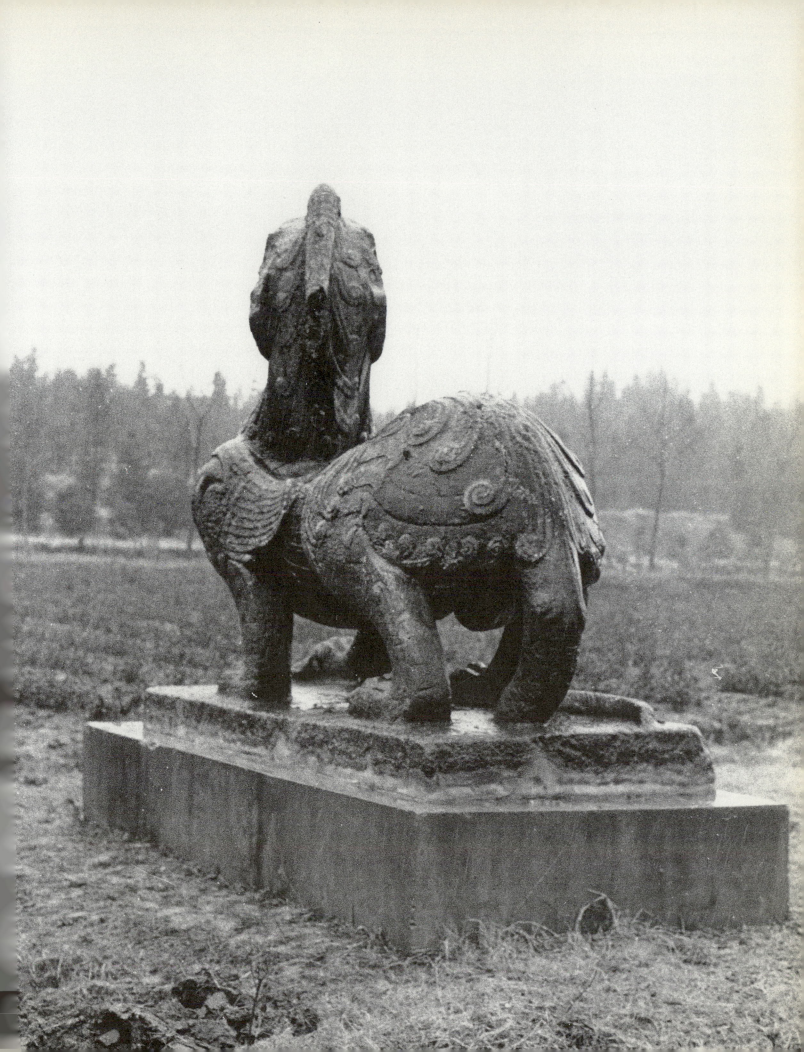

ous bodies are filled with movement and answer more closely to Western ideas of sculptural beauty than most other spirit road statuary.

This trait in Chinese sculpture can often throw light on the original purpose or position of a stone figure. It enables us, for example, to determine the original orientation of Han tomb felines; it can suggest whether or not a particular stone figure was intended for a spirit road. It has also through the ages had a negative effect on Western appreciation of spirit road figures when these have been seen in isolation in a museum.

The connections with painting were more complex. It was recognized that sculpture embraced elements of both calligraphy and painting, and the same ranking system which applied to the arts in general applied within the field of sculpture. A stone tablet with an inscription reflected the primacy of calligraphy among the arts and was prized above all other forms of carving. Under the Song, for example, a flourishing interest in archaeology led to the compilation of careful records of surviving monuments. Stone inscriptions were always described in detail, whereas statues in the round were sometimes dismissed as "carved stones." After an inscription, the next
109–114 best was a stone picture—an engraving or a stone relief such as the famous carvings of Tang Li Shimin's six steeds. Sculptural decoration and reliefs were frequently based on drawings, and styles in painting affected styles in sculpture.

Chinese attitudes towards stone sculpture were influenced by an ancient belief in the inherent power of an image to bring about that which it represented or symbolized. The picture or stone relief of an ordered society would, for example, by its existence strengthen that society. The statue of a fierce beast would deter both human wrongdoers and evil spirits. This belief that an image could influence both the material and spiritual worlds applied to all kinds of images. In the case of stone, however, its effect was magnified through the association of stone with immortality. Stone endured; it possessed longevity, itself a means for attaining immortality. The powers of a stone figure were thus designed for eternity. This made the choice of subject a matter of prime importance and, not surprisingly, there arose a close connection between stone sculpture and the state. Of all the arts it was the most dependent on official patronage; its powers were harnessed by the establishment for their own purposes: moral, practical, political, and magical.

State control of the inherent powers of statuary reached an apogee in the spirit road tradition. For almost its entire history, the use of monumental tomb statuary was subject to regulation by imperial decree. In imperial spirit roads, statuary was chosen to produce a deliberate statement about the nature and aspirations of the dynasty. As long as the tradition remained alive, each dynasty reformulated its message—a message which reflected

contemporary beliefs and circumstances. Once a new pattern was established, it lasted the rest of the dynasty.

In the long run, this close connection with state and imperial purposes affected not only subject matter but style and pose. It left little room for experimentation or for independent schools similar to those which arose in painting, and stone sculpture, particularly spirit road sculpture, became the most conservative of all the arts. The overwhelming importance of observing correct ritual in ancestor worship meant that even stylistic changes were subordinated to the general conventions governing the nature and pose of classical tomb statuary. On one hand, these conventions imposed a certain uniformity; on the other, they gave the spirit road tradition the strength to withstand outside influences such as Buddhism. Foreign motifs such as the lotus base only appeared in spirit road statuary after they had been thoroughly assimilated into native Chinese art.[4]

The supposed or desired powers of a subject were frequently expressed through symbolism. The use of animal subjects was at least in part derived from early sacrificial and ritual associations, and the notion that animals were a media of communication with spirits was already clearly formulated during the Shang dynasty.[5] All statues of animals in their natural state possessed supernatural powers.[6] The statue of a fierce beast would thus have a practical effect in deterring both worldly and spiritual wrongdoers; it would also facilitate contact with the other world and help the soul of the deceased on its perilous journey to its new abode. (All the helpers of the fabled Queen Mother of the West in the land of the immortals were animals.) When the Chinese wished to accentuate these magical qualities they drew on a repertoire of conventional attributes commonly associated with the supernatural: wings, horns, scales, flames, or outstretched tongue. Real animals were portrayed in conventional poses emphasizing the values they symbolized. The Han tiger, king of the wild, symbolizing the ruler and unlimited power, was always shown in action, walking with the suppressed energy of a beast about to spring; the sheep or ram, symbol of filial piety, kneels to take its mother's milk. These conventional poses, which were inherited from earliest historical times and applied to all media regardless of size, created a long-lasting system of readily understandable symbolism. Jade and bronze figurines of sheep from the Shang and Zhou periods are shown in the same position as monumental stone sheep some two thousand years later.

The supposed powers of images imposed severe restrictions in the field of sculptural portraiture. As a general rule, the less durable the medium, the greater was the Chinese artist's latitude, and clay figurines and clay, wooden, and lacquer statues cover a wide range of human subjects realistically interpreted. The tacit association of stone with immortality, however, created a situation in which a stone portrait of an evil man was a contra-

3. Statue of Li Bing, the great third-century master of irrigation, carved in A.D. 168 and found in riverbed at Dujiang Weir in 1974. Fulong Miao, Guanxian, Sichuan. Height 2.9 m.

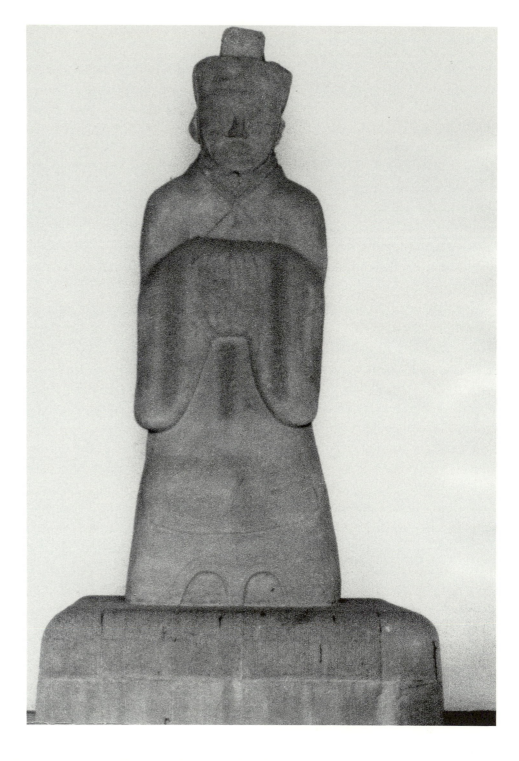

diction in terms. Immortality was for the virtuous and the scope of stone portraiture was thus virtually limited to representing heroes or sages.[7] A conventional pose was adopted which left little room for idiosyncracy. In classical stone sculpture the human subject usually stands at ease, hands in front, often holding or resting on an emblem of office; he looks straight

ahead with a serious but relaxed expression. Occasionally, as with the statue of the early tenth-century ruler Wang Jian, found in his tomb on the outskirts of Chengdu, there is an attempt to show distinguishing characteristics such as deep eyes and high cheekbones; but even here the overall expression and demeanour differ little from the earliest "portrait" we have—the statue of Li Bing from the second century, found in the Dujiang irrigation works in Sichuan.[8] Applied to officials standing in spirit roads, the object of the sculptor was to create a picture of the virtues that characterized, or at least ought to characterize, civil and military advisers to the emperor. Carried to its logical extreme under later dynasties, this theory led the sculptor to produce figures which represented the office rather than the man. Sculptural attention was concentrated on the reproduction of clothing, uniforms, and emblems of office, producing a noticeable contrast between the abstract, almost stereotyped expression of the model and his detailed costume. The need for accuracy brought the historical bonus that these figures are reliable examples of contemporary ceremonial attire.

The degree of abstraction was in direct ratio to the rank of the subject. When persons of lower status were shown, the purpose was to create a general picture of how such a person of this or that profession looked. In other words, his appearance became important and one is left with the paradox that whilst statues of named individuals were carved to represent the general ideal of a genus, statues of a random example of a genus were frequently based on individuals. The statues of the Indian mahouts and foreign envoys on the Northern Song imperial roads, for example, show such a refreshing variety of lifelike expressions that it is hard to believe that they are not based on living portraits. The sculptors have recognized that the role of these figures was to represent their occupation and "foreign-ness"; unlike the Chinese officials, it did not behove them to epitomize virtue.

Just as sculpture was considered a craft rather than an art, the Chinese sculptor held the position of an artisan rather than an artist. His position was similar to that of many European sculptors in the Middle Ages: he was at best a master craftsman, at worst a manual labourer. As in the European Middle Ages, the role of craftsmen tended to be hereditary and concentrated in certain areas. Villages, sometimes whole regions, were renowned for their sculptors, who were summoned en masse when an imperial work was commissioned. In the provinces, this tradition still survives. The inhabitants of the Wu Tai Mountains in Shanxi and in the barren regions of North Shaanxi around Suide and Mizhi are famous for their skill in stonework; Huian in Fukien Province is known as a county of stone carvers. Huian carvers were summoned to decorate many of the modern Chinese revolutionary monuments such as the Sun Yatsen Mausoleum

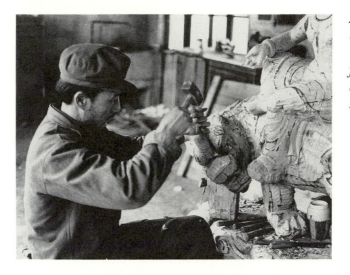

4. *Stone worker at Beijing Stone Sculpture Factory. The upper part of the figure and hand have already been worked smooth.*

5. *Stone working tools, Beijing Stone Sculpture Factory.*

in Nanjing and the pillars of the Great Hall of the People in Beijing. "Wherever there are stones," it is said, "there are the footsteps of Huian's stone carvers."[9] Sometimes local specialties develop; in Pucheng County, northeast of Xian, Shaanxi, there is a local art of carving stone tethering posts.[10]

Few Chinese sculptors are known by name; when a sculptor can be identified as a historical personage, it is always through some other connection.[11] Most often he is mentioned for having been a painter. It is characteristic that in the case of Li Shimin's six steeds, the name of the painter whose works are believed to have served as models has been preserved but that of the actual sculptor has not. Occasionally a sculptor is known for having been commissioned by the emperor to copy a famous Buddhist image brought from India. In rare cases there are records of a sculptor being commissioned to execute a portrait, but these statues were almost invariably modelled, not carved in stone. There are a few instances of sculptors having carved names on stone monuments, but these are generally believed to be the names of those responsible for the work rather than the names of actual craftsmen.[12]

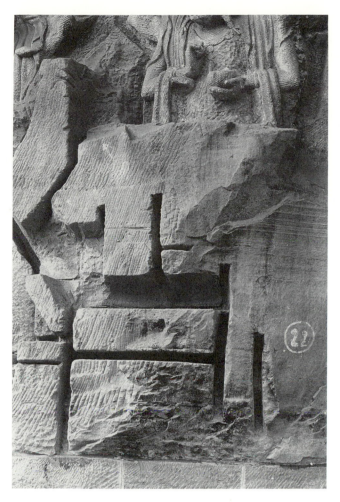

6. Unfinished stone carving at Baodingshan, Dazu, Sichuan, c. 1271.

There is an important difference between traditional Chinese and Western stone techniques. The basic Chinese tools—the hammer, punch, and chisel—are similar to their Western counterparts; the bow drill was introduced under the Song but was little used in large-scale carving. The art of pointing, the use of calipers to transfer measurements from a model to the block of stone, was not, however, introduced in China until this century and is still confined to those with an academic training. This meant that the difference between metal and stone sculpture was much greater than in the West. The sculptor in metal enjoyed the same ease of expression as the modeller of clay figures since his statue was first worked in a soft medium such as clay or wax. The stone sculptor had to work directly onto the stone.

There are no indications that models were used for monumental statuary. No mention of such models has yet been found in the records and no objects have been discovered which can be identified as models for a larger statue.[13] Stone reliefs were carved from drawings, and drawings—or, later, wood-

blocks—were almost certainly used for human statues with their accurate depictions of costume and official emblems.

Methods of transporting and carving the stone remained basically unchanged throughout the period we are considering. The stone was hewn into large blocks which were worked close to their final site. (It is not uncommon to find an unfinished statue or one that was abandoned because of a flaw in the stone, lying a few metres from a finished spirit road.) Transport was a major problem. Wherever possible, the stone was carried by water; on land it was transported in carts or on rollers. Stone for the great Southern Dynasties statues at Danyang, Jiangsu, for example, was brought from a quarry outside Nanjing over one hundred kilometres away. It was taken first by river, then on a specially dug canal to the entrance of the imperial graveyard. The last stretch on land could only be carried out in winter. The way to the site was paved with a layer of squashed onion-like plants which, when frozen, provided a smooth surface for rollers bearing the stone blocks.[14]

4–6 The sculptor worked round the block of stone, starting from the top. The design was first drawn, then roughly chiselled on the four sides. After this a series of increasingly fine chisels were used, first chipping, then rounding and smoothing. Finally the statue was sanded and polished with sand or soft stone and water.[15] Narrow or tall statues, such as figures of people, were worked with the slab placed nearly horizontally with the head-end slightly raised. When the statue was finished it was erected in its final position by pulley. Here too there was little change in method. Peasants restoring Southern Dynasties statues in Jiangsu in the 1950s constructed pulleys similar to those shown on Han funeral bricks.

2

WESTERN HAN AND THE
EMERGENCE OF STONE TOMB
STATUARY

Stone monumental sculpture was a relatively late development in Chinese history; the earliest known examples date from the second century B.C. Evidence of sculptural work in stone before this period is scanty and much depends on legend. Recent archaeological research indicates that in regions where traces of megalithic settlements have been found, such as Southwest China (Sichuan), it may be possible to trace a line from the worship of large stones to the early use of stone figures for magical purposes.[1] In the Neolithic period the Shu tribe in Sichuan erected large stones on the top of hills whilst a neighbouring tribe worshipped white stones, placing them on their rooftops to avert evil. The use of large stones, even carved stones, to mark graves, is mentioned in fourth-century B.C. legends from this region, and this practice may have contributed to later developments in the use of large stone sculpture.[2]

The late emergence of stone sculpture can hardly have been due to technical considerations. By the time stone sculpture became popular, the tools and techniques for working hard materials such as jade had been in use for over a thousand years. Large-scale modelling and casting techniques were equally developed: recently discovered larger-than-life-size bronze figures of men found in Guanhan, Sichuan, are reckoned to date from before 1000 B.C. whilst the extraordinary underground pottery army guarding Qin Shihuang's tomb show what could be done in clay. It seems more probable that the reason for the belated appearance of stone sculpture lies in changing attitudes towards stone as a material. A few stone figurines have been found at the Late Shang settlement at Anyang (c. 1300–1027 B.C.), but in style and decoration they appear as imitations of the far more numerous jade and bronze figurines from the same royal tombs.[3] This treatment, coupled with the marked paucity of stone carvings from the Zhou dynasty which followed, suggest that stone, unlike jade or bronze, was at that time considered a less appropriate medium for the ritual and sacrificial purposes which these objects served.

However, a change in attitude towards the use of stone seems to have taken place towards the end of the third century B.C. There are several 15

records of large stone statues from the Qin dynasty, and although no statuary from this period has yet been found, some substantiation for belief in these Qin figures exists. Tall stone warriors, for example, placed on tombs by later dynasties, are known as *wengzhong*; this harks back to the record of a stone statue Qin Shihuang had made of one of his guards, Ruan Wengzhong, who was exceptionally tall.[4] An inscription on a statue from A.D. 168 of the great third-century B.C. hero Li Bing accords with records of stone figures of men and rhinoceroses which Li Bing is said to have had carved when he completed his irrigation works in Sichuan.[5]

With the second century B.C. we move into historically verifiable facts. An analysis of the numerous Western Han stone carvings found throughout China suggests that the emergence and popularity of this form of sculpture were associated with a growing preoccupation with immortality and the land of the immortals. Early examples of Western Han statuary include a wide variety of subjects, including figures of animals, humans, monsters, and immortals. There is of course an element of chance in what has survived after two thousand years, but these figures have certain features in common. They reflect a strong sense of the supernatural and a belief in the close connection between this and the spirit world. There is no apparent distinction between tomb and non-tomb statuary, and the figures reflect a common set of conventions and underlying beliefs about the nature of the universe and possible methods of attaining everlasting life which were later to be absorbed into the spirit road tradition. Created to establish contact with the spirit world, these statues were placed in open-air sites considered likely to attract spirit beings. In this context, stone was the perfect medium: its practical qualities of endurance, which gave it a symbolic association with immortality, were combined with a very low re-use value. Unlike bronze and other valuable metal figures, a stone statue could not be melted down and re-used; it was therefore less likely to be stolen.

Some of these Western Han statues can be identified from literary records which clarify the association of stone statuary with the spirit world and, in particular, with the search for immortality. This search took many forms. Some interpreted the idea of a land of the immortals literally and travelled in search of the Blessed Isles over the Eastern Sea or went west to seek the mountain abode of the fabled Queen Mother of the West. Some tried elixirs (cause of many an early death), whilst others built towers to bridge the gap between the two worlds or tried to attract spirit helpers by suitable painted or engraved decoration. Han Wudi was advised by diviners that if he wished to communicate with spirit beings he must portray them on the daily objects of life; otherwise they would not come.[6] Developing this theme, the emperor created "paradise gardens" or "hunting parks" incorporating his ideas about paradise. With their blend of wild nature and civilization,

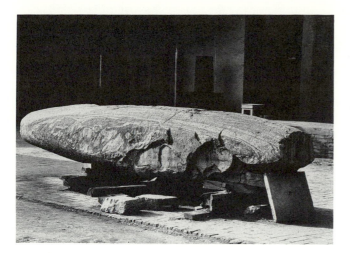

7. *Fish or whale from site of Han Wudi's artificial Lake Taiye, Jianzhang Palace, now Shaanxi Provincial Museum. Length 4.9 m.*

these artificial landscapes—microcosms of the universe—served religious and magical purposes based on the belief that by recreating or making a replica of an object, one gained a certain power over it.[7]

As a decoy duck will bring in wild fowl, stone figures of immortals were placed among the artificial mountains and lakes in these parks to attract immortals. It is known that statues of the Spinning Maiden and Cowherd, heroes of a popular legend who were transformed into stars separated by the Milky Way, were placed one at each end of a bridge over a replica of the beautiful Lake Kunming in Han Wudi's hunting park outside the capital, Chang'an (Xian).[8] (There was a multiple symbolism here: Lake Kunming was a famous lake in Dian territory on the southern borders of the Han empire; by recreating this lake in his own park, Han Wudi was furthering and anticipating his projected conquest of the Dian kingdom.) In 1978 two figures were found in a site which corresponded both with the early records and with an eighth-century description of the statues given by the Tang poet Dufu. It is difficult to see their features, worn as they are with age, but there seems little doubt that they are the original Western Han carvings.[9]

In another park near his Jianzhang Palace, Han Wudi had a large stone fish—some say a whale—placed by the artificial Lake Taiye. The fish, described as thirty Chinese feet long, was said to roar and move its gills when the weather was bad and appears to have been part of a larger complex addressing the spirit world: in the middle of the same lake was a platform seventy metres high described as a possible place for meeting immortals. In 1973 a fish of the right size, now in the Shaanxi Provincial Museum, was found on the banks of the dried-out lake in the position described.[10]

The most famous group of Western Han tomb statuary is, however, from the tomb of general Huo Qubing, who died at the age of twenty-four in 117 B.C. Huo Qubing conducted a series of brilliant campaigns against the

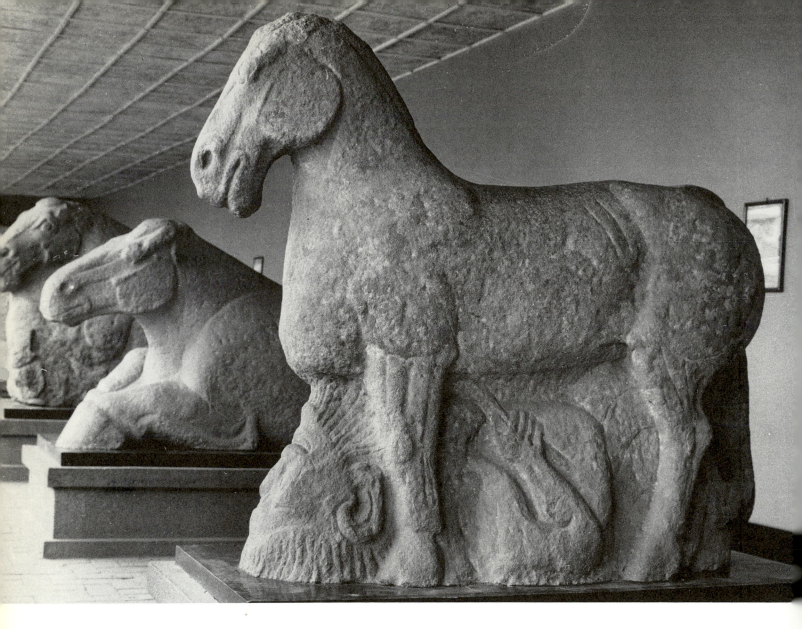

8. *"Horse trampling a barbarian," tomb of Huo Qubing (d. 117 B.C.), Maoling, Shaanxi. Height 1.68 m; length 1.9 m.*

Chart 1

8,9

Xiongnu on the western frontier; by opening the Gansu corridor he secured China's route to the West. In recognition of his great achievements, Han Wudi awarded him the highest possible honour—a state funeral and a grave within the imperial tomb complex. He ordered the tumulus to be made like Mount Qilian, site of one of Huo Qubing's famous victories in Gansu, and it is recorded that this artificial mountain was covered with large boulders brought from afar and with strange stone animals and monsters.

The arrangement was highly symbolic. At one level it represented the young general's victories over distant peoples. The subjection of this distant region was underlined by its recreation in the imperial tomb area at the heart of the Chinese empire. The message was even more clearly stated by the statue which Segalen dubbed "horse trampling a barbarian." The horse represented Huo Qubing's valiant cavalry; the pinioned barbarian, struggling with bow and arrow, the defeated Xiongnu. On another level, the

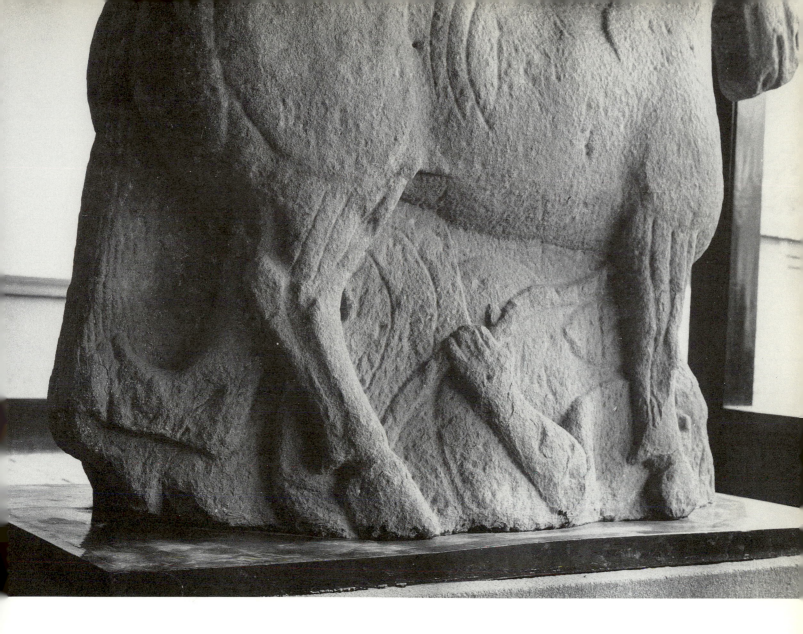

tumulus with its statuary appears to have been, like the paradise gardens
or, on a smaller scale, like the hill censers of the period (conical, mountain-
shaped incense burners peopled with strange beasts and spirits), a deliber-
ate attempt to create a meeting place between this world and the next. It
was believed that spirits dwelled in mountains; the land of the immortals
lay far to the west beyond the barbarians. By reproducing the exotic nature
of such a land with its wild creatures and fabulous monsters, an opening
was given to the spirit world where it would be most useful—within the
grounds of the imperial tomb.

It is an extraordinary collection of statuary. As well as the "horse tram-
pling a barbarian," there are wild and domestic animals including horses
in different positions, a tiger, ox, toad, wild boar, and elephant. There are
also strange carvings of monsters, two small fish heads, and two tailored
blocks with characters identifying people involved in the carving. When

9. Detail of figure 8.

10. Statues from tomb of Huo Qubing: (1) Fish. Height 70 cm; length 110 cm; width 44.5 cm. (2) Fish. Height 70 cm; length 154.5 cm; width 107 cm. (3) Toad. Height 70 cm; length 1.54 m; width 1.07 m. (4) Wild boar. Height 0.62 m; length 1.63 m. (5) Elephant. Height 0.58 m; length 1.89 m; width 1.03 m. (6) Frog. Height 0.55 m; length 2.85 m; width 2.15 m. (7) Zuo ci gong. These characters indicate that the carving was done by members of the "Left Office of Works." (8) "Horse trampling a barbarian," barbarian's head reversed. From this angle the face looks like a mask. Drawings by Mageli Fowler.

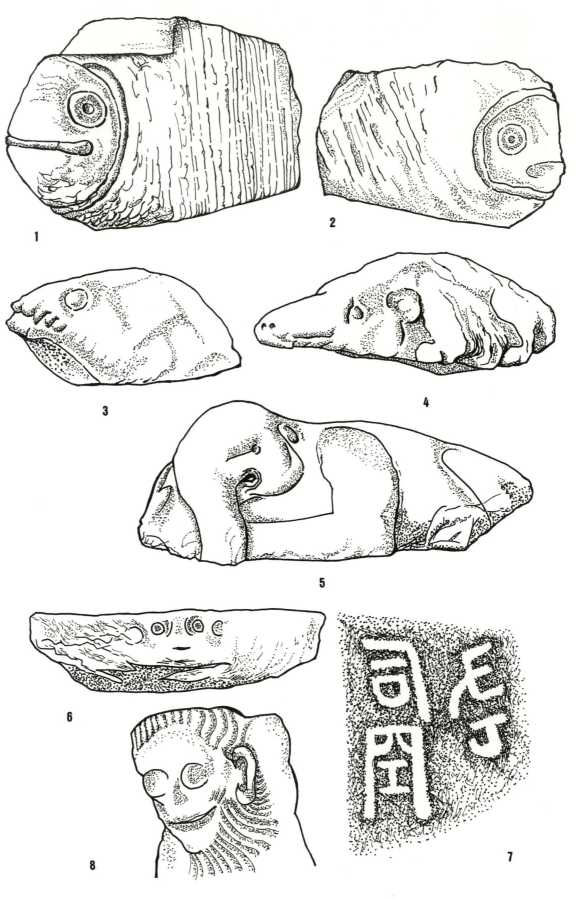

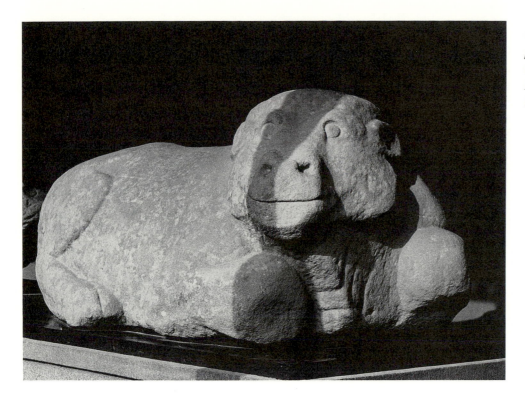

11. Reclining ox with panel carved on back, tomb of Huo Qubing. Height 1.6 m; length 2.6 m.

Segalen visited the site in 1914, these figures were mostly still in situ, scattered over the tumulus. Now they are housed in a small museum at the foot of the tomb.[11]

The statues reveal a wide variety of sculptural approaches. A few stones, like the fish heads and blocks with inscriptions, have tailored sides and were clearly carved for architectural purposes: the fish heads, found in 1914 in use at the gateway to a small Daoist temple on the summit, may have been intended as doorpost heads or lintels.[12] They are designed to be seen from the front and the carving is entirely symbolical: the fish face is enclosed in a double circle and the eyes are carved like a *bi*—a circular jade disc with a hole in the centre, symbol of the sky and used since earliest times in sacrifices to heaven. The largest group—animals carved from boulders with suggestive shapes—are a triumph of imagination. The aim of the sculptor was to bring the animal to life by identifying its essential characteristics in as few strokes as possible. It is a highly sophisticated technique, not unlike that used many centuries later by the Tang painter Liang Kai in his famous portrait of the poet Li Po, which was done with only a few brush strokes.[13] In some cases large areas of the stone are left unworked, but most animals are recognizable from all aspects. This accords with their apparently random placing. Lines are curved, emphasizing movement: a few rippling lines on the flanks suffice to indicate that a resting tiger may be about to spring.

10(1)(2)(7)

11,10(3–6), 12,13

12. Tiger, tomb of Huo Qubing. Height 0.8 m; length 2 m.

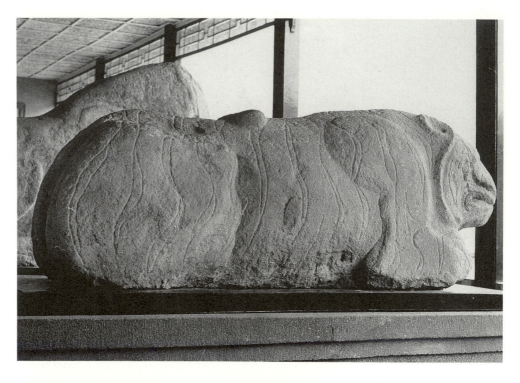

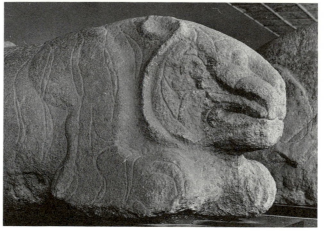

13. Tiger's head.

14–16 Seldom has movement been shown so vividly in stone as in the statues of two horses—one caught in the act of rising, the other about to jump.

 Three carvings of monsters raise an interesting question of perspective.
17 One portrays a man with a large head and outsize hand, fingers outstretched and palm upwards as if saying "Stop"; another shows a man hugging a
18,19 small bear, and a third, which at first sight looks as if it is a monster devouring a sheep, can be seen from the rubbing to be a monster holding a
20,21 small creature by the scruff of the neck. At the lower end of this figure,

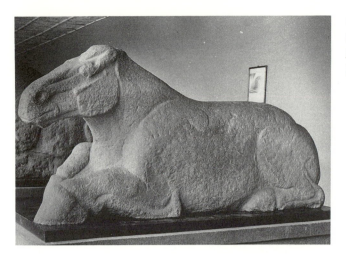

*14. Horse about to get up,
tomb of Huo Qubing.
Height 1.44 m;
length 3.6 m.*

near the back legs and tail of the monster, is another animal from whose mouth emanates a long coil or breath of wind, a symbol of communication. All three are carved on the upper surface of very large, flat boulders. The outlines are drawn rather than carved, with bold incised lines exaggerating the features. The curious thing about these carvings is that they make no sense to an observer on the ground. You can walk all round the boulder without being able to see what it represents. This cannot have been acciden-tal—the tomb as a whole bears all the signs of a most carefully thought-out project—and it is difficult to escape the conclusion that these figures were directed at observers from above. In this they are unlike any other known tomb statuary.[14]

The "horse trampling a barbarian" is different from the other statues. Here the subject has been imposed on the stone rather than inspired by it. The head and shoulders of the horse are free but the rest of the horse and all of the man are fitted into a narrow, almost two-dimensional rectangular form. This carefully balanced composition is a study in contrast: the horse, above, stands dominant and passive; below lies the prostrate man, strug-gling and defeated. Once again there seems to be a double symbolism: on one level, as we have seen, the horse and barbarian proclaim the identity of the tomb occupant by their obvious reference to Huo Qubing's victories; behind this, the conscious juxtaposition of opposites suggests a reference to *yin-yang*, the Chinese philosophical concept of interacting opposites.

8,9,10(8)

15. Horse about to jump,
tomb of Huo Qubing.
Height 2.4 m;
length 1.5 m.

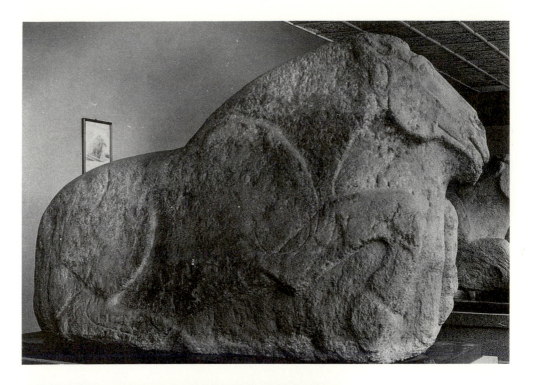

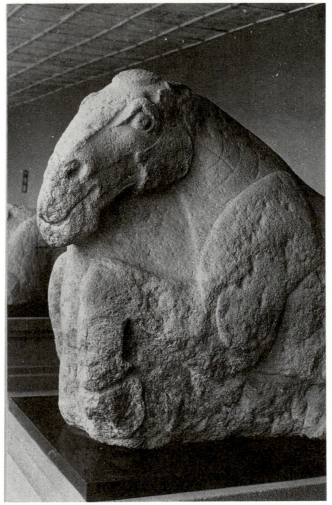

16. Horse about to jump.

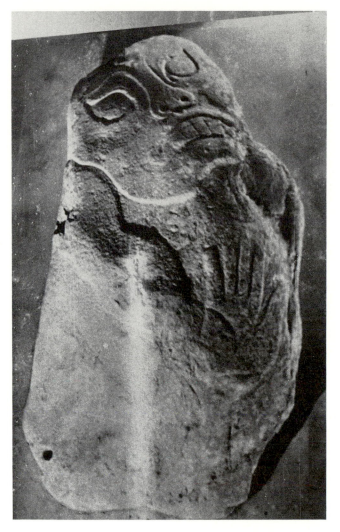

17. *Man with large head and hand seen from above, tomb of Huo Qubing. Length 2.22 m; width 1.2 m.*

This statue was found standing just west of due south of the tomb, facing east; in other words, it flanked the southern approach to the tomb and would have had a counterpart on the eastern side, facing west. Unlike the other animal figures, it was carved with a definite approach in mind. Detail is concentrated on the flat sides, which would have been visible to people approaching or leaving the tomb on a north-south axis.[15] This is a ceremonial statue, a monument marking an approach, and as such a direct forefather of Eastern Han spirit road statues.

In recent years, other Western Han stone animals, such as the tiger in the Taiyuan Museum, Henan, have been found in different parts of China.[16] Although rougher in execution, these are carved in a manner similar to the Huo Qubing animals: they appear singly and are not carved with a definite approach in mind, suggesting that if they were associated with a tomb, they were placed on the mound rather than at an entrance.

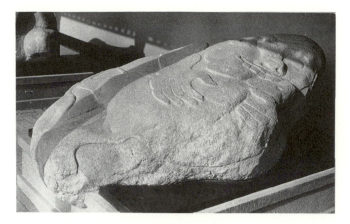

18. Man hugging a bear,
tomb of Huo Qubing.
Length 2.77 m; width
1.7 m.

19. Rubbing of
figure 18.
Courtesy of Dr.
L. Sickman.

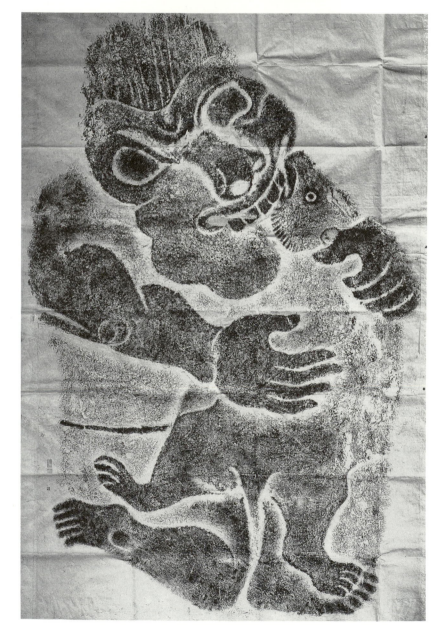

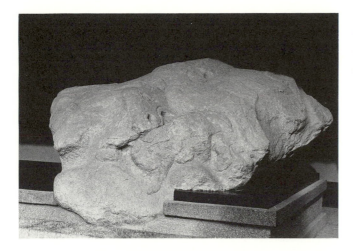

20. *Monster and small animal, tomb of Huo Qubing. Length 2.74 m; width 2.2 m.*

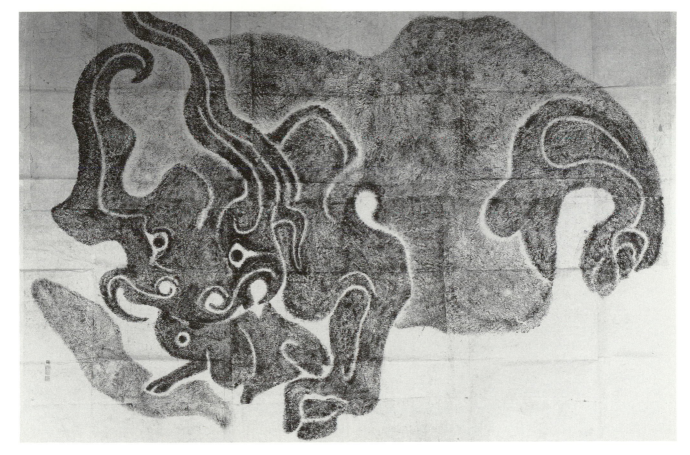

21. *Rubbing of figure 20. Courtesy of Dr. L. Sickman.*

3 EASTERN HAN AND THE ESTABLISHMENT OF THE SPIRIT ROAD

When a road is opened in front of a tomb and stone columns built to mark it, this is called a spirit road.
—History of the Later Han: Biography of the Tenth Prince of Guangwu, *annotated by Li Xian*

In the first century of this era, Han Mingdi introduced a change in ritual which had a decisive effect on the development of stone monumental sculpture. He transferred rites and sacrifices previously held outside the grave area to the tomb itself. Under the Qin and Western Han, minor daily rites were carried out by local tomb attendants at a small temple west of the tomb; the major rites were the occasion for a ceremonial visit by the descendants to the ancestral temple in the palace or city.[1] Building on a custom already practised by some noble families, Han Mingdi increased the importance of the major sacrificial occasions by using them to assemble his nobles and ministers, to bestow rewards and honours, and strengthen political ties; at the same time he moved their venue to the imperial ancestral tomb. The tomb thus became a focal point for both secular power and the all-important practice of ancestor worship. This enhanced role entailed two practical changes in tomb planning: the construction of a sacrificial hall in which to hold the ceremonies, and the erection of a spirit road of statuary above ground. These innovations became permanent elements in the classical Chinese tomb pattern.

The sacrificial hall, filling the role of the temple or hall in which the sacrifices had previously been performed, was built in the place of honour, south of the tumulus and underground grave chamber. Given the importance of appearance in Chinese ritual, the establishment of a ceremonial approach was a natural consequence. In secular life the approach to a palace or temple on an imperial occasion would have been from the south up a wide alley lined with guards; this arrangement was now reenacted at the tomb, and since the occupant of the tomb should be accorded the same honours as the

living, it was fitting that he should have a permanent guard of honour—in other words, a guard of stone.

The idea of placing stone figures on a tomb approach spread rapidly. It spread horizontally and vertically—throughout the empire and from the emperor downwards. In a time of economic expansion new-found wealth poured into lavish building projects, and historical sources are full of descriptions of glorious palaces with elaborate sculptural decoration. Extravagance in funerary arrangements was led by the emperor—critics complained that construction of an imperial mausoleum absorbed up to a third of the state income in taxes—but nobles and high officials were quick to follow suit. Under the prevailing Confucianism filial piety was a cardinal virtue; it implied incorruptibility, a qualification for high office. Ostentatious expenditure on parental funerals or tombs provided visible proof of filial piety and was thus a possible way to promotion. Tomb monuments became status symbols honouring both the dead and their living descendants, and officials vied with each other in funerary extravagance. The content and size of stone monuments were, like the height of the tumulus and number of trees planted within the grave area, strictly regulated according to the rank of the deceased. After eighteen hundred years, the large number of surviving monuments gives an idea of the extent and scope of this wave of tomb building.

From its inception the avenue of stone figures addressed this world and the next. In Han Confucian philosophy these worlds were seen as parallel organizations; although it was recognized that the other world was spiritual and therefore different in kind, the meeting which took place during the major sacrifices was conceived, at least in part, as a meeting between two equal powers. Just as death was the central pivot providing the link between two existences, so that in some ways dying became the most important part of a person's life, so the tomb became the central contact between the two worlds. The tomb was an exit and an entrance; it faced both ways—a point clearly brought out in Eastern Han tomb decoration.

Although the spirit road had developed in answer to a practical worldly need, the use of stone brought spiritual associations. The role of spirit road statuary was in many respects similar to that of Western Han stone figures in paradise gardens, only the venue had changed. Whereas the Western Han had conceived of contact with immortals in natural or simulacra of natural surroundings and had placed their stone figures accordingly, the Eastern Han regarded the tomb as a focus for such meetings and concentrated stone decoration in this area. Stone invaded every aspect of the tomb. As well as the statuary, there were stone sacrificial halls, stone underground chambers, stone tomb bricks and tomb doors; funeral objects previously

22. Pingyang que *(left), Mianyang, Sichuan, A.D. 190–195. Buddhist niches on lower part of* que *were carved on the orders of Liang Wudi in A.D. 529. The tomb axis is almost east-west, but the decoration assumes a north-south axis. Height c. 6 m, of which 1.5 m are underground.*

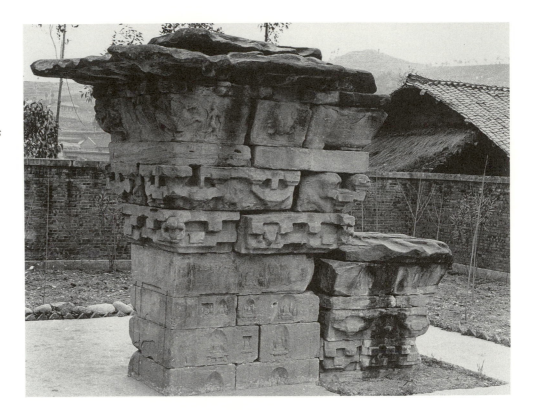

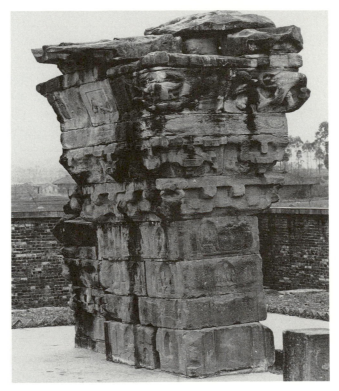

23. Pingyang que *(right).*

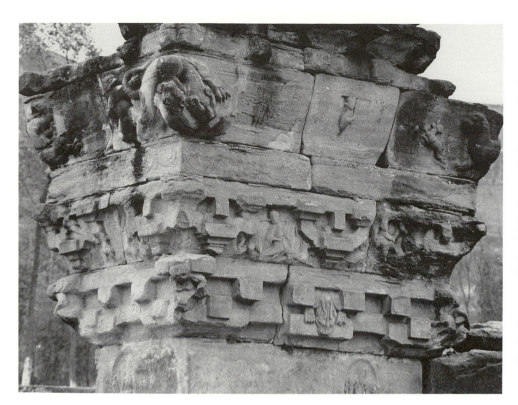

24. *Upper southern face of Pingyang* que *(left), showing figure in half-opened door. The theme of a man pulling or trying to catch the tail of a wild beast, seen on the upper southwest corner, recurs several times in Sichuan* que *decoration. It may stem from a second-century work, the* Huainanzi, *in which a long-vanished time of perfect peace is recalled: "Tigers and leopards could be pulled by the tail; vipers and snakes could be trod upon"* (Huainanzi, *8/5 a-b).*

made in other materials, such as wooden memorial stelae and coffins, were now copied or made in stone. These stone objects were covered with sculptural decoration: from large spirit road monuments carved in the round to small engraved reliefs on tomb bricks, the choice of subject matter and message conveyed was of a piece. The spirit road was thus only part of the much larger tomb complex.

The Han imperial tombs were heavily plundered after the fall of the empire; their surface monuments were destroyed and little remains apart from tumuli. There are references to stone horses and elephants on imperial spirit roads, but as yet their exact content has not been established.[2] (A possible imperial statue, a stone elephant found near Luoyang, is described below in the section on animal statuary.) By good fortune, however, the tomb monuments of several high officials have been preserved, and from these and from historical records the general structure of non-imperial Eastern Han spirit roads is clear. The tumulus and sacrificial hall were set in a square walled enclosure on a north-south axis. Leading from the south to the southern gate of this enclosure was an avenue consisting of three sets of stone monuments: monumental towers, or *que*; animals and/or humans; and memorial stelae, or *bei*. This basic pattern lasted throughout the history of the spirit road. Each set had its functions; over the years

Chart 2

25. Fan Min que *(east) and felines, Lushan, Sichuan, A.D. 205. The* que *is made of soft red sandstone and the sculptural decoration is badly eroded. Height of* que *c. 5.5 m.*

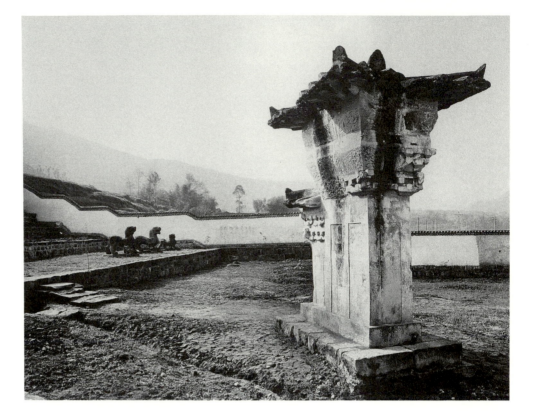

the size, shape, number, and relative importance of the figures within the set varied according to the circumstances and beliefs of those who erected them. Each monument had representational and symbolic attributes subject to similar fluctuations: sometimes the reflection of reality, the emphasis on worldly power, was paramount; at others, the dominant impression was one of supernatural ability to help or protect. The combination of the different elements, however, always produced a picture of a desired state of affairs which the existence of the spirit road would help to bring about.

Of the three sets of spirit road monuments in the Eastern Han, the towers, or *que*, held pride of place. Not only were they the largest of the three; they were also the most expensive. A *que* cost nearly four times as much as a stone lion, ten times as much as a memorial stele.[3] Their original preeminence still holds good and these stone constructions are among the most valuable archaeological remains from the Han period in China. They provide a clear example of Han architectural styles; their decoration includes detailed engravings of contemporary activities, of historical events, legends, and beliefs, whilst the ensemble illustrates a highly developed mastery of stone sculptural techniques. As Lartigue concludes: "Ils sont pour l'histoire de la sculpture chinoise les documents les plus importants qui aient été consultés jusqu'içi."[4]

Colour 1

22–27

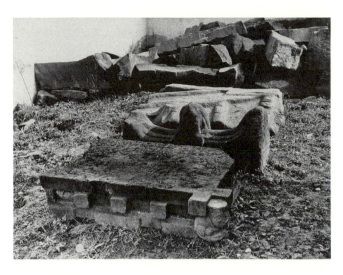

26. *Parts of Fan Min* que *roof with small atlantean beam support.*

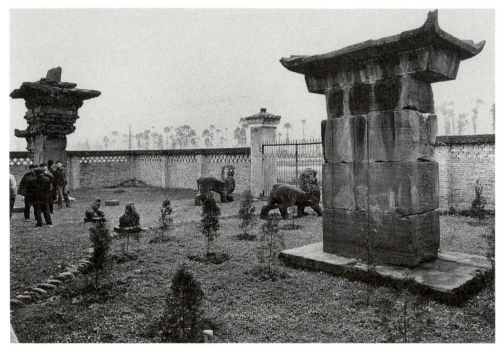

27. *Gao Yi's* que *and felines, Ya-an, Sichuan, A.D. 209. This site has one of the most complete sets of Eastern Han tomb statuary. The western* que *is well preserved; the eastern* que *has lost its upper section and carries a Qing roof. Originally the larger felines faced each other 16.4 m apart, 43 m south of the tomb. The small seated lions are Qing.*

Some thirty stone *que* have survived; the majority are in Sichuan; the others, including three at Dengfeng, Henan, which were placed in front of temples rather than tombs, are in Henan and Shandong. (These provinces are all famous for their stonework; tomb *que* in regions where stone was not so readily available were made in wood and have therefore perished.) There are various reasons for the preponderance of surviving monuments in Sichuan: the original number may have been larger—under the Eastern Han, Sichuan was already a prosperous area with a large population and correspondingly large number of senior officials entitled to *que*; geogra-

phy certainly played a part. Even today the remaining *que* are for the most part in mountainous, relatively inaccessible regions, and it is noticeable that whilst detailed analyses of the Henan and Shandong *que* have been made, the only serious Western investigation into Sichuan *que* is that made by Segalen in 1914. As will be seen below, the Sichuanese *que* form a separate group distinguished both in form and style of decoration from those in Henan and Shandong.

These *que* are reproductions in stone of Qin and Han wooden towers used in lay architecture to distinguish the entrance to important buildings such as palaces, offices, and temples. The towers were always placed in pairs, framing the approach. Each *que* consisted of a main tower which stood either alone or with one or two shorter contiguous "supporting towers." These were known as single, double, or triple *que*, and their use was regulated according to rank. The triple were reserved for the emperor; the double for the four highest ranks of officials corresponding to provincial governors or above.[5] There are no extant examples of stone triple *que*, but earthen examples have been excavated at palace gateways; most of the Sichuan *que* are double.

The history of such towers is very ancient. Originally they were part of the gate in city or palace walls, and some form of earthen *que* have probably existed since the earliest walled enclosures. At an early stage they were detached from the wall and placed as independent structures in front of the entrance.[6] Records of *que* go back as far as the Zhou dynasty; Qin Shihuang had *que* in front of one of his palaces[7] and by the Western Han they were a prominent feature in palace architecture, where their distinguishing characteristics were double or treble roofs and height. A contemporary poet describing one of Han Wudi's palaces refers to "the Heaven-reaching *que* of the gateway" which were surmounted by bronze phoenixes. Rubbings of Eastern Han tomb bricks show numerous examples of *que* outside the entrance to large houses or palaces. Occasionally the pair of towers are joined by a covered bridge, creating an archway, but usually, like the tomb *que*, they stand independently in front of the entrance.[8] The close correspondence between these pictures of wooden *que* and the stone tomb examples reinforces the belief that the latter were accurate reproductions of contemporary structures and as such a valuable source of material about Qin and Han building techniques.

There is an important architectural difference between the *que* of Shandong and Henan and those of Sichuan: in the former the body of the tower is regular with flat sides carved with friezes reaching up to the overhanging roof; in the latter, the upper part of the body is irregular, consisting of overlapping layers of stone. These, carved like wooden roof brackets, carry much of the sculptural decoration. The Sichuanese *que* roof structures are

24

28. House with pair of que, rubbing of brick from Eastern Han tomb, Yinan, Shandong. The area between the que *and the main door belongs to the house and servants can be seen preparing food; the horses and chariot remain "outside the* que.*" (From Chen Mingda, "Han daide shi que," p.17.)*

unlike those found in Han pottery tomb models of houses from the same region and suggest that the two distinct styles of building known under the Song and later were already developed under the Han.[9]

The practical role of the *que* was to proclaim the status of a building; they were symbols of authority and as such were used to display government proclamations and official decrees.[10] As well as signalling status, *que* marked a boundary. It is clear both from tomb brick pictures and from literary sources that the frontier between a building or city and the area outside was marked not by the gateway but by the *que* which stood outside the gate. Outside the walls but "within the *que*" was still part of the complex; the outside world began beyond the *que*. A rubbing of a tomb brick from Yinan shows the situation very clearly: outside the palace walls but within the *que* the cook and other domestics are working; here hangs the house bell and on the ground are various household objects. Outside the *que* are two tethered horses and a chariot with horse and driver: this is the equivalent of being in the street.[11]

This form of architecture was highly symbolic. By its height the *que*, like other towers, provided a possible link with heaven. Height in architecture was a perquisite of royalty, of the Son of Heaven. Height in itself symbolized a link with what was above; there was also a connotation of purity. We have seen that the Eastern Han conceived the universe as two parallel systems; according to one view these two were joined by a column—a Jacob's ladder for the use of spirits and mortals passing from one world to the other. A tall tower became the symbol of such a link, and towers were decorated to provide a pleasing ambiance for spirits.[12] The pair of *que*, as a gateway, symbolized the passage of the soul of the deceased into the spirit world. They marked the pathway along which the coffin was carried to the tomb, point of departure for the journey to the next world. This symbolism is stressed by the use of the term "spirit road" in most *que* inscriptions. A common form of inscription is "the spirit road (*shen dao*) of the deceased X, governor (or similar rank) of Y . . . under the Han dynasty." Short and to the point, it identifies the worldly status of the deceased whilst referring to his spiritual journey.[13]

The remainder of the sculptural decoration provides a great, still relatively

28

1

2

3

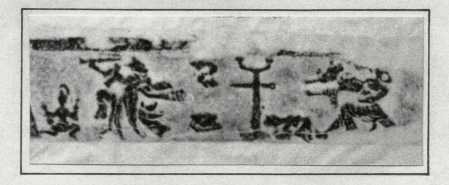

4

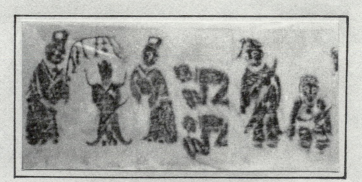

5

6

untapped source of knowledge about Han customs and ways of thought. The carving on the *que*, like the entire stone decoration of the tomb, above and below ground, placed the tomb in its correct relationship to the cosmos and stressed the parallel hierarchies of this world and the next. Frequent use of the four mythical directional beasts—the Green Dragon of the east, the White Tiger of the west, the Black Tortoise and Snake of the north, and the Vermilion Bird of the south—ensured that the *que* filled its allotted space in the universal order; this was essential if cosmic harmony was not to be disturbed. A north-south orientation was assumed even when the lie of the land did not permit it in practice. The green dragon of the east was thus always on the right as you faced the tomb, the white tiger of the west on the left.

The entire subject matter is symbolic, exemplifying belief in the power of an image to bring about that which it represents. On the flat sides of the body, above the inscription, engraved friezes of social and ritual events such as military processions and hunting and banqueting scenes are designed to strengthen the political structure of that society.[14] In the upper sections, moral behavior is encouraged by depictions of legends and historical incidents—such as Jin Ke's assassination attempt on Qin Shihuang or the Western Zhou regent, Duke Zhou Gong, refusing to usurp the throne of his nephew, the lawful king. Winged spirits and wild fighting beasts call to the inhabitants of the other world who could help the deceased on his journey to the land of the immortals.

The architectural difference between Sichuanese and other *que* mentioned above affects style. The Shandong and Henan friezes are strictly schematized and little more than engraved on the flat surface of the tower body; the decoration of Sichuan *que* is altogether more exuberant, influenced by the art of the Dian minority in southern China in which struggles with nature and wild animals play a large role. These Sichuanese irregular upper sections are masterpieces of sculpture. There is a perfect sense of composition—figures carved almost in the round are fitted in between, behind, and around the imitation roof brackets. The corners are rounded by large animals in motion—pairs of intertwined felines or a prancing horse or tiger. The successive layers slope outwards so that every detail is visible from the ground.

Certain symbolic themes recur. An interesting one is the figure, usually female, looking round or beckoning through a half-open door. It occupies a central position in the southern upper face of the *que* and appears on stone coffins and stone tomb chamber doors.[15] According to Daoist mythology, the entrance to a grotto was a boundary between the world of spirits and the world of men, between mortality and eternity. The underworld was *yin*, the female component of *yin-yang*, and Tang poets mention *yin* being

29. Rubbings: (1, 2) Spirit leading a winged horse and a feline following a small hare, Pingyang que, corner carvings, upper roof section. (3) Border between upper layers engraved with spirits, strange monsters, and possibly the Queen Mother of the west on a two-headed throne. Pingyang que. (4) Historical scene: Jin Ke's assassination attempt on Qin Shihuangdi. Upper roof section, Gao Yi que. (5) Moral scene: Duke Zhou Gong refusing to usurp the throne from his young nephew, King Cheng (under a panoply). Upper roof section, Gao Yi que. (6) Border between upper layers, Gao Yi que.

30. *Eastern Han stone coffin, Chongjing Museum, Sichuan, with figure in half-open door and a pair of* que. *Note the distinctive use of the chisel to emphasize different planes.*

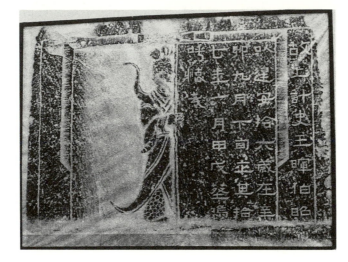

31. *Southern end of stone coffin of Wang Hui, d. A.D. 222, Lushan, Sichuan, with crowned and winged figure standing in half-open door. Unlike other Sichuan examples, this stone coffin is carved to imitate a wooden coffin made from a single large, ribbed tree trunk.*

represented by females welcoming worthy souls leaving this world.[16] The in-betweenness shown in these scenes—the door half open, the figure half in and half out—symbolizes the position of the deceased and the function of the tomb as a contact between two worlds. Here again is a reference to the journey into the dark which the soul must take; here is the hoped-for helper who will guide his way. Other themes are less easy to explain. As it is with the symbolic frieze along the top and bottom of the Bayeux tapestry, the events or legends to which they refer which would have been familiar and readily understandable to contemporaries have now been forgotten and their significance is hard to grasp.

The spirit road *que* is an Eastern Han phenomenon. A few examples of stone *que* from the third and fourth centuries have been found in Sichuan, but these are all in remote regions cut off from the mainstream of development, and under later dynasties the role of the tomb *que* was filled by a pair of pillars. Earthen *que* continued in use in secular and tomb architecture for nearly a thousand years: in Tang and Song tombs these purely architectural features acted as territorial markers and symbols of status, but they were undecorated and carried no symbolic message.[17]

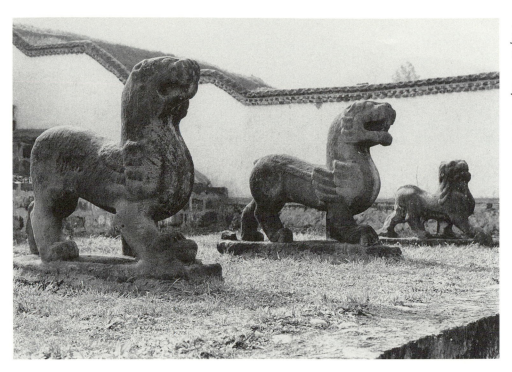

32. *Fan Min tomb. The felines were moved into the present enclosure in 1956; in 1914 Segalen found the two larger beasts facing each other in situ. Height of felines c. 1.5 m, 1.5 m, and 1 m.*

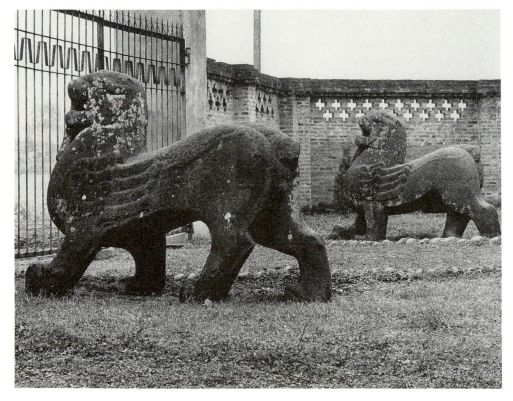

33. *Gao Yi felines, clearly carved to be seen from the side. Height 1.1 m; length 1.9 m; width 0.5 m.*

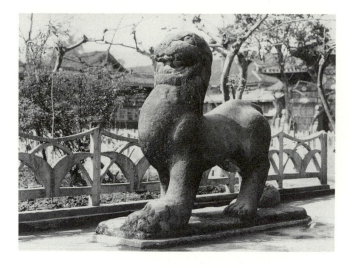

34. Stone feline from early second-century tomb of Minister Ling Di in the Eastern Han state of Shu (Sichuan), Lushan Cultural House, Sichuan. Height 1.67 m.

The stone *que* had replaced the wooden *que* outside the temple or hall in which the sacrifices had previously been held. The next section of the spirit road, the stone men and animals, replaced the living guard of honour lining the temple approach. Like their living counterparts, they existed both as guardians and as status symbols. The number and nature of the sculptures proclaimed the status of the deceased.

The inclusion of animals in such a guard arose from the cosmic significance of the spirit road: these guards had to provide protection in the spiritual as well as the physical world. For such a task, animals were the natural choice. There was, as we have seen, an ancient link in Chinese thought between animals and the spirit world;[18] the symbolic use of animals for spiritual purposes was deeply entrenched in Chinese society, and when the Chinese wished to create a being with supernatural powers they tended to give it animal form. Not only the helpers of the immortals were animals; those who attained immortality frequently reappeared as animals: Heng He, who stole the elixir of immortality, was transformed into a hare which can still be seen with his pestle and mortar in the full moon. Stone beasts similar to those which had been placed on tomb mounds in the Western Han dynasty or earlier were now brought into the systematized framework of the Eastern Han tomb.

Both stone animals and stone officials have been found from the Han period, but so far not on the same tomb. It is not clear whether they were alternatives, whether the choice depended on rank or was a regional difference. The surviving statues of animals far outnumber those of humans, and the wide variety of animal subjects mentioned in literary records includes horses, elephants, rams, sheep, oxen, camels, tigers, and fabulous beasts.[19] The first two seem to have been reserved for imperial spirit roads; a few

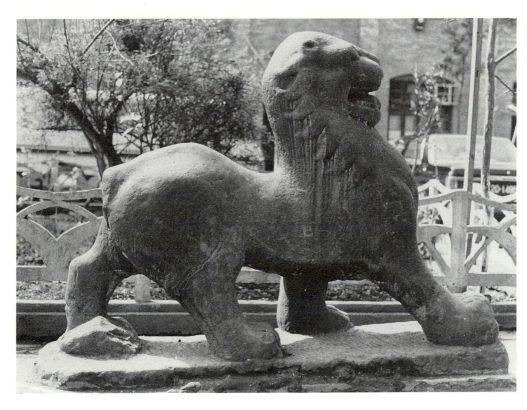

35. Stone lion from tomb of Minister Ling Di, Lushan Cultural House, Sichuan. Height c. 1.6 m.

stone sheep and rams have been found, but the majority of extant sculptures from this period are based on the tiger. The tiger appears in many guises: as a tiger or lion with or without wings or other supernatural attributes, and in a variety of fabulous forms known by ancient names for beasts with mythical qualities. The tiger was well known to the Han; it was the king of the wild, symbolizing courage, dignity, and military prowess. As dragons could summon rain, tigers could summon the wind, a vital means of communication with the spirit world.[20] The powers of the tiger were limitless, paralleling the power of the ruler, and its presence on a tomb was therefore a sign of harmony between the political and natural orders. It was above all a guardian against evil spirits (it was particularly effective against the dreaded *wang liang*, which ate dead men's brains), and even today tigers are embroidered on the slippers and caps of small children as a protection against evil.

When the lion appeared, it was as an alter ego of the tiger. Unlike other spirit road beasts, the lion had no history in Chinese art and literature; it was not native to China—lions had been received as tribute from the first century onwards, but they were confined to the imperial menagerie—and general knowledge of the lion was limited to drawings or hearsay.[21] It was known to come from the West (the White Tiger symbolized the West) and,

32,33

34,35

36. Eastern Han winged feline, Guanlinmiao Museum, Luoyang. Height c. 1.5 m.

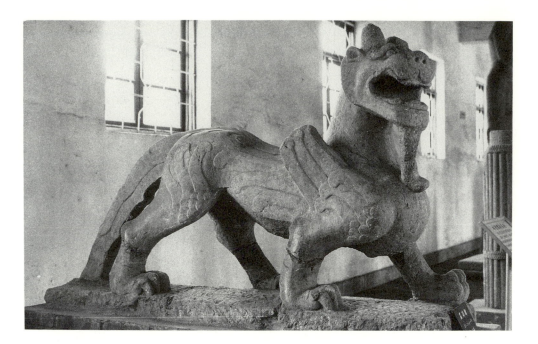

like the tiger, to be a king among beasts and a fearless hunter. For the Chinese it was the qualities of the animal rather than its exact appearance that mattered, and the lion and tiger were recognized as beings of the same ilk. The only distinction between Han lions and tigers is that the former are shown with large manes.

The addition of wings, horns, and beards seems to have been a question of choice or style rather than principle, and there is no indication in surviving statuary from this period that a figure with these supernatural signs enjoyed a higher status than an unadorned tiger. Among the remaining beasts in Sichuan and Shandong there is little difference in the general appearance between those with wings and those without; the wings are modest and lie back along the flanks. In Shaanxi and Henan, however, there was a preference for more fanciful forms: inspired by earlier talismans such as the beautiful silver inlaid bronze chimera found in the Warring States period tomb of the king of Zhongshan, tomb felines are sinuous, with elongated necks and prominent, convincing wings. Sometimes the name of a mythical creature was carved on its flank or shoulder.[22] There was a wide choice of names, but the most popular were *tianlu, bixie,* and *qilin.*

These names had a long history. Ancient Chinese texts abound with descriptions of mythical beasts and the same name had many definitions, the same beast many names. In the Han period, for example, the *tianlu* had the symbolic and basic physical attributes of a tiger, but the common translation for its name is "heavenly (*tian*) deer (*lu*)" and earlier versions of the species are described as a kind of winged deer.[23] In the end what mattered was

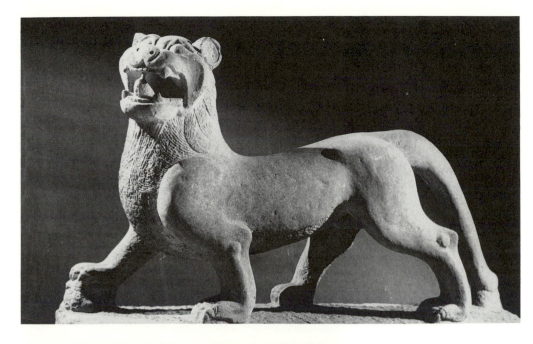

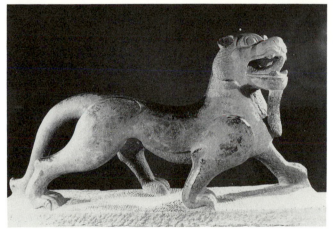

37, 38. Stone felines,
second century, Shaanxi
Provincial Museum.
Height 1.05 m, 1.09 m.

the animal's function. Its appearance and name must suggest its abilities. *Bixie* meant "repel evil"; *qilin* (often confusingly translated as "unicorn") was anciently the name for a pair of creatures, the female being the *lin*.[24] Like the *tianlu* it brought good fortune and its appearance just before the birth of Confucius gave it an association with good government and peace or stability.

These creatures were all talismans and small versions were worn like modern charm lockets or bracelets. A sixth-century historian writing on costumes in the Han dynasty noted that when empresses visited the ancestral temples, they wore pendants in their headdresses "in the shape of bears, tigers, *tianlu* and *bixie*," and the highest-ranking imperial princes

39. *Stone feline, tomb of Zongzi, Nanyang, Henan, c. A.D. 167. Height 1.65 m.*

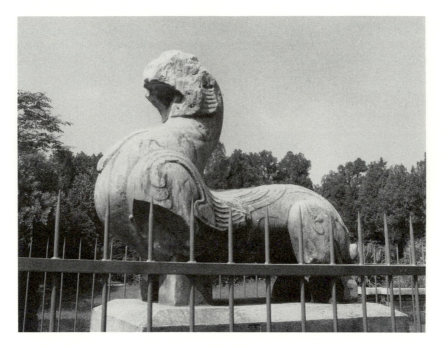

and princesses "were accustomed to wear a buckle in their sash in the shape of a golden head of a *bixie*, adorned with white pearls."[25]

The combination of Han Confucian orthodoxy and the ceremonial requirements of the spirit road had a decisive influence on sculptural style. The orientation, size, and shape of spirit road animals were determined by the overall tomb plan, and never again is a tomb statue inspired by the shape of the stone. These statues, like the "horse trampling a barbarian," retain the rectangular shape of the block from which they were carved. The statues were designed to face each other across the spirit way, and detail was concentrated on the flat flanks which would have faced the tomb visitor. All but one of the known surviving felines adopt the same stance.[26] They walk forward, with the forefoot nearest to the grave in front; often this rests on a small creature. Their heads are lifted, the mouth is usually open, sometimes with a ball in it or with the tongue hanging out. Compared with later spirit road figures they are small: the tigers on the tomb of Gao Yi, for example, are little more than one metre high, 1.9 metres long, and 0.5 metres wide; those on the Fan Min tomb at Lushan range from 1.5 metres to barely one metre high.

Despite their narrow framework, these Eastern Han felines are alive. Concentrating on the essence of the creature, the sculptors have created figures which convey all the qualities of a wild and powerful hunter. Carving is still kept to a minimum but the stance of the beast, the hunched shoulders, and muscular back give a vivid impression of strength, suppressed energy, and speed. Their symbolic message is clear.

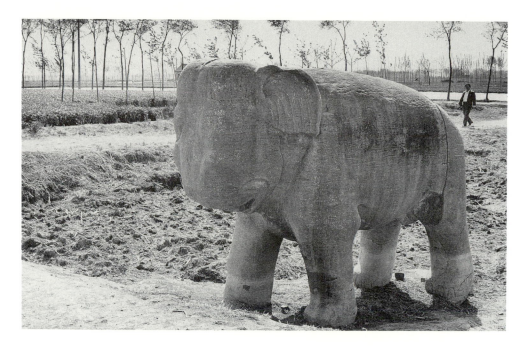

40. *Stone elephant near White Horse Temple, Luoyang, Henan. Han dynasty? Height 2.4 m; length 3.5 m; width 1.2 m.*

Before leaving the animals, it is worth mentioning a possible Han stone elephant which has recently been found a few kilometres from the White Horse Temple, near Luoyang in one of the two Eastern Han imperial tomb areas. It is notoriously difficult to date a stone statue unless there is a correspondence between the site and historical records. There is no scientific method of dating stone, and without evidence of the use of a dateable sculptural tool, the method of carving is of little help. Style is unreliable; it can provide an earlier limit but does not exclude conscious archaism in later periods. In this case, the evidence is circumstantial.

The elephant bears all the marks of a spirit road animal. It stands on an east-west axis facing east and according to villagers there was another elephant fifty metres to the east, facing it, which is now unfortunately submerged. The animal is large—2.4 metres high, 3.5 metres long, and 1.2 metres wide—and stands in a typical Han spirit road position, that is, walking. (From the Tang onwards, spirit road animals stand still.) There are records of elephants on the tomb of the first Eastern Han emperor, but a north-south line between these elephants does not lead to any known Han mausoleum. They stand, however, two kilometres south of a group of five Eastern Han mausolea at Mangshan, and it has been suggested that they may have marked the entrance to the imperial grave area. Elephants were placed on Song imperial tombs, but there are no known large non-Han tombs in the vicinity.[27]

Very few Eastern Han spirit road officials have survived and none of those known are still in situ. The best-preserved are a pair of guardians now in

40

41. *Civil official from tomb of an Eastern Han duke of Lu; one of a pair now in courtyard of Confucian family palace, Qufu, Shandong. Height 2.54 m.*

41,42 the Confucian Temple at Qufu, Shandong; another pair, more worn, are at Dengfeng, Henan, and the head of a stone man has been found in Sichuan. Inscriptions on the Confucian pair identify them as a military official and a civilian official holding a high position in the ceremonial rites. This idea of providing the deceased with representatives of the two main branches of power persisted throughout the later history of the spirit road; their relative precedence and their accoutrements always reflected reality.

 The best examples of human statuary from this period are nonfunerary—
3,43,44 the statues of Li Bing and his companion with a spade, found in the bed of the River Min during work on the site of Li Bing's original irrigation works at Dujiang Weir, Sichuan, in 1974 and 1975.[28] The records relating to these statues throw an interesting light on the purposes for which stone statuary was created. (It should be remembered that before Buddhism had introduced an alternative tradition of stone sculpture, there was no apparent distinction between funerary and nonfunerary stone figures; all were governed by a common set of conventions which persisted in the spirit road tradition after other branches of sculpture had succumbed to Buddhist influences.)

42. *Military official, tomb of an Eastern Han duke of Lu, Qufu. Height 2.5 m.*

The statue of Li Bing is identified by an inscription referring to "the prefect Li Bing" and "the making of three gods to perpetually guard and preserve the waters" in a date equivalent to A.D. 168.[29] This text and the site of the two figures give weight to third-century B.C. records of the stone statues of five rhinoceroses and three men which Li Bing is said to have had made after the completion of his vast irrigation project.[30] One rhinoceros is said to have stood in front of a temple, another in front of an official building; the remaining three and the three men were placed in strategic points in the river system. The original account makes clear that whereas all the figures were intended to reinforce the system of water control by influencing the water spirits, the men, unlike the rhinoceroses, also served a practical, educational role. They were sited and designed as water gauges: if the water fell below the level of their feet, it was time to take precautions against drought; if it rose above their shoulders, against flood.

The recently discovered figures appear to be replacements for the original three stone men and served similar purposes. By reminding people of Li Bing and his exploits, they brought home the need for irrigation works and, through the spade, to dig deep canals. (It is an ancient Chinese axiom that

43. *"Man with a spade,"
found in 1975 near statue
of Li Bing at Dujiang
Weir, Guanxian,
Sichuan. A wooden spade
with a replaceable metal
cap similar to the one
shown here was found
during the excavation of
the Western Han tombs at
Mawangdui, Henan.
Fulong Temple,
Guanxian, Sichuan.
Height without head,
1.89 m.*

successful flood control demands deep canals, low dykes.) Designed like
their predecessors as water gauges, the figures provided technical help in
water control and, by representing those who subdued the turbulent River
Min, exerted power over unruly water spirits.

Although parts of each statue have been worn smooth by the current,
the river mud acted as an excellent preservative and the sculptural details
are surprisingly well preserved. The statues are large—Li Bing is nearly

44. Detail of figure 43.

three metres high—and perfectly proportioned. In this, the earliest known Chinese statue of an identifiable person, all the conventions which govern later stone portraiture are already present. Both figures are shown full-length, facing forward: Li Bing has his hands clasped in front of him; his headless companion holds a spade in exactly the same way as later stone warriors hold swords. The face of Li Bing reflects the wisdom and dignity of a hero-sage.

Thanks to the good condition of the stone, it is possible to see the distinctive Han use of a chisel for decorative effect. Parallel rows of narrow chisel strokes were used to accentuate the difference between two planes; the direction of the strokes changed with the plane. The same technique can be seen on Han stone coffins and tomb doors, where contrast between chisel marks and smooth sections emphasized subject matter or movement; sometimes the round subject of a relief would be striated whilst the background was worked smooth; at other times the background was striped and the raised subjects smooth.

The last monuments in the spirit road—the memorial stelae—were copies

30,44

45. *Gao Yi stele on square base carved with directional symbols: Green Dragon of the east and White Tiger of the west.*

in stone of earlier wooden stelae. The wooden stelae had a history as ancient as that of the wooden *que*. Originally a pair of stelae, each with a hole through which a rope was threaded, were used to lower the heavy coffin into the grave. After the burial, these wooden slabs were inscribed with the titles and dates of the deceased and placed upright on his tomb. Although no longer of practical use, this hole was retained in stone stelae until the Tang dynasty. Han stelae have been found with both pointed and rounded crowns;[31] the crown was decorated with hornless dragons and the inscription was asymmetrical, to one side of the central hole. Some stelae, like that of Gao Yi (A.D. 209), in Sichuan, had square bases circled by dragons; others had tortoise bases. The tortoise base was a Han innovation; the earliest known example is on the Fan Min tomb (A.D. 205) in Sichuan, but there are records of such bases from the preceding century. (The tortoise was chosen as one of the nine sons of the dragon, the *ba xia,* renowned for its ability to carry heavy weights.)[32]

Under later dynasties the spirit road expanded; at times it was over a kilometre long and had a hundred or more stone figures. All the basic fea-

46. The earliest surviving example of a tortoise-based stele, Fan Min tomb.

tures of the later avenues were, however, present in these earliest examples. The spirit road which emerged under the Eastern Han was an amalgam of Han Confucian philosophy and tomb practices and much earlier unwritten beliefs in the inherent powers of stone sculpture, the importance of symbolism, and the role of animals as links with the other world. It was a status symbol; in accordance with the maxim that the dead must be treated like the living, it reflected real life. At the same time it addressed the other world, providing contact, protection, and help for the problems of this world and for the perilous journey to the next.

4 THE PERIOD OF DISUNION

During the Period of Disunion which followed the fall of the Han empire, the history of the spirit road was nearly as complicated as the political situation which it reflected. No less than thirty dynasties assumed power in 360 years. In the Three Kingdoms period (220–280) which followed the Han, some Han-style monuments continued to be made in the western kingdom of Han Shu, and a few *que* have survived from this time in the remoter parts of Sichuan. In another of the kingdoms, however, the Wei dynasty led a reaction against Han tomb extravagance and spirit road statuary—a reaction which eventually spread throughout the country. For nearly a century there was a break in the spirit road tradition. When it was resumed towards the end of the fourth century, the country was divided into two: the north, under non-Han nomadic tribes who espoused Buddhism, and the south, under traditional Chinese rule. The spirit road developed differently in the two halves of the country.

The first Wei emperor, Wei Wudi (Cao Cao), left instructions that his funeral should be kept simple and that no jade, gold, or treasure should be buried in his tomb. His son, Wei Wendi, carried this further and, in a general attack on funeral extravagance, specifically declined the use of stone figures for his own tomb.[1] The Wei example was followed by the succeeding dynasty, the Western Jin, and an imperial decree of 278 stated that "stone animals and memorial stones . . . were more injurious to the people than anything else in exhausting their wealth and were therefore entirely forbidden and abolished."[2] These regulations seem to have been obeyed. No spirit road statues from this period have been found; their role seems to have been entrusted to stone guardians carved on the posts of the underground doorway leading to the tomb chamber, whilst a stone "tomb tablet" took the place of the memorial stele.[3] (At first this was shaped like a stele with a rounded top, but later it was reduced in size to a small square block, often with a lid.)

This reaction against Han funeral ostentation was partly dictated by economic necessity, partly by a recognition of the social burden and misery caused by competitive expenditure on tombs. It was strengthened by a rec-

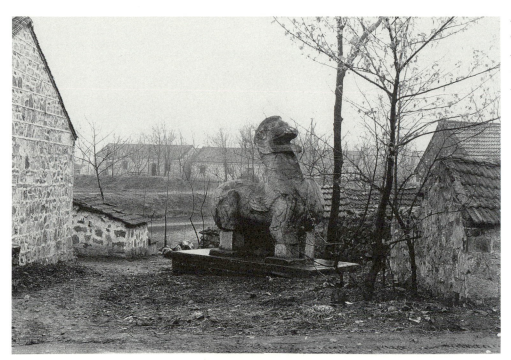

47. *Earliest known example of a Southern Dynasties* qilin, *tomb of Song Wudi (d. 422), Nanjing, Jiangsu. Height without legs, 2.56 m; length 3.18 m.*

48. *Tomb of Song Wudi, eastern* qilin *visible above village rooftops.*

ognition that the very magnificence of the Han mausolea had carried the seeds of their destruction: all the Han imperial tombs had been sacked and robbed during the last days of the empire.

Slowly, however, the deep-rooted wish to give visible proof of filial piety and respect for ancestors reasserted itself. In the south the spirit road revived and blossomed, producing some of the finest stone sculpture in the round ever made in China. It is not clear exactly when the use of tomb statuary was resumed, but there are records of tombs with spirit roads from the Eastern Jin (317–420). A Tang dynasty poet refers to stone animals on a ruined imperial grave from this period,[4] and a Song diarist, Lu Yu, records that when he was travelling in present day Jiangsu in 1170, he was told that

49. *Tomb of Song Wudi, western* qilin. *Height 2.8 m; length 2.96 m.*

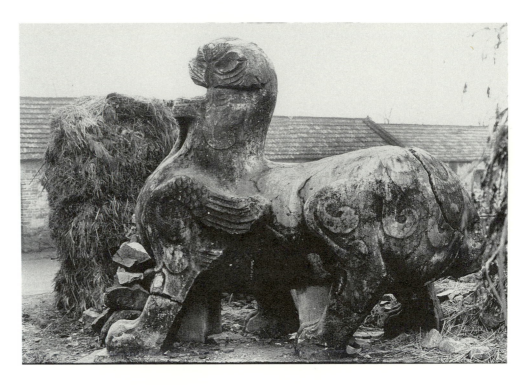

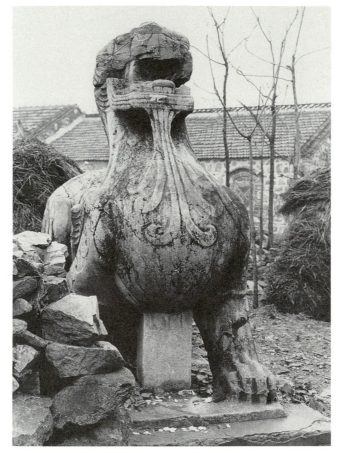

50. *Tomb of Song Wudi, western* qilin.

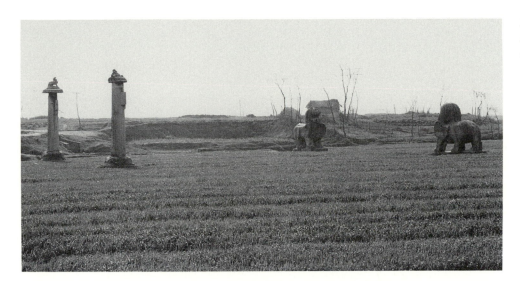

51. Statuary on tomb of Liang prince, Xiao Ji (d. 529), Nanjing.

the tomb of the emperor Huan Wen (312–373) was near his lodging. "There are stone beasts and stone horses which are marvellously made, and there is also a stele, on which are carved such things as the carriages, horses, and attire of that time. It is well worth seeing. I regretted that I had never been there."[5] The mention of stone horses is interesting: horses are mentioned on Han imperial graves, but there are no known stone horses on Southern Dynasties tombs from the fifth and sixth centuries.

Virtually all the surviving spirit road statuary from the Period of Disunion belongs to the last four of the six Southern Dynasties—Liu Song (420–479), Southern Qi (479–502), Liang (502–557), and Chen (557–589)—and is found in the neighbourhood of their capital, Nanjing, and nearby Danyang. Over thirty tombs have been found with surface remains of which nineteen have been positively identified.[6] The earliest post-Han identifiable tomb dates from 422 on the tomb of Song Wudi; from then on the pace of building was striking: in the twenty-three years of Qi rule, eight imperial mausolea were built (for seven emperors and the founding emperor's father); six of the surviving Liang royal tombs around Nanjing were built in eleven years.

47–50

These Southern Dynasties tombs were very different from their Han predecessors. Tombs were small, surface constructions minimal, and the use of statuary restricted to the imperial family. (All the spirit roads so far identified belong to imperial or royal tombs; none have been found from tombs of high officials.) These changes were to some extent dictated by economic conditions. Political fragmentation, with frequent dynastic upheavals and warfare, led to a declining population and a stagnant economy in which whole regions returned to barter. In this climate, large-scale projects like the

52. Qilin *at Lingkou, Danyang. One of a pair flanking the canal built to transport stone from Nanjing for the Qi and Liang imperial tombs in Danyang, late fifth century. In 1170 a Song traveller, Lu Yu, noted that these great beasts had "fallen by the side of the road; they were already broken, and parts were missing" (Chang and Smythe,* South China in the Twelfth Century, *pp. 46–47). Height without legs, 3.8 cm; length 4 m.*

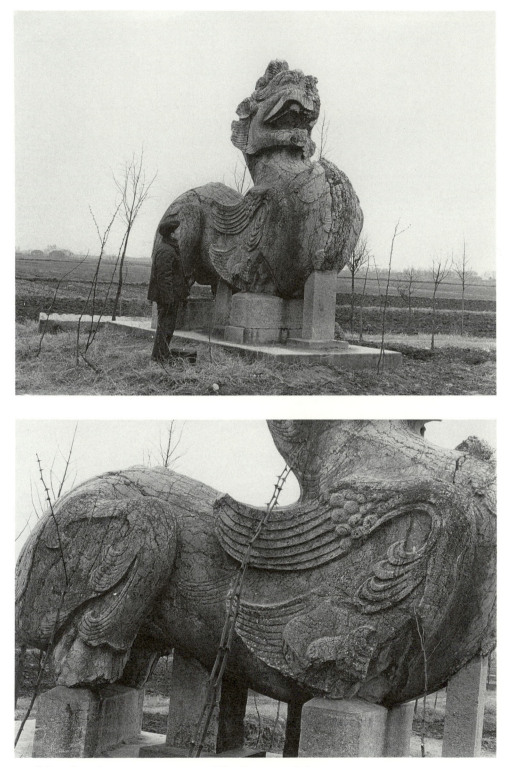

53. Qilin, *Lingkou, wing patterns. The Song used this type of prickly rambler, as effective as any barbed wire, for tomb fences.*

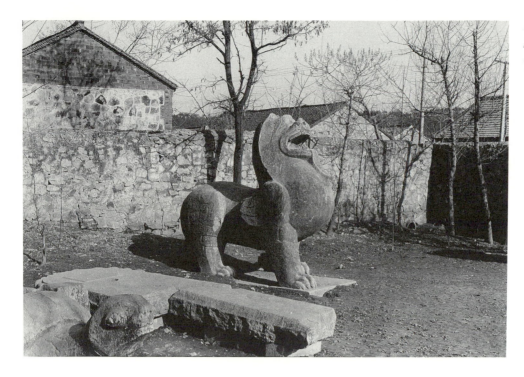

54. Bixie, *tomb of Liang prince Xiao Xiu (d. 518). Height 2.95 m; length 3.35 m.*

Han mausolea—Han Wudi's Maoling took fifty years to build, with a workforce recruited from all over the country—were no longer feasible. Fear of grave robbers or of tomb desecration by political rivals—there are frequent accounts of members of newly established ruling houses deliberately destroying the tombs of their predecessors [7]—reinforced an economical approach and suggested restraint in the use of buildings or monuments which would draw attention to the site of a tomb.

Of equal importance, however, were changes in the intellectual climate. The close association between the Han empire and Han Confucian philosophy meant that the collapse of the former entailed a certain discrediting of the latter. Han Confucian orthodoxy, which had suited the purposes of the official class in a well-ordered, centralized society, offered little help in times of collapse, and Confucian doctrines with their emphasis on this world were unable to satisfy the deeper needs of the people. Beset with problems beyond their control, they sought solace in the metaphysical, turning first to Daoism and then to Buddhism. (Buddhism spread throughout China, but whereas it was the official religion in the north, in the south it was only one of three sets of beliefs, tolerated equally with Daoism and Confucianism.) Daoism breathed new life into literature and art. Han emphasis on spatial relationships, forms, and limits was rejected in favour of flowing lines suggesting flexibility, a lack of clear-cut boundaries, and endless motion. Xie He formulated his Six Principles for Painters stressing the

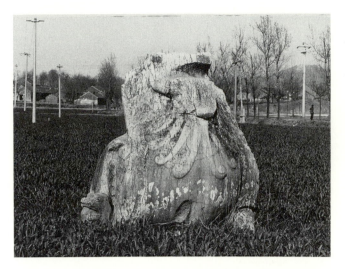

55. Bixie, *tomb of Liang prince Xiao Dan (d. 522), Nanjing. A small cub peering out from the side may have been placed there for structural reasons. Length 3.8 m.*

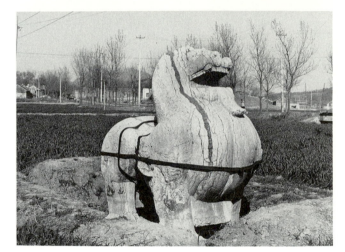

56. Bixie, *tomb of Liang prince Xiao Hui (d. 526), Nanjing. This beast was repaired in the 1950s.*

need to catch the essence of a subject rather than making a faithful reproduction. Typical of the new climate were the changes which took place in calligraphy, which now achieved a preeminence among the arts which it has never lost. Wang Xizhi, an ardent Daoist and one of the great calligraphers of all time, evolved the beautiful Chinese "grass script" (*cao shu*). His characters, "light as a floating cloud, vigorous as a startled dragon,"[8] were cursive and flowing, expressing emotion—very different from the square, clearly defined characters of Han official *lishu*.

Whilst Daoism was affecting attitudes to art, Buddhist immigrants were introducing foreign art motifs from India, Central Asia, and even Europe. Despite the political division of the country, there was a continuous cross-fertilization of ideas: refugees from the north settled in the south, whilst members of deposed Southern Dynasties families and their entourages sought sanctuary at the northern courts. Seldom in Chinese history has

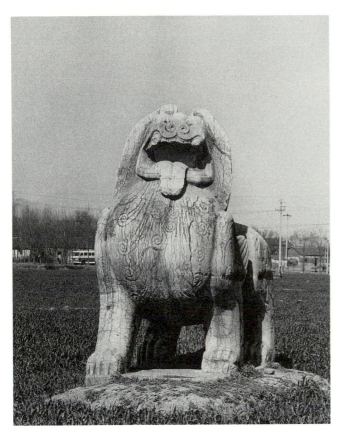

57. Bixie, tomb of Liang prince Xiao Jing (d. 523), Nanjing. Height 3.5 m; length 3.8 m.

there been such an onslaught of new ideas, and foreign influences were accepted, digested, adapted, and then assimilated. In this way Buddhist symbols like the lotus became accepted in the Chinese repertoire of decorative motifs, no longer bearing a specifically religious significance.

These developments affected the tomb layout and the nature and execution of the spirit road statuary of the Southern Dynasties. The influence of the Daoist desire to achieve harmony with nature can be seen in a reinterpretation of the principles of geomancy, or *fengshui*, which determined the choice of an auspicious site. Under the Han, the need to ensure that the tomb was correctly placed in relation to the cosmos was paramount, and good *fengshui* demanded as far as possible a correct north-south axis. Now priority was given to merging with the landscape and an auspicious site was determined by the lie of the land, by the contours rather than the compass. Tombs have been found facing south, west, and east. Tombs were tunnelled into the hillside—"back to the mountain, face to the plain"; ideally the entrance to the tomb was sheltered from view by a fold in the hills. Surface constructions were minimal and placed, with the spirit road statuary, out of sight of the tomb entrance, on the plain below. The tomb area seems to have

Chart 2

58. Pair of qilin *on tomb of Song Wendi (d. 453), Nanjing. These figures were previously attributed to the nearby tomb of Chen Wendi, d. 566. Height of right figure, 3 m; length 3.1 m. Height of left figure, 3.1 m; length 3.19 m.*

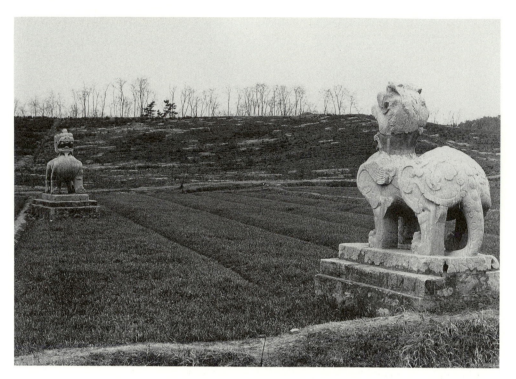

been delimited by corner posts but not walled.[9] (Sacrificial halls are mentioned in the histories, but no remnants of buildings or enclosing walls have ever been found; a stone inscribed with the words "Chuningling northwest corner" was found near the statuary on Song Wudi's tomb, Chuningling.)[10] The way from the statuary to the grave was long and winding, reflecting Daoist ideas of flowing movement. The choice of a mountain site for the underground chamber was partly dictated by practical considerations—the plain was wet, a hillside tomb could be easily drained;[11] it also went some way towards solving the eternal dilemma of how to provide the dead with luxury whilst preserving his tomb from violation. (Even today, the distance between statuary and tomb, often up to one kilometre, poses serious difficulties for archaeologists trying to identify the tomb to which a particular spirit road belongs.) The result was tombs which merged into the countryside—a sharp contrast to the square, fortified Han enclosures with their strict rules of orientation. Small in scale, these Southern Dynasties tombs lacked the grandeur of their Han predecessors, but they enjoyed a feeling of space and unity with the landscape unknown to the Han tomb.

Colour 2, 51,71

The avenue of figures was short and wide, with up to forty-five metres between the two sides. It consisted of a pair of gigantic fabulous beasts, a pair of columns, and one or occasionally two pairs of memorial stelae.[12]

The animals take first place. Much larger than the other monuments, it is they, rather than the columns or stelae, which proclaim from afar the rank

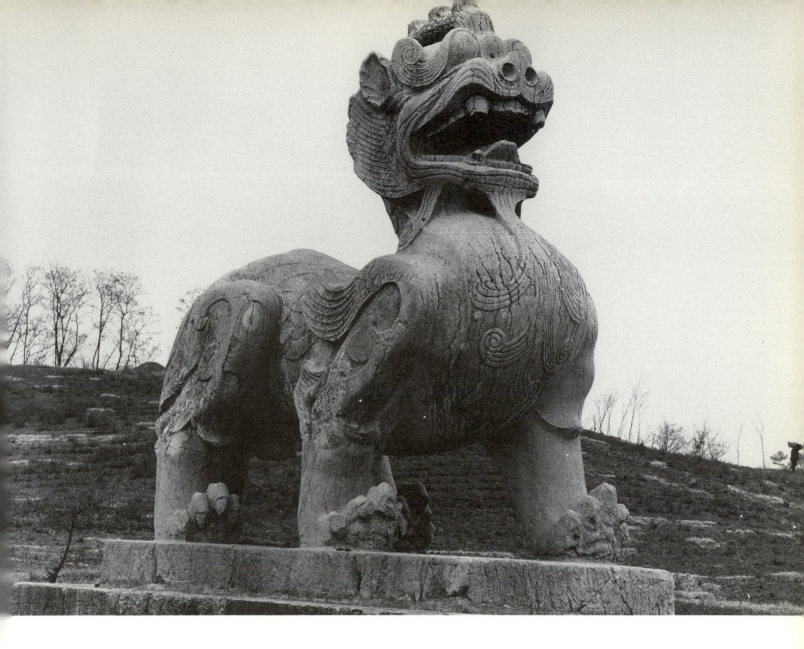

of the deceased. Imperial tombs were guarded by horned creatures with
beards, known as *qilin*; royal tombs by hornless felines known as *bixie*, with
lion manes, large open mouths, and long outstretched tongues.[13] Both sorts
were winged and both are quite literally supernatural, averaging between
three and four metres in height. (The largest pair at Lingkou are nearly
four metres high without their legs.)

The creatures are clearly descended from Han tomb felines. The *bixie*
have evolved from the Sichuan and Shandong tiger type, but there has been
a subtle change: the predatory suppleness of the King of the Wild, with its
hint of speed, has been replaced by a greater emphasis on the regal nature
of the beast. These are solid creatures, four feet firmly on the ground and
strength concentrated in the powerful haunches, shoulders, and the lifted
head apparently roaring to the heavens. (The symbolism of the tongue,

Colour 3
Colour 4

52,53

54–57

59. *Tomb of
Song Wendi,
right* qilin.

60. *Rear part of right* qilin, *tomb of Song Wendi.*

61. *Wing pattern, right* qilin, *tomb of Song Wendi. The four wing patterns are dissimilar.*

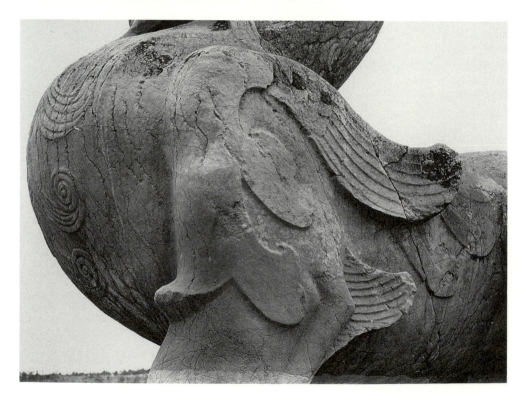

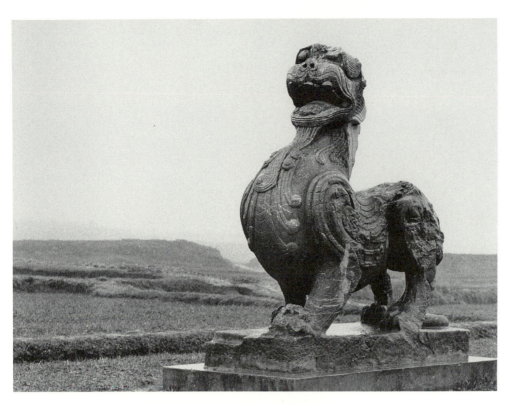

62. Qilin *(right), tomb of Qi Xuandi (posthumously ennobled, 479), Danyang, Jiangsu. Height 2.75 m; length 2.95 m.*

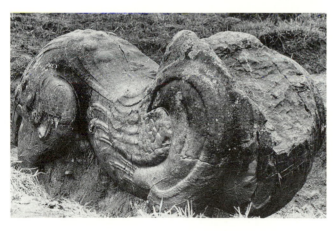

63. Qilin *(left), tomb of Qi Xuandi.*

64. *Pair of* qilin *on tomb of Qi Wudi (d. 493), Danyang, Jiangsu. Height of right* qilin, *2.8 m; length 3.15 m.*

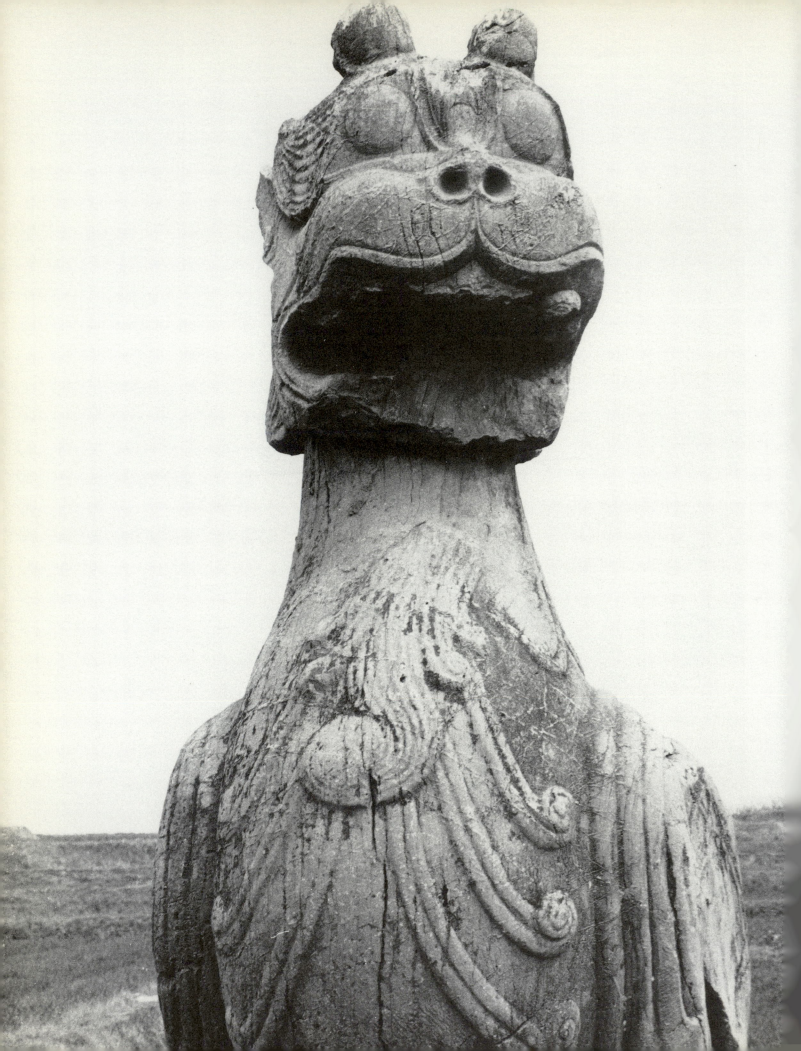

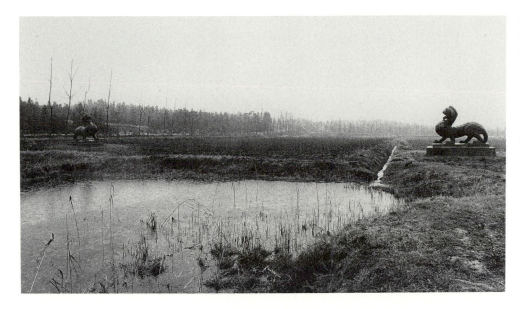

66. Pair of qilin *guarding tomb of Qi Jingdi (posthumously ennobled, 494), Danyang, Jiangsu. Their heads turn towards the grave hidden in the hills more than a kilometre away.*

which must have been readily understandable at the time, is not clear. Some see it as a prayer for rain; others as a form of communication with the other world.)[14] The *qilin* are more elegant; with long, sinuous bodies and serrated spines, they hint at dragon ancestry and are developed from the type of Han tomb beast found in central China, such as the pair at the Guanlinmiao, Luoyang. The talisman origin of these creatures is underlined by their elaborate surface decorations, reminiscent of those found on early bronze, jade, or pottery figurines. Their whole bodies are covered with curves: complicated, upturned wings with delicately carved pinions, whirls of beard and hair on the chest and haunches, and a long coiled tail. Within each group of animals there are considerable variations in form. The post-Han hiatus in the spirit road tradition had given the sculptors an unusual freedom in interpreting their subjects: for once they did not have to copy what their fathers had done and could give fuller rein to their imagination. The time scale and sample are too small to indicate any dynastic development in style, but there are clear regional differences. The Danyang beasts are longer and more serpentine than their Nanjing counterparts; even the otherwise stocky *bixie* take on a certain elegance.

58–78

79
80–82

These Southern Dynasties creatures have been called "the most noble creatures to guard any tomb in Asia."[15] To be appreciated fully they must be seen in their natural habitat, for, like all Chinese monumental sculpture, their size and stance depend on the distance between them and the length of the spirit road. No one who has seen them standing silently in the rice fields, gazing with heads turned up the valley towards a long-vanished tomb, can ever forget the sight. No other dynasty has produced figures with such a monumental presence. The great winged horses of the Tang are compa-

65. *Head of right* qilin, *tomb of Qi Wudi.*

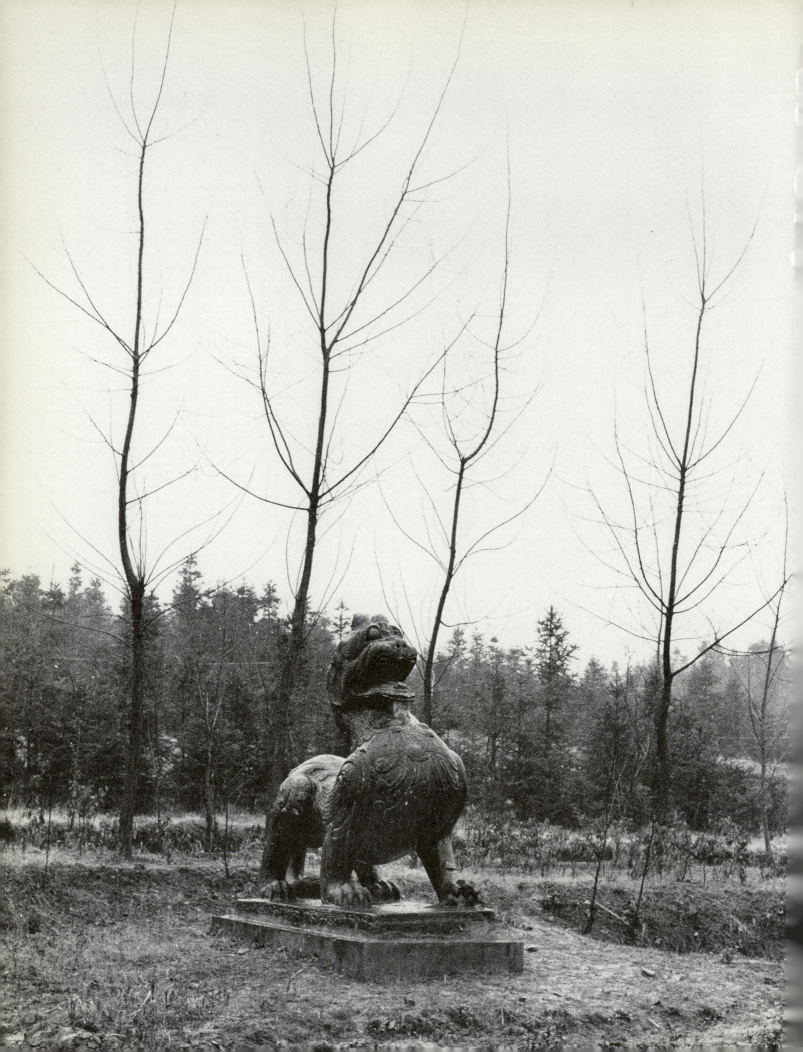

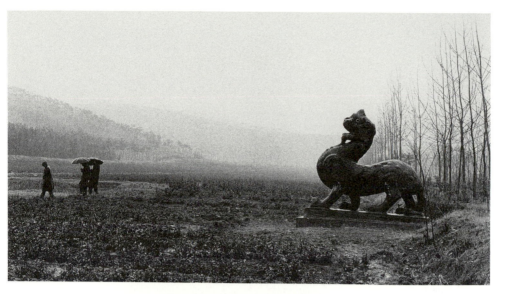

68. *Tomb of Qi Jingdi,* qilin *(right).*

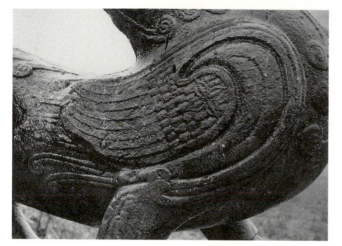

69. *Wing pattern,* qilin *(right), tomb of Qi Jingdi.*

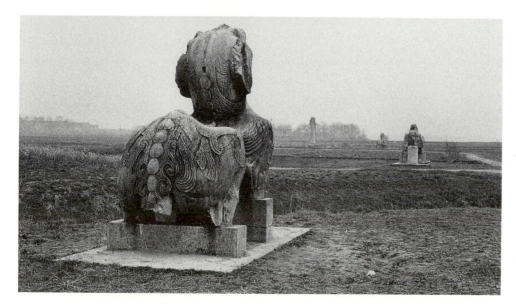

70. Qilin *with distinctive beaded spine, on tomb of Qi Mingdi (d. 498); statuary from the tomb of Liang Wendi can be seen in the background. Height without legs, 2.7 m; length 3 m.*

67 *(opposite). Tomb of Qi Jingdi,* qilin *(right). Height 2.75 m; length 3 m.*

71. Tomb of Liang Wendi (posthumously ennobled, 502), father of the founder of the Liang dynasty, Liang Wudi; Danyang, Jiangsu. Two qilin, *one complete and one damaged column, and two tortoise stelae bases have survived in situ.*

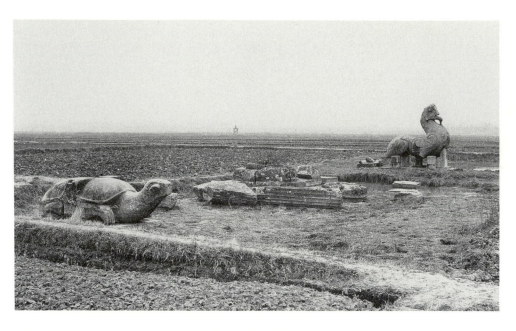

72. Tomb of Liang Wendi.

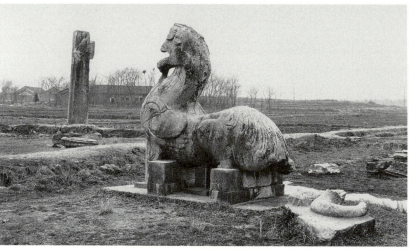

73. Tomb of Liang Wendi: column base carved with mythical creatures set in a framework of flower patterns.

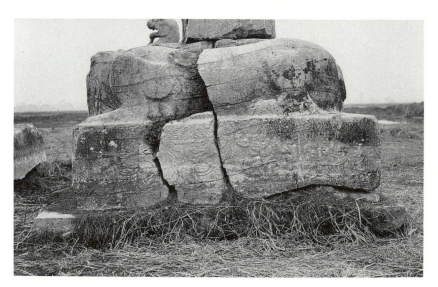

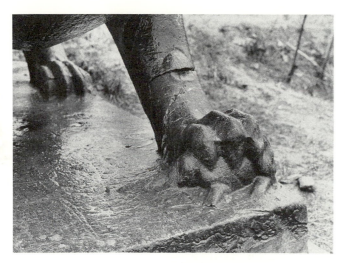

74. Qilin *foot, tomb of Liang Wendi. Southern Dynasties* qilin, *like most Han felines, have their fore-front paw resting on a small creature; the* bixie *have all four feet firmly planted on the ground.*

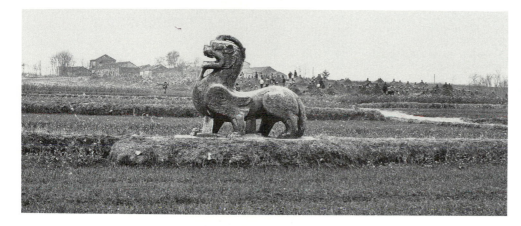

75. Qilin *on tomb of Liang Wudi (d. 549), Danyang, Jiangsu, with modern village graves festooned for the Qing Ming festival in the background. Height 2.8 m; length 3.1 m.*

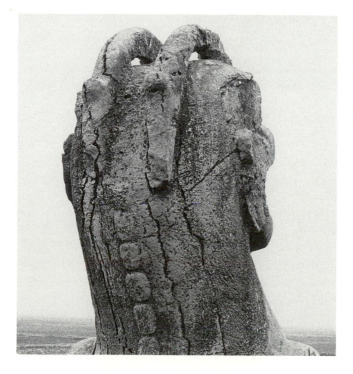

76. *Tomb of Liang Wudi: unbroken pair of double horns. To distinguish between one- and two-horned Southern Dynasties fabulous beasts, the former are called* qilin, *the latter* tianlu.

77. Qilin, *tomb of Liang Jian Wendi (d. 551), with modern graves in the background, Qing Ming festival.*

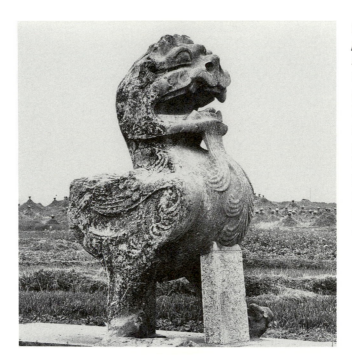

79. *Wing and beard patterns of Southern Dynasties* qilin: *(1) Song Wudi. (2) Song Wendi. (3) Qi Xuandi. (4) Qi Wudi. (5) Qi Jingdi (left). (6) Qi Jingdi (right). (7) Qi Mingdi. (8) Liang Wendi (left). (9) Liang Wendi (right). (10) Liang Wudi. (11) Liang Jian Wendi. (12) Lingkou. (13) Chen Wudi.*

78. Qilin *(left), tomb of Chen Wudi (d. 559), Nanjing. Height 2.57 m; length 2.5 m.*

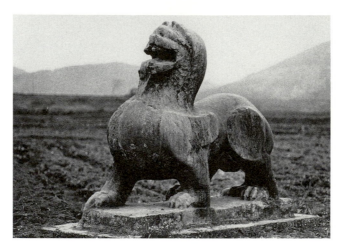

rable in size, but despite their fine carving they lack the vitality and pent-up energy of these Southern Dynasties beasts. The sculptors have developed the Han ability to catch movement in stone, and here on a gigantic scale are animals that almost quiver with life. Their balance is perfect and the movement which runs from the turning head to the curved haunches is continuous and natural. This movement brings a sense of limitless energy, of self-sufficiency. Created amidst disorder and uncertainty, they exude self-confidence; at no other time has the pure idea of power been so successfully reproduced in stone. With their unlimited ability to guard against evil and to bring good fortune, nothing more was needed. Any additional guardian figures would be an anticlimax implying that, after all, the abilities of the first pair were not as boundless as suggested.

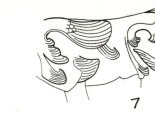

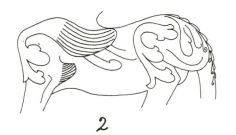

1

7

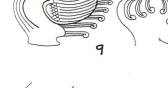

2

8

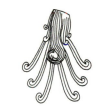
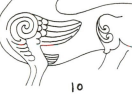

3

9

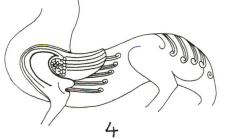

4

10

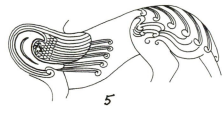

5

11

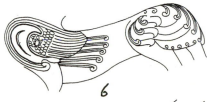

6

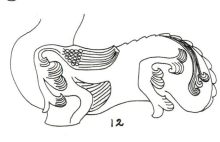

12

13

80. Pair of bixie *from an unknown Southern Dynasties tomb, Shuijingshan, Danyang.*

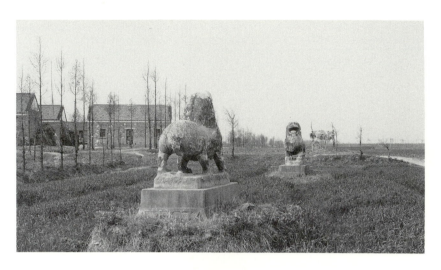

81. Bixie, Shuijingshan. Height 1.45 m; length 1.85 m.

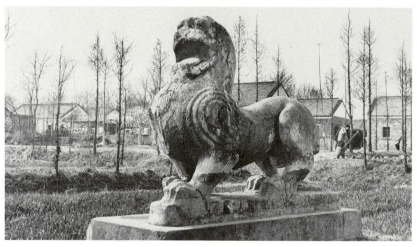

82. Only surviving example of a sitting tomb animal from the Southern Dynasties period: a bixie from an unknown tomb at Lanshilong, Danyang. Height 1.5 m; length 1.6 m.

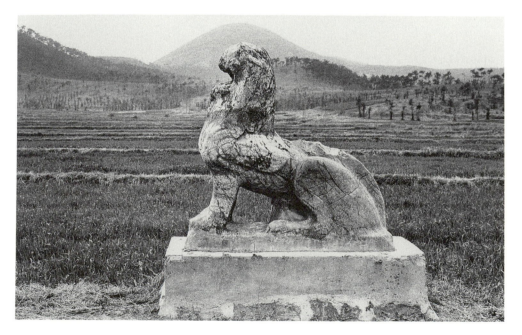

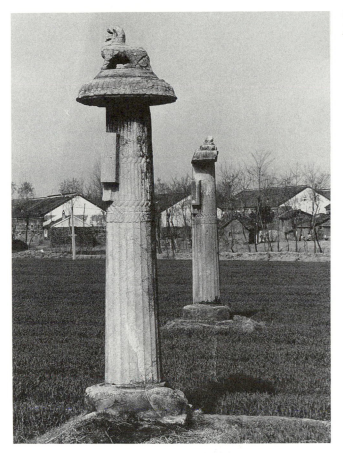

83. Columns, tomb of Xiao Ji.

The second set of monuments, the fluted columns, replace the Han *que*. 83
It is not clear why the *que* went out of fashion as a tomb monument. (It
remained in use in palace architecture.) Possibly it was too expensive; cer-
tainly the gate-tower form, implying walls, and the Han Confucian deco-
ration accorded ill with new ideas. Like the *que*, the Southern Dynasties
column was based on a real architectural feature and is known to have been
used to mark official buildings, bridges, and postal stations. A pair of col-
umns with inscription tablets can be seen marking the ends of a crowded
bridge on an Eastern Han tomb brick;[16] the earliest known column of this
type was excavated in 1956 in a Beijing suburb, where it formed part of
an Eastern Han memorial archway.[17] The Southern Dynasties examples
perform the same basic functions as the *que*—marking an entrance and
identifying the deceased—but the dominant position held by the *que* has
now been ceded to the animals, and the role and scope of symbolic dec-
oration is correspondingly reduced. The inscription referred to the "spirit
road" and gave the name, office, and titles of the deceased; one of the pair
of inscriptions was sometimes in mirror writing.[18] This may have been a 84
fashion (one Kong Jing Tang was famous for his mirror calligraphy),[19] but

84. Tablet with an inscription in mirror writing, tomb of Xiao Jing. In Liang royal tombs the size of the characters on the inscription tablet was graduated according to the degree of affinity with the dynastic founder's father, Liang Wendi. His characters are 22 cm high; those of his sons, Xiao Hong and Xiao Jing, are 10 cm high, whilst those of his grandson, Xiao Ji, are only 6 cm high.

85. Column (top missing) and stele, tomb of Xiao Xiu in a primary school courtyard, Nanjing.

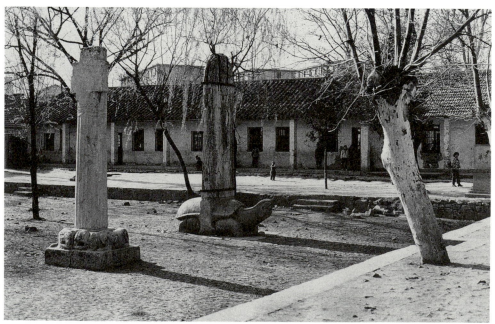

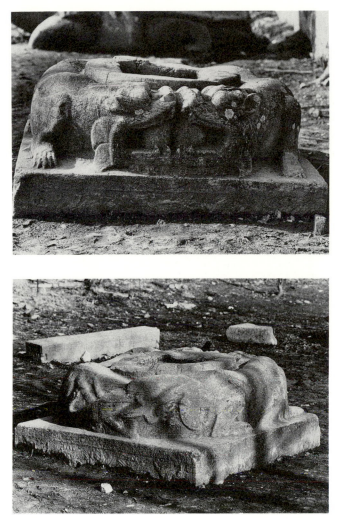

86, 87. Base of column, tomb of Xiao Xiu. The two dragons with intertwining tails hark back to the Han dynasty stele base of Gao Yi.

even today it is not uncommon to find one of the pair of red paper inscriptions framing a doorway at New Year, written in mirror writing to enable the spirits to read it more easily.

The decoration of these elegant columns illustrates the extent to which foreign and Buddhist motifs had become absorbed into Chinese funerary art—the use of Buddhist symbols in this context had become a question of style and fashion rather than a statement of belief. The entire construction is a medley of old and new. The square base is engraved with Han-style winged spirits against a flower-and-plant-type background which emerged in southern China in the fourth century; the pair of dragons encircling the column shaft are pure Han, almost identical to those surrounding the Gao Yi stele in Sichuan; the shaft has both concave and convex fluting. It has been suggested that the upper convex fluting refers to the Southern Dynasties, sometimes known as the "belted bamboo dynasties," but it is hard to

73,85–87

45

88. Column and stele with engravings on side of tablet, tomb of Liang prince Xiao Hong (d. 526), Nanjing.

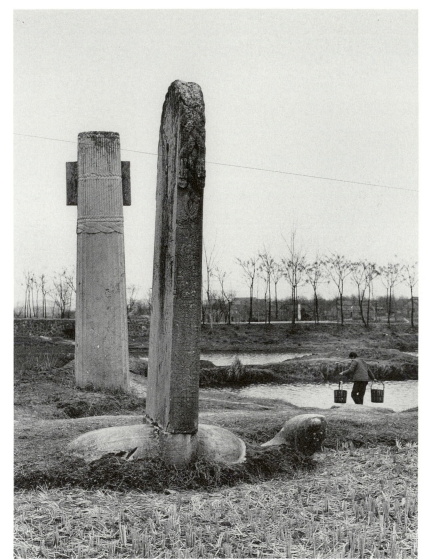

88,89,90 escape the conclusion that the concave fluting below is of Greek origin, possibly introduced originally by one of the foreign sculptors imported to work on the great northern Buddhist sites. (In subsequent Chinese architecture the column takes many forms, but this kind of fluting is not seen again.)

26 The Atlantean figures supporting the inscription tablet are descended from those supporting the eaves on Han *que* but are now frequently shown in the

91 guise of Buddhist demons; the purely Chinese miniature fabulous beast on the top of the column stands on a Buddhist-inspired lotus base.

92,93 A similar blending can be seen on the memorial stelae. Basically the same as their Han predecessors, retaining the hole copied from the original wooden versions, they are more than twice as tall and have one un-

usual characteristic: the sides of the tablet are engraved with small pictorial reliefs set in a framework of honeysuckle or other intertwining plants.[20] (This feature is also found on stelae in the north.) The basic subject matter of spirit creatures is very similar to that found in Han dynasty tombs at Xuzhou, Jiangsu, but there are clear Indian Buddhist influences. Contemporary interest in calligraphy is reflected in the occasional duplication of stelae: in the spirit road of one of the Liang royal princes, Xiao Xiu, for example, it is known that four famous calligraphers wrote the texts on the four stelae. The best surviving stele, with a text of over twenty-eight hundred characters, is on another Liang royal tomb, that of Xiao Dan, and is renowned as an example of Wang Xizhi's school of writing.

94

89. Upper part of column, tomb of Xiao Hong.

90. Engraving on side of column tablet, tomb of Xiao Hong.

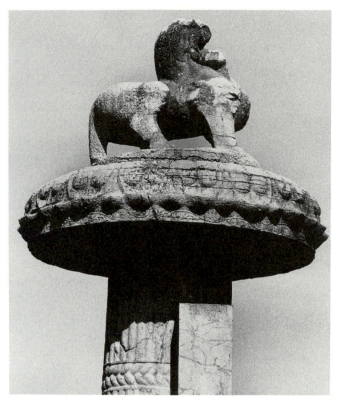

91. Top of column with small bixie, *tomb of Xiao Jing.*

Taken as a whole, the spirit road of this period conveys a very different message from that of its Han dynasty predecessors. The Han spirit road provided an orderly dialogue between two parallel systems: there was a balance between earthly and spirit world subjects. The Southern Dynasties spirit road is primarily addressed to the other world. Apart from the inscriptions on the column tablet and memorial stele, there is no reference to the known world.[21] The great winged animals, helpers of the immortals, promised by their presence protection against danger and help in reaching the land of the immortals; the same themes governed the decoration of the column and stele with their friendly spirits and terrifying demons. There are no stone officials because humans had no place in this context. The stone official was a Han Confucian concept which served no role in a tomb designed to emphasize man's unity with nature and the omnipresence of the spirit world.

The glorious Southern Dynasties beasts had no descendants, and these spirit roads, with their emphasis on movement and flowing lines, proved a dead end. When the empire was reunited under the Sui and Tang, the spirit road was reinterpreted and for inspiration the new rulers, themselves from the north, drew on the traditions which had been kept alive in that part of the country.

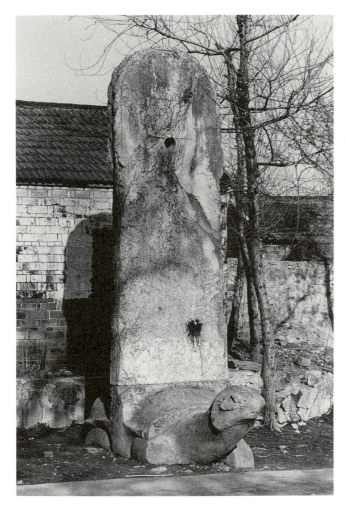

92. *Stele, tomb of Xiao Xiu. Unusually, this tomb had two pairs of stelae with inscriptions by four famous calligraphers. Two complete stelae and two tortoise bases have survived; the inscriptions, no longer legible, are known from earlier rubbings and eulogize the deeds of Xiao Xiu. Height 4.35 m.*

93. *Engraving on stele face, tomb of Xiao Hong. Southern Dynasties stelae retained the hole which the Han had copied from wooden stelae. Originally a pair of wooden stelae were placed at each end of the grave; the heavy coffin was then lowered with the aid of a rope threaded through these holes.*

94. Panelled engravings on side of Xiao Hong stele, showing a mixture of Han and Buddhist influences. Similar friezes have been found on Northern Dynasties stelae from the same period.

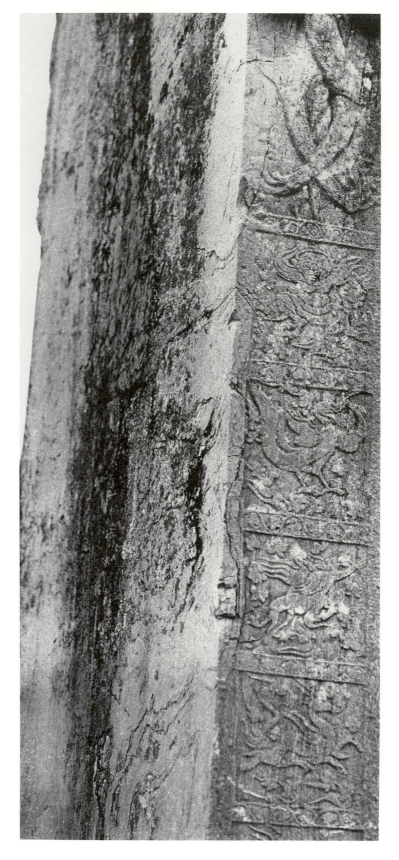

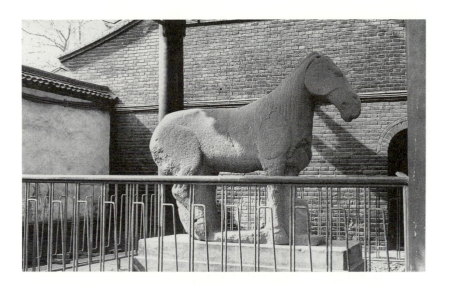

95. Da Xia winged horse with cloud patterns between front and back legs, A.D. 424, found in Chang'an (Xian). Shaanxi Provincial Museum, Xian.

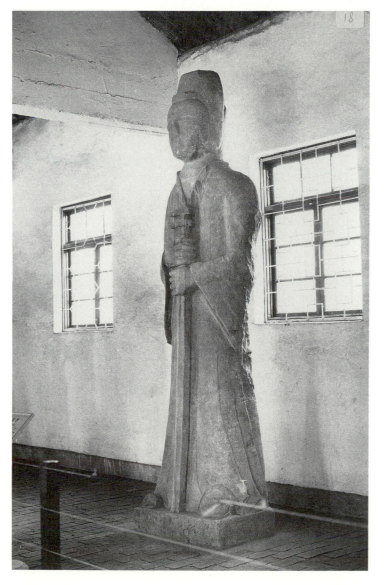

96. Guardian from tomb of Northern Wei emperor Xiaodi (d. 530), excavated in 1976 at Mangshan. Guanlinmiao Museum, Luoyang. Height 3.14 m.

82 | THE PERIOD OF DISUNION

97. Northern Wei lion, from Mangshan. Guanlinmiao Museum.

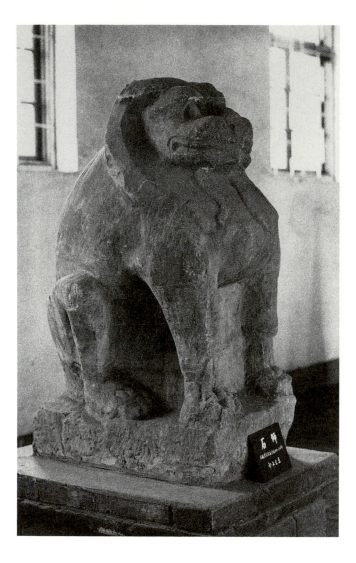

It is at first sight curious that whilst the spirit road in the traditional south developed along a path outside the mainstream of spirit road history, the north, under non-Han rulers with a foreign religion, preserved classical Han forms. The explanation for this apparent paradox is that in the south ancestor worship at the tomb retained its paramouncy and was therefore adapted to and affected by changes in the prevalent philosophies. In the north, where the wealth and artistic energy of the state was poured into the great Buddhist shrines with their myriad stone carvings at Yungang and later, Longmen, there was a loosening of the bond between ancestor worship and the tomb. In order to become acceptable to the Chinese people, Buddhism had had to adopt some elements of ancestor worship; the lapse in the spirit road tradition which followed the fall of the Han empire facilitated a certain transference of ancestor worship from the tomb to the Buddhist cave or grotto, and there are numerous records of both non-Han rulers and

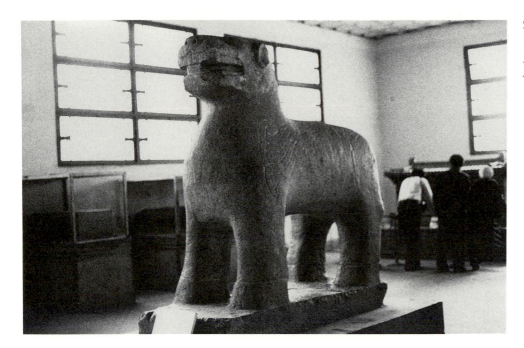

98. Winged beast, Western Wei period (535–556). Shaanxi Provincial Museum, Xian.

their Chinese subjects dedicating specially commissioned Buddhist shrines to their ancestors.[22] This led to a decline in the importance of the tomb, with spirit road sculpture taking second place to Buddhist sculpture.

Beneath the Buddhist splendour, however, Chinese tomb practices were kept alive. The paucity of surviving surface monuments suggests that the level of activity was low, but in so far as tombs with spirit roads were built at all, they followed Han patterns. (To maintain its integrity, a people under alien rule tends to preserve its traditions unchanged.) As far as can be seen from archaeological evidence and from written records, tombs in the north continued the Han traditions of artificial tumuli set in square, often walled enclosures with stone figures outside the southern gate.[23] Only a handful of spirit road sculptures have survived, none of which are still in situ. These include a beast from the Western Wei dynasty (535–556) in the Shaanxi Provincial Museum in Xian and a guardian figure, or *wengzhong*, from the Northern Wei emperor Xiao (d. 530) in the Guanlinmiao Museum, Luoyang. It is difficult to judge anything about style from such a small sample, but the animal figure is static, with none of the Han or Southern Dynasties movement; the guardian is tall and thin, in memory of Qin Shihuang's giant guard, Ruan Wengzhong, and follows Han traditions in human sculpture, standing with his sword in the same position as Li Bing's headless companion with a spade.

95–98

98

96

5 SUI AND TANG DYNASTIES

Reunification of the empire came from the north. The founders of both the Sui and Tang dynasties came from families with a tradition of holding high office under the northern emperors. Building on a foundation laid by the short-lived Sui, the early Tang rulers inaugurated one of the greatest periods in Chinese history. Subduing unruly neighbours, they secured the frontiers and developed an efficient central administration which provided the base for an extraordinary expansion in trade and the economy. The first half of the Tang dynasty has been described as the Golden Age of China. Self-confident, prosperous, and vital, Tang China was a highly civilized society with an unprecedented level of artistic achievement. In the seventh century, the capital, Chang'an, was the largest and most splendid city in the world, and its streets were thronged with foreigners from Central Asia, from Arab, Persian, and Indian states, and from Japan and China's closer neighbours.

With reunification and the reestablishment of strong centralized government, Han Confucianism came into its own again. Its value in reinforcing state power and creating a supply of able and loyal administrators was recognized and its doctrines were deliberately revived and adapted to contemporary needs. The first Sui emperor, aware that in the long run belief in legitimacy based on a mandate conferred by heaven was a more effective means of preserving unity than the sword, cultivated the use of ancestor worship for political purposes: defeated captives were brought to pay respects at the imperial ancestral hall before being pardoned and reintegrated into society.[1] The Tang developed this and revived to the full the Han use of ancestor worship at the tomb as an instrument of state power. Like the Han, they built vast mausolea designed to impress; this visible proof of a powerful imperial society with its magnificent constructions dedicated to the ancestors reinforced belief in the legitimacy and continuity of the dynasty as well as in the cohesion of the empire. By reviving the Han system of "accompanying burials" whereby exceptional service to the state was rewarded by the highest possible honour—a permanent resting place within the imperial grave precinct—the Tang used the tomb to attract talent into the imperial service and to ensure loyalty to the throne.[2] The great ancestral rites became

84 political occasions in some way comparable to state coronations or funerals

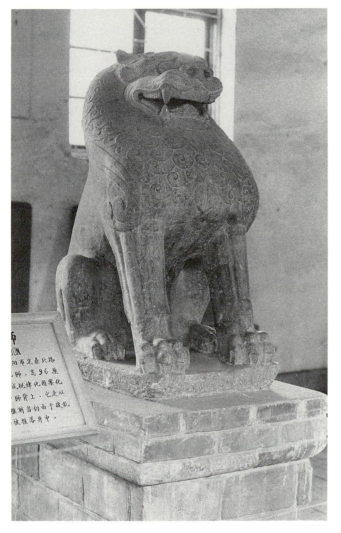

99. Sui dynasty lion, from palace gate, Guanlinmiao Museum, Luoyang, Henan.

today: the use of ancient ritual and emblems stressed legitimacy; the pomp and circumstance reflected the power of the state and its ruler, whilst the occasion provided a useful meeting place for the leading figures of the day. Individual rulers might hold Daoist or Buddhist beliefs, but these were not allowed to affect their funeral arrangements, which were a matter of state policy. (The empress Wu Zetian [d. 705] was an ardent Buddhist, personally responsible for the construction of many magnificent Buddhist monuments, but no sign of this is reflected in Qianling, the tomb which she shared with the third Tang emperor, Gaozong [d. 683].)

Colour 5

It took nearly one hundred years for the Tang imperial tomb pattern to crystalize. The tombs of both the Sui emperors were based on the Han plan which had been kept alive under the Northern Dynasties and had large artificial tumuli placed in square enclosures on a north-south axis; no statuary has survived in situ, but it is believed that there was a short spirit

99 road leading to the southern gate. (A seated lion from a Sui palace gate can be seen in the Guanlinmiao Museum, Luoyang.) The founder of the Tang dynasty, Gaozu (Li Yuan; d. 635), refused to build a mausoleum for himself and stipulated in his will that he wanted a modest burial. His son Taizong, better known as Li Shimin, interpreted this by ordering that "as to the style and dimensions of his burial place, the Chang mausoleum of the Han dynasty should be taken as a pattern and that the number of people to be summoned to work at it should be fixed in a liberal spirit."[3] The result was a smaller version of the Sui tombs. At the same time, however, Li Shimin designed his own tomb, Zhaoling, and with a stroke of imaginative genius chose the auspiciously shaped Nine Dragon Mountain, nearly twelve hundred metres high, for a site. Turning to Southern Dynasties notions of *fengshui*, he allowed the landscape to determine the tomb plan: his grave is tunnelled into the south face of the mountain, but the slope on this side was so steep that the main sacrificial hall and spirit road statuary had to be placed on the more gentle slopes to the north. Li Shimin's successor, Gaozong, refined his father's ideas, producing at Qianling a synthesis of the two disparate threads which had developed during the Period of Disunion. Here southern use of landscape suggesting a mountain site was combined in a dramatic way with the traditional Han tomb pattern; the spirit road was extended down the mountainside and lined with well over one hundred monuments.

Li Shimin's exuberant appropriation of a whole mountain for a tumulus was followed by most of the later Tang emperors, and these Tang mausolea are amongst the most spectacular tombs the world has ever seen. Eighteen of the twenty Tang emperors are buried on the north bank of the River Wei in three groups, north, northwest, and northeast of the capital, Chang'an.[4] (Fourteen are mountain tombs; the other four, like those of royalty and high officials, were built on the flat ground with artificial tumuli.)

Chart 3

The imperial tomb was based on the plan of Chang'an, with three enclosures (the inner, imperial, and outer cities) delimited by three pairs of earthen *que*. The inner city, walled with four gates facing the cardinal directions, corresponded to the imperial palace and enclosed the underground grave chamber and the main sacrificial hall, where the major rites were performed on certain fixed days in the year. South of this, in the imperial city, were the memorial stelae and spirit road with its attendant stone officials and animals. The outer city, encompassing the first two on the west, south, and east, extended down the mountainside with halls for minor rites, dwellings for officials responsible for the upkeep of the tomb, and "accompanying tombs." Here lived palace attendants, often including the empress dowager, who tended the daily needs of the deceased by laying out fresh clothes and water for washing, and serving him four meals a day.

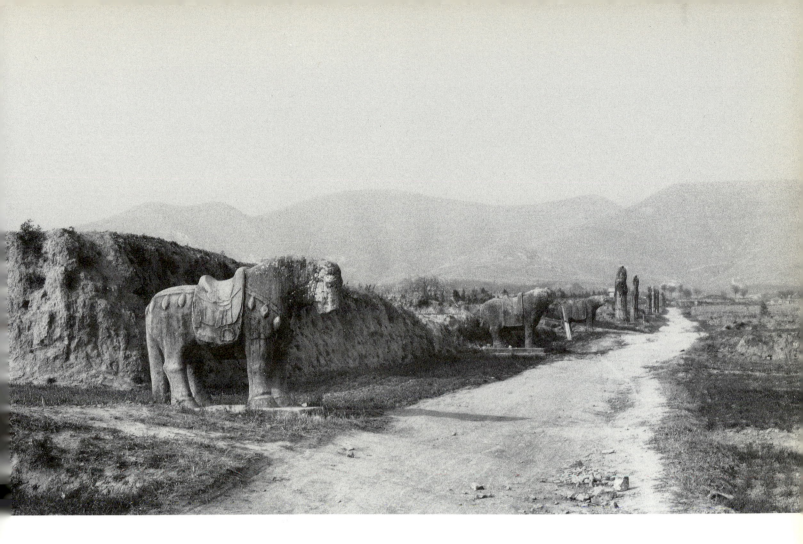

The scale was vast. Each of the first five mausolea had 378 halls or chambers; Zhaoling, the largest tomb, covered 182 square kilometres; at Qianling the outer wall was 40 kilometres long.[5] The tomb resembled a living city. After the fall of the Tang dynasty a certain chief, Wen Dao, systematically looted all the imperial tombs in his area. It is recorded that "of these, Zhaoling was stronger than the others. From the road which led to the mountain, Dao saw that the buildings and mansions were grand and beautiful, both in regard to architecture and size, but that they did not differ in style from human dwellings."[6]

Like the tomb plan, the final spirit road pattern was fixed at Qianling. The Qianling spirit road, with 125 stone sculptures still in place, is the best preserved and most restored and will therefore be used as a model for discussing Tang tomb statuary, but other, less accessible mausolea with equally dramatic sites have most of their statuary intact. On the whole, the statuary on mountain sites has survived better than that on the plateau. The carvings at Qiaoling (tomb of Ruizong, d. 712), Tailing (tomb of Xuanzong, d. 761), and Jianling (tomb of Suzong, d. 762) are particularly fine. At Jianling a small mountain stream has, through the centuries, eroded a gully over five

100. Spirit road, Qiaoling, tomb of Tang Ruizong (d. 712), Pucheng County, Shaanxi.

Colour 6,
100

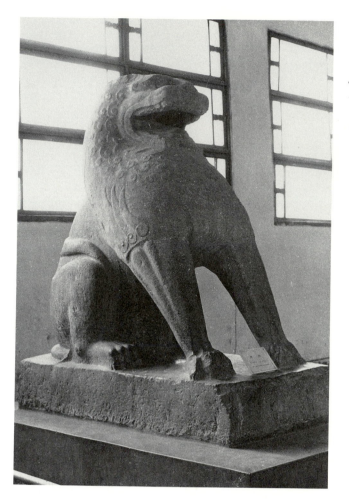

101. Seated lion from Yang Kangling, tomb of Tang Gaozu's grandfather. Shaanxi Provincial Museum, Xian.

hundred metres deep down the centre of the spirit road, and to get to the far side you have to walk more than a kilometre up the mountain and cross over by the pair of seated lions guarding the former southern gate into the inner enclosure. Similar erosion can be seen down the middle of the spirit road at Duanling (tomb of Wuzong, d. 846).

The statuary on the early transitional tombs, before the official pattern was established at Qianling, shows an intriguing variety of subjects and styles. There appear to have been no fixed rules. A seated lion from Yong Kangling, tomb of the first emperor's grandfather, can be seen in the Shaanxi Provincial Museum. At Xianling, tomb of the first Tang emperor, there were a pair of columns, a pair of rhinoceroses, and two pairs of tigers. (One tiger and one rhinoceros are now in the Shaanxi Provincial Museum; one tiger and one column are still in situ; the second rhinoceros has recently been buried in the fields to facilitate the modernization of agriculture.)[7] The emperor's preference for tigers may derive from the fact that his grandfather's second name was *hu*, or tiger. The rhinoceros was believed to exert

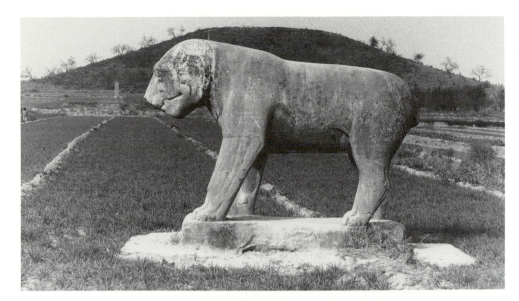

102. Tiger at Xianling, tomb of the first Tang emperor, Gaozu (d. 635), San Yuan County, Shaanxi. The companion to this statue is in the Shaanxi Provincial Museum, Xian. Height c. 1.8 m.

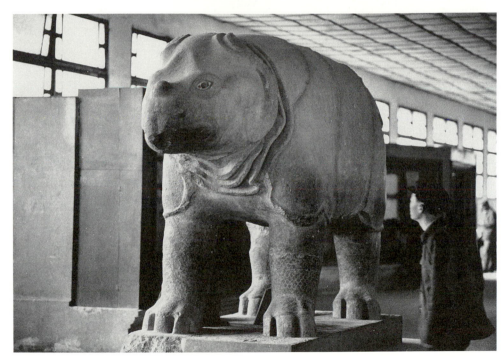

103. Rhinoceros from Xianling. Shaanxi Provincial Museum. The companion to this was recently buried in situ in the field in the interests of mechanization of agriculture. The rhinoceros was associated with water control and Li Bing, the great third-century B.C. engineer, had stone statues of rhinoceroses made to subdue the waters at Guanxian, Sichuan. This is, however, the only example of a rhinoceros placed on a tomb. Four characters beneath the right front foot refer to the filial piety of Gaozu's son, Taizong. Height c. 2 m.

102

103

power over river and water spirits—Li Bing, as we have seen, used stone rhinoceroses for this purpose in the third century B.C.—but this is the only occasion when it appears on an imperial grave. The stocky tigers are carved in the northern sculptural tradition and have little in common with the agile felines of the Southern Dynasties. The rhinoceros provides the first glimpse in monumental tomb sculpture of the famous Tang realism. The artist has caught the characteristic heavy stance, the hanging folds of skin, and the small eyes, even showing with the bulging but undeveloped horn that his

104. This column at Xianling is clearly from a transitional period. The small beast on top and the entwined symbolic directional beasts round the base hark back to the Southern Dynasties; the octagonal shaft, with its shallow plant and flower engraving, is typically Tang. Height 3.7 m.

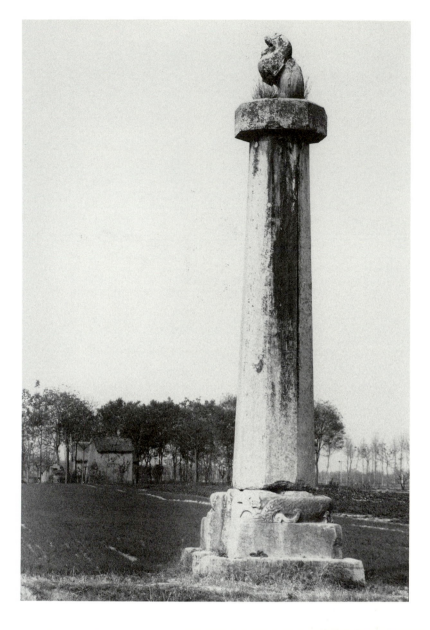

105. Column base, Xianling.

106. Column engraving,
Xianling.

model was a young animal. The surviving column is unlike any other known 104–106
tomb column. The base, with a pair of dragons encircling the column shaft,
and the small lion on top of the column remind one of Southern Dynasties
columns; the octagonal shaft is similar to that of all later Tang columns.
Whereas, however, these are engraved with magnificent moving dragons,
spirits, and flowers, the decoration here consists of intertwining, stylized,
almost geometrical plant patterns framed by vertical rows of linked beads.
It is tempting to speculate whether this could have been the form of the
column of the Northern Dynasties, of which there are, as yet, no known
surviving examples.

The statuary from the second emperor's tomb, Zhaoling, is even more 107,108
varied. It includes a standing lion and a fascinating sculpture of a man,
alas headless, carved in one piece with a lion. (This is now in the Shaanxi
Provincial Museum.) The man, much smaller than the lion, stands with his
back to the animal, his left hand outstretched in a posture which brings to

107. Lion from Zhaoling, tomb of Taizong (Li Shimin, d. 649). Shaanxi Provincial Museum. Height c. 2 m.

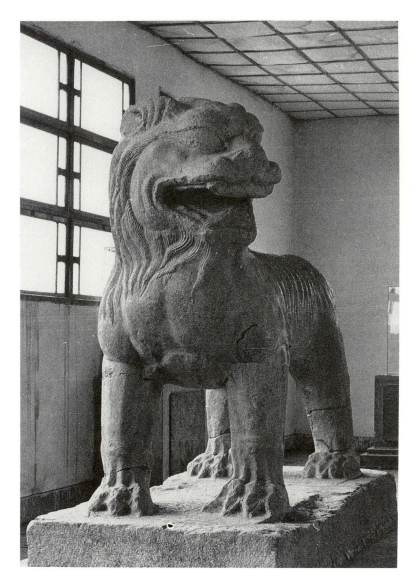

mind the initial stages of the present-day Lion Dance as seen in the performances of acrobatic troupes and in popular parks on national holidays in modern China: the huge but not completely serious lion being dominated by the sheer pose of the slender human. From this tomb also came some of the most famous of all Tang tomb sculptures—the set of stone reliefs of Li Shimin's six steeds. It is known that the emperor commissioned the court painter Yan Liben to make portraits of his favourite war chargers, and these reliefs are believed to be based on the resultant drawings. These carvings—pictures in stone—are beautifully conceived and executed; the horses are portrayed so realistically that it has been possible to identify each by historically recorded characteristics. Designed to stand three on each side, the animals are shown progressively walking, trotting, and galloping, creating a moving frieze.

109–114

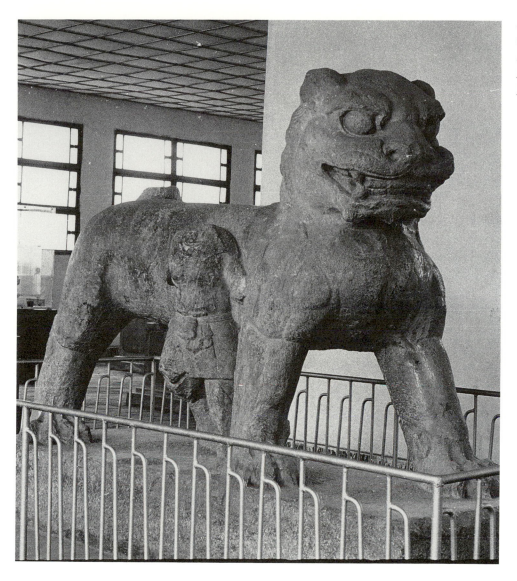

108. *Lion and attendant (lion dance?) from Zhaoling. Shaanxi Provincial Museum. Height of lion, 1.6 m.*

This transitional period ended with the third imperial tomb, Qianling. The pattern established here and copied on all later Tang mausolea consisted of a basic complement of sixty-two stone monuments: one pair each of columns, winged animals, and ostriches followed by a guard of honour with five pairs of horses with grooms and ten pairs of officials and a pair of stelae outside the southern gate. A pair of lions guarded each of the four gateways into the inner enclosure, and three pairs of horses, representing the imperial stables, stood outside the northern gate. This was the minimum; additional statues have been found at Qianling and some of the later mausolea.[8] The use of statuary on lesser tombs was strictly regulated according to rank: Shunling, the tomb of Wu Zetian's mother, gives an interesting illustration of this, having three distinct sets of spirit road statuary corresponding to the different ranks bestowed posthumously on the deceased by her imperial

Chart 4

115–127

109–114. Stone portraits of Tang Taizong's favourite "six steeds" from Zhaoling, believed to be based on drawings by the Tang court painter Yan Liben. The horses were placed in two covered terraces on the east and west sides of the courtyard in front of the main sacrificial hall, north of the tomb. (Owing to the lie of the land, the main buildings at Zhaoling were on the northern slope of the mountain.) The individual horses have been identified from contemporary descriptions and are, respectively, Teqingbiao (bay), Saluzi (deep brown), Shifachi (bright chestnut), Quanmaowo (bay with a white mouth), Qinzhui (pale grey), and Baitiwu (black with white hoofs). Each played a role in the imperial campaigns, and Saluzi is shown with the famous commander Qiu Xinggong pulling an arrow out of its flanks during a battle in which Qiu saved the emperor's life.

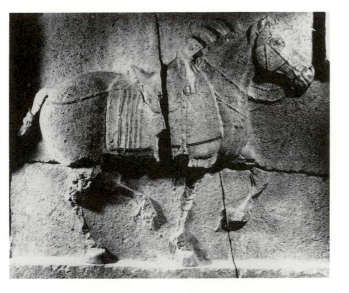

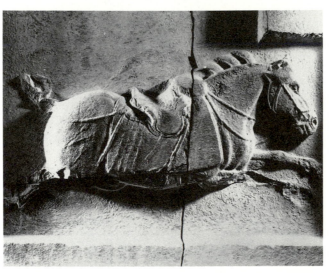

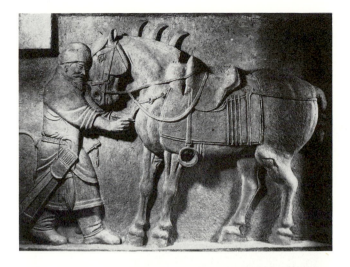

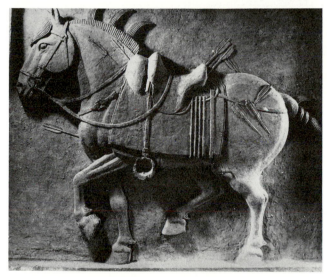

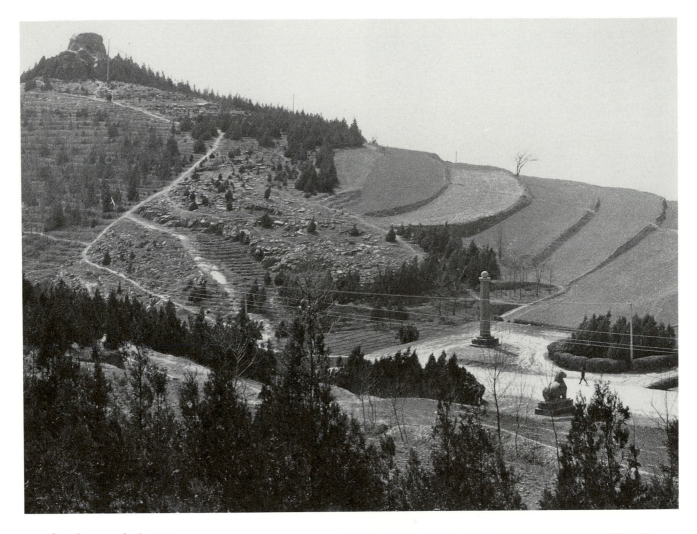

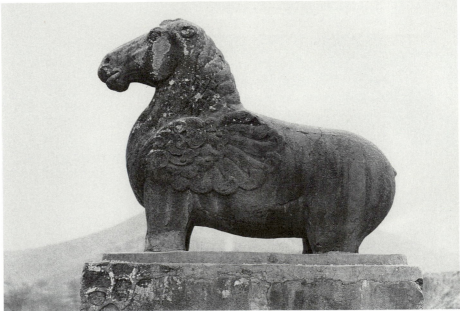

115. Southern end of spirit road at Qianling, showing column, winged horse, and one of the que at the entrance to the second tomb enclosure.

116. Winged horse (east), Qianling. The pair of winged horses fell from their pedestals during an earthquake in the Ming period. When Segalen visited Qianling in 1911, only part of the western horse was visible; this one was completely buried. Height 2.8 m; length 3.17 m.

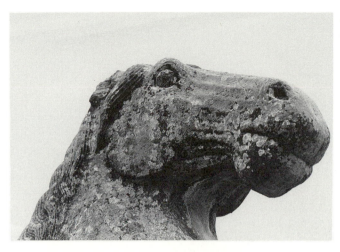

117. Head of eastern winged horse, Qianling.

118. Ostrich, Qianling. Height 1.8 m; width 1.3 m.

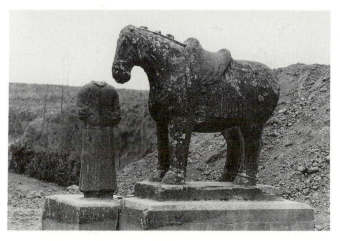

119. Ceremonial horse and groom, Qianling.

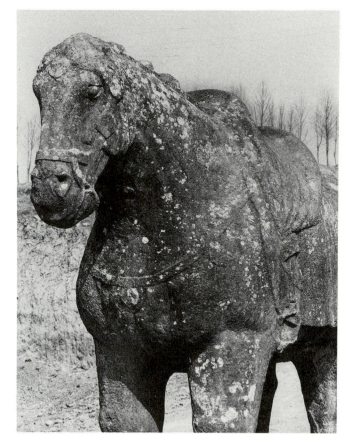

*120. Ceremonial horse,
Qianling. Height 1.8 m.*

Chart 6

128,129

130,131

daughter (see Appendix A). An excellent example of a royal tomb is Gong-ling, tomb of Gaozong's crown prince, Li Hong, which has a complete set of statuary. Military commanders and senior ministers were entitled to a pair of columns, a stele, or a pair of stelae, and several pairs of tigers and sheep. Sometimes these animals were arranged in the customary way—one or two pairs of sheep followed by one or two pairs of tigers; sometimes the rams are on the east side, the tigers on the west. (Here the animals seem to have taken on some of the symbolism of stone officials: the rams, symbols of filial piety and hence incorruptibility, stand in lieu of senior officials; the tigers, symbols of strength and courage, in lieu of the military.)

These Tang spirit road sculptures give vivid confirmation that tomb statuary reflects the spirit of the age. In the early half of the dynasty, the statuary on both imperial and lesser tombs is redolent with imperial might; individual figures are large and vigorous—officials at Qianling, for example, average four metres high; the standard of carving reflects high standards in other arts, and some of the winged animals and lions are among the finest monumental statues ever made in China. With time, however, repetition brought sterility; after the disastrous An Lushan rebellion in 755, the standard of carving, like the fortunes of the dynasty, declined and later statues were often small, hurriedly carved, and stereotyped.[9]

The Tang spirit road is primarily addressed to this world. The role of the tomb as an entrance to the next world and the existence of spirit creatures were recognized by the inclusion of a pair of winged beasts, usually horses, but the larger part of the avenue—renamed *yudao*, or "imperial way," rather than the traditional "spirit way" (*shendao*)—was a symbolic representation of worldly elements and functions. The tilt in favour of the representational and away from the supernatural aspect was permanent: all subsequent dynasties included at least one pair of mythical creatures whose abilities reflected dynastic aspirations and needs, but the qualities chosen served practical problems of government, and there was never again a return to the Southern Dynasties reliance on such animals for supernatural protection. This realistic approach reflected the attitude of the early Tang rulers: Taizong (Li Shimin), for example, chided officials who came to report good or bad omens, pointing out as Cassius had to Brutus that whether a dynasty or a man prospered depended on the quality of its government and the actions of the man, not on heaven and its portents.[10]

This practical attitude entailed two developments in sculptural approach: a shift towards realism and a change in the conventions governing animal statuary.

Tang tomb sculptures, like the better-known and more lively tomb figurines, are designed to give an accurate picture of reality. To exert its inherent powers, the stone image needed to reproduce correctly that which it represented. Even subjects chosen for purely symbolic or magical reasons are shown as figures taken from real life: the great winged horses at Qianling are real horses to which wings have been added. (As the confidence of the dynasty waned, the fabulous nature of these beasts became more pronounced: in later winged horses, the area beneath the belly was left solid and carved with clouds to indicate the sky.) The ostrich—symbol of the Vermilion Bird of the south (the Tang dynastic colour was red) and possibly, since it appears first on the tomb of Wu Zetian, of the phoenix, itself symbol of the empress—is carved with meticulous attention to detail and shown in lifelike poses which differ from tomb to tomb and from one side of the alley to the other. The presence of this novelty (the first examples were brought as gifts from Tochara in Central Asia in 650) emphasized, like the great Tang hunting parks and imperial menageries with their exotic beasts, the extent of the imperial domain.

In the major part of the avenue, the representational guard of honour, this preoccupation with accuracy gives us a faithful picture of contemporary customs. During the early years of the dynasty there was no clear distinction between military and civilian posts, and the ten pairs of tomb officials wear identical robes and hold long swords. In the first part of the eighth century, however, the careers were separated and from this time on, stone civilians, carrying the *hu,* symbol of high imperial office, stand in the place of hon-

116,117

132–138

Colour 7

Colour 8

118,139,
140

121–123

141–146

Colour 9

121. Official, Qianling.
Height 4.1 m.

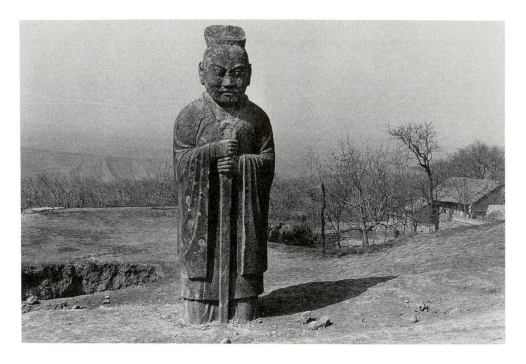

122. Official, Qianling,
Height 4 m.

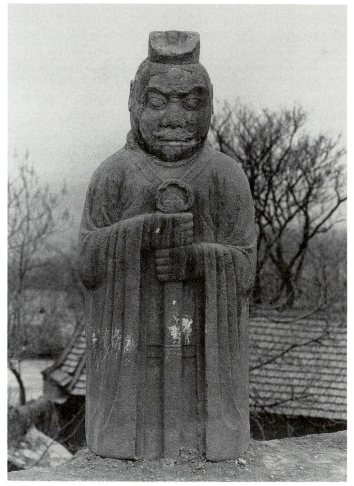

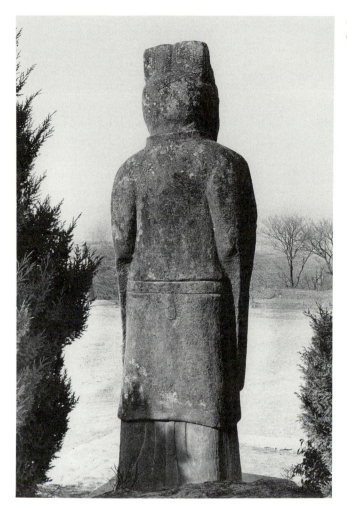

123. Official, back view, Qianling.

our on the east; military officials with a sword on the west.[11] The accuracy of the harness and trappings on the ceremonial horses at Qianling can be checked by comparing them with a similar horse guard in a mural in the contemporary tomb of the Tang prince Yide nearby.

119,120, 147,148

In animal statuary the Han distinction between untamed nature and civilized man was replaced by an affirmation of man's dominion over the natural world. This again reflects a genuine change in conditions and attitudes: in the highly developed Tang state, wild beasts could no longer claim equality with man. The change was expressed in two ways: by giving animals harness and, often, human attendants, and by showing them in a stationary position. Even the fabulous beasts are tame: they possess supernatural attributes but no longer suggest unbridled strength.

This change is typified by the lions. The Han prowling feline has been ousted by a Buddhist-inspired door guardian. In its three centuries or more of domicile in China, the Buddhist lion, like the lotus, had become assimilated into traditional Chinese thought, and this substitution was total

Colour 11

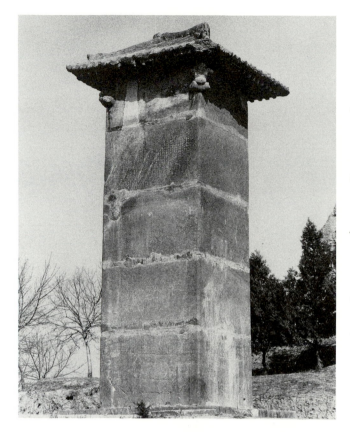

124. Stele (west) erected by Wu Zetian in honour of Gaozong. In the text, originally engraved with characters inlaid with fine gold sand on a background of black lacquer, Wu Zetian likens the emperor's deeds to the glory of the heavenly bodies, and the seven sections of the que—base, five layers of stone blocks, and roof—are said to represent the sun, moon, and five planets, Venus, Mars, Saturn, Mercury, and Jupiter. Qianling. Height 6.3 m.

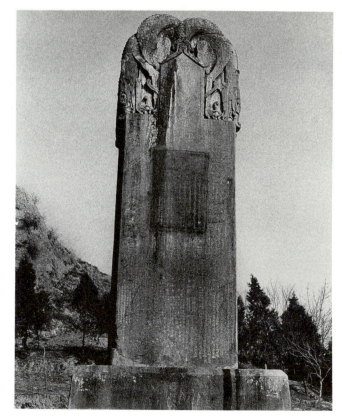

125. Wu Zetian's stele (east), Qianling. Known as the wu zi bei (stele without characters), the stele carries thirteen inscriptions, mostly from the Song and Jin dynasties, including one in both Han and Nuchen, a script which has since become extinct.

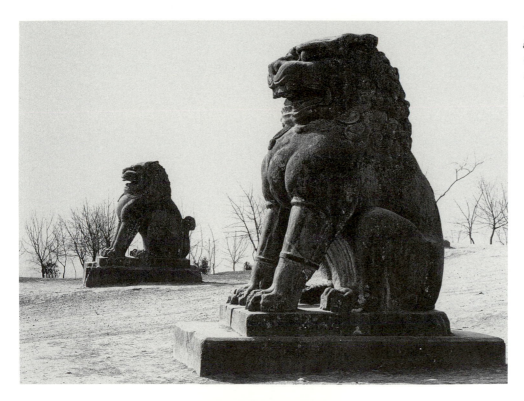

126. *Pair of lions guarding southern entrance to inner tomb enclosure, Qianling. Height 3.35 m.*

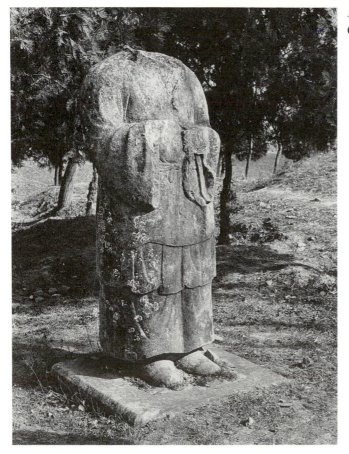

127. *Foreign dignitary, Qianling. Height c. 2 m.*

128. Gongling seen from the tumulus looking south. This is one of the best-preserved nonimperial Tang tombs with a perfect set of statuary. Li Hong was said to have been poisoned by Wu Zetian and the stele, placed unconventionally halfway down the east side, was erected later by Gaozong to vindicate his son's honour. The two mounds in the foreground are the remains of the southern gate towers of the inner tomb enclosure.

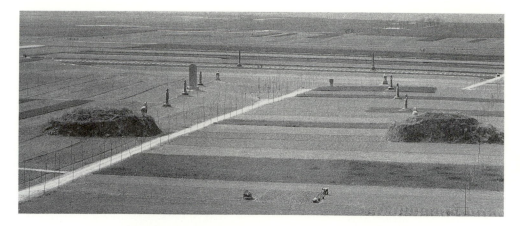

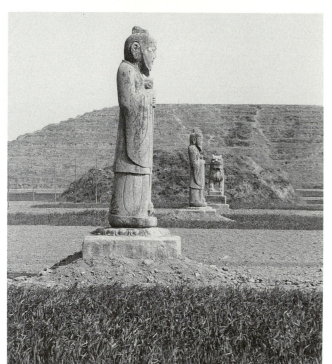

129. Officials and lion with tumulus in background, Gongling, tomb of Li Hong, Tang Gaozong's crown prince (d. 675), Yanshi County, Henan. Lotus bases were sometimes used for Tang royal or official tomb statuary, but never on imperial tombs.

130. West side of General Li Ji's spirit road. Tang officials were entitled to stone rams and tigers, which could either be placed three-a-side, as here, or in pairs—two pairs of tigers followed by two pairs of rams. There was a similar flexibility with stelae: sometimes a pair flanked the upper end of the spirit road; sometimes a single stele, on a square or tortoise base, stood at the southern end of the avenue.

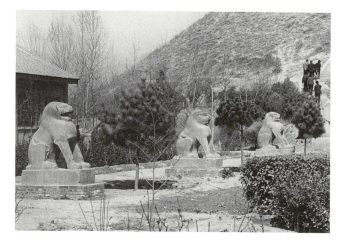

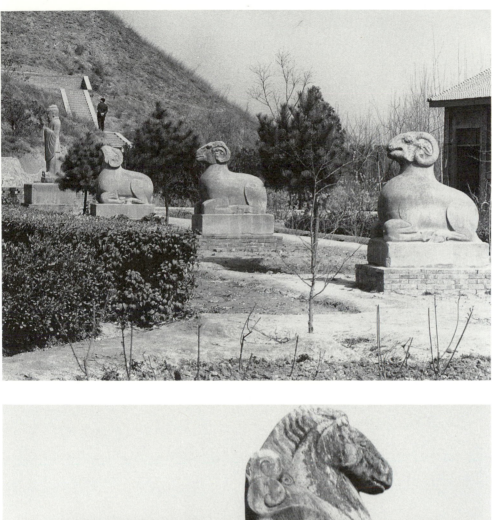

131. East side of spirit road of General Li Ji, "accompanying burial," Zhaoling. The ram nearest the tomb lifts its head as if it hears the general approaching. Late seventh century.

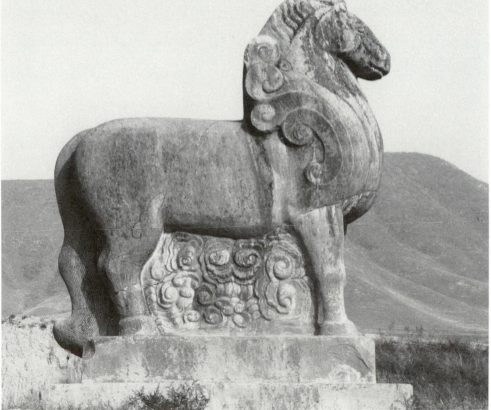

132. Winged horse, Tailing, tomb of Tang Xuanzong (d. 761), Pucheng County, Shaanxi.

133. Head of winged horse (west), Jianling, tomb of Tang Suzong (d. 762), Li Quan County, Shaanxi.

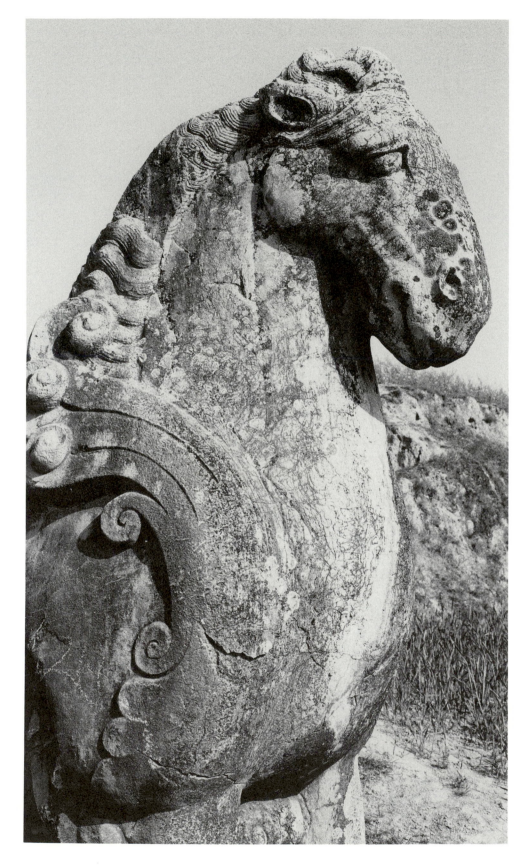

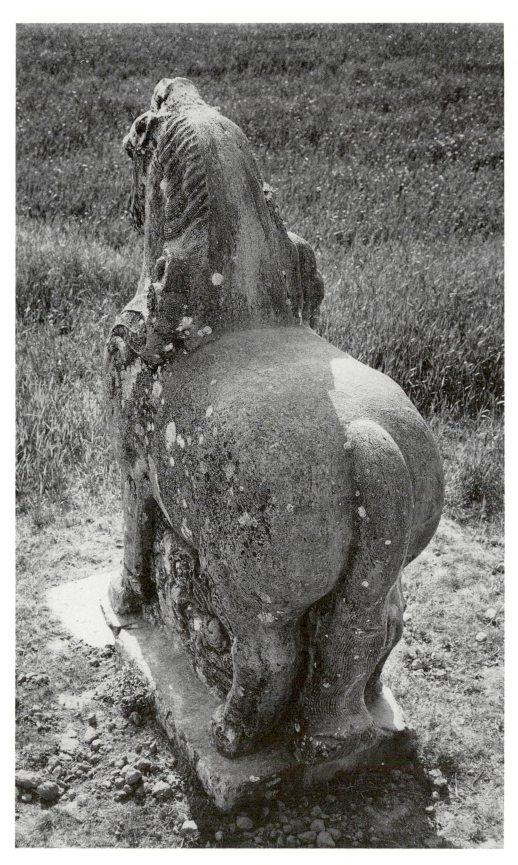

*134. Winged horse (west),
back view, Jianling.
Height 2.4 m; length 2 m.*

135. Winged horse,
Zhenling, tomb of Tang
Xuanzong (d. 859),
Jingyang County,
Shaanxi.

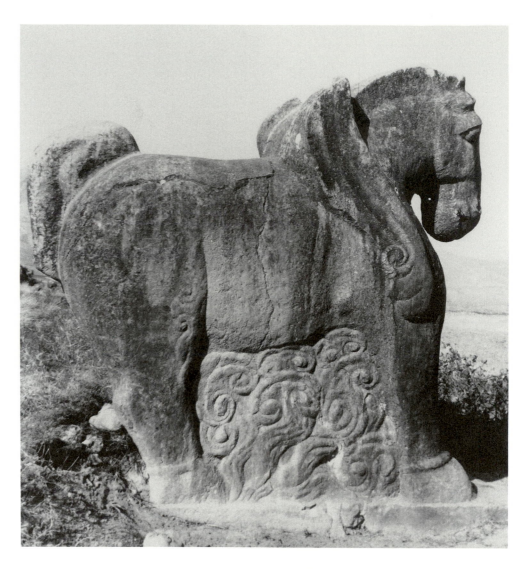

136. Winged beast,
Qiaoling, tomb of Tang
Ruizong (d. 712), Pucheng
County, Shaanxi.
Height 3.5 m.

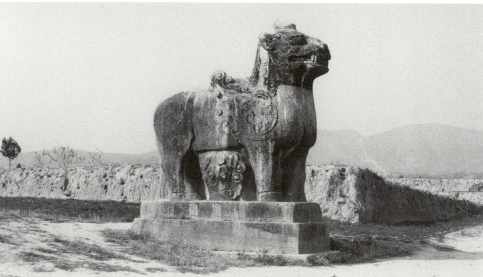

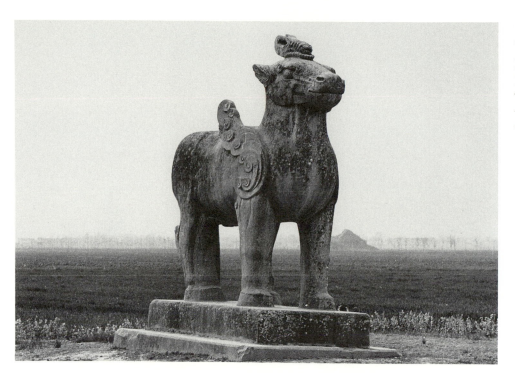

137. Winged beast (west), Shunling, tomb of Wu Zetian's mother, Lady Yang (d. 670), near Xianyang, Shaanxi. Height 4.15 m; length 4.2 m.

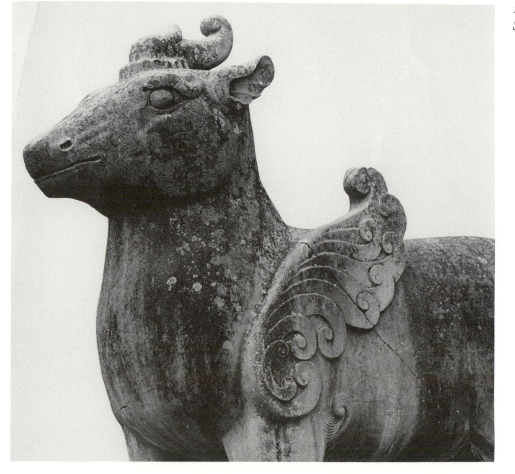

138. Winged beast (east), Shunling.

139. *Ostrich, Qiaoling.*
Height of slab, 2.2 m.

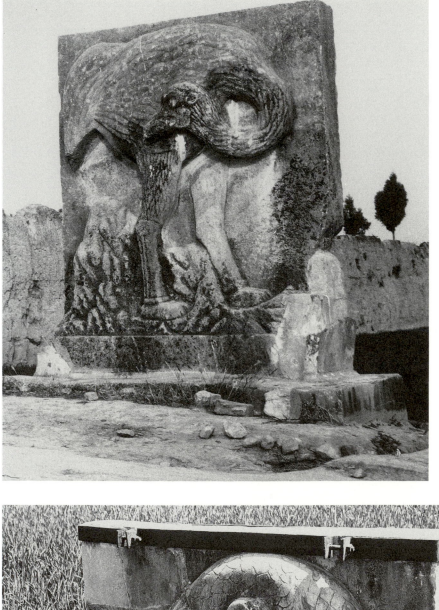

140. *Ostrich, Jianling.*

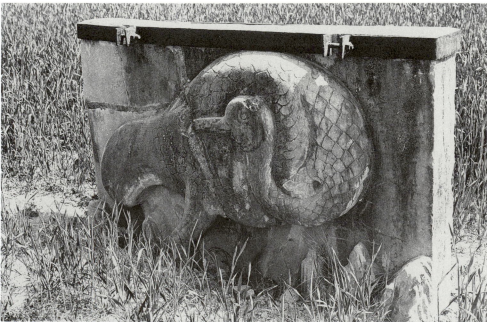

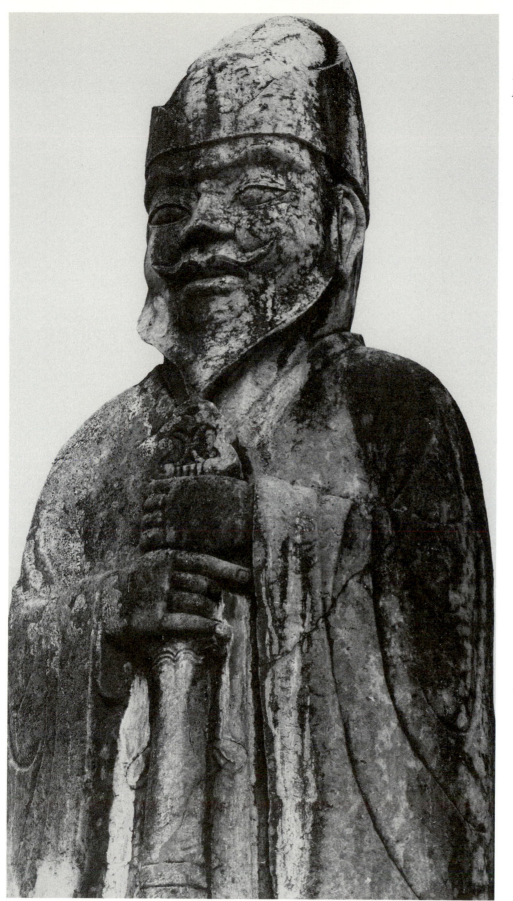

141. *Official, Qiaoling.*
Height 4.3 m.

142. Civil official,
Jianling. Height 4 m.

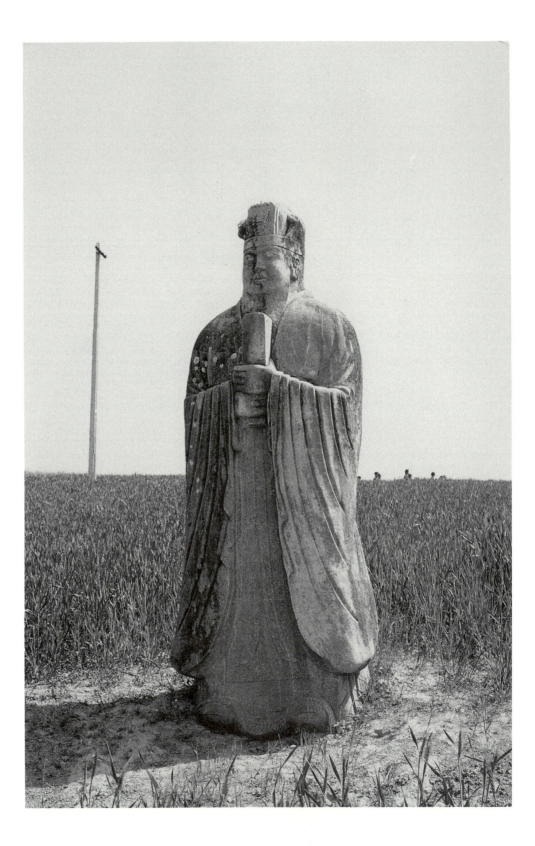

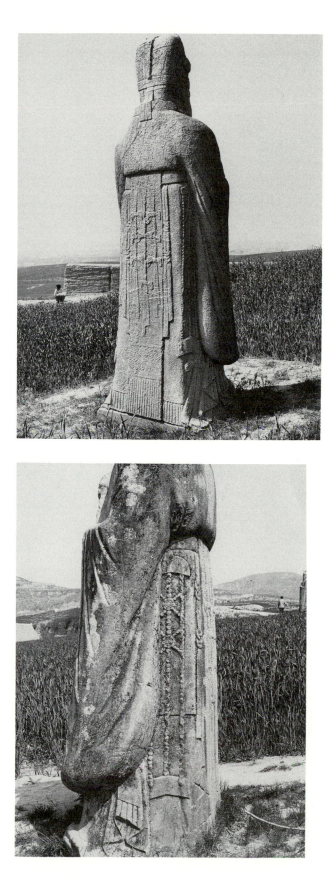

*143, 144. Back and side of
civil official, Jianling.*

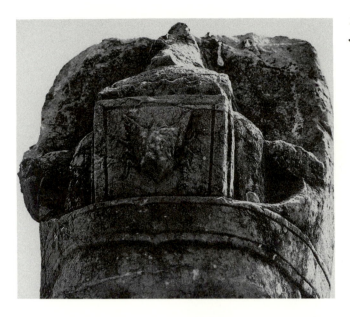

145. Hat of civil official, Jianling.

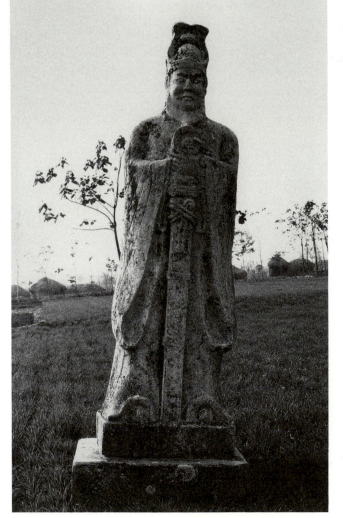

146. Military official, Duanling, tomb of Tang Wuzong (d. 846), San Yuan County, Shaanxi. Height 3.5 m.

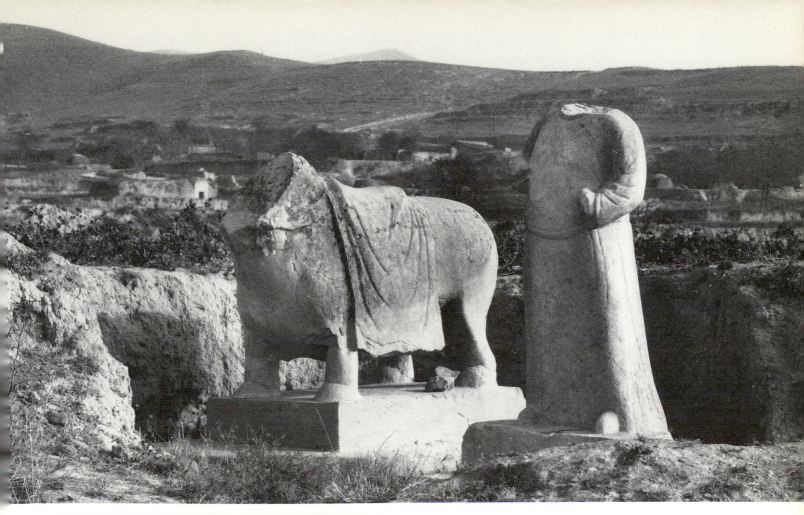

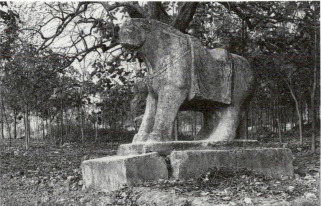

148. One of three pairs of horses outside the northern gate of Tang imperial tombs, representing the imperial stables. Qiaoling. Height c. 2 m.

147. Ceremonial horse and groom, Tailing.

and permanent:[12] from the eighth century onwards, all tomb lions, whether standing or seated, outside the gates or in the spirit road, are of this domesticated type. The Tang spirit road lions do not, like their myriad successors still standing outside large buildings and temples, wear a collar; the best examples are magnificent creatures, radiating life and energy, but their stance and position within the imperial complex show that they no longer symbolize wild nature and that their role is to serve the will of man.[13]

126

149–154

*149. Pair of lions, west
gate, Qiaoling.
Height c. 2.5 m.*

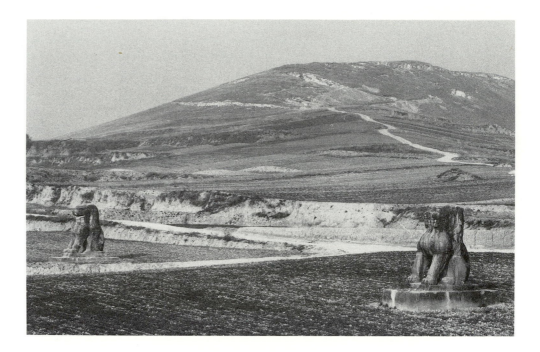

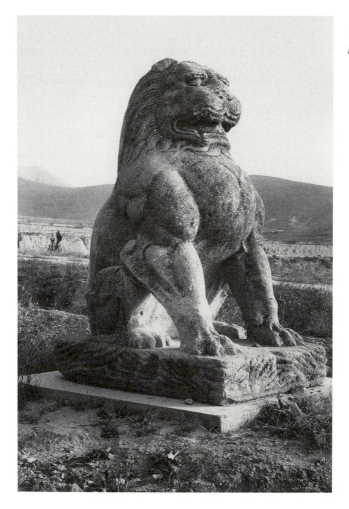

*150. Male lion, south
gate, Tailing.*

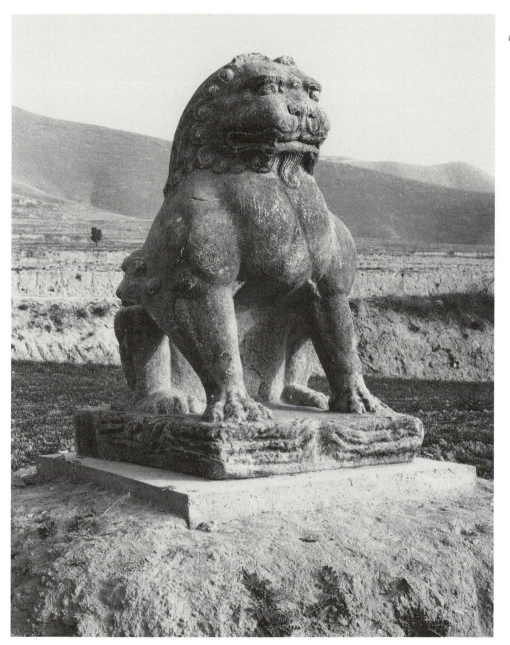

151. Female lion, south gate, Tailing.

Before we leave the Tang tombs, one further point should be noted: the occasional inclusion of groups of foreigners for a purely political purpose. These statues formed part of the ceremonial approach but did not stand in the avenue itself. Li Shimin had placed on his tomb statues of fourteen eminent captives, each with his name and rank carved on his back.[14] The presence of these figures corresponded to current practices, as seen above in the Sui treatment of captives;[15] the primary purpose of this statuary, however, was to demonstrate to the world the military victories leading to the

Colour 10

152. Male lion, south gate, Jianling.

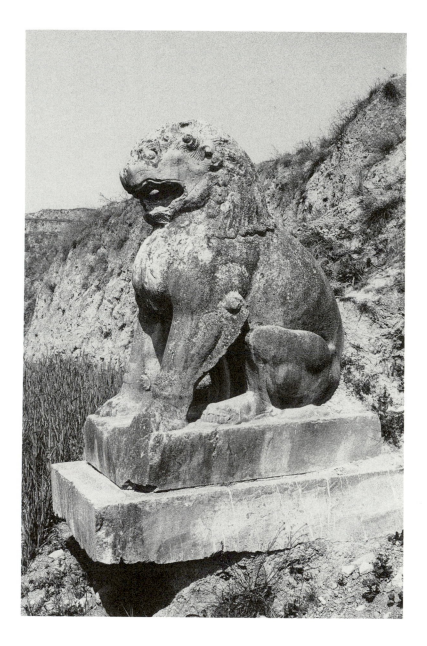

consolidation of the empire. At Qianling a host of foreign dignitaries stand in rows, east and west of the central approach just outside the southern gate to the inner tomb enclosure. Like the foreign grooms, these figures of foreigners were all decapitated in some early wave of xenophobia. Sixty-one figures have survived, wearing national costumes with a variety of objects such as snuff horns, purses, and knives; one holds a bow, others appear to be bearing gifts or to have held a flagpole or banner.

For a long time it was believed that these represented foreign chieftains attending Gaozong's funeral, but recent research has shown that they were

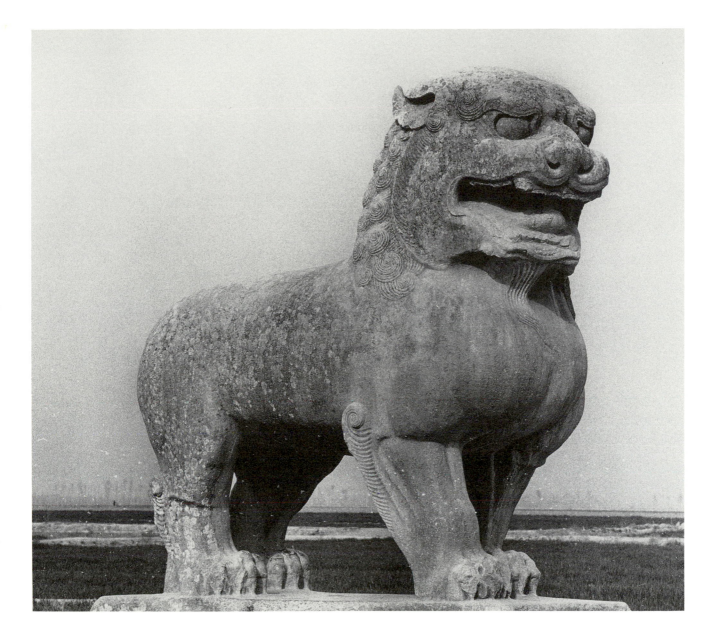

erected long after his death and possibly even after Wu Zetian's death. Identified by Song rubbings of the original inscriptions on their backs, giving names, titles, and places of origin, many of the people depicted had been dead some twenty years before Gaozong's funeral; others only achieved high office long after his death. They were chieftains or nobles from border or minority tribes who held office under the Tang emperor or had other close links with the court.[16] These statues served a purpose similar to that of "accompanying burials." Foreign dignitaries presumably preferred to be buried in their own lands, but their services to the Chinese

153, 154 (overleaf). Male and female lions, Shunling. Although all the lions on Tang imperial tombs are seated, lions at the southern gate of the royal tombs, Shunling and Gongling, are standing. Height 3 m; length 3.45 m.

*154. Female lion,
Shunling.*

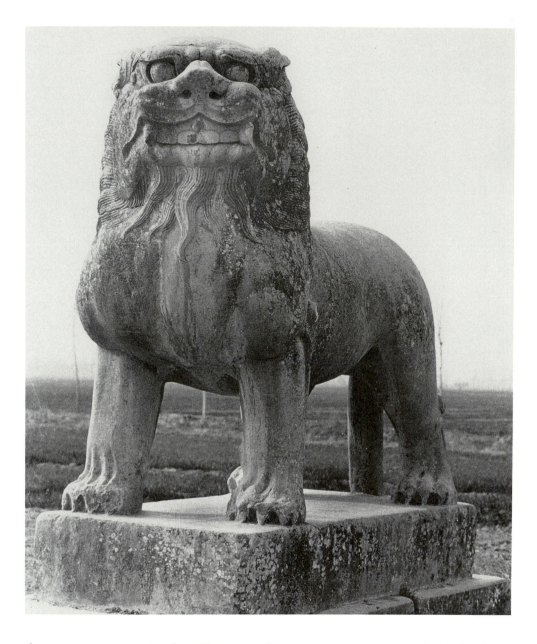

throne were recognized and honoured by permanent memorials in the form
of these stone effigies; their presence on the tomb strengthened links with
their states whilst illustrating the extent of imperial connections.

The Tang spirit road formed a turning point in the history of Chinese
tomb statuary. From now on the imperial avenue always includes stone
officials as well as animals and fabulous creatures; the larger part of the
statuary is representational, reflecting contemporary customs, and even the
magical aspects of the statuary are primarily concerned with the known
world rather than the unknown. Tang concern for accurate reproduction
and the portrayal of stationary rather than moving animals had a lasting
influence on Chinese tomb sculptural style.

NORTHERN SONG DYNASTY

Once again the fall of a great dynasty was followed by a time of confusion—the Five Dynasties and Ten Kingdoms (907–960)—with splinter states competing for the throne. During this period China was threatened by the rise of powerful neighbours on her northern and western borders; in the north the "Sixteen Provinces" were lost to the Khitan (Liao) and the empire which was reunited under the Song in 960 was both smaller and weaker than its Tang predecessor.[1] Convinced by a series of military defeats that they could not subdue their enemies by force, the Song resorted to diplomacy and signed treaties with the Liao and later with their powerful western neighbour, the newly established kingdom of the Western Xia, in which they undertook to pay both states an annual tribute of silver and silk; in a break with tradition, the Liao state was accorded parity with the Chinese empire. (Whilst involving loss of face, these treaties brought the Song a century of peace and an increase in trade which more than compensated for the amount paid in tribute.)[2]

Against this unpropitious background, the Song produced one of the great periods of Chinese civilization. Hemmed in by hostile neighbours, they turned inwards, seeking strength in the past. There was a conscious revival of classical beliefs in which Han Confucianism was reexamined and its basic weaknesses remedied by an eclectic incorporation of metaphysical elements from Daoism and Buddhism. The resulting Neo-Confucianism, with its emphasis on reason and the moral nature of political society, dominated Chinese thought until the middle of this century. Fascination with the past brought an active interest in archaeology (much of our knowledge of early Chinese stone inscriptions is derived from rubbings made by Song archaeologists) and a fashion for archaism—the deliberate use of ancient art styles and objects and a reconstruction of ancient practices. At the same time, technical and scientific inventions produced a striking expansion in trade and industry and the formation of a new, educated, urban class. Cut off from the traditional transcontinental trade routes in the northwest and northeast, merchants found new outlets overseas; this was the first great era of maritime commerce. Not least, it was an age of intense intellectual and artistic activity. Song landscape painting, porcelain, jade, and ivory artefacts are amongst the finest the world has ever seen.

121

The Song tombs reflect the external limitations of the empire, the rich variety of life within its frontiers, and contemporary admiration for the past. Unlike the Tang, with their individual mausolea spread over a large area, *Chart 7* the Northern Song stressed dynastic cohesion by creating a family burial ground. Eight mausolea (the tombs of the first seven emperors and that of the dynastic founder's father) and the tombs of twenty-one empresses and of over two hundred lesser members of the imperial family, plus some "accompanying burials" of officials who helped to found the dynasty, are situated in three groups in an area fifteen by ten kilometres, southwest of modern Gongxian.[3] The choice of site and tomb plan were to a great extent determined by two archaistic beliefs derived from Han or pre-Han texts: the "five sounds theory" of geomancy and the "seven months rule."

According to the five sounds theory, choice of a propitious site for a grave depended on the family name of the deceased. All sounds were divided into five groups: *gong, shang, jue (jiao), zhi,* and *yu*—each with their beneficial directions and geographical conditions.[4] The Song family name was Zhao, in the *jiao* group, for which northwest and southeast were the prescribed directions; for this group a site should have mountains in the south and slope downwards towards the north. The Song tombs fulfill these conditions: they are all laid out on an axis six degrees west of north pointing directly to the highest of the Song Mountain peaks in the southeast. These are the only dynastic tombs which face the mountains rather than having them as a shield behind the tumulus; even more unusual, the spirit roads slope downwards. Today silt has raised the level within the tomb enclosures and this effect is somewhat disguised; in some tombs, however, the decline was so marked that the base of a pair of *que* at the southern end of the spirit road was higher than the top of the tumulus.[5]

The seven months rule had an equally decisive effect. Based on the Zhou Book of Rites, the *Li Ji,* in which it is written that "the Son of Heaven is encoffined on the seventh day and interred in the seventh month," this rule was interpreted to mean that no work could be done on the emperor's tomb during his lifetime and that the entire construction of the tomb, from the choice of site to the final interment, had to be completed within seven months of his death.[6] The time limit influenced the choice of site since speedy access, especially from the stone quarries, was essential.[7] It limited the scale of building (one is tempted to believe that the rule was revived to justify economy): Song tombs are modest—an imperial mausoleum was only half the size of the tomb of a Tang crown prince.[8] Finally, it led to the repeated use of a prearranged tomb plan: the imperial mausolea are virtually identical, laid out with geometric precision on the plain. The basic plan is similar to the Tang city-tomb, but the outer enclosure, no longer walled, 53 was marked by a hedge of prickly plants.

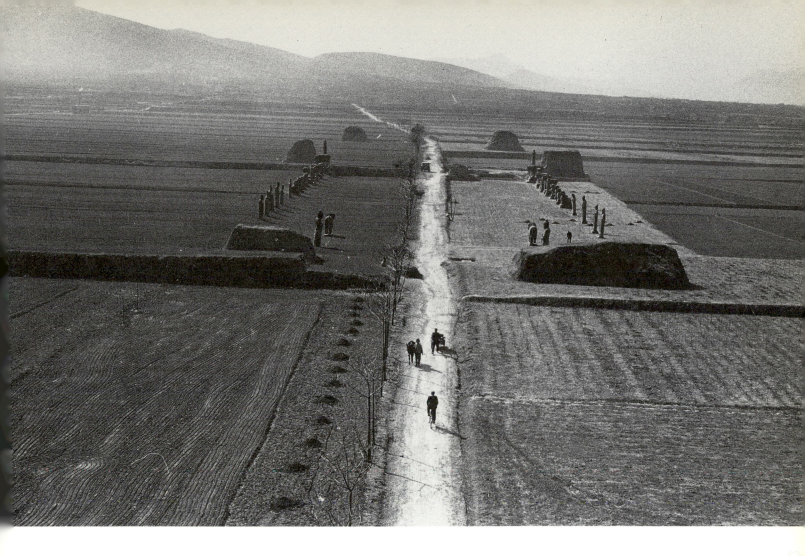

Although the tombs were sacked twice (by the Jin in their invasion of 1125 and a century and a half later, by the Mongols), there are sufficient remains of tumuli and rammed-earth foundations of walls, corner towers, and *que* to indicate the original design. More important, the spirit road statuary has survived almost in its entirety. Over one thousand statues, many over four metres tall, are still in situ. This vast repository of tomb sculpture was carved in a period of 124 years.

The Song spirit road is short and wide and the statues stand close together as if lining a courtyard rather than forming an alley. (At Tang Qianling, the imperial way is one kilometre long and 25 metres wide; the comparable figures for a Song tomb are 150 metres by 40 metres.) Designed to be seen from a distance of 20 metres, the figures are taller than customary, with detail concentrated on the front. The statuary continues right up to the tumulus, two pairs of palace servants or eunuchs standing within the inner enclosure, and the whole arrangement gives a strong impression of a theatrical setting. This is a mise-en-scène in stone with even the mounting blocks in place, waiting for the emperor to emerge from his underground

155. Yong Tailing, tomb of Song Zhezong (d. 1100), Gongxian, Henan, from tumulus looking south.

155,156
Chart 8

157

158–160

156. Yong Xiling, tomb of Song Taizong (d. 997). The mound on the right is the tumulus; the smaller mound on the left is the remains of the gate tower into the enclosure.

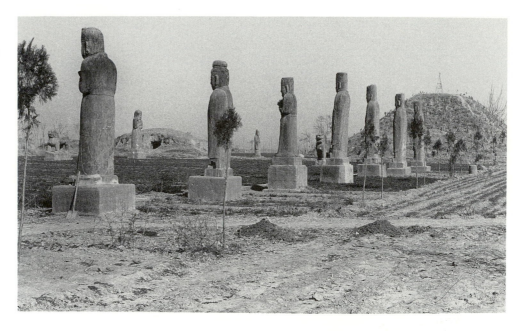

157. North end of spirit road with civil official, lion, "heavenly guards," and a pair of eunuchs (one broken) at the entrance to the inner tomb enclosure, Yong Xiling.

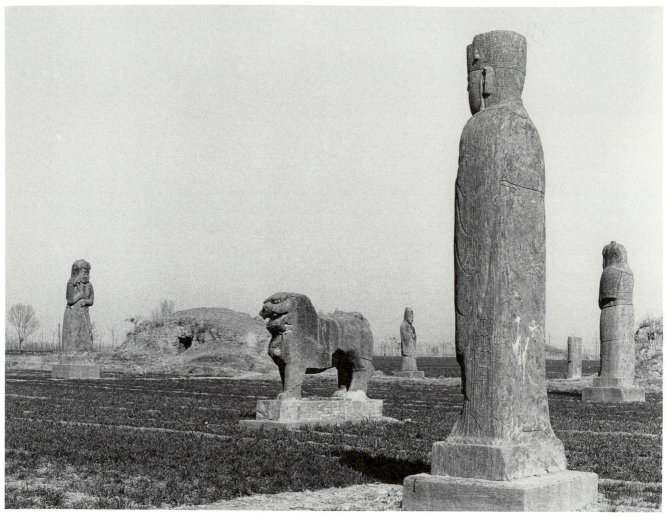

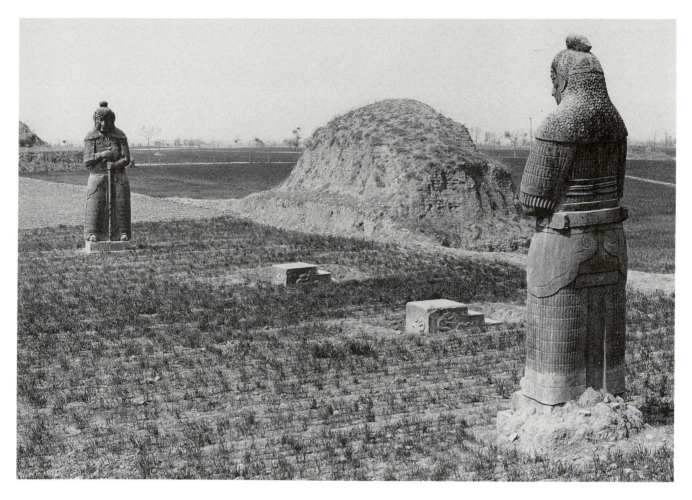

158. *"Heavenly guards" and mounting blocks, Yong Yuling.*

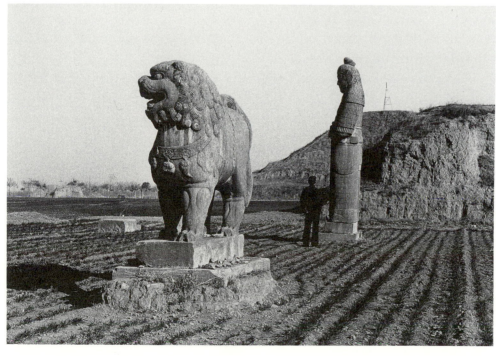

159. *Lion, mounting block, and "heavenly guard," with gate tower and tumulus in background, Yong Yuling.*

160. Mounting block carved with dragons and clouds, Yong Tailing.

palace. Tang grandeur, with its imaginative use of nature to convey a sense of limitless power, has been replaced by a world of moderation in which boundaries are made by man. In the Tang tombs the eye was drawn outward across the valley to distant mountain horizons; in the Song tomb the eye is contained. The tall statues on the flat plain frame the approach, directing attention to the tumulus ahead.

The subject matter, more varied than in any other dynasty, includes Tang subjects, subjects mentioned in records of Han tombs, and a few specifically Song ingredients reflecting the insidious presence of the world outside China.[9] The Song approach to the spirit road is fundamentally the same as the Tang: the statuary represents an imperial occasion and is primarily addressed to this world, but there is an increased use of animals for purely symbolic reasons.

Colour 12

161–170

171–174

175,176

From the Tang came the columns, the horses, the military and civilian officials, the lions, and the auspicious bird. The symbolic aspects of the Tang ostrich are now recognized: this is the Vermilion Bird of the south, portrayed as one of those patchwork fantasies of which the Chinese were so fond. Sheep (or rams) and tigers, common to Han and Tang tombs of officials, appear in their ancient traditional form derived from Bronze Age figurines—the kneeling sheep symbolizing filial piety, the tigers, martial

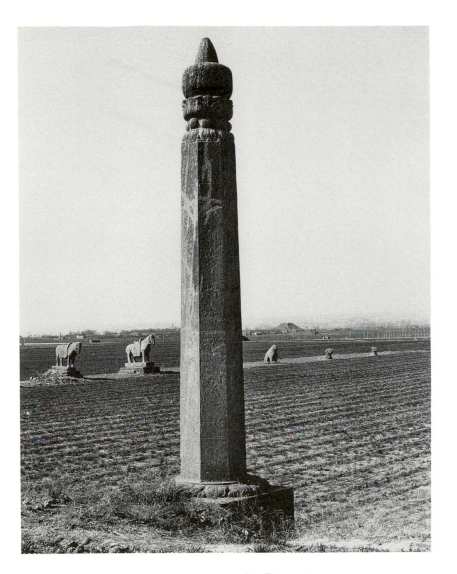

162. Engraving on column at Yong Yuling, tomb of Song Shenzong (d. 1085), Gongxian.

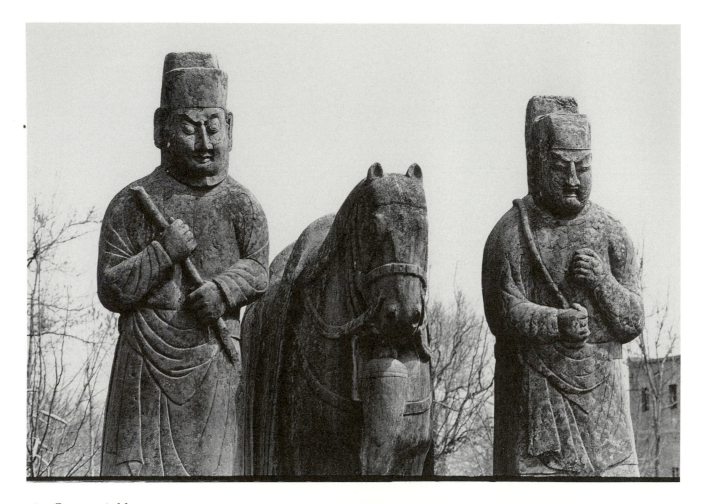

163. *Ceremonial horse and attendants (one non-Han), Yong Xiling. Height of horse, 2.36 m; of grooms, 2.9 m.*

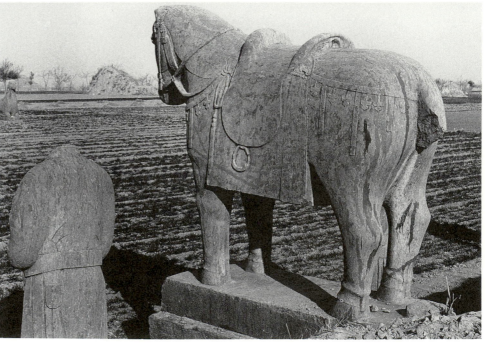

164. *Ceremonial horse, Yong Yuling. Height 2.1 m.*

valour. The elephants are a clear throw-back to the Han. As seen earlier, there are records of stone elephants on the tomb of the first Eastern Han emperor; elephants were present on important Eastern Han ritual occasions and were sent, for practical reasons, ahead of the imperial cortège to test the strength of bridges. Here, like the horses with their attendant officers, they play a ceremonial role, their beautiful embroidered saddlecloths and decorated harness bringing a whiff of exotic luxury.[10] The mahouts, clearly from Southeast Asia or India, wear bejewelled headbands over their long, curly locks; some have earrings, jewelled armbands, and anklets as well as necklaces.

The colossal guards at the northern end of the courtyard and the eunuchs within the southern gate of the inner enclosure reflected practice in real life. The eunuchs, or palace servants, have slender bodies, sloping shoulders, and curved eyebrows; they stand where they belonged, within the palace (grave) enclosure. The guards were based on the emperor's personal guard of ten, chosen especially for their height and known as "Heavenly Military Officers" (*tian wu guan*). They flanked the emperor when he went outside the palace and stood in each corner of the hall during an imperial audience.[11] It is not clear whether these two sets of stone officials were a Song innovation or whether they had also been included in some Tang tombs. Traces of a pair of human figures have been found just inside the southern gate of the inner enclosure at Tang Qianling, which could perhaps have been palace servants.[12]

Unique to the Song tombs are the choice of a fabulous beast which speaks foreign languages and the inclusion of foreign ambassadors. The *jiao duan*, an ungainly winged and horned quadruped, could traverse mountains and seas, covering up to eighteen thousand *li* in a day. Understanding all foreign tongues, it kept the emperor in touch with what was happening in distant countries. Here is a striking example of the maxim that dynasties create fabulous animals with those qualities they most desire. For the Song, living in a multistate system among equal or near-equal neighbours, survival depended on well-informed diplomacy—hence the *jiao duan*, the only dynastic mythical creature to recognize the existence of a world outside China. Equally unusual are the six envoys. Standing three-a-side, these represent different countries, the selection of countries varying from tomb to tomb (see Appendix B).

They are not the only foreigners on the tomb; the mahouts and some of the horse officials are non-Han, but these, like Tang grooms, were only adjuncts to the ceremonial animals they attended. These foreign emissaries, unlike the special group of foreign dignitaries at Tang Qianling, who stand outside the main avenue, take their place in the hierarchy of the spirit road, standing below the Chinese officials and above the horses and their atten-

165. Early Northern Song dynasty military official, Yong Changling (976). Height 4.1 m.

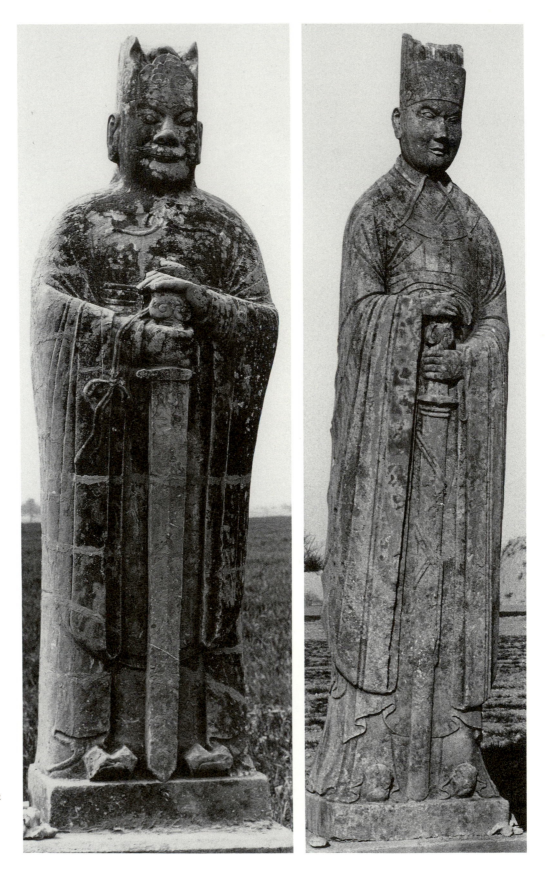

166 (far right). Late Northern Song dynasty military official, Yong Yuling (1085). After a century of peace, the robust warrior has been replaced by a courtier only distinguishable from his civilian counterpart by his long sword. Height 3.9 m.

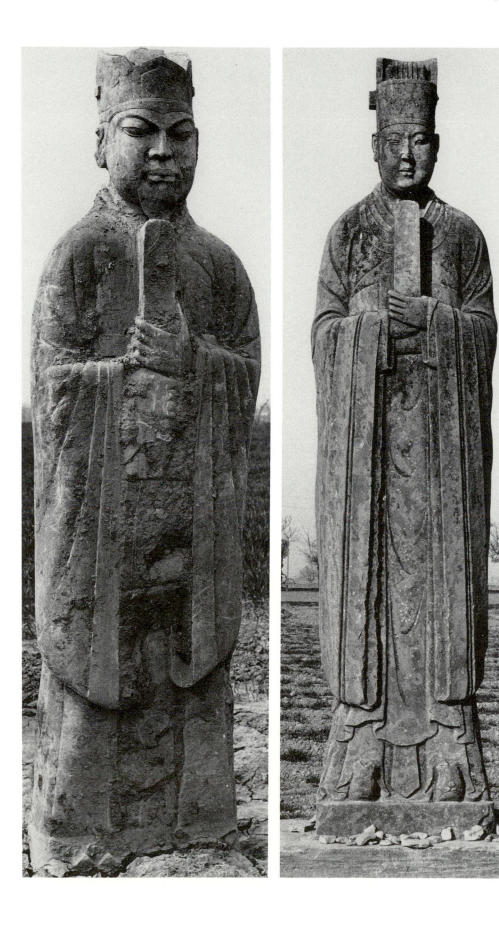

167 (far left). Early Northern Song civil official, bearing the hu, *a tablet symbolizing high office. Yong Changling (976). Height c. 4 m.*

168. Late Northern Song dynasty civil official, Yong Yuling (1085). Height c. 4 m.

169. Civil official, back view, Yong Tailing (1100).

dants. Their presence on the tomb and the nature of their gifts suggests that the occasion portrayed by the Song spirit road array may have been the imperial audience held on New Year's Day or possibly the emperor's birthday.[13]

194 These statues are a delight. Carved with the utmost attention to detail, their strange costumes and outlandish features bring a breath of the outside world into the dusty Gongxian plain. Here are Arabs with turbans and long robes, earrings, and luxuriant beards, clutching bowls of precious stones; here are soft-skinned Southeast Asians, their tunics tied with

193,195

long, soft bows under capes, bare or sandalled feet, earrings and hair tied in double knots with thin scarves, offering rhinoceros horn or ivory; here,

295(1) in riding garb with boots and three-quarter-length costume, a balaclava-type helmet-hat covering the nape of the neck, is a man from the steppes.

196,197 A Korean stands with a beautifully chased, inlaid box, whilst a Khotanese wearing a distinctive pointed hat proffers another selection of jewels.

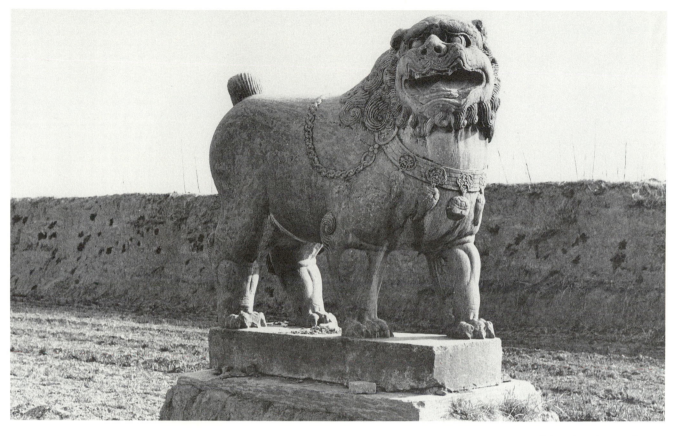

170. Lion (east), south gate, Yong Yuling. On Song imperial tombs, the lions outside the southern gate are always standing, those at the east, west, and northern gates, sitting. Height 2.36 m.

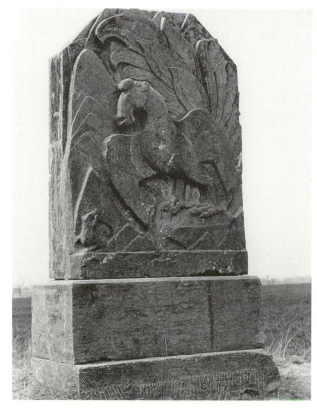

171. Auspicious bird, Yong Changling. Height 2.2 m.

172. Auspicious bird, Yong Xiling. Height 3.17 m.

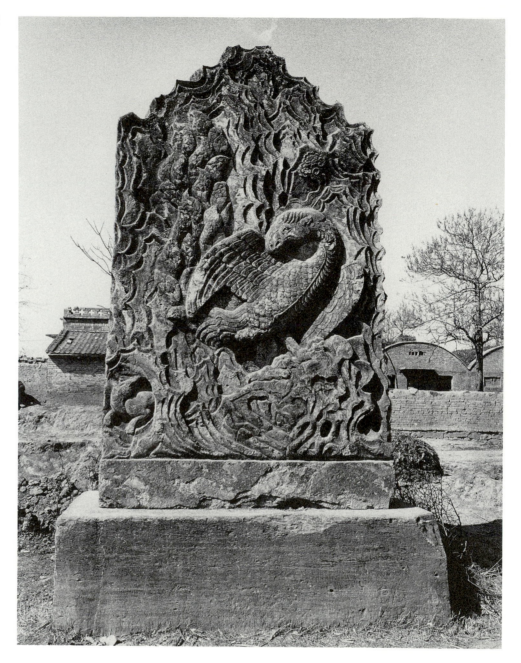

Given the size and number of Song tomb statues and the speed with which they were executed, it is not surprising that there are wide fluctuations in sculptural standards. In the early tombs Tang influence is clear: animals are thick-set; humans tend to be plump and round-cheeked; from the mid-eleventh century onwards a process of elongation sets in. The ideal of the human figure has changed and officials are tall and elegant; sheep develop long, slender necks and the tiger resembles a sleek cat. Typical examples of this distinctive mid– and late Northern Song style can be seen

175,176

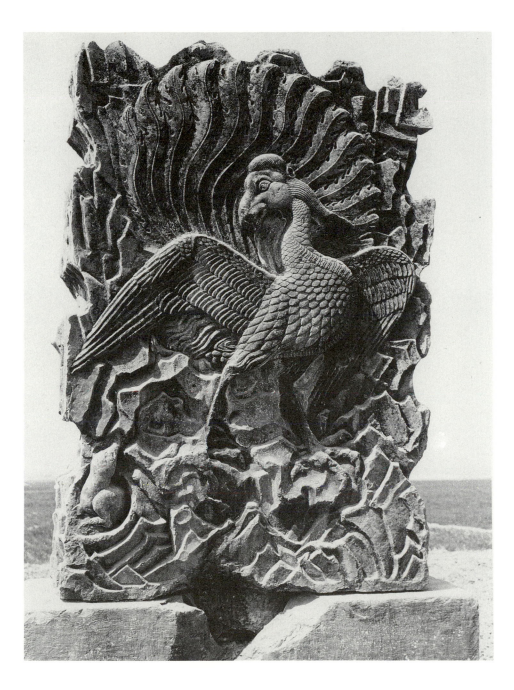

173. Auspicious bird, Yong Tailing. Height 2.3 m.

at Qufu, Shandong, in the strange animals guarding the gates of the Con- 198–200
fucian palace and in the almost five-metres-tall officials on the Song spirit
road which leads to the tomb of Confucius in the family cemetery nearby.

The Song adopted Tang sculptural realism, but in dealing with horses
and elephants came nowhere near the Tang rendering of real animals; when 192
imagination was called for, as in the *jiao duan*, it failed. The most skilful
carving is found in human statuary, where the variety of subjects illustrates
Chinese stone portrait sculpture at its best. The statues of military officials,

174. *Small animal on bird slab, Yong Zhaoling, tomb of Song Renzong (d. 1063).*

175. *Tigers and rams, Yong Yuling.*

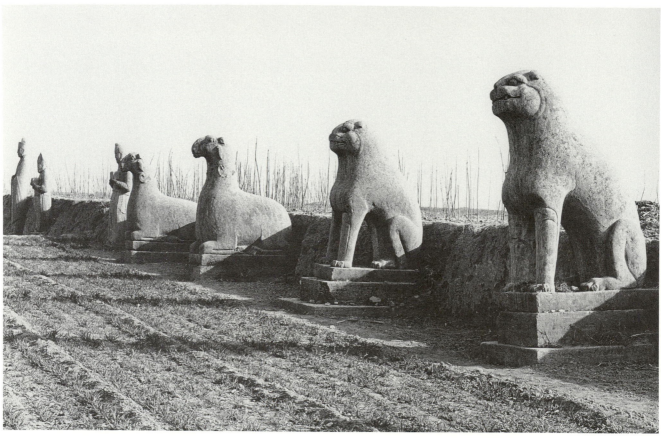

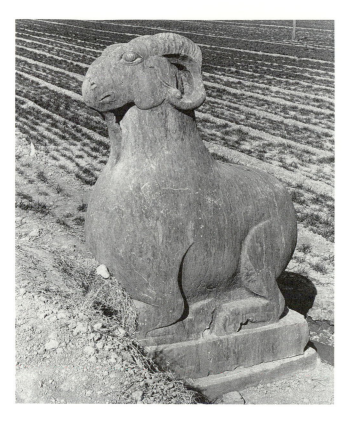

176. Ram, Yong Changling. Height 1.6 m.

177. Elephant and mahout, auspicious bird and fabulous jiaoduan, *Yong Xiling. Height of elephant, 2.86 m.*

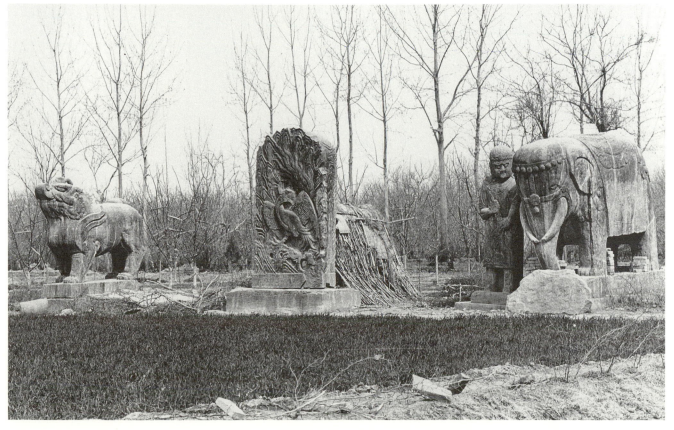

178. Elephant and mahout, Yong Changling.

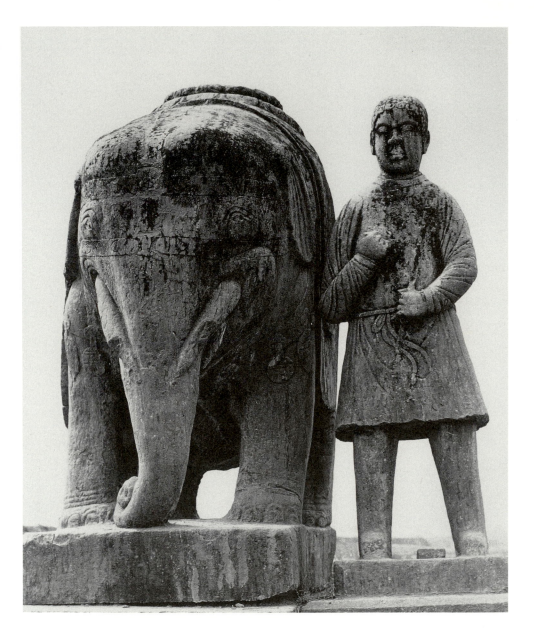

165,166

168

179. Elephant and mahout, Yong Tailing. Height of elephant, 2.4 m; length 1.7 m.

190

for example, portrayed the gradual process whereby the stalwart military on the early tombs, fresh from the fray of battle, were softened and gradually assimilated into court life. Not only their clothing but their features changed, and on the later tombs the smooth-faced, elegant military commanders are only distinguishable from their civilian counterparts by their emblem of office, the long sword. In the mahouts, grooms, and ambassadors, the sculptors were freed from traditional restraints governing the representation of Chinese worthies and produced lively portraits based on live models or contemporary drawings.[14] Despite the size of these figures, the same delicacy in carving detail is shown as in small figurines; the ability to reproduce different materials in stone was carried to new heights, and you

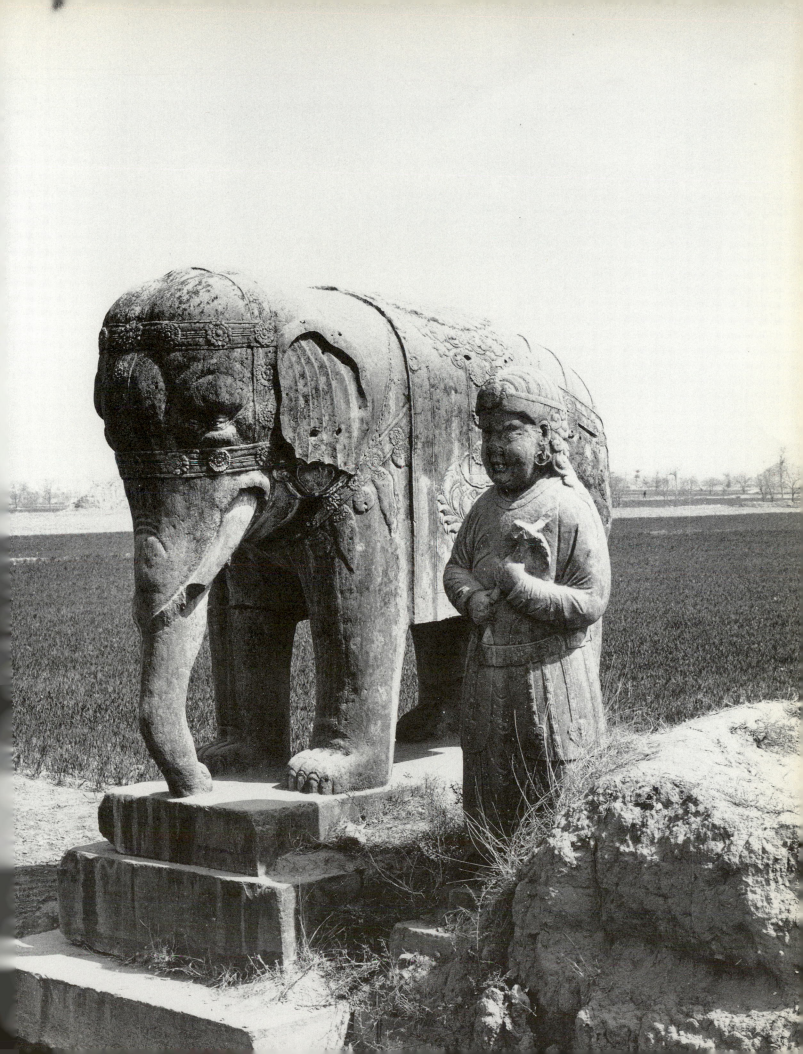

180. *Elephant trunk, Yong Dingling.*

181. *Elephant saddlecloth, Yong Houling, tomb of Song Yingzong (d. 1067), Gongxian.*

182. Mahout in sleeveless tunic wearing necklace, earrings, armband, and bracelets. Yong Dingling, tomb of Song Zhenzong (d. 1022), Gongxian. Height 2.74 m.

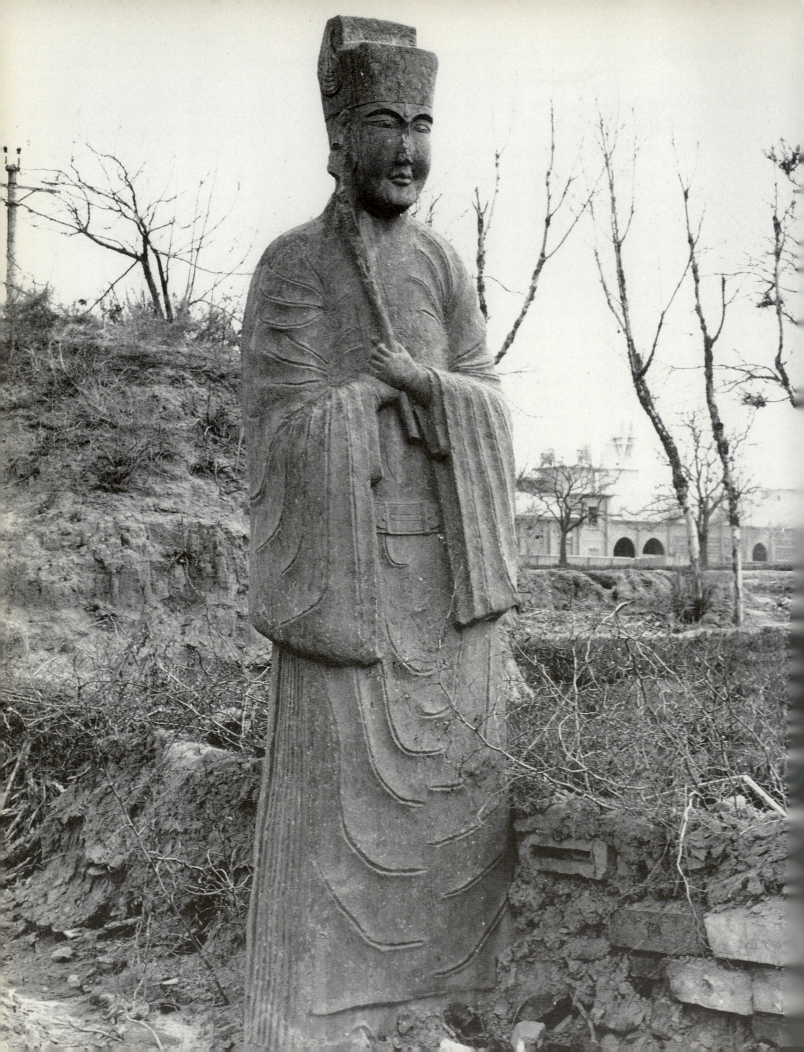

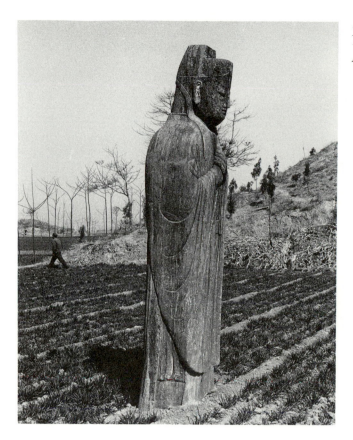

*184. Eunuch by tumulus,
Yong Changling.
Height 3.1 m.*

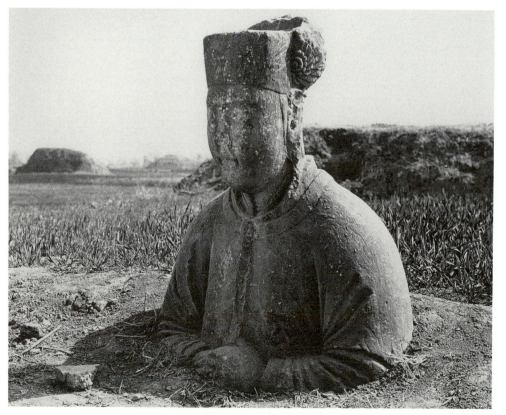

*185. Eunuch half-buried
by the rise in ground
level, Yong Tailing.*

*183 (opposite). Eunuch
inside southern gate to
inner tomb enclosure,
Yong Zhaoling.
Height 3.6 m.*

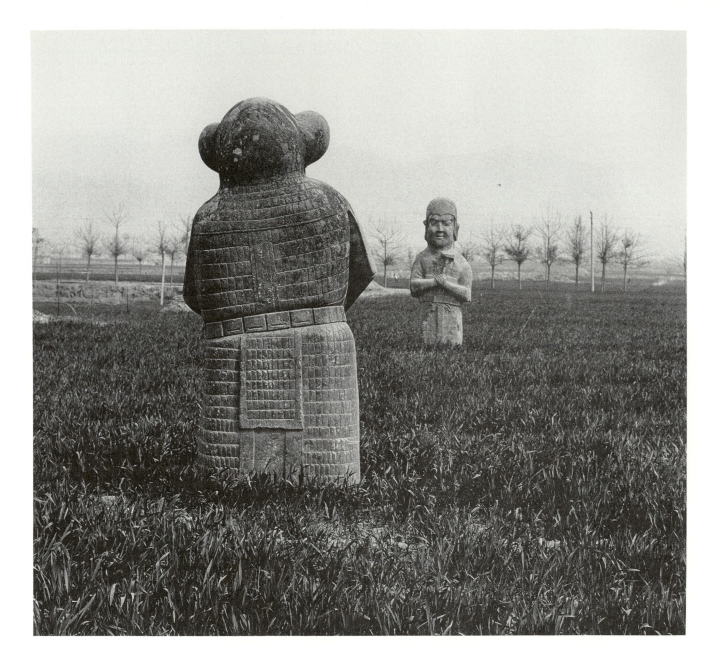

186. *"Heavenly guards," Yong Changling. This is the only tomb in which the guards are dissimilar. The ground level has risen; their full height is about four metres.*

187. *"Heavenly guard," Yong Changling.*

can almost feel the different textures in the armour-suit of the guards: the leather straps with metal fastenings, breastplates partly woven from leather thongs, cord ties, metal belts, and soft, silken-pleated underskirts.

Recent discoveries have thrown some light on the expense of these tombs. Despite the built-in economy of the "seven months rule," the human and financial burden was crushing. Records from the site of the quarry for stone for the last Song tomb, Yong Tailing, show that three months were allowed for stone cutting. Nearly 33,000 large blocks were cut by a work force of 9,744 soldiers and masons gathered from afar. During these three months,

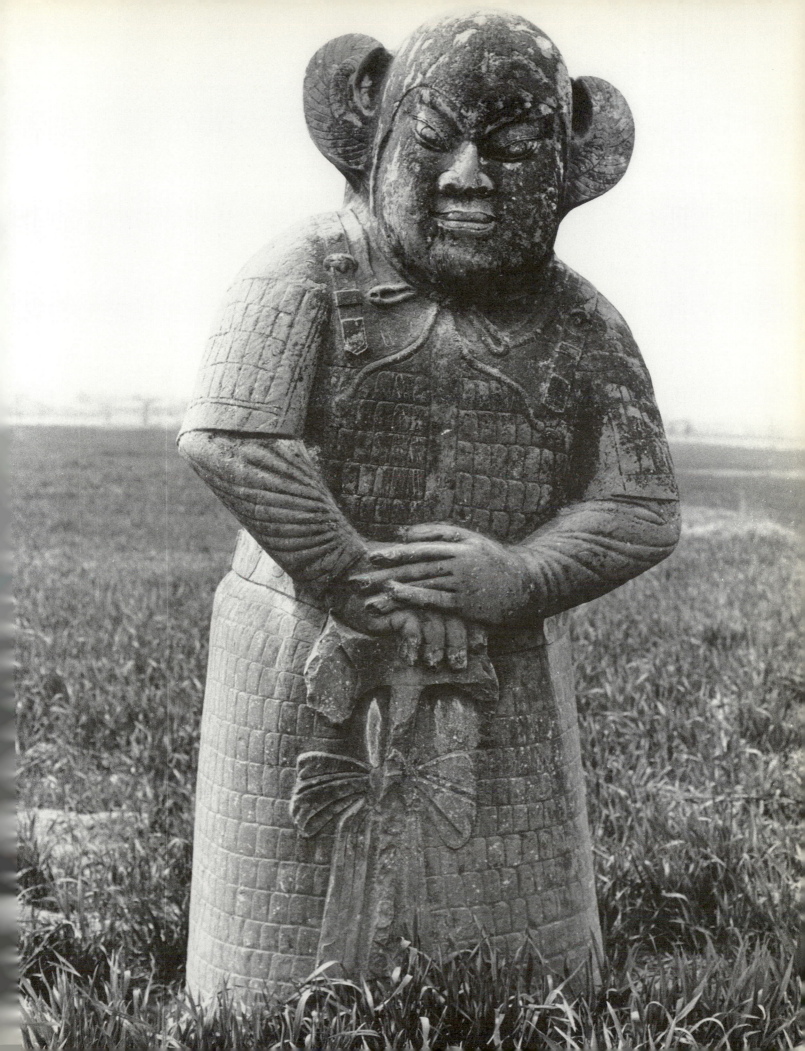

188. "Heavenly guard,"
Yong Zhaoling.
Height 3.9 m.

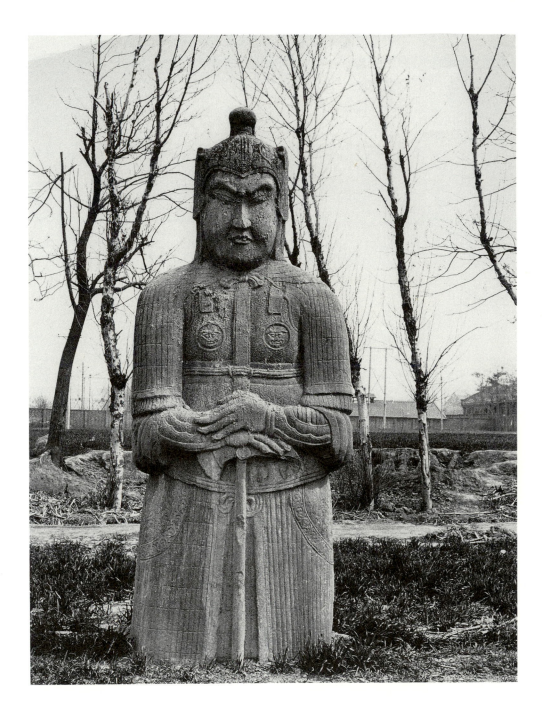

189. "Heavenly guard,"
Yong Yuling.
Height 4.1 m.

nearly 2,000 men had to be replaced because of illness.[15] Comparisons of cost are always uncertain, but according to Chinese figures, 46,700 people were mustered for building Renzong's tomb, Zhaoling, and the Finance Department allocated 4.5 millions of cash to cover its cost. This was nearly six times the total annual amount paid in tribute, and the tomb, in seven months, absorbed over 10 percent of the annual state income.

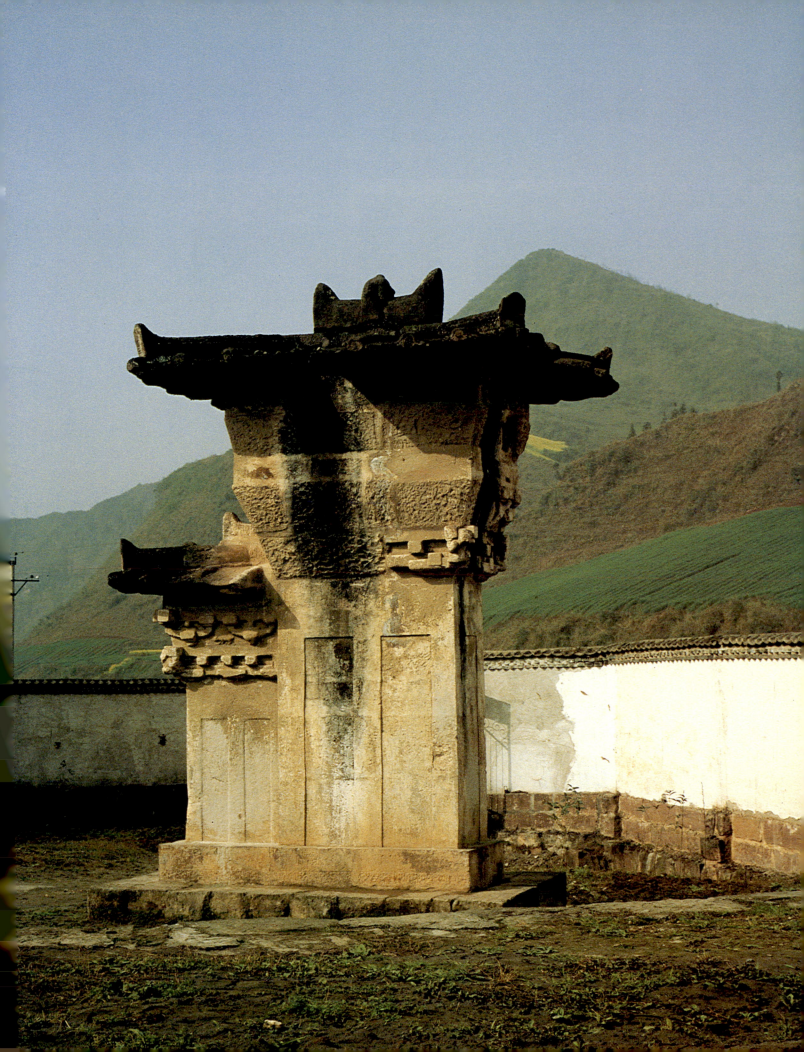

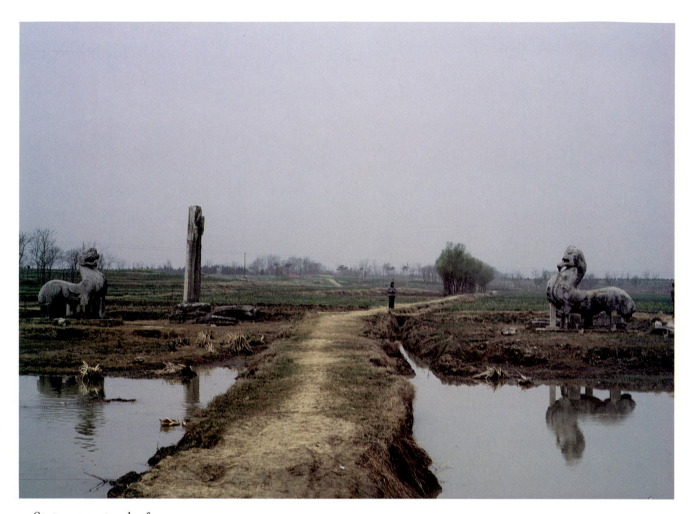

2. Statuary on tomb of Liang Wendi, father of the founder of the Liang dynasty (posthumously ennobled, A.D. 502), Danyang, Jiangsu.

3 (top right). Qilin, *tomb of Qi Wudi (d. 493), Danyang. Height 2.2 m; length 2.7 m.*

1 (preceding page). Eastern Han que, *tomb of Fan Min (d. 205), Lushan, Sichuan. Height c. 5.5 m.*

4 (bottom right). Bixie, *tomb of Xiao Jing (d. 523), Nanjing, Jiangsu. Height 3.5m; length 3.8 m.*

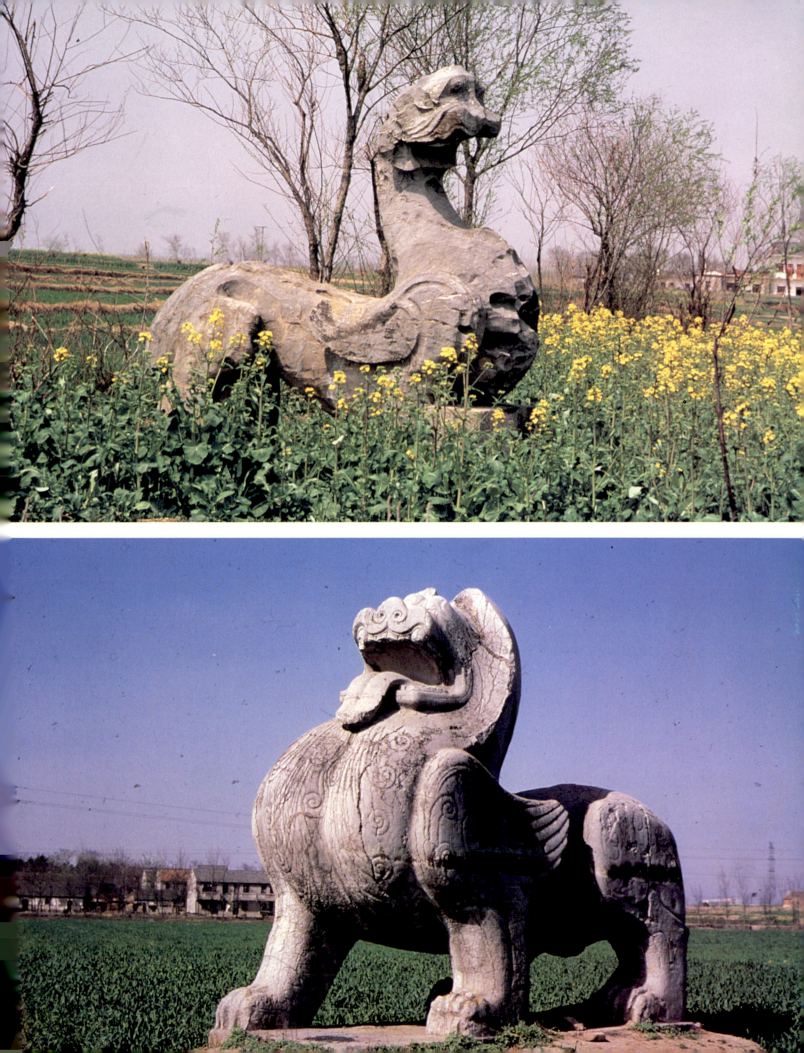

5. Spirit road at Qianling, tomb of Tang Gaozong (d. 683) and the empress Wu Zetian (d. 705), near Xian, Shaanxi, looking north.

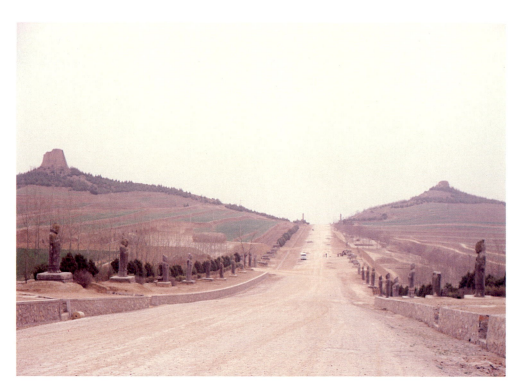

6. West side of spirit road, Jianling, tomb of Tang Suzong (d. 762), Li Quan County, Shaanxi.

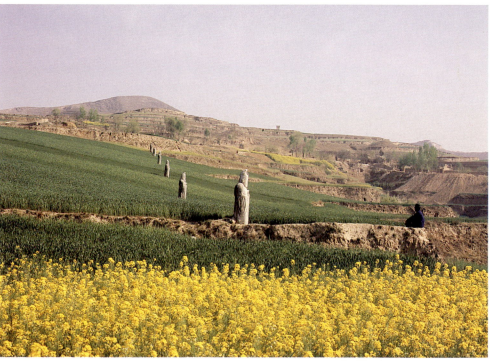

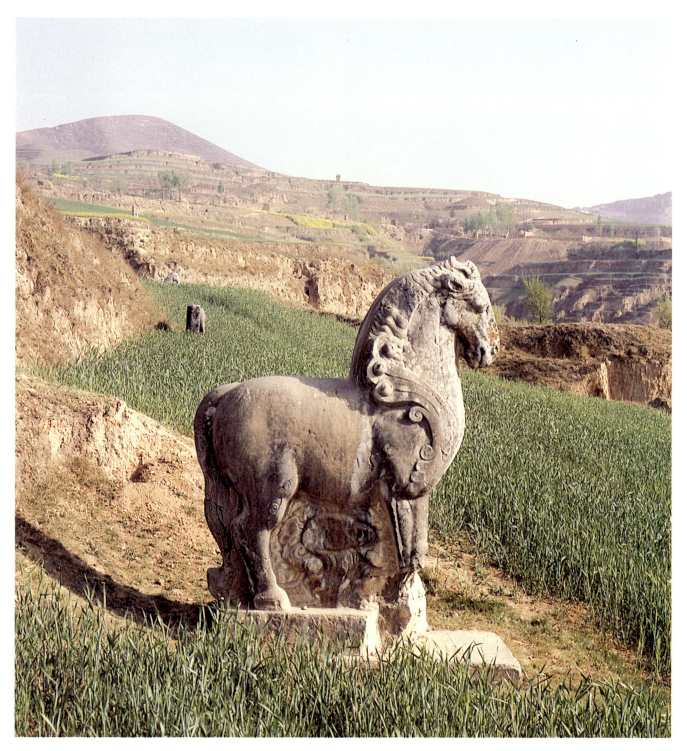

7. *Winged horse (west), seen from south, Jianling, tomb of Tang Suzong (d. 762), Li Quan County, Shaanxi. The eastern side of the spirit road is on the far side* of the ravine, which can only be crossed at the entrance to the inner tomb enclosure, one kilometre further north. Height 2.4 m; length 2 m.

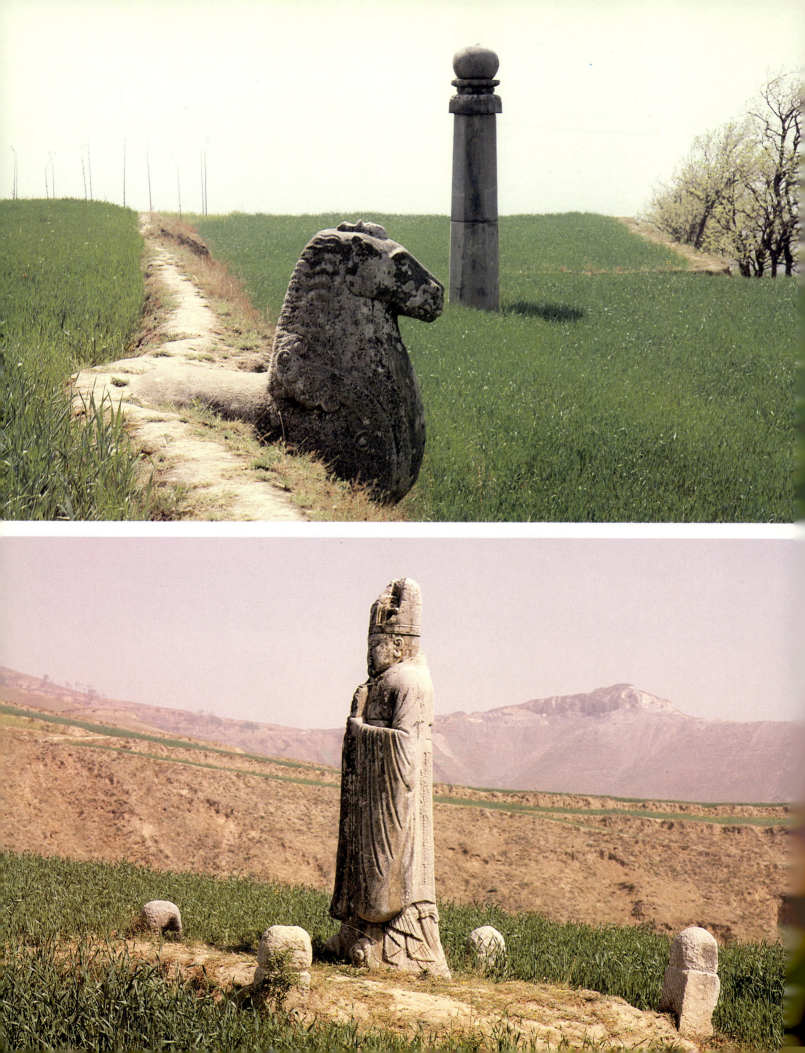

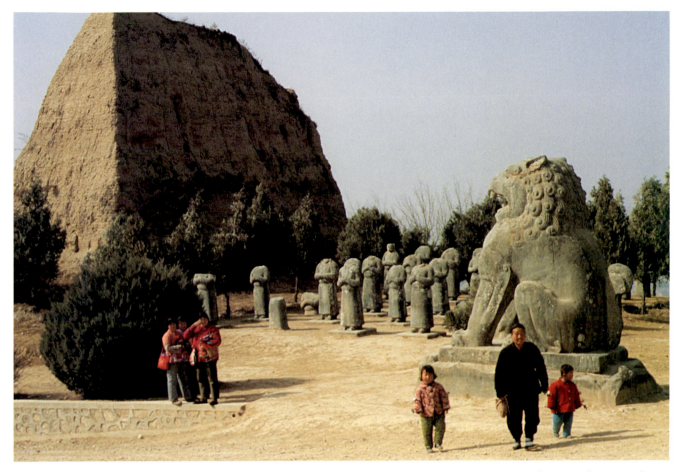

*10. Lion and group of
decapitated statues of
foreigners, Qianling.*

*8 (top left). Column and
winged horse on east side
of ravine, Jianling.*

*9 (bottom left). Civil
official, Jianling.
Height c. 4 m.*

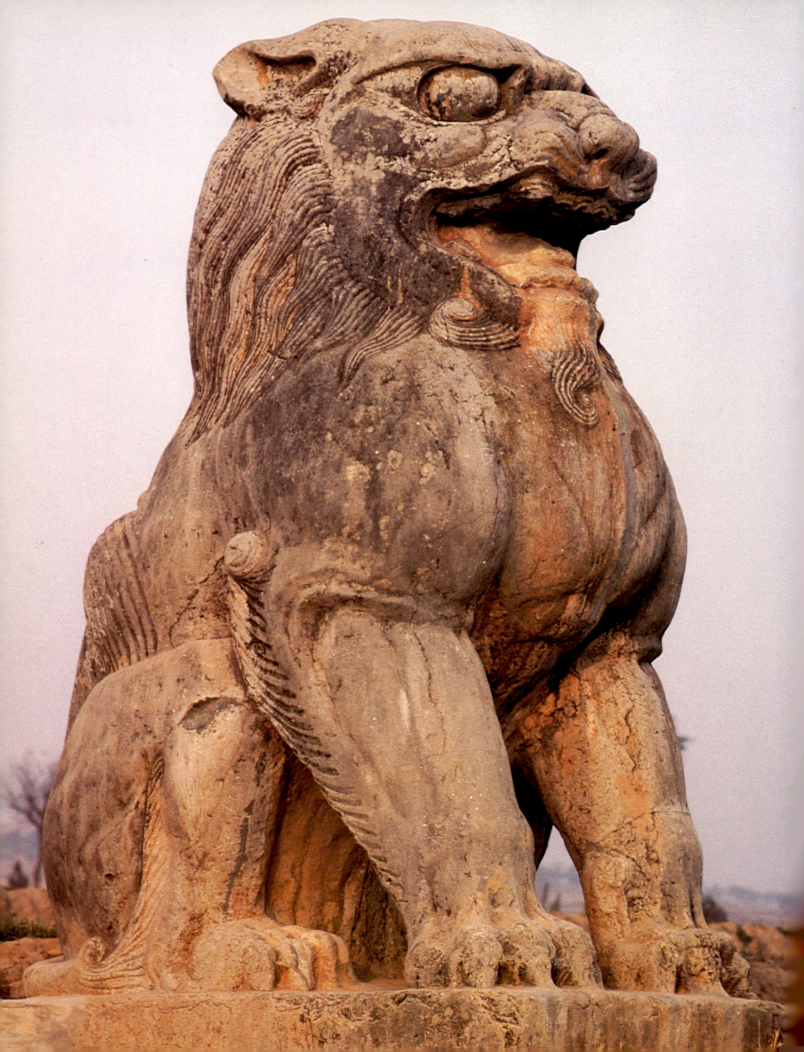

12. Column, elephant, and auspicious bird, with remains of gate tower, Yong Changling, tomb of Song Taizu (d. 976), Gongxian.

13. Horses and grooms, Yong Xiling, tomb of Song Taizong (d. 997), Gongxian.

11 (opposite). Male lion, southern gate, Qiaoling. Height 2.8 m.

14 (overleaf). Huangling, tomb of the first Ming emperor's father, constructed 1370–1379, Fengyang, Anhui. The statuary was discovered in the fields during the Cultural Revolution and reerected in situ in the early 1980s.

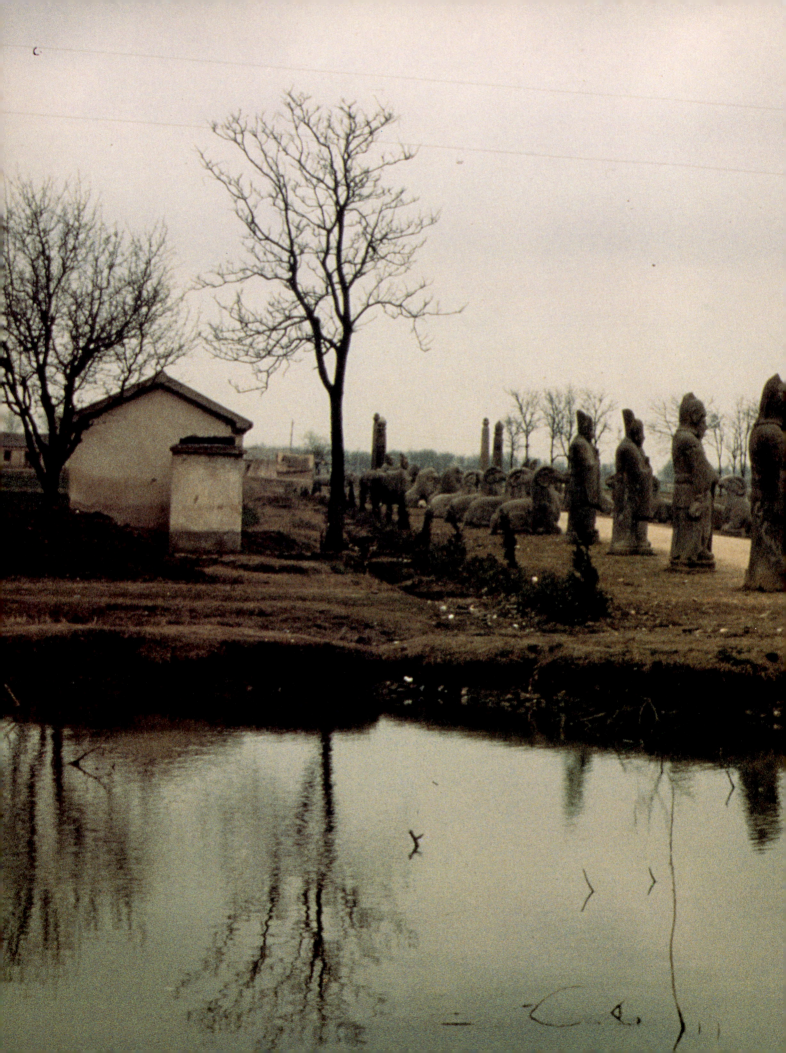

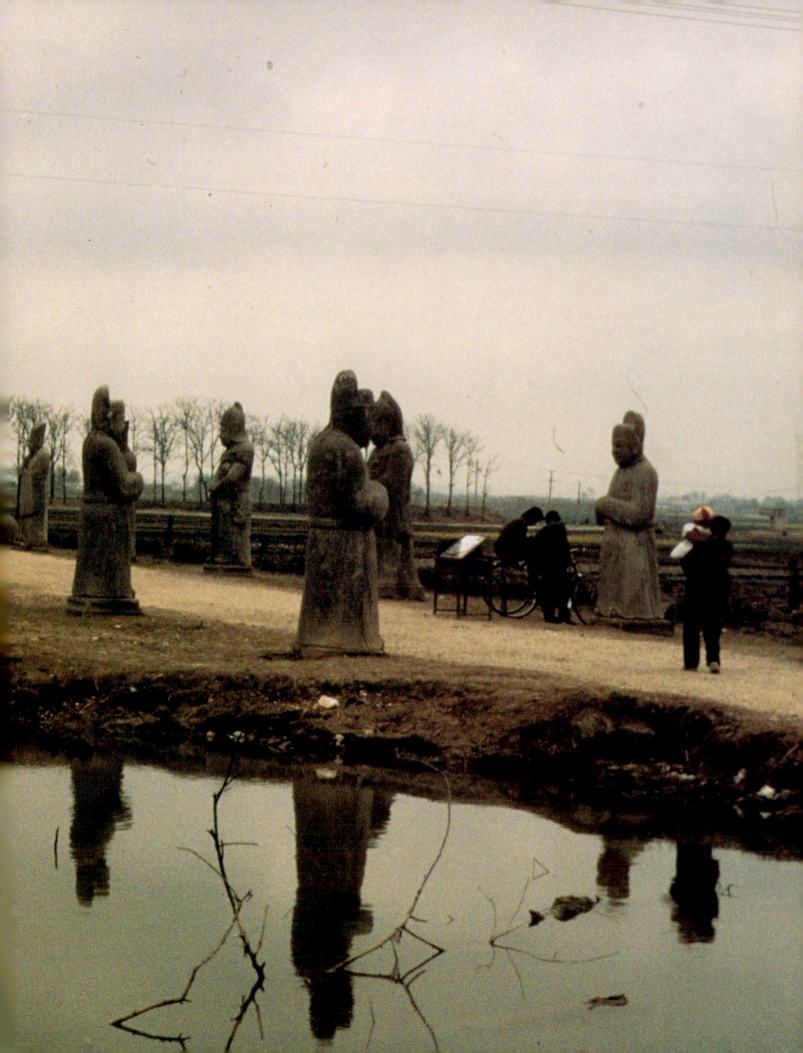

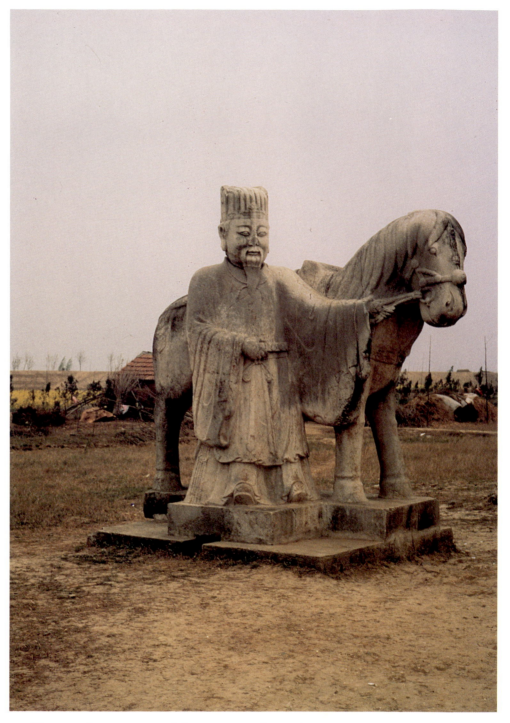

15. *Horse and groom, carved from one piece of stone, Zuling, tomb of the first Ming emperor's grandparents, constructed 1385–1413, Lake Hongse, Jiangsu. Submerged in the lake during the mid-seventeenth century, the statuary was rediscovered after the great drought of 1962–1963. Height of horse, 2.65 m; of official, 2.9 m.*

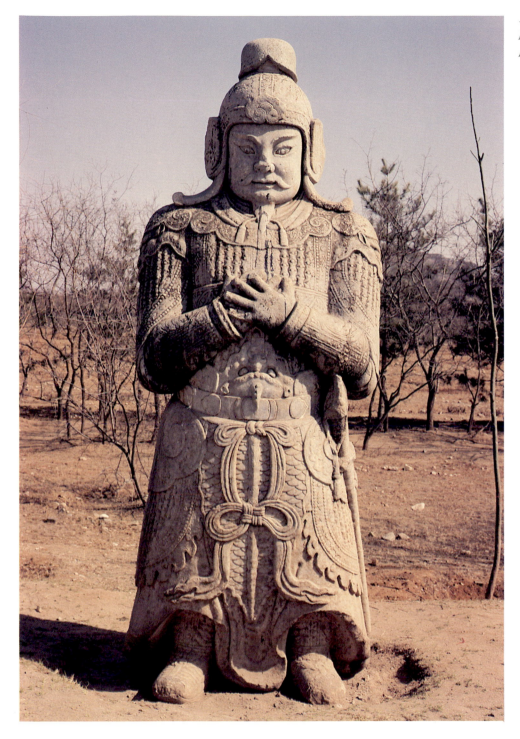

16. Military commander,
Ming Tombs near Beijing.
Height c. 3 m.

17. Pai lou, *Valley of the Thirteen Ming Tombs, Beijing, 1540.*

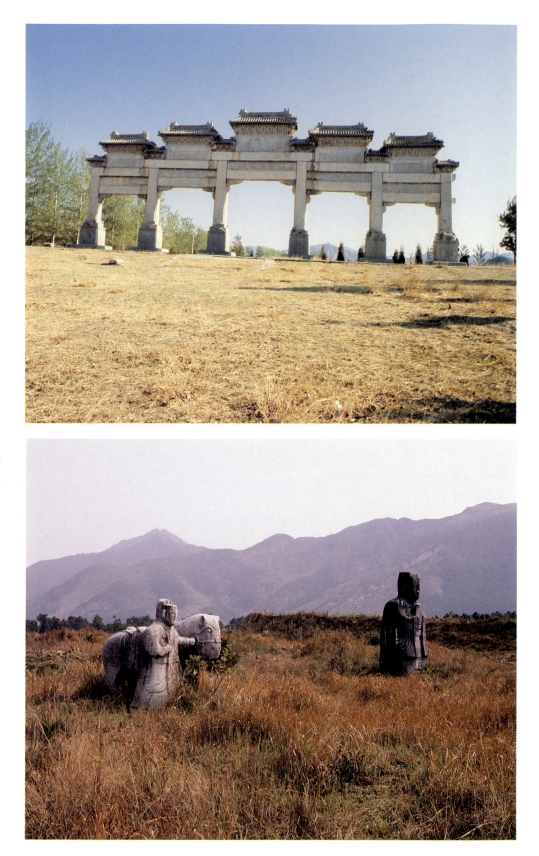

18. *Horse and groom, tomb of Ming prince Zhu Zuojing (d. 1469), Guilin.*

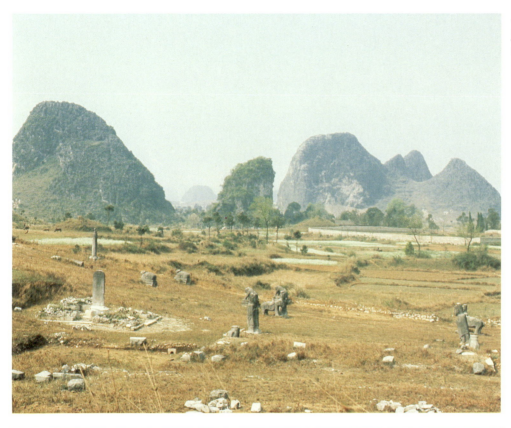

*19. Spirit road of Ming
prince Zhu Renshang
(d. 1610), Guilin.*

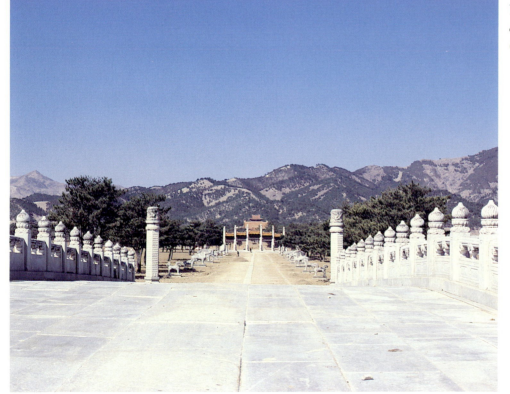

*20. Spirit road leading to
Yuling, tomb of the Qing
emperor Qianlong
(d. 1799), Eastern Tombs.*

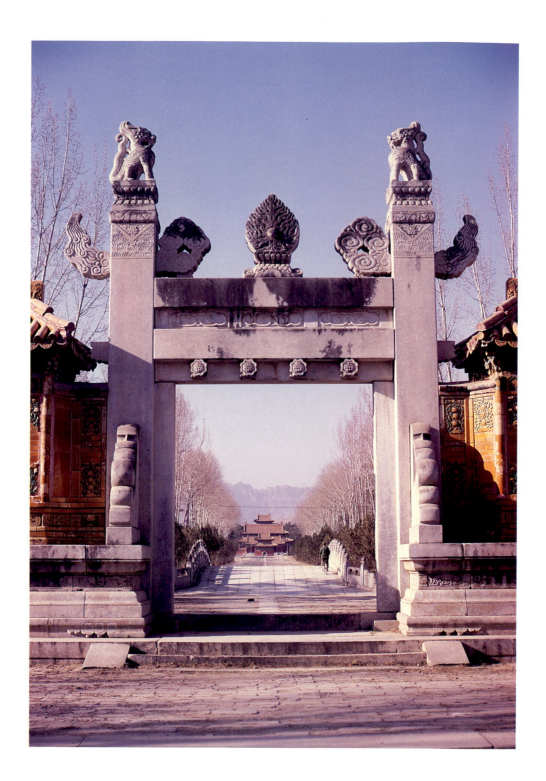

21. Changling, tomb of Qing Jiaqing (d. 1820), Western Tombs, Hebei.

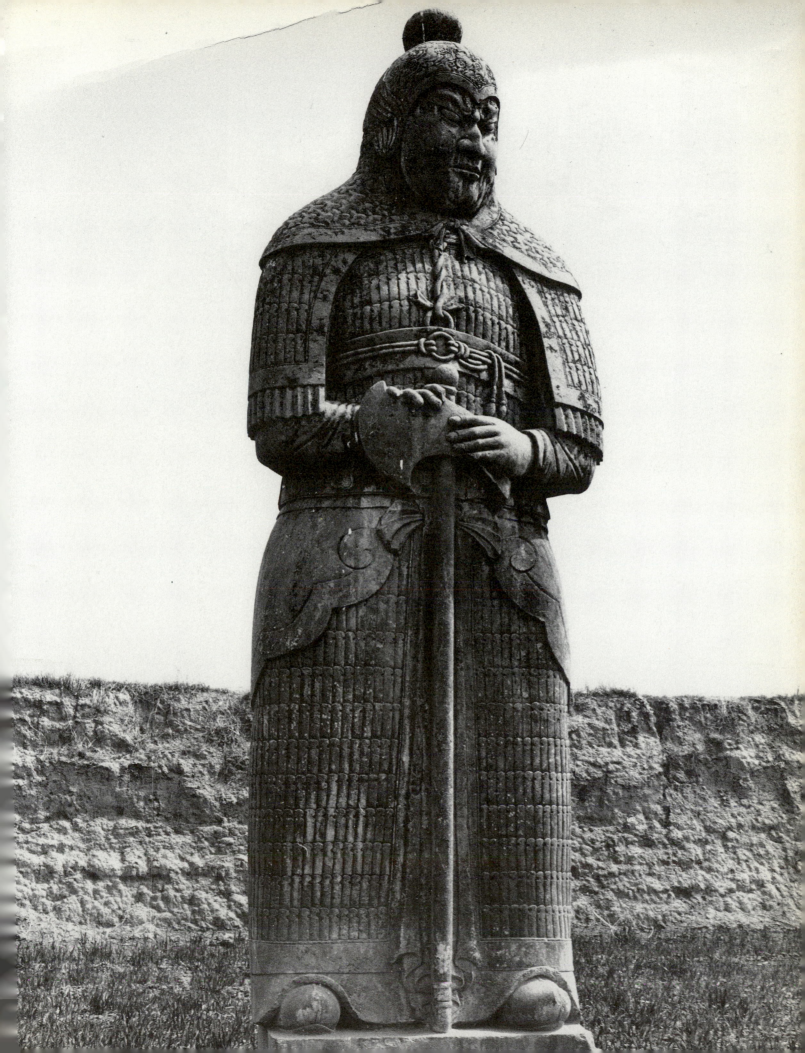

190. Detail of overskirt of "heavenly guard," Yong Xiling.

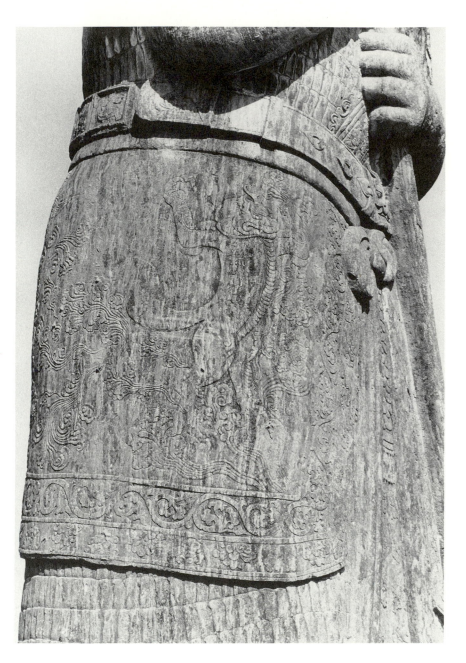

191. Fabulous jiaoduan *which could travel eighteen thousand* li *a day, crossing seas and mountains, and could speak all foreign tongues. Yong Yuling. Height 2.22 m.*

For the second half of the Song dynasty, there were no spirit roads. Determined to regain the northern half of the country, the Southern Song regarded their sojourn in Hangzhou as temporary. Burials were provisional, awaiting return to the dynastic graveyard at Gongxian. Their tombs were given the official name "temporary sepulchres" (*cuan gong*) rather than mausoleum (*ling*);[16] the scale was very small, tumuli being only two metres high and a bare five metres in circumference. The omission of spirit road statuary was deliberate: spirit roads were associated with permanence and had no place in a temporary grave.

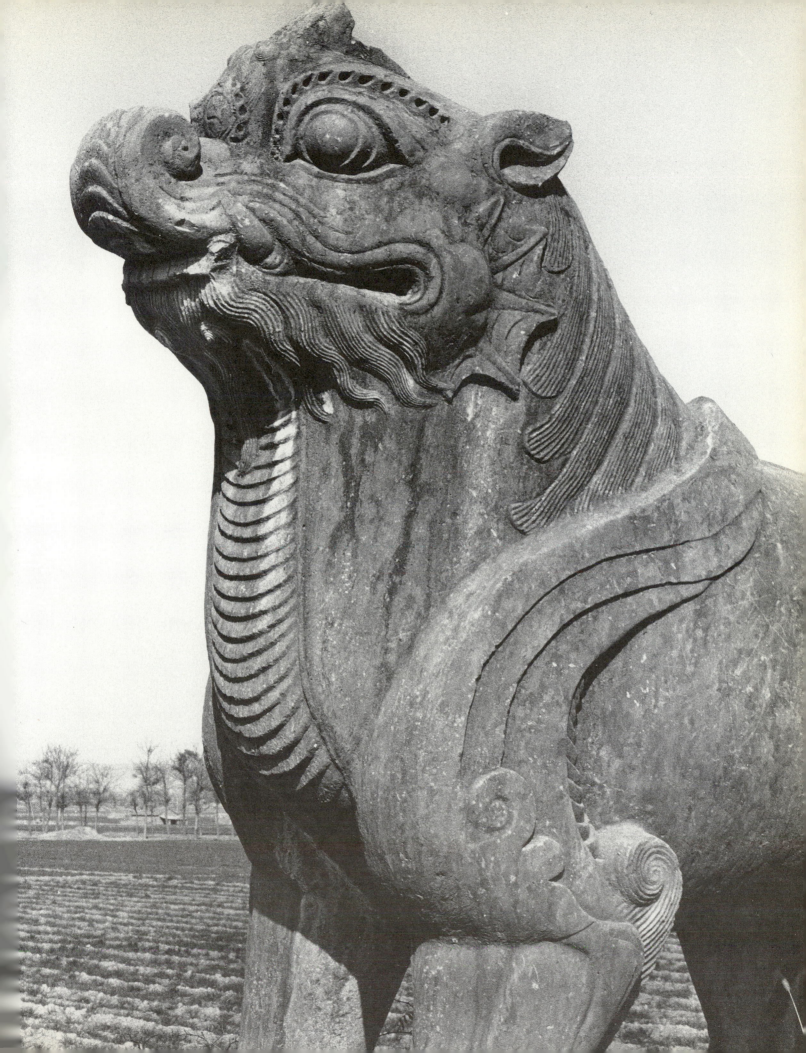

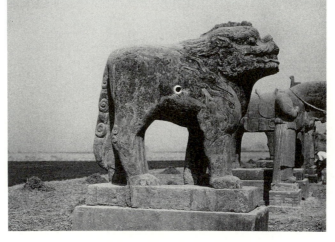

192. Jiaoduan, *Yong Tailing*. Height 2.33 m.

193. *Southeast Asian (Javan?) with double turban and bearing a rhinoceros horn. Yong Xiling (T2/E2). Height c. 3 m.*

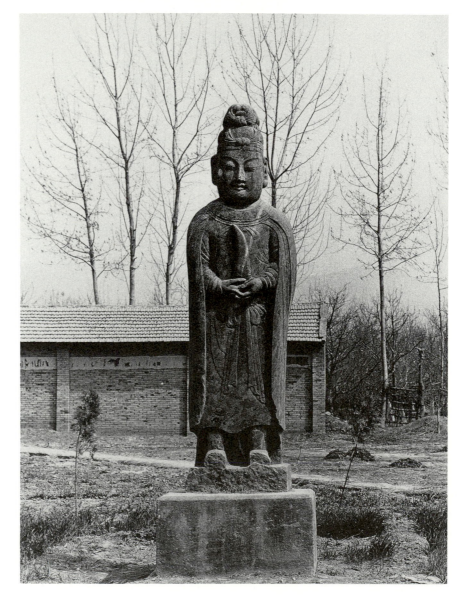

194 *(opposite). Arab ambassador, Yong Dingling (T2/W1). Full height 3.15 m.*

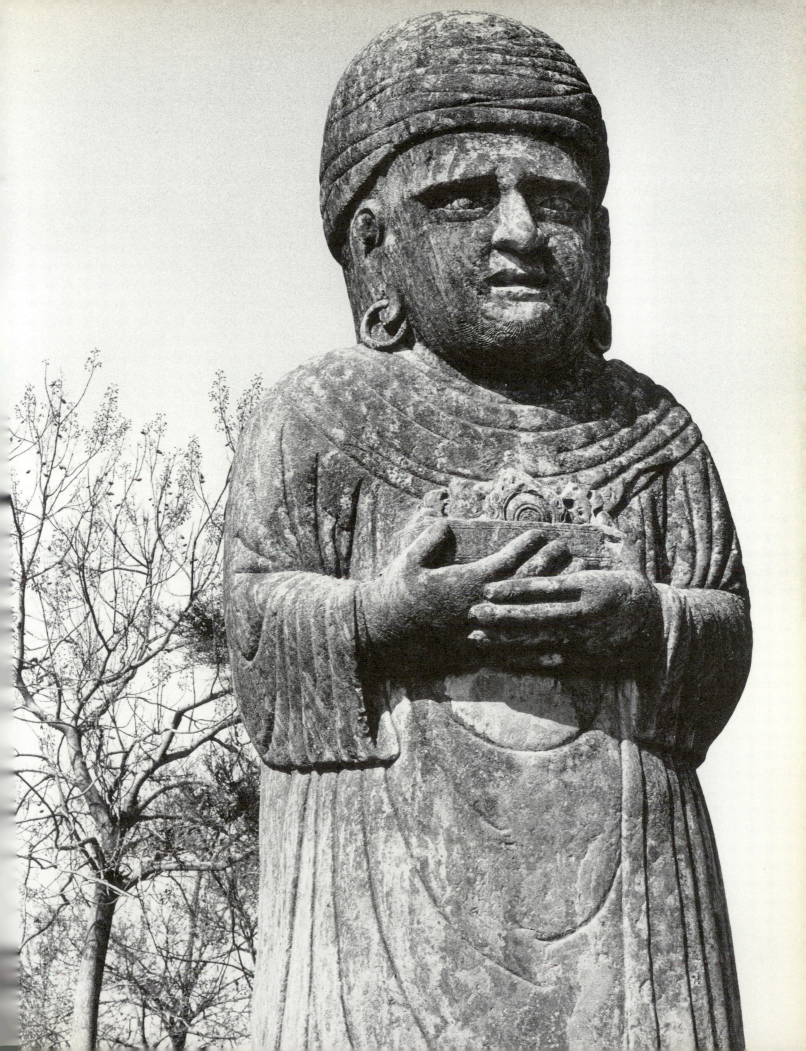

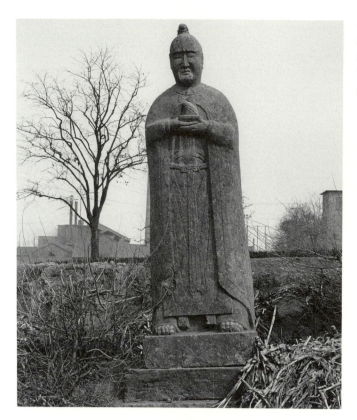

195. Ambassador from Southeast Asia, possibly Champa (southern Vietnam), Yong Zhaoling (T4/E1). Height 2.5 m.

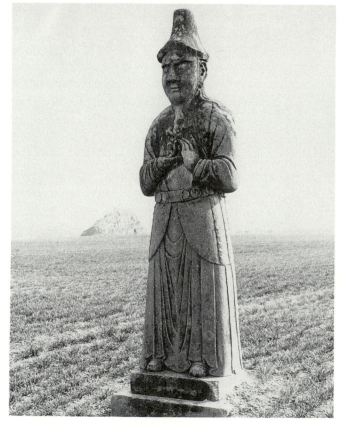

196. Kotan ambassador, Yong Tailing (T7/E1). Such a hat can be seen in the painting of a horse and Khotanese groom by Zhao Yong (b. 1289) in the Freer Gallery, Washington, D.C. Height 2.75 m.

197 (opposite). Korean, bearing credentials or messages of goodwill. The chased box resembles mother-of-pearl-inlaid lacquers of the Koryo period. Yong Xiling (T2/W2). Height 3.35 m.

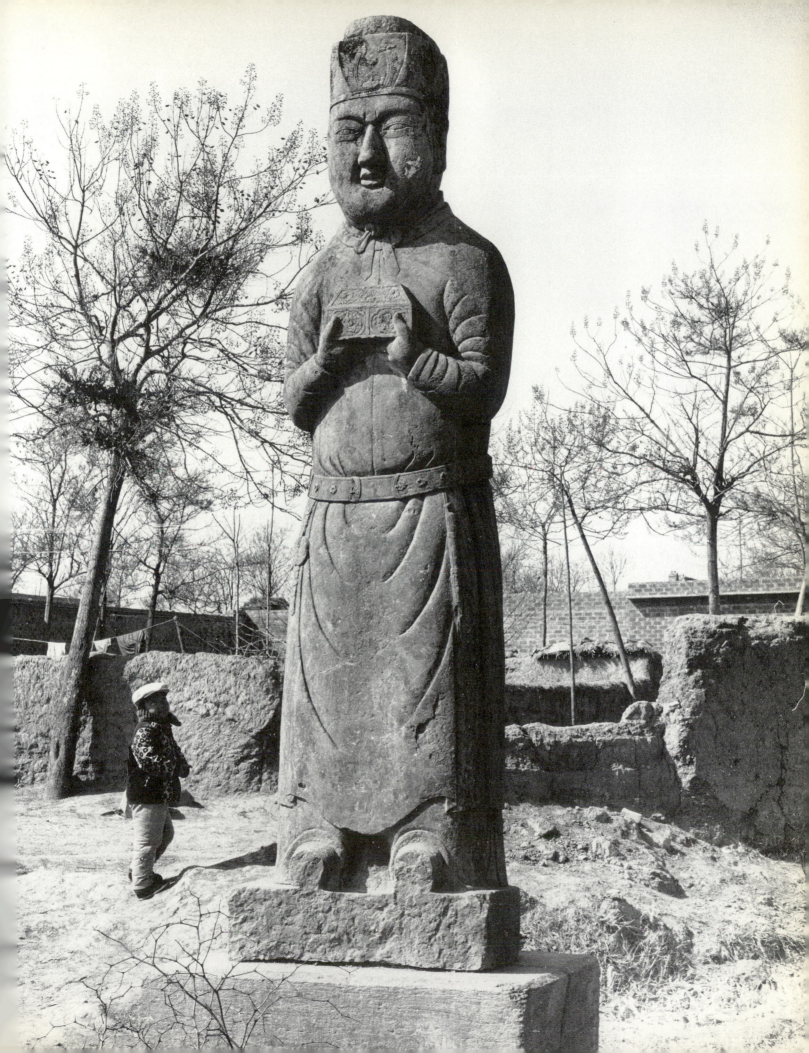

198. Song dynasty spirit road in honour of Confucius, Confucian family cemetery, Qufu, Shandong.

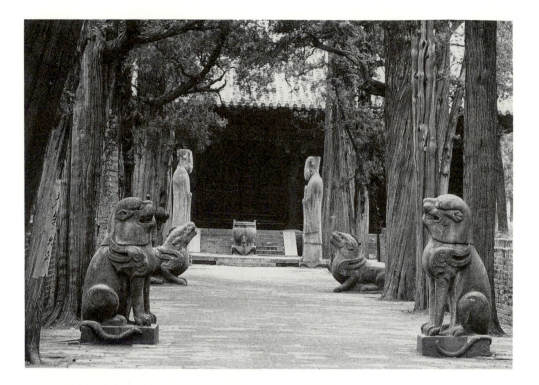

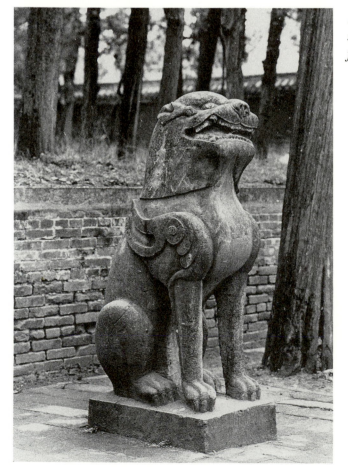

199. Fabulous beast, Song spirit road, Confucian family cemetery.

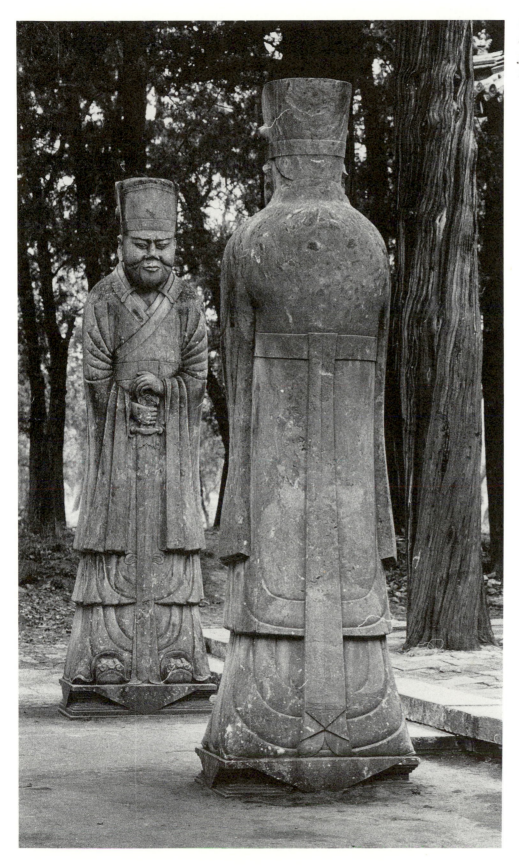

200. Pair of officials, Song spirit road, Confucian family cemetery. Height 4.3 m.

7 MING AND QING DYNASTIES

The Ming dynasty inaugurated the last stage in the long history the spirit road. The pattern established in the early fifteenth century with Xiaoling, the tomb of the first Ming emperor, Hongwu (Zhu Yuanzhang) at Nanjing, and perfected in the great spirit road in the Valley of the Ming Tombs (or, as the Chinese call them, the Thirteen Tombs) northwest of Beijing, was copied by the Qing and lasted until the fall of the empire in 1911. The Ming is the earliest dynasty from which tomb buildings have survived and in which the spirit road can be seen in its proper relationship to the rest of the tomb complex. It is also, thanks to the rediscovery of two early mausolea, the dynasty in which the different stages in the development of a new dynastic spirit road pattern can most clearly be followed.

A large amount of Ming tomb statuary has survived—not only on imperial mausolea but on provincial princely tombs and numerous tombs of military and civilian officials throughout the country. Generally speaking, the early statuary belongs to a transitional period; the distinctive Ming approach which dominated the rest of spirit road history was not developed until the early fifteenth century. It is no coincidence that this dividing line corresponds with political developments. Although the empire was extended and reorganized in the fourteenth century, Hongwu's death in 1398 was followed by a short, bitter war of succession and it was not until the reign of the third Ming emperor, Yongle (1402–1424), that the dynasty consolidated and stabilized its position. It was at this point that the Ming tomb and spirit road patterns were finalized.

From the outset, the Ming was a consciously *Chinese* dynasty. The long years of alien rule had bred an intense feeling for Chinese traditions and values, and Hongwu drew on earlier Chinese dynasties for inspiration, adopting the maxim "Learn from the Tang and the Song." The classical tenets of ancestor worship and legitimacy derived from the Mandate of Heaven were revived, and within a year of his accession Hongwu had visited and appointed tomb guardians for his parents' grave. In the following year work was begun to transform their pauper's mound into an imperial tomb.

Colour 14

156

Huangling, at Fengyang, Anhui, was the first of the transitional tombs; it was followed in the 1580s by a second imperial tomb, Zuling, on the site

of Hongwu's grandparents' grave on the banks of Lake Hongse, Jiangsu, which was dedicated to three sets of paternal ancestors. Both these early mausolea were believed to be irrevocably lost in the seventeenth century— one by despoliation, the other by flooding—but in recent years the spirit roads of both have been rediscovered and reerected in situ. Still little known, they are examined in more detail in Appendix C.

These were the first mausolea to be built since Yong Tailing, tomb of the seventh Song emperor, in 1100. The Southern Song, as has been seen, hoped for eventual reburial in the family grave area at Gongxian and confined themselves to temporary sepulchres without spirit roads. The Mongol Yuan eschewed Chinese burial habits, retaining their own customs and sending corpses back to the northeast to be laid out in the open. The very few spirit roads from tombs of Chinese officials which have survived from this long period, such as that of General Yue Fei (d. 1142) at Hangzhou, are similar to those of the Northern Song; under the Yuan few Chinese could afford such honours and there was no incentive for change. After this break of over 250 years in the imperial tomb tradition, it was natural to turn to the past for examples. Both the layout and statuary of Huangling and Zuling illustrate the extent to which early or transitional Ming tombs were inspired by Tang and Song traditions.

Of the two, Huangling was the more important. It was designed as part of a grandiose project for a new capital city, Zhongdu, on the site of Hongwu's birthplace and his parents' grave at Fengyang.[1] The city was abandoned in favour of Nanjing in 1375, but the tomb was completed and the first rites performed there in 1379. In the overall plan, the tomb was approached through the central southern gate of the city, giving the unusual result that Huangling faces north instead of south. The tomb was based on the North-ern Song mausolea at Gongxian—it is known that Hongwu sent for plans of these in 1369[2]—and was a typical Tang/Song city-type tomb with square enclosures and corner and gate towers. A similar plan was followed for Zuling but on a much smaller scale. The construction of Zuling, started in 1385, was protracted into the early fifteenth century, the period in which a specific Ming tomb style was being evolved for Hongwu's own tomb in Nanjing; additions were later made to Zuling to bring it closer to the new orthodox pattern. Thus, whereas Huangling belongs architecturally to the Tang/Song tradition, Zuling is a curious mixture of the old and new.

The two spirit roads bear all the hallmarks of hurried research with no ap-parent underlying philosophy beyond the wish to revive classical traditions. They are short and narrow; the tall statues (well over three metres high) are placed close together, giving a crowded impression. The varied subjects are mostly culled from the Song, but they also include a Tang-inspired "heav-enly horse" with clouds between the legs and two Ming innovations: a new

Chart 9

201–204

Chart 10

205

201. *Ming map of Hongwu's projected capital, Zhongdu, and ancestral mausoleum, Huangling, at Fengyang, Anhui. Recent research has shown that in fact there were twelve gates in the city walls. Designed to be approached from the southern central gate of the city, the tomb was entered from the north, not the south.*

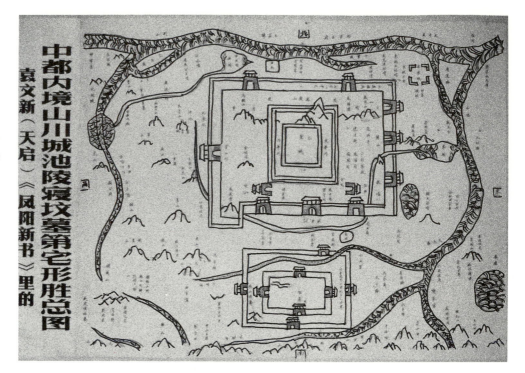

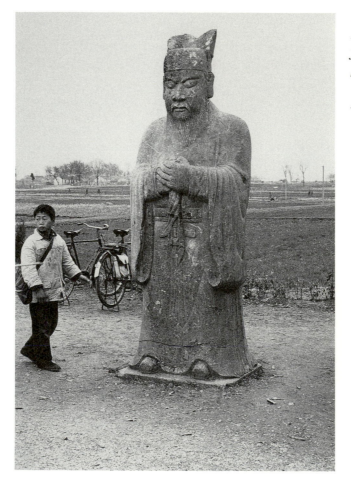

202. *Bearded civil official, Huangling, tomb of the first Ming emperor's parents (constructed 1370–1379), Fengyang, Anhui. Height 3.2 m.*

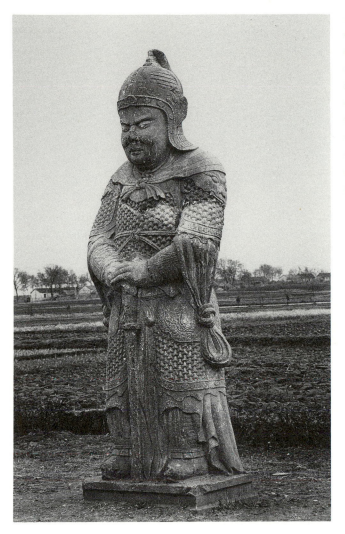

203. A clean-shaven military official. This is a reversal of the norm: the military were usually bearded and civil officials clean-shaven. The military stand above the civil officials, reflecting the paramouncy of the army in the early years of the dynasty. Huangling.

version of the fabulous *qilin* and the lion, which has been moved from its position as a gate guardian to a regular place in the spirit road. The choice of a dynastic fabulous beast was thus made in the first decade of the dynasty, long before the final spirit road pattern had been fixed. This Ming *qilin* had little in common with its powerful and protective Southern Dynasties namesake; it stemmed from a pre-Han version of the creature, which was renowned for its gentle, peaceful nature and its wisdom. (Such a *qilin* was seen before the birth of Confucius.) These early Ming *qilin* are closer in appearance to the ungainly Song *jiao duan* than to the typical *qilin* of later Ming and Qing periods.[3]

The arrangement of the statuary indicates a certain confusion about the principles on which the avenue was based. There are, unusually, six pairs of lions; the columns have lost their role as markers at the start of the alley and

206,207

192

204. *Bearded military official, showing helmet and epaulette, Huangling.*

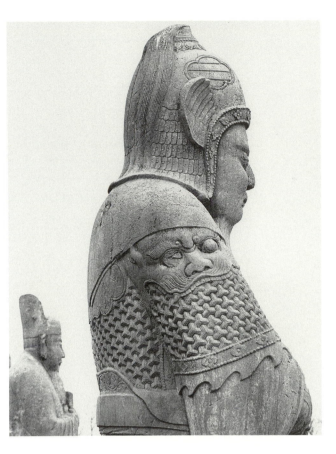

205. *Northern end of spirit road, Ming Zuling (constructed 1385–1413), tomb of the first Ming emperor's grandparents, Lake Hongse, Jiangsu. This tomb was submerged in the mid-seventeenth century and the statuary was only rediscovered after a severe drought in 1962.*

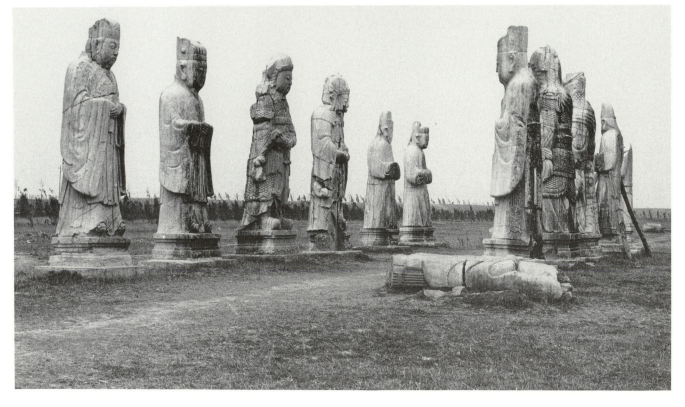

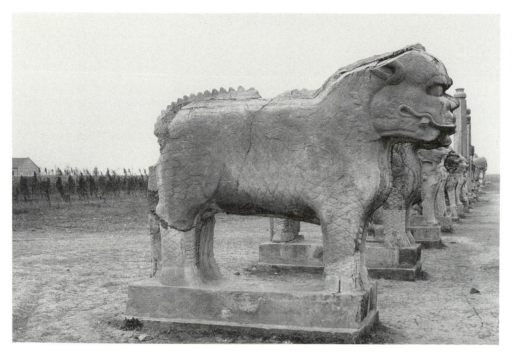

206. Qilin, *Zuling. This beast is closer in appearance to the Song* jiaoduan *(fig. 192) than to later Ming* qilin.

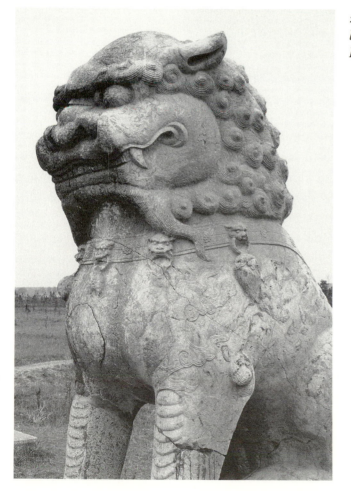

207. *One of the twelve lions at Zuling. Height 2.5 m.*

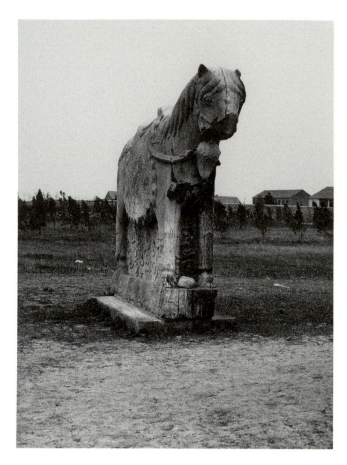

208. "Heavenly horse," Zuling. The sculptors have made a deliberate contrast between this cartoon-like figure, representing an idea or symbol, and the ceremonial horse and groom (colour 15), which are carved fully in the round. Height c. 2.75 m.

208,209
Colour 15

stand between the lions and the horses; inexplicably, they are duplicated. The eunuchs are placed outside the inner enclosure beside the military and civilian officials of the outer court; the mythical "heavenly horse" is shown with human attendants next to the more traditional ceremonial horse. This is no longer the representation of a real imperial occasion.

The sculptures show strong Song and Yuan influences. This is particularly noticeable at Huangling, where the sculptors would have grown up under the Yuan. Inexperienced in carving tomb statuary, they turned to the Song statuary for models, and some of the figures, such as the slender rams

210

and tigers with elongated necks, could pass unnoticed into a Northern Song spirit road at Gongxian. As at Gongxian, the horses and their attendants are depicted in ceremonial attire. In pictorial decoration, however, the sculptors

211,212

maintained Yuan customs, choosing popular Yuan flower and plant motifs; the carving on one pair of the Huangling columns is remarkably similar to that on the decorative friezes in the Yuan archway, Juyongguan (1345), at the Nankou Pass north of Beijing. By the time Zuling was constructed, a more independent style had developed. There is a rare individuality about the Zuling statues—a sense of humour in the carving of the pride of lions

209. Saddle of ceremonial horse, Zuling.

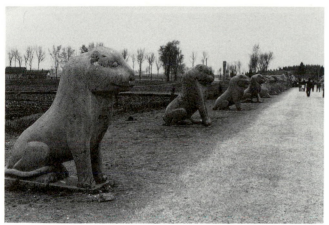

210. Tigers, Huangling.

and an accuracy in the characterization of the human figures—not found in other dynastic tomb statuary. The officials are carved as if they are really standing out of doors with the wind blowing the skirts of a military officer, the beard of a civilian. The vigour and liveliness of these sculptures reflect the growing confidence of the dynasty; they may also be due, in part, to the distance from the capital and consequent freedom from official restraints.

213–216

With the construction of Hongwu's own mausoleum, Xiaoling, this transitional period ends. Although the main buildings were finished in the late 1380s, the spirit road statuary, like the memorial stele, could not be erected until after the emperor's death; they date from 1413, in the reign of the third Ming emperor, Yongle.[4] By this time the Ming dynasty was in full strength and in a position to adapt the revived funeral traditions to its own needs. Within the framework of classical traditions governing ancestor worship at the tomb, there was a conscious reappraisal of tomb practices and structures, a reinterpretation of the principles of *fengshui*, and a reformulation of the symbolic message of the spirit road.

Chart 11

The principles of *fengshui* which determined the site of Xiaoling and the choice of the Valley of the Thirteen Tombs for the Ming dynastic grave

211. One of two types of column on Huangling and Zuling. This style of column is unique to the early Ming period and can be seen on tombs in the Nanjing region of commanders such as Li Wenzhong (d. 1385), who helped Hongwu establish the dynasty. Huangling. Height 5.8 m.

area near Beijing, are those which governed the placing of most traditional Chinese buildings until well into this century. More than any other factor, Ming *fengshui* is responsible for the harmony which exists between classical architecture and its surroundings. The intellectual approach of the Song, with its modest, repeatable plan imposed on the ground, did not satisfy the needs of the new empire; the Ming revived Southern Dynasties and Tang use of natural features to enhance the grandeur and beauty of the tomb. An auspicious site was protected by mountains or hills from evil spirits or dominant winds in the north; soft hills on the sides tapered to an open prospect in the south, and ideally a river or stream flowed across the site in front of the buildings. Interpreted on an imperial scale, this indicated a sheltered valley facing south; the main constructions nestled in the northern foothills, approached by a stately spirit road leading from the southern entrance to the valley.[5] The overall impression of imperial power is as strong as in a

212. Column engraving, Zuling. The floral and plant patterns are similar to those on the Yuan gateway (1345), Juyongguan, near Beijing. Height 6.5 m.

Tang tomb, but there is none of the dramatic Tang exuberance; this is an inward-looking arrangement reflecting the wish for peace and security.

The Ming replaced the Tang/Song fortified city-type tomb with a tomb based on the imperial palace. Illustrating the Han concept "Heaven round, Earth square," they introduced for the first time a distinction between the worlds of the living and the dead. The tomb consisted of two parts—a series of rectangular courtyards with halls and side buildings leading to a circular, fortified enclosure with the tumulus and underground grave chamber. The ceremonial rites and sacrifices belonged to this world and were performed in the "square"; the dead lay immured in the "round." Architectural methods emphasized the contrast: the first part of the tomb was a replica of contemporary palace architecture, with its perishable but easily renewable wood framework and bright colours; in the sombre tomb enclosure, constructions were of undecorated stone, built for eternity.

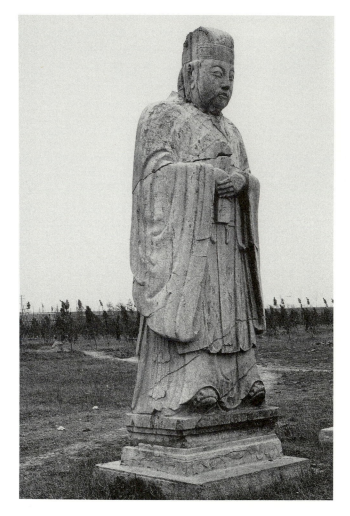

213. Civil official, moustached but without beard, still standing below the military. Zuling. Height 3.25 m.

As in the time of Han Mingdi, the change in tomb plan was associated with a change in ritual practices. The custom by which former members of the imperial entourage lived on the tomb, performing daily rites for the deceased, was dropped (until 1464 the Ming continued the Mongol practice whereby concubines were immolated on the emperor's death); there was thus no need for the Tang and Song "outer enclosure" or "lower palace," with its minor halls and dwellings.[6] The importance of the major rites was enhanced by recreating the setting of an audience in the imperial palace: the Sacrificial Hall at Changling, tomb of Yongle, the first emperor to be buried in the Valley of the Thirteen Tombs, is a replica of the Hall of Supreme Harmony in the Forbidden City. (Until the introduction of modern construction methods, these were the two largest buildings in all China.)[7]

The spirit road underwent a similar transition. The naturalism of Tang and Song spirit roads was replaced by Ming symbolism. The Ming spirit

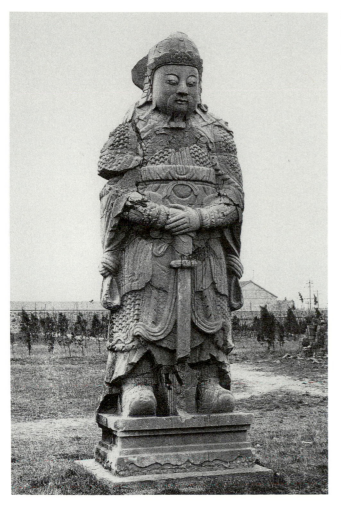

214. Military official with skirt and beard blown by the wind, Zuling. Height 3.4 m.

road was an expression in stone of abstract symbolic concepts. The spirit road no longer represented an imperial occasion; it symbolized the empire. The avenue was long and narrow (3 metres wide and 863 metres long at Xiaoling; 10 metres wide and one kilometre long in the Valley of the Thirteen Tombs) and followed the contours, rising, falling, and if necessary turning. (At Xiaoling it skirts a high mound believed to be the tomb of Sun Quan, a hero from the Three Kingdoms period.) Imperial grandeur was enhanced by the addition of stone monuments on the central axis—a colossal stele in a pavilion at the southern end of the spirit road [8] and the Dragon and Phoenix Gate, a free-standing triple gate designed to thwart evil spirits, at the northern end. (Believing that evil spirits could fly only in straight lines, the Ming blocked all straight vistas in the tomb area with doors, door screens, or free-standing gates of this type.) Later, at the Valley of the Thirteen Tombs, the process was carried further with the construction in 1540 of a magnificent marble archway, or *pai lou,* and the erection of

Chart 12

217–219

Colour 17
220,221

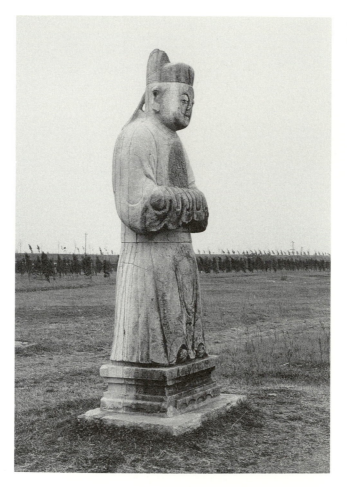

*215. Eunuch, Zuling.
Height 2.9 m.*

*216. Panel on back of
eunuch's robe.*

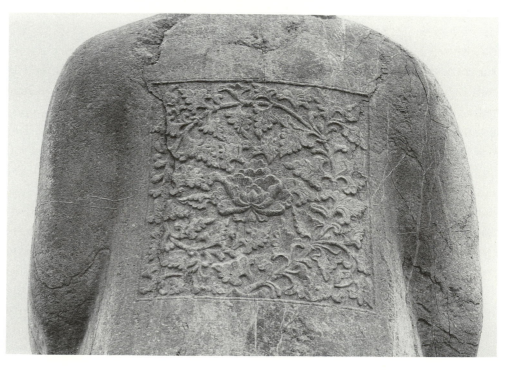

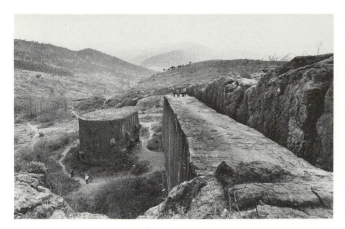

217. Unfinished headpiece and shaft for a memorial stele designed by Yongle for Hongwu's mausoleum, Xiaoling. During eight years' work on these two stones, the largest of which weighs some fifty thousand tons, so many workers died that this area is still called "death's head valley."

four beautiful *hua biao* columns around the stele pavilion. Nowhere is imperial unity proclaimed so clearly as in this valley, where a single approach serves thirteen tombs.[9] The tombs, spread out in the northern foothills, are arranged like the branches of a tree, dependent on the central trunk. It is a highly successful arrangement which stresses the cohesion and continuation of the empire, irrespective of which particular member of the dynasty sat on the throne.

Animal subjects were chosen for their symbolism. There were six sets of animals—three natural and three fabulous—each shown sitting and standing. (There is a legend in Nanjing that the standing pair, on guard, change places with the resting pair at midnight.) The natural animals denoted the extent of the empire: elephants from the south, horses from the west, and camels from the north. The fabulous beasts—*qilin*, *xiezhai*, and lions—described the nature of the imperial government. The presence of a *qilin* on the tomb indicated that the empire was at peace with a wise ruler on the throne. The *xiezhai* was a symbol of justice, whilst the lion stood for authority and power.[10] Except for the lion, with its apparently inalienable collar, none of the animals wear any trappings and there are no grooms or attendants. These stone figures represent an idea, not a ceremonial function.

There is a similar abstraction in the human officials. All traces of individuality have been eliminated, leaving an impassive expression of ideal virtue. The process, begun at Xiaoling, is perfected in the Valley of the Thirteen Tombs, where it seems as if a fine veil has been drawn between these figures and reality; here is the final representation of the office rather than the officeholder.

In keeping with Hongwu's dictum that "eunuchs must have nothing to do with the administration," eunuchs were banished and there is no indication of a world outside China. This exclusion of foreigners was not a sign of xenophobia: the early Ming empire was open to the outside world. This

Chart 13

222,223

224

225
226

227,228

229–233
Colour 16

218. Memorial stele, dedicated to the Ming dynasty, Ming Tombs, Beijing.

219. Stele marking the approach to Xianling, tomb of Ming Hongxi (d 1425), Ming Tombs, Beijing.

220. Qilin *on ceremonial archway* (pai lou), *1540, Valley of the Ming Tombs, Beijing.*

221. *Dragon on* pai lou *base, Ming Tombs, Beijing.*

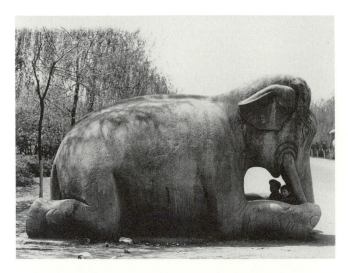

222. Elephant, Ming Tombs, Beijing.

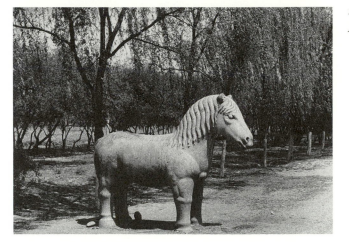

223. Horse, Ming Tombs, Beijing.

224. Qilin, *symbol of peace and wise government, Ming Tombs, Beijing.*

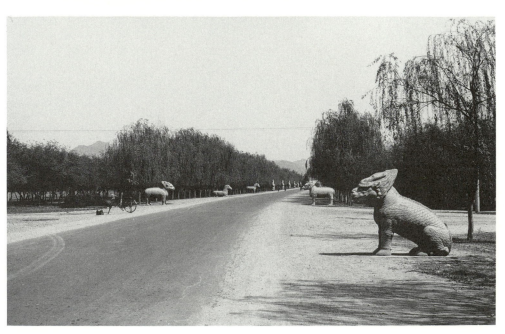

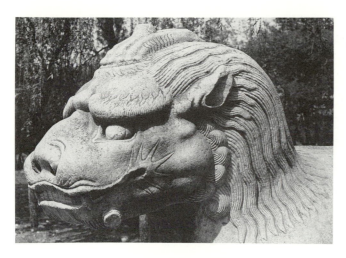

225. Xiezhai, *symbol of justice, which roared when it saw wrongdoing. Ming Tombs, Beijing.*

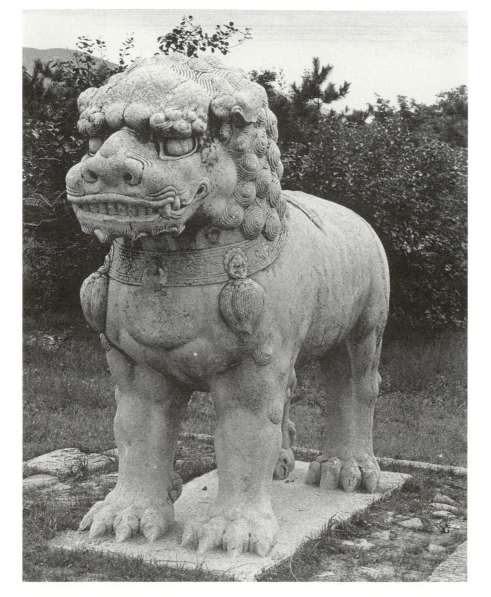

226. *Lion, Ming Tombs, Beijing.*

*227. Military officials,
Xiaoling. Height c. 3 m.*

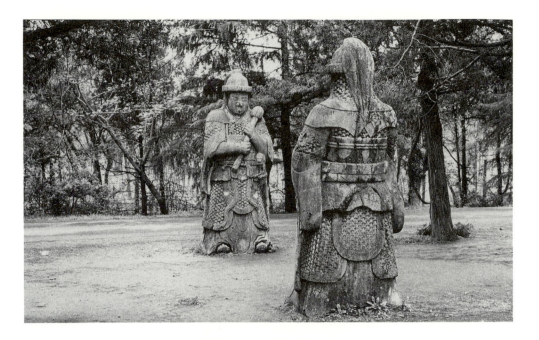

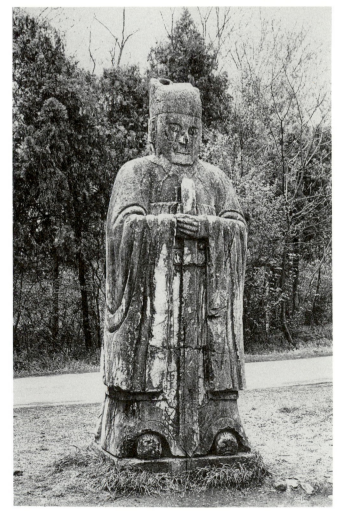

*228. Civil official,
Xiaoling. These figures
are made from a soft red
sandstone which has
weathered badly.
Height c. 3 m.*

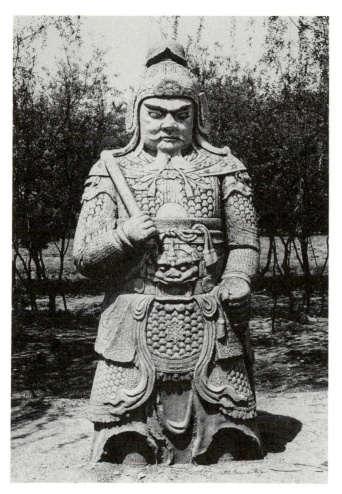

*229. Military commander
with baton, Ming Tombs,
Beijing. Height 3.2 m.*

was an age of exploration in which Admiral Zheng He made his great voyages to Africa and India; there were settlements of foreign merchants in the large coastal cities, and foreign students attended the university in Nanjing. It was rather that foreign elements had no place in this affirmation of a *Chinese* empire. It was felt that the realm of ancestor worship and the imperial tomb and spirit road belonged to an exclusively Chinese sphere reflecting ancient Chinese traditions and beliefs associated with the very existence and continuity of the Middle Kingdom. This feeling ran very deep. After the Manchu dynasty had been overthrown in 1911 and the empire replaced by a republic, the first president, Dr. Sun Yatsen, visited Hongwu's mausoleum in Nanjing and, in a solemn symbolic ceremony, handed the realm which had been under foreign rule for more than 250 years back to the Chinese emperors.[11]

There were clear stylistic changes. The sculptors at Xiaoling seem to have deliberately repudiated the Song influences which were so strong in the transitional tombs. All traces of Song elongation disappear and the figures

234–236

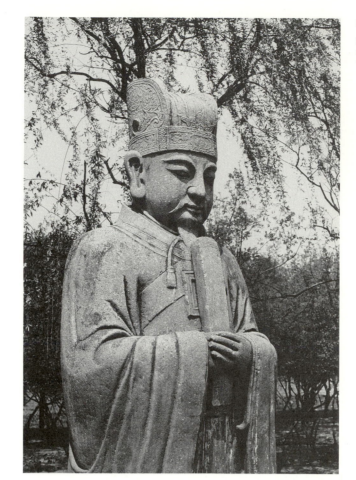

230. President of one of the Six Boards, Ming Tombs, Beijing.

are smaller and rounder—the outline of the seated elephant almost forms a semicircle. In the Valley of the Thirteen Tombs they are thick-set and on a truly monumental scale. At the same time, Ming love of symbolism and the fabulous affected sculptural style and choice of decorative motifs. The flowers and plants so dear to the Yuan were replaced by lotus, thunder, cloud, and other geometrical patterns; the most popular subjects for panel decoration were fabulous creatures in their natural habitat of mountains, clouds, and sea. It is in relief decoration that Ming sculpture is seen at its best: in the moving *qilin*, *makara*,[12] and lions on the *pai lou* bases, in the writhing dragons on the *hua biao* columns, and in the intricacies of the military uniform or the embroidered panels on the back of civilian robes. Once again the change in style can be pinpointed to the beginning of the fifteenth century. Stone reliefs from the abandoned Zhongdu or the old Ming palace at Nanjing, destroyed in 1402, include realistic landscapes with plants and living creatures. The only stone carvings which show natural creatures and landscape in the whole Valley of the Thirteen Tombs are on the tomb of the last emperor, which was erected by the Qing.

220,221

232,233

231. Grand Secretary, Ming Tombs, Beijing.

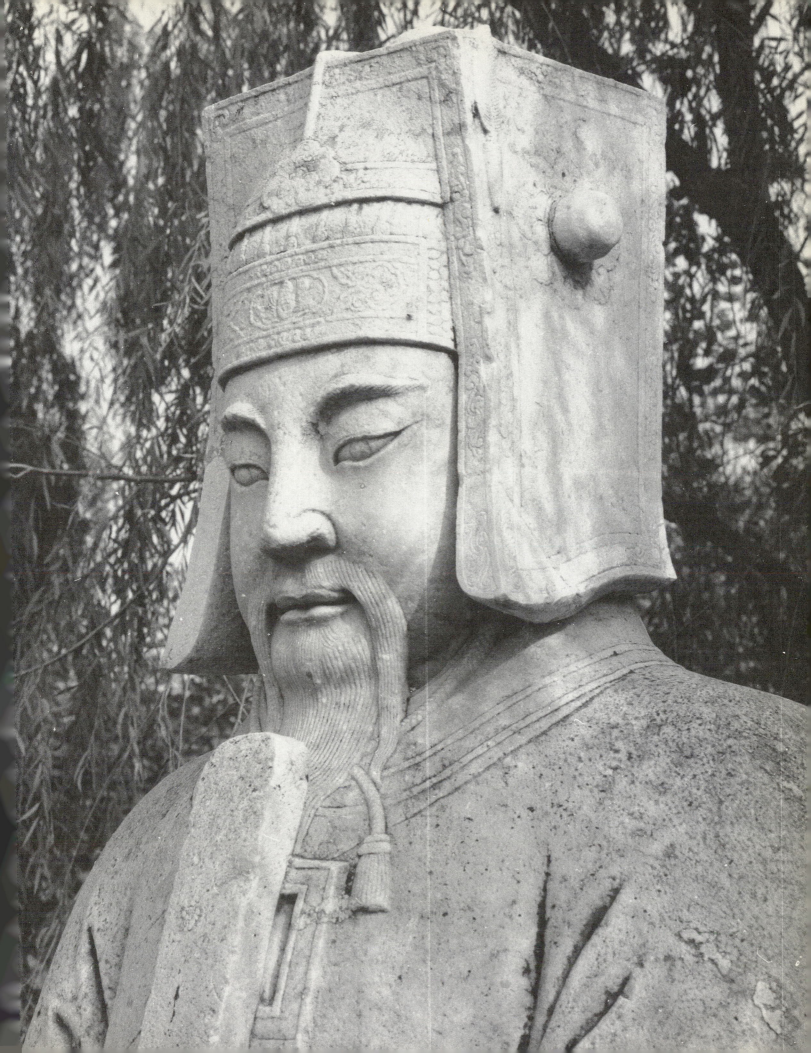

232. *Back of robe with galloping horses, symbol of vigilance, military commander with folded hands, Ming Tombs, Beijing.*

233. *Back of robe with cranes, symbols of the two highest ranks of civil officials, President of one of the Six Boards, Ming Tombs, Beijing.*

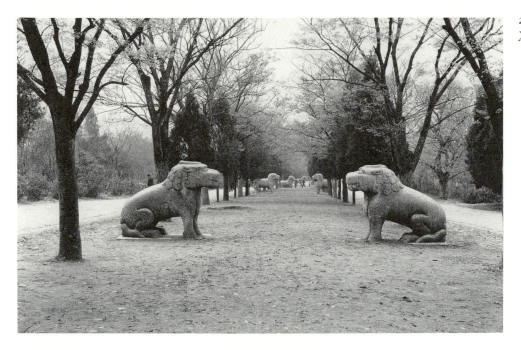

234. Seated qilin,
Xiaoling.

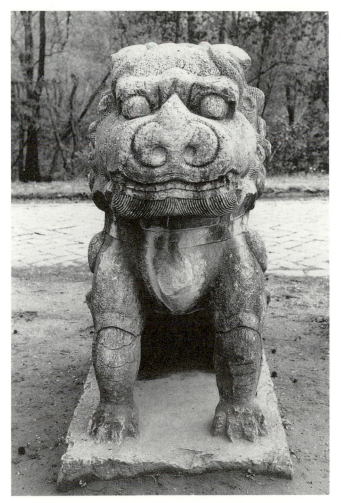

*235. Lion, Xiaoling.
Height 1.6 m.*

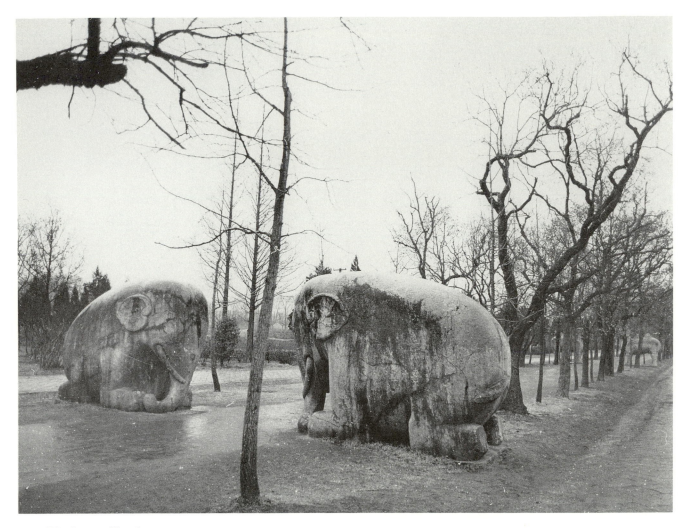

*236. Elephants, Xiaoling.
Height c. 2.5 m.*

162,237 Finally, there was a change in sculptural technique. Tang and Song shallow engraving on flat surfaces gave way to deep engraving with high relief in which the subject matter was given almost three-dimensional form. The contrast can be seen clearly by comparing Ming spirit road beacons or columns with those from Tang or Song tombs.

This was the imperial pattern. In princely and official spirit roads there was more flexibility. In order to reduce the risk of court intrigues, Ming emperors often appointed members of the family as provincial governors; once appointed, they were forbidden to return to the capital and remained in their provinces establishing local princely dynasties.[13] No systematic study of these tombs has yet been made, but it is clear that distance from the capital gave these local rulers considerable lati-

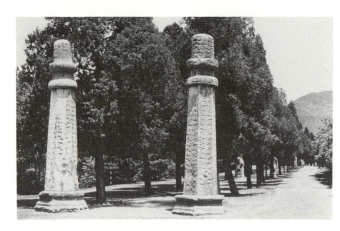

237. Beacons marking right-angled turn in spirit road at Xiaoling, Nanjing.

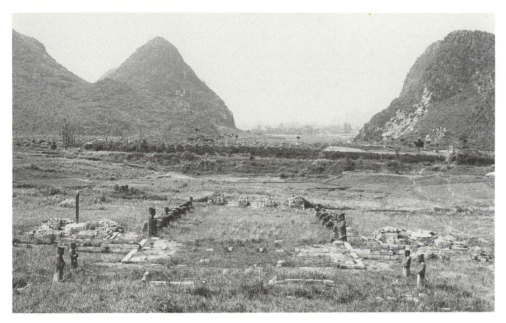

238. Spirit road of Ming prince Zhu Yueqi (d. 1516), Guilin, taken from the tumulus looking south. Two pairs of palace servants stand within the remains of the inner tomb enclosure. As in Tang tombs, a pair of stelae on tortoise bases flanked the upper end of the spirit road.

tude. At Guilin, eleven tombs spanning the period 1392–1612 have survived with their spirit roads. In this secluded region pre-Xiaoling transitional conventions were preserved and the spirit roads include palace servants, saddled elephants, and horses with grooms; there are also strong local influences—columns encircled by almost three-dimensional dragons and officials having the features of minority tribes. In the spirit road of Prince Lu Jian (d. 1614) at Xinxiang, Henan, full rein has been given to Ming love of the fabulous. There are nine pairs of mythical creatures, placed in ascending height, each distinguished by a selection of the conventional supernatural attributes of wings, scales, horns, and flames.[14]

The largest collection of official tombs is in the Nanjing region, belonging to officials who helped Hongwu establish the dynasty. Most of these, like the tomb of a young king of Borneo who died whilst visiting Nanjing

238–242
Colour 18
Colour 19

243–247

248–252

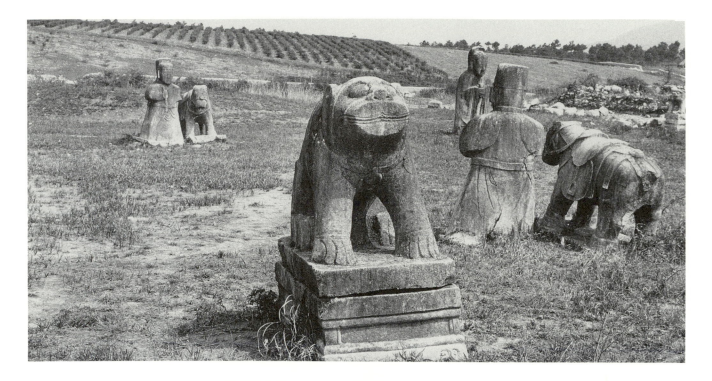

239. *Spirit road with right-angled turn, tomb of Ming prince Zhu Guiyu (d. 1489), Guilin.*

240. *Column with dragon, tomb of Ming prince Zhu Luhu (d. 1612), Guilin.*

241. New tombs among old, tomb of Ming prince Jingfu (d. 1523), Guilin.

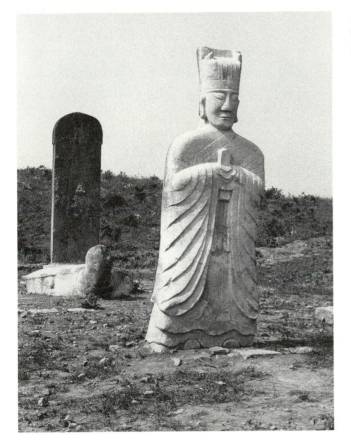

242. Non-Han official tomb of Ming prince Zhu Luhu, Guilin.

in 1408, are from the transitional period and include columns similar to those at Huangling and Zuling, Song-type rams and tigers, and saddled horses with grooms. There is a fine spirit road for a Ming civil official in the Gongxian burial grounds, and an impressive pair of warriors have survived on the tomb of the fifty-ninth direct descendant of Confucius in the family cemetery at Qufu.

253–254

255,256

243. Ceremonial archway (pai lou), tomb of Ming prince Lu Jian (d. 1614), Xinxiang, Henan.

244. Three of the nine fabulous beasts on tomb of Prince Lu Jian.

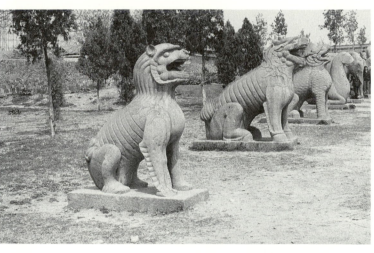

245. Fabulous beast, tomb of Prince Lu Jian. Height c. 2 m.

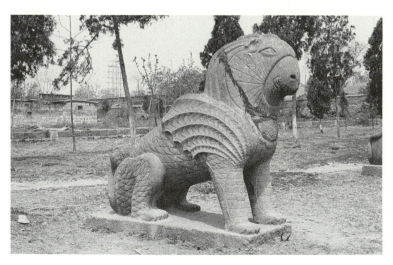

246 (opposite). Civil official (non-Han), tomb of Prince Lu Jian.

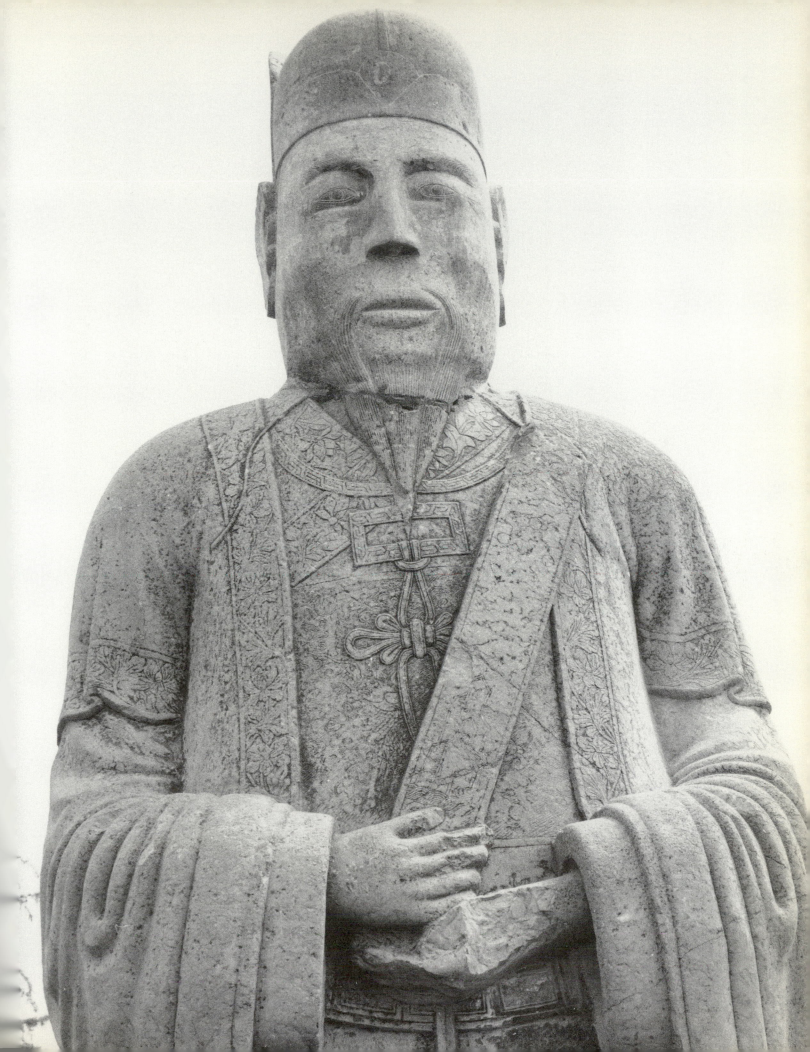

247. *Saddlecloth, tomb of Prince Lu Jian.*

248. *Spirit road on tomb of Ming general Wu Liang, late fourteenth century, Nanjing.*

249 (opposite). *Horse and groom, Wu Liang tomb, Nanjing.*

250. *Military official, tomb of the young king of Borneo who died in 1408 on a visit to Nanjing.*

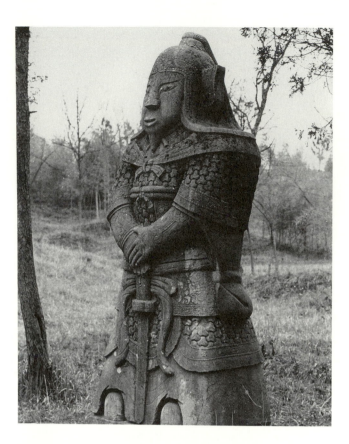

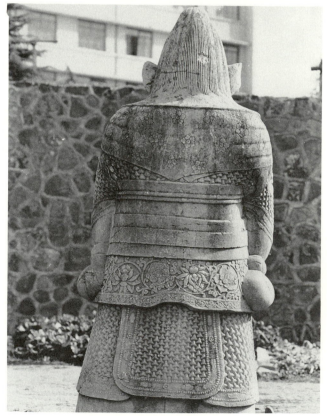

251. *Back view of military official, tomb of Ming general Xu Da (d. 1384), Nanjing.*

252. *Tiger, tomb of king of Borneo.*

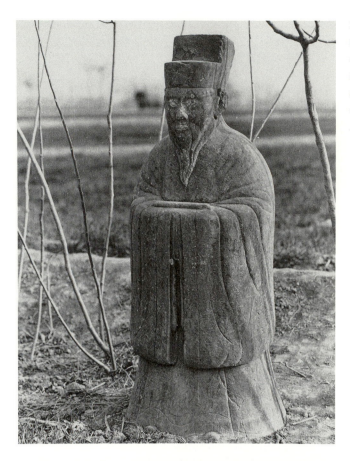

253. *Civil official, bearing a scroll with the imperial authorization for erecting a spirit road, tomb of late sixteenth-century Ming official, Gongxian, Henan.*

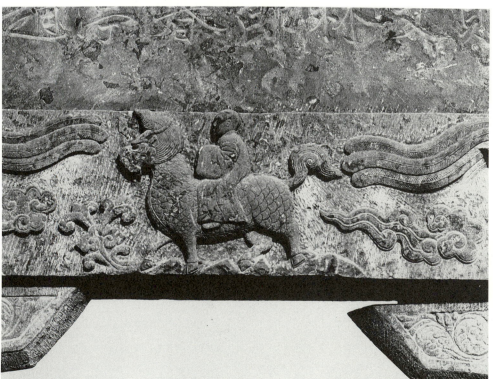

254. *Detail of ceremonial arch showing the deceased riding to the next world on a* qilin, *tomb of late sixteenth-century official, Gongxian.*

255 *(opposite). Ming warrior on tomb of the fifty-ninth direct descendant of Confucius, Confucian family cemetary, Qufu, Shandong. Height c. 3.5 m.*

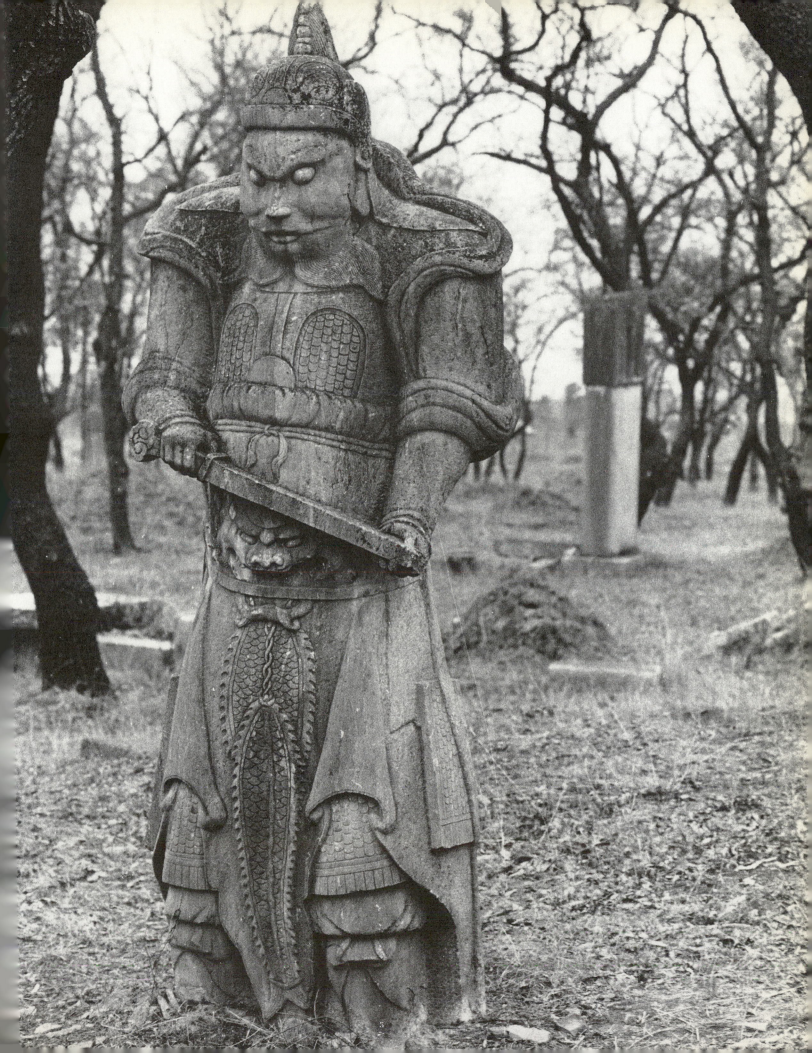

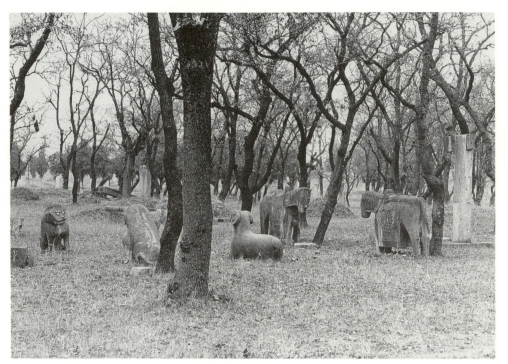

256. Spirit road on Ming tomb, Confucian family cemetery, Qufu.

258. Back view of lion, Fuling. Height with pedestal, c. 1.8 m.

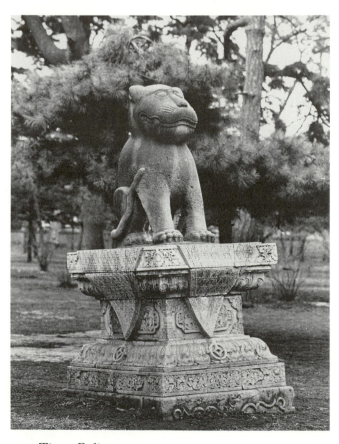

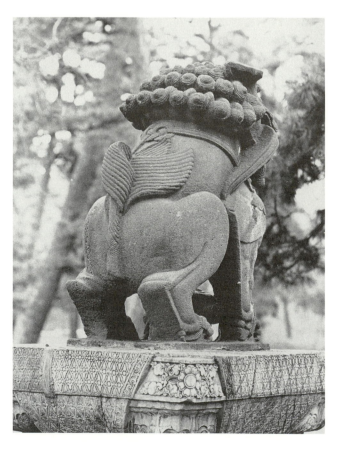

257. Tiger, Fuling. Height c. 1.5 m.

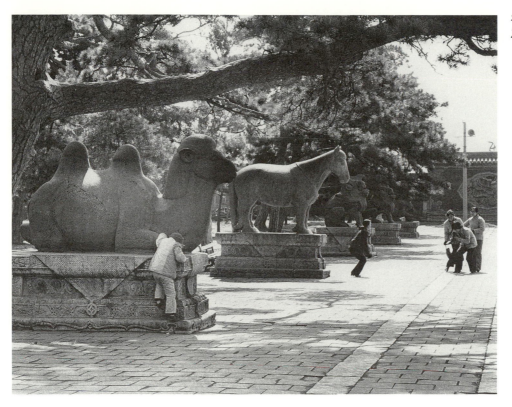

259. Avenue of animals, Zhaoling.

The Qing provide little more than a postscript to spirit road history. For the Qing, the spirit road was a borrowed institution. The Qing, or Manchus, a non-Chinese people from the northeast, were from the start anxious to impress on the Chinese that the new dynasty was legitimate and entitled to the Mandate of Heaven. To this end they adopted Chinese customs and traditional practices, including ancestor worship and the whole ceremonial approach to death and burial. They assumed responsibility for the mausolea of earlier dynasties; they gave the last Ming emperor, Chongzhen, who had hanged himself on Coal Hill as Beijing fell to the invaders, a proper burial in Valley of the Thirteen Tombs, and appointed descendants of the Ming as officials in charge of maintaining the Ming dynastic burial ground. The grandeur of the Qing dynasty was, like that of its predecessors, reflected in the splendour of the imperial tombs with their formal approach, but the spirit road lost its philosophic importance; it remained a copy, adapted in details to changed circumstances but never coming to life.

There are three sets of Qing graves: the Northern Tombs, near Shenyang in the northeast (formerly Manchuria), and the Eastern and Western Tombs near Beijing. The two first Manchu emperors who died before the conquest of China and their paternal ancestors are buried in the three Northern

260. One of a pair of ceremonial archways (pai lou) flanking entrance to Fuling, tomb of Tianming, the first Manchu emperor (d. 1626), erected after 1644 on the orders of his grandson, Shunzhi, first Qing emperor of China. Shenyang, Liaoning.

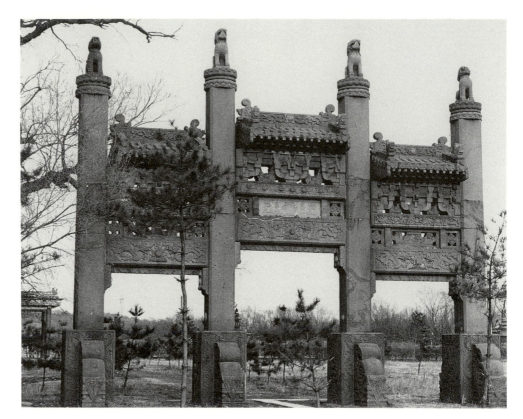

Chart 14

257,258

259

260–263

Tombs. The earliest of these, Yongling, is almost entirely Manchu in style, with several white funeral mounds enclosed in a walled, city-like enclosure and without a spirit road.[15] In the other two, Fuling (1629) and Zhaoling (1643), the spirit road was added later, on the orders of the first Qing emperor of China, Shunzhi (r. 1644–1661). The statuary is confined to a few pairs of animals; officials in the region would have been Manchu, and it may have been contrary to local customs to make stone statues of men.

It is clear that the sculptors were not accustomed to carving figures in the round, and there is a striking contrast between the delicacy of the architectural stonework and the angularity of the spirit road figures. The animals retain the shape of the block from which they were carved; there is no attempt to round corners and each beast presents four flat sides. These small figures on large pedestals remain alien imports, contributing little to the general pattern of the tomb.

The northern sculptors were, however, masters of the use of stone in an architectural context. The archways, pillars, bridges, staircases, and balustrades are carved in a distinctive northern style, with a skilful decorative use of different-coloured stone. The French sinologist Gisbert Combaz records that some of this stone was brought on specially constructed roads from Mount Yizhou, over eight hundred kilometres away.[16] Surface decoration is

261. Pai lou *base, Fuling.*

ornate and shows a love of plant and flower motives; there was a tendency 264,265
to ornament bases and pedestals as if they were pieces of furniture covered
with embroidered cloths, or with framed panels with landscapes including
humans and natural animals. There is a marked horror vacui reminiscent
of Victoriana.

After the fall of Beijing in 1644, the Qing emphasized the permanence of
their move to the Chinese capital by establishing an ancestral burial ground
within reach of the city. The first emperor chose a site some eighty kilo-
metres to the east of Beijing, but made no preparations for his own tomb.
This was left to his son, Kangxi, who prepared a mausoleum on the Ming
pattern. The site corresponded to Ming ideas of *fengshui* and was sheltered Chart 15
to the north by an impressive wall of mountains. The first tomb, Xiaoling,
was placed under the highest northern peak and approached by a mag- 266
nificent avenue based on that in the Ming Valley of the Thirteen Tombs.
The ceremonial monuments—the *pai lou,* the great stele pavilion with its
four elegant *hua biao,* and the Dragon and Phoenix Gate—are almost exact
replicas of the corresponding Ming monuments; there are only minute dif-
ferences in the placing of a ribbon or a cloud. The choice of animals, their
size, and style of carving are the same as in the Ming avenue; the only
substantial difference is that while the Ming erected two pairs of military 267–269

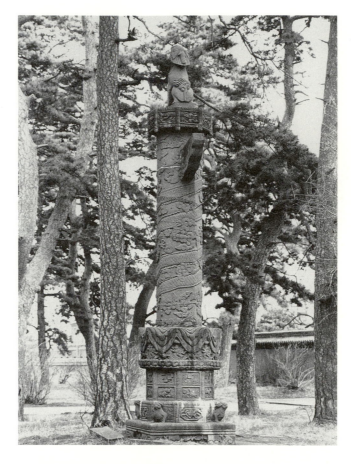

262. Hua biao *column, Fuling. Height c. 4 m.*

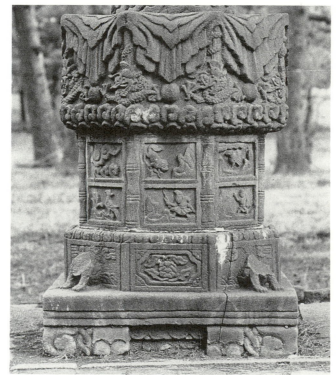

263. *Base of* hua biao *column, Fuling.*

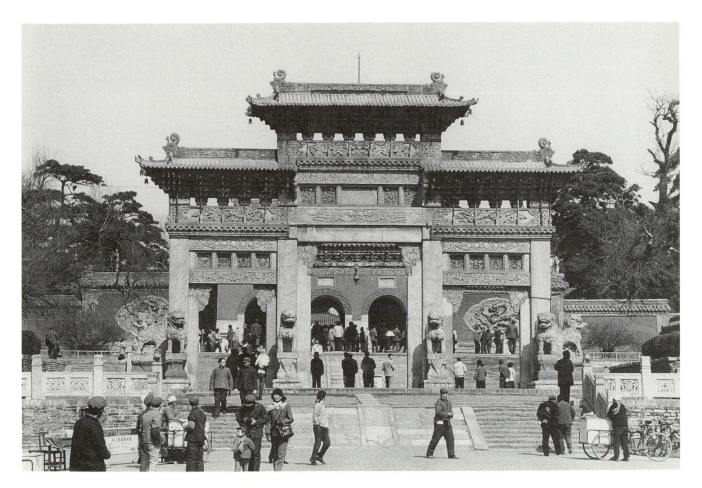

264. Pai lou, *Zhaoling, tomb of the second Manchu emperor, Tianzhong (d. 1643), Shenyang, Liaoning. The upper sections of the white archway are studded with red, blue, green, and black stones.*

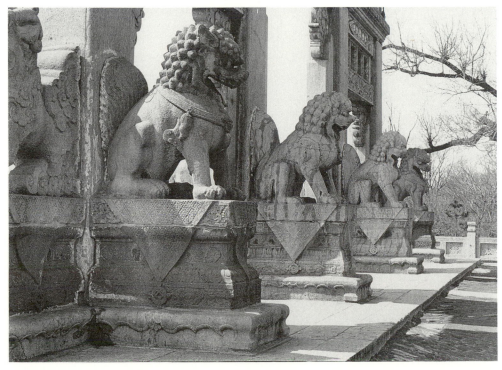

265. *Base of Zhaoling* pai lou.

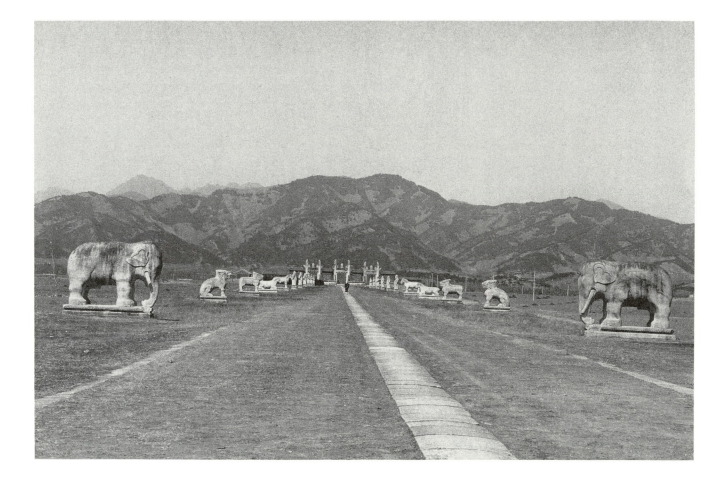

266. *Spirit road leading to Xiaoling, tomb of the first Qing emperor, Shunzhi (d. 1661), Eastern Tombs, Hebei.*

270

Chart 16

Colour 20

commanders and four pairs of civil officials, the Qing had three pairs of each. These are dressed in Manchu style and wear the pigtail which the Manchu forced the Chinese to wear. Instead of the traditional Chinese *hu*, the civil officials hold necklaces of large beads with both hands.[17]

Possibly Kangxi intended this avenue to serve the Qing Eastern Tomb burial ground in the same way as its Ming predecessor served the entire Ming tomb area. Such unity, however, did not accord with the loose-knit structure of the Qing family, in which an emperor was free to choose his own successor and the eldest son seldom inherited the throne. When Kangxi died, his tomb was provided with its own spirit road and approach monuments, and this example was followed by almost all later Qing emperors.[18] The idea of unity was further shattered by the third emperor, Yongzheng, who, on the advice of geomancers, chose a completely new site about eighty kilometres west of Beijing.[19] His successor, the great Qianlong, returned to the Eastern Tombs and later emperors were buried in either the eastern or western cemeteries according to choice.

A further difference from Ming practices concerned the treatment of

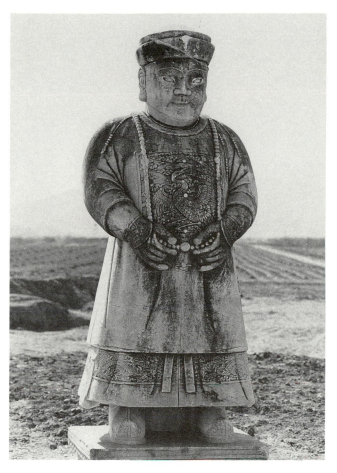

267. Civil official, spirit road leading to Xiaoling, Eastern Tombs. Height c. 3 m.

widows. Ming empresses and concubines who became the mother of an emperor were entitled to burial in the imperial tomb. The only Ming mausoleum to be excavated, Dingling, tomb of the thirteenth Ming emperor, Wanli, shows that side chambers with their own entrance tunnels were built for a possible reopening of the tomb after the main entrance had been closed. Under the Qing, an imperial mausoleum was never reopened, and empresses and important concubines who died after the emperor were buried in separate tombs east or west of the imperial mausoleum.[20] These tombs were smaller versions of the imperial mausolea but had no spirit roads.[21]

The dual nature of Qing rule was reflected in the duplication of memorial stelae, allowing for both Chinese and Manchu inscriptions. The texts on the Dismount Tablets, ordering officials and others to dismount when passing the tomb, were similarly duplicated. (In the northern Zhaoling, the Dismount Tablets were inscribed in Chinese, Manchu, Mongolian, Tibetan, and Uighur.)

In some curious way, the repetition of these tomb monuments on later

271,272

268. *Back view of figure 267 showing the pigtail which the Manchu forced Chinese men to wear.*

269. *Front panel of civil official's robe with* chaozhu *beads. These beads, which could be made from a variety of materials, were not confined to court use and were worn on important occasions. Dingling, Eastern Tombs.*

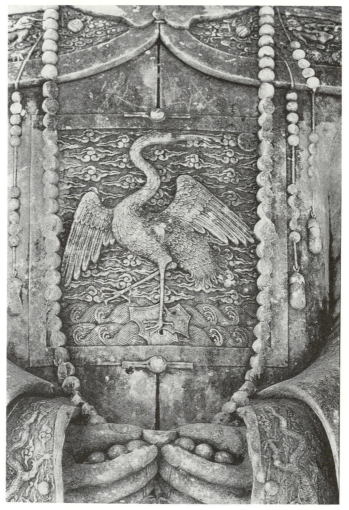

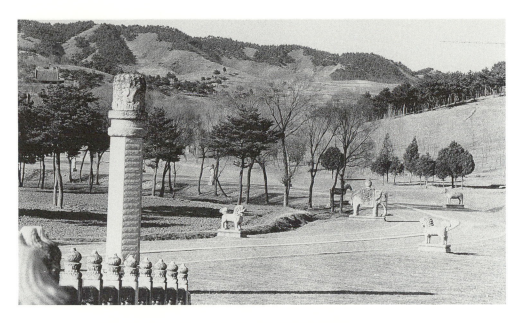

270. *Curved spirit road leading to Jingling, tomb of the second Qing emperor, Kangxi (d. 1722), Eastern Tombs.*

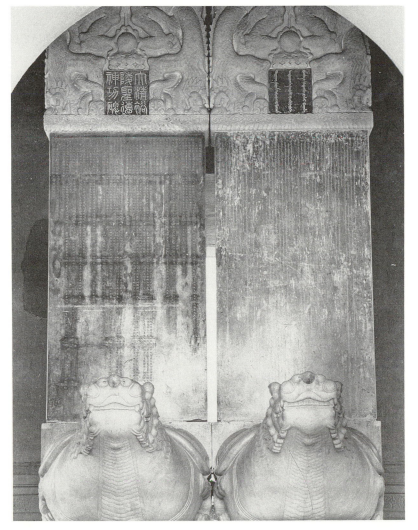

271. *Double stelae with inscriptions in Manchu and Han, Tailing, Western Tombs.*

272. *Tablet in Manchu and Han ordering riders to dismount as they passed Xi Zhaoling (West Zhaoling), tomb of the widow of the second Manchu emperor, Tianzhong. The empress chose to be buried near her son and grandson in the Eastern Tombs rather than next to her husband's tomb, Zhaoling, Shenyang. Qing empresses were not allowed spirit road statuary.*

273–275

276,277

278

279–285

tombs reduces the impact of the central spirit way. The stone figures in these lesser avenues appear to take second place to stone monuments with an architectural origin; the stone animals and men have been included by convention rather than conviction. The figures are small, sometimes little more than one metre high, and their numbers greatly reduced; animals are always shown standing and their symbolic significance is obscured. The elephant, for example, is carved with an embroidered saddlecloth, bearing a Buddhist-type jar on its back. There is no distinctive dynastic fabulous beast. The Ming *xiezhai* is replaced by a *suanni* which, according to some, was one of the nine sons of the dragon with qualities similar to those of a *qilin*. The officials provide excellent examples of Qing court dress, but the alleys as a whole convey no message; neither do they represent a ceremonial occasion. They are merely a part of the overall stone decoration of the tomb complex.

Colour 21

The glory of these tombs is found in the architectural stonework. Much of the charm of the two sites lies in the profusion of white marble monuments crisscrossing the valleys. In the Eastern Tombs the floor of the valley is flat and the tombs can be seen from afar, lying at the foot of the steep mountain wall enclosing the northern end of the cemetery; the valley of the Western Tombs is hilly and forested, and no one tomb is visible from another. Both areas are well watered and each tomb approach is adorned with up to three sets of single-, triple-, or five-arched bridges with dazzling white marble balustrades.[22] The relative importance of architectural features and statuary is illustrated in two cases in which an emperor recorded a wish for economy. In a memorandum justifying his choice of the Western Tombs site, Yongzheng, the third emperor, stated that he wanted a modest funeral: "The outlines and dimensions shall be projected on an economi-

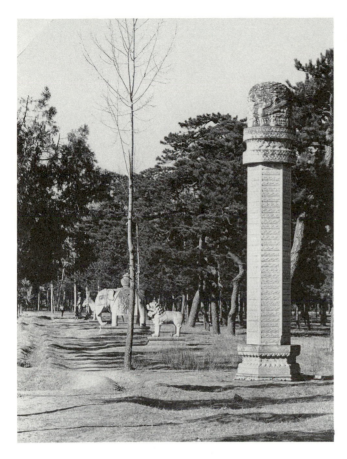

273. *Spirit road leading to Changling, tomb of Jiaqing (d. 1820), Western Tombs.*

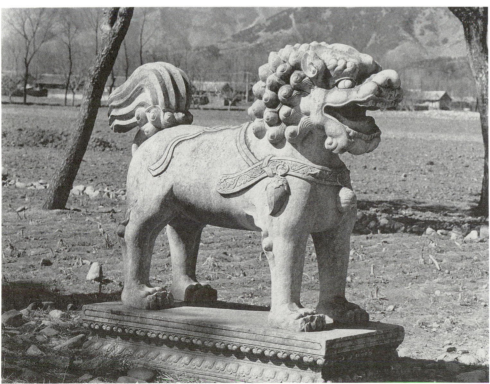

274. *Lion, Yuling, tomb of Qianlong (d. 1799), Eastern Tombs. Height c. 1.5 m.*

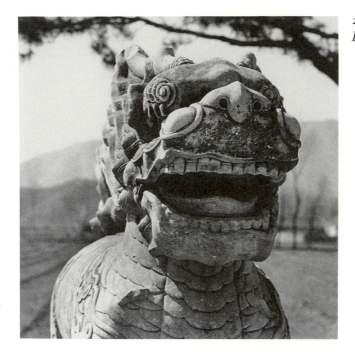

275. Qilin, *Yuling,*
Eastern Tombs.

276. *Elephant with*
saddlecloth and Buddhist-
inspired vase, Changling,
Western Tombs.

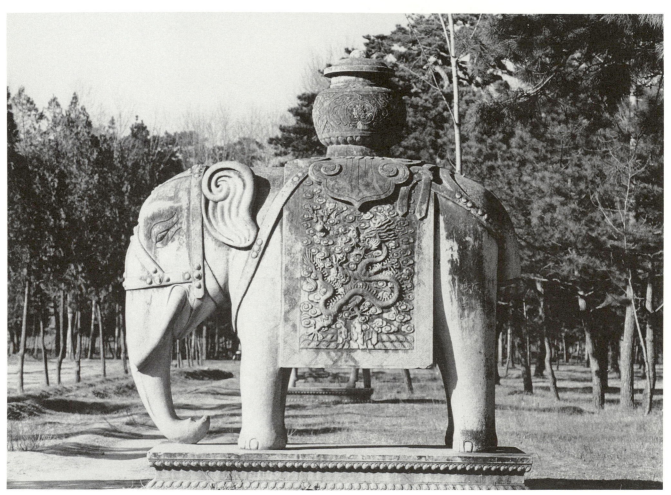

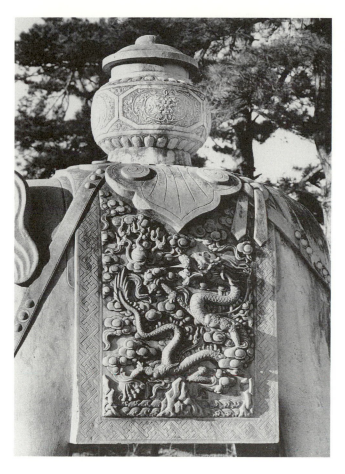

277. *Elephant cloth and vase, Changling, Western Tombs.*

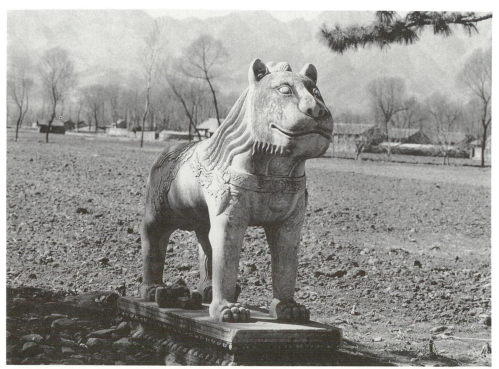

278. Suanni, *the Qing version of the Ming* xiezhai, *Yuling, Eastern Tombs. Height c. 1.5 m.*

279. Military official,
Jingling, Eastern Tombs.

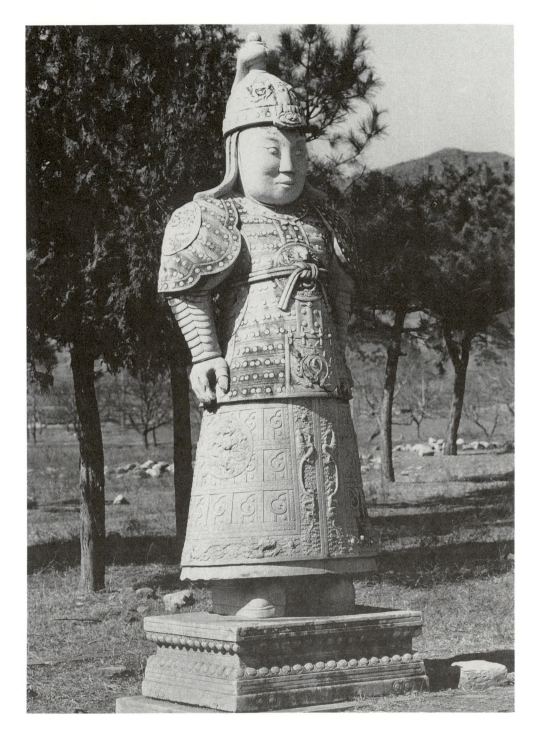

279. Military official,
Jingling, Eastern Tombs.

cal and plain base and such things as stone images, etc., which require an excessive amount of stone cutting and greatly exhaust the strength of the people, need not be made."[23] Whilst his spirit road is indeed modest, having small, indifferent carvings, the entrace to his burial ground is adorned with more marble monuments than that of any other imperial cemetery. Its ap-

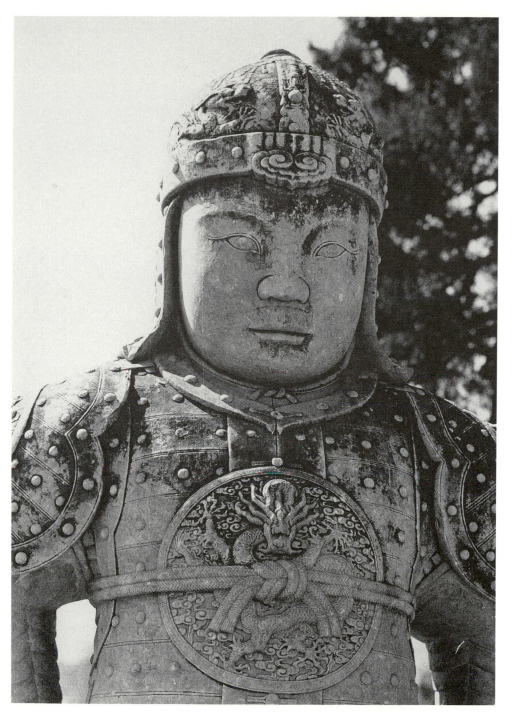

*280. Military official,
Yuling, Eastern Tombs.*

proach, with a five-arched bridge leading to a courtyard formed by three
elegant *pai lou*, is a complex of unusual beauty. Daoguang, the sixth em-
peror, who was known to be homesick for his northern homeland, specified
that on grounds of economy he wanted no spirit road and no painting or
gilding on the tomb woodwork; instead he used the fragrant *nanmu* wood

286–290

281. Back view, military official, Yuling, Eastern Tombs.

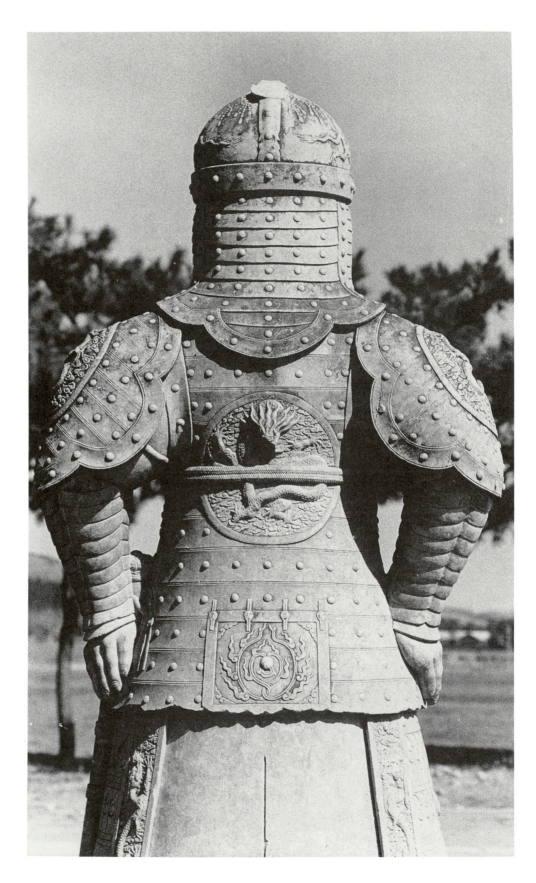

282. Side panel and hand with archer's ring, military official, Yuling, Eastern Tombs.

283. Sword, military official, Yuling, Eastern Tombs.

*284. Civil official,
Tailing, Western Tombs.*

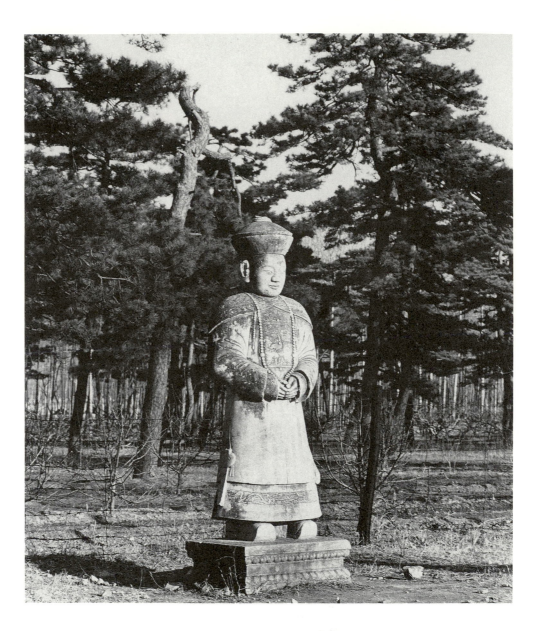

from southwest China, whose surface was so fine that it did not need deco-
rating, and provided colour in the northern way by using rare stone. These
materials had to be transported from distant parts of the empire, and the
final cost far surpassed that of a tomb with painted woodwork and statuary.

The practice of erecting spirit road statues survived the fall of the empire
in 1911. Yuan Shikai, who tried to make himself emperor in 1915, had a
spirit road erected on his grave in 1916. The military in this avenue wear
contemporary uniform with epaulettes and round tin hats. Stone tomb ani-
mals from the 1920s and possibly later can be found in remote country
areas, and the tomb of the last direct descendant of Confucius to be buried
in the family cemetery at Qufu has a spirit road dating from 1934. Contrary

291,292

285. *Sword and purse, civil official, Yuling, Eastern Tombs.*

286. *Bridge leading to* pai lou *and main entrance to the Qing Western Tombs, Hebei.*

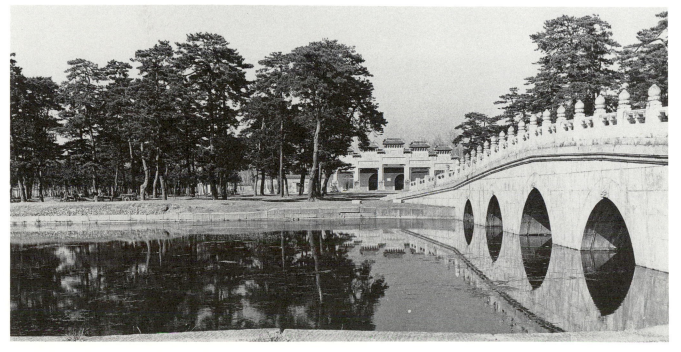

287. Pai lou *and Great Red Gate, heralding the approach to Tailing, tomb of the third Qing emperor, Yongzheng (d. 1735), Western Tombs.*

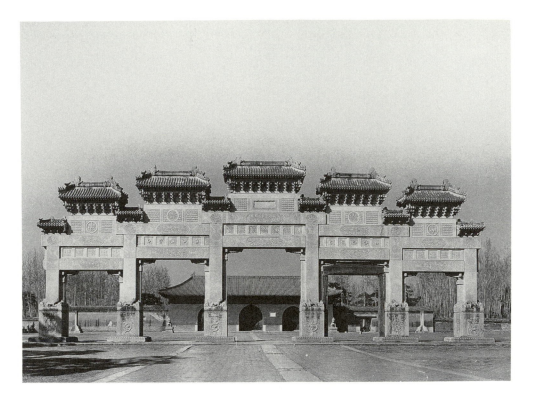

288. Roof decoration, pai lou, *Western Tombs.*

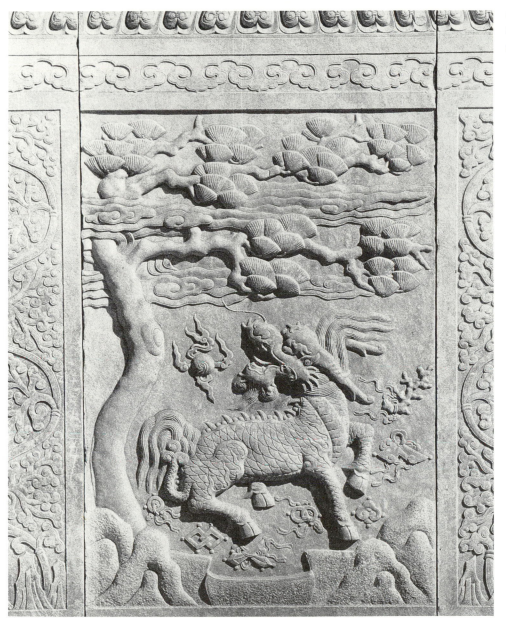

289. Qilin *playing with the "eight Buddhist symbols,"* pai lou *base, Western Tombs.*

to tradition, the officials in this avenue are dressed in out-of-date costumes and bear anachronistic *hu,* as if they were still serving an emperor.

As long as the spirit road represented a philosophy, it remained at the heart of the imperial burial system. It was a living institution which grew and changed in answer to changing circumstances and beliefs. Once the belief lapsed, it atrophied; the statues no longer possessed inherent powers and the avenue no longer provided a convincing link with the other world or expressed imperial aspirations. Officially, the spirit road tradition came to an end in the twentieth century; in reality this powerful form of statuary fell silent under the Qing.

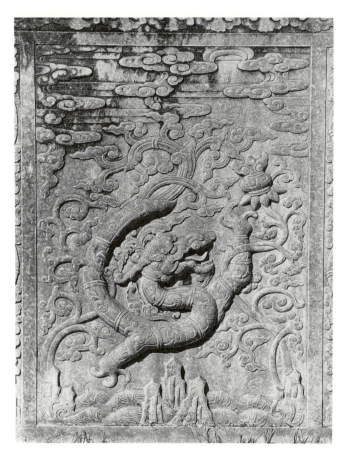

290. Three-clawed dragon reaching for the "night-shining pearl," Western Tombs.

291. Tomb of the last direct descendant of Confucius to be buried in the family cemetery at Qufu, Shandong, in 1934.

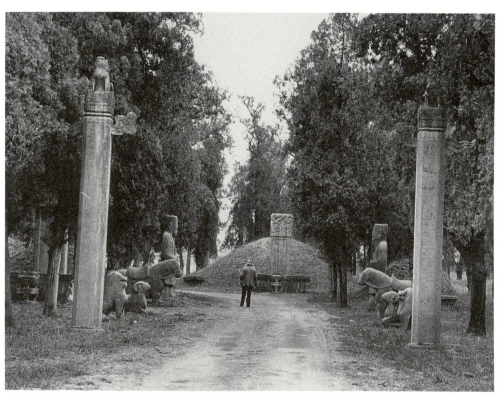

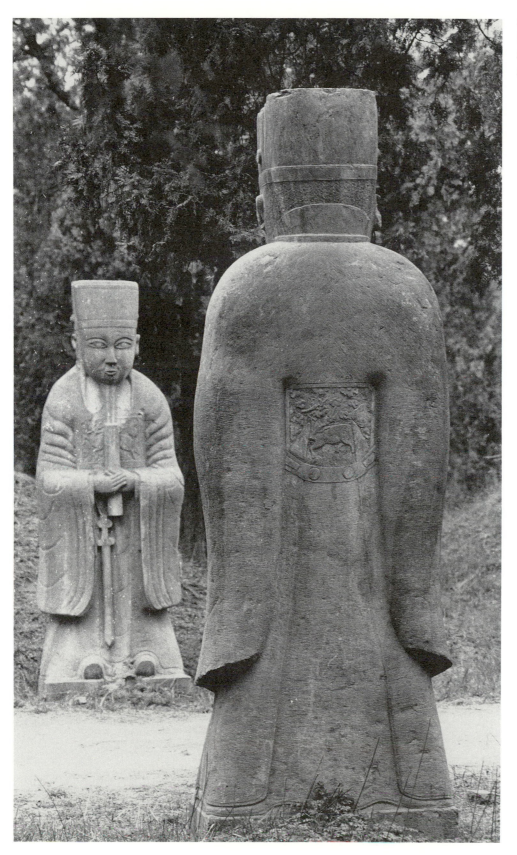

292. *Civil officials, 1934,*
Qufu. In a break with
tradition, they no longer
wear contemporary dress.

APPENDIX A

SHUNLING

Lady Yang, the mother of Empress Wu Zetian, was buried at Shunling, thirty-five kilometres northeast of Xianyang, Shaanxi, in 670. In 684 the empress raised her mother posthumously to royal rank, and in 689 awarded her imperial status.[1] With each promotion the tomb statuary was increased, and there are three sets of spirit road statues on the tomb.

Although Lady Yang's funeral was on an imperial scale, she was at that time only entitled to a noble's grave (*mu*). This is reflected in the modest size of the tumulus, the inner enclosure, and the first set of statuary: a pair of officials and two pairs each of rams and tigers. The second spirit road with seven pairs of officials belongs to the royal period. The number seven is unusual: at Gongling, tomb of the crown prince, Li Hong (d. 675), there are only three pairs; imperial mausolea had ten. Possibly the royal spirit road was not completed before the deceased received imperial rank and the tomb was renamed a mausoleum (*ling*).

The process of transforming the tomb into a mausoleum was never finished, and only the stone monuments and a pair of earthern *que* to the south indicate the site of the projected enlarged tomb area. The seated lions to the east, north, and west of the present enclosure would have been outside the gates of the new wall; the saddled horses stand in the correct place for an imperial tomb outside the northern gate which was never built. Had the plan been carried through, the dimensions of the tomb would have been 1.25 kilometres from north to south and 866 metres from east to west, larger than those of Gongling. (The Shunling tumulus is only 48.4 by 48.5 metres at the base and 12.6 metres high; that of Gongling is 163 by 147 metres at the base and 50 metres high.)

The third spirit road, which is incomplete, begins with a pair of earthen *que* 630 metres south of the present gate into the tomb enclosure. About 80 metres north were a pair of columns (only one top remains); 50 metres further north are a large pair of winged animals, typical Chinese amalgams referred to by many names but answering most closely perhaps to "heavenly deer" (*tianlu*). These are the largest surviving complete Tang tomb statues. The animals and their pedestals are carved in one piece, 4.15 metres high, 4.2 metres long, and 1.5 metres wide. Two square bases, thirty and sixty metres north of the winged animals, suggest that there may have been two pairs of human statues here. One hundred and fifty-five metres further

Chart 5

293

137, 138

216

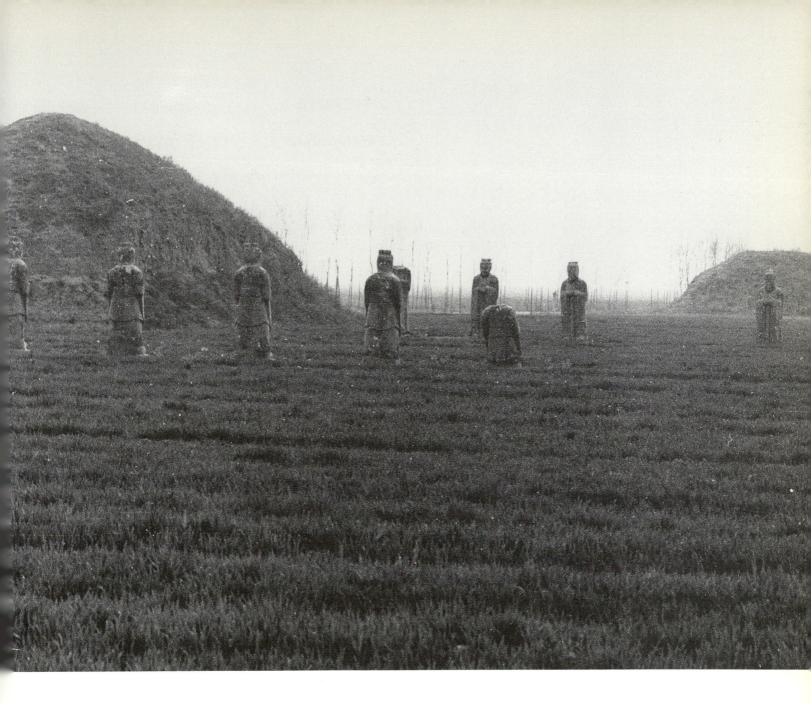

north, outside the south gate and facing south, are two impressive stand-ing lions, male and female. In front of the southern gate is a small pavilion with a stele engraved with a map of the Shunling area. The original stele was broken in the great earthquake of 1555 and the various pieces used to strengthen the banks of the River Wei. Two sections recently found in the riverbed are now in Xianyang Museum. The memorial text was written by the Empress Wu in a square, bold calligraphy and includes several of the new characters which the empress had invented. (Among the many ac-tivities of this extraordinary woman was an attempt to reform certain basic characters such as "day" and "month," which she considered too compli-cated.)[2]

153,154

293. *Row of officials, Shunling, second period, c. 684.*

APPENDIX B

FOREIGNERS IN THE NORTHERN

SONG SPIRIT ROADS AT GONGXIAN

294–296 The tentative identification of these envoys is based on the following assumptions:

1. The figures were intended to be identifiable by their physiognomy, clothing, and gifts.
2. The envoys represent countries with which China had a regular exchange of embassies.
3. The envoys are placed according to precedence, reflecting the importance of the country to China and its propinquity.
4. The convention that China was the central kingdom obtained, and envoys were chosen to represent the different compass points.
5. The six envoys in each tomb represent different countries; the selection of countries is not the same for each tomb.

Statues are numbered by tomb (T1, T2, etc.) and then from the south, in three rows on both east and west. Thus in the second tomb, for example, the place of honour in the row nearest to the emperor and on his left would be T2/E3 and the lowest place in the sixth tomb would be T6/W1. Definite attribution is stated under the illustrations without comment; when it is only probable, it is put in quotation marks.[1]

193,194 The first point above can indicate general regions of origin, particularly for envoys from distant lands such as Arabs with turbans or barefoot Asians carrying rhinoceros horn. The gifts are not always helpful since many envoys, particularly of the nearer and more important countries, carry a box containing an official letter of greetings or congratulations.[2] Identification by clothing is complicated by the Chinese custom of giving foreign envoys gifts which included items of Chinese clothing such as gold or silver belts, Chinese hats, and robes. (Typical gifts from the emperor to an envoy at New Year were: a golden belt, a Chinese hat, high boots, a *hu*, two hundred bolts of silk, one hundred taels in silver articles, a horse and saddle.)[3] Some of the figures wear two belts—their own soft tie or sash and a Chinese metal belt. Envoys from Korea and Jiaozhi wore Chinese-style clothing. There is the additional difficulty that these statues always mirrored contemporary styles: fashion over the period changed, so that even when a figure can be

218

(1) *Korean with metal embossed hat, bearing a bottle, Yong Dingling (T3/W2). Height c. 3 m.*

(2) *Barefooted ambassador from Southeast Asia bearing ivory, Yong Dingling (T3/E2). Height c. 3 m.*

(3) *Uighur ambassador? Yong Dingling (T3/E1). Height 3.3 m.*

(4) *Ambassador, origin uncertain, Yong Zhaoling (T4/E3). Height 3.2 m.*

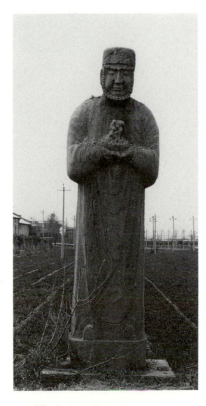

(5) *Moslem ambassador, Yong Zhaoling (T4/W1). Height 2.6 m.*

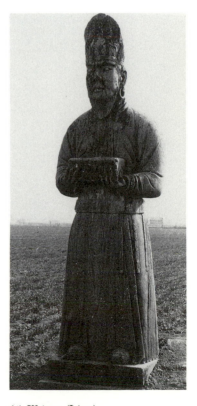

(6) *Khitan (Liao) ambassador, Yong Tailing (T7/E3). Height 2.75 m.*

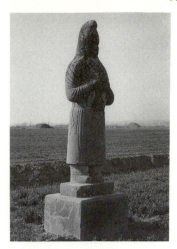

(1) Uighur? Yong Changling (T1/W2).

(2) Origin unknown, Yong Changling (T1/E1).

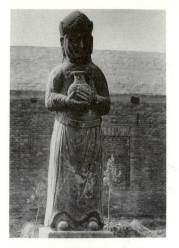

(3) Tangut? Xong Xiling (T2/W3).

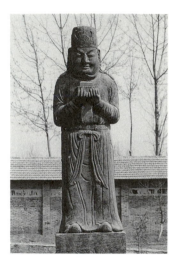

(4) Khitan/Liao, Yong Xiling (T2/E3).

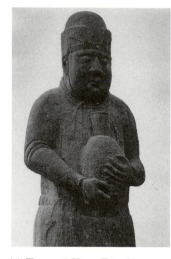

(5) Tangut? Yong Dingling (T3/W3).

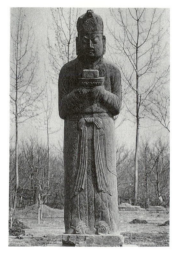

(6) Uighur? Yong Dingling (T2/E1).

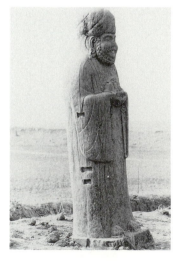

(7) Arab, Yong Dingling (T3/W1).

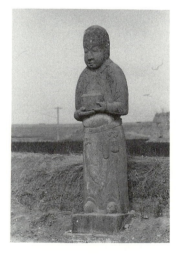

(8) Khitan/Liao, Yong Dingling (T3/E3).

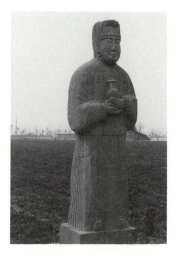

(9) Korean? Yong Zhaoling (T4/W2).

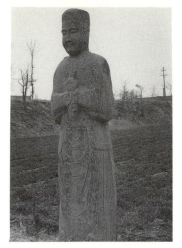

(1) Tangut? Yong Zhaoling (T4/W3).

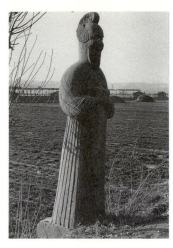

(2) Origin unknown, Yong Houling (T5/W2).

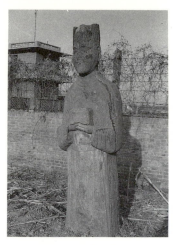

(3) Liao? Yong Houling (T5/E3).

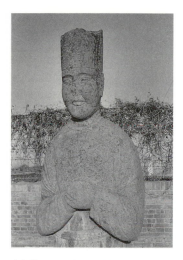

(4) Korean, Yong Houling (T5/E2).

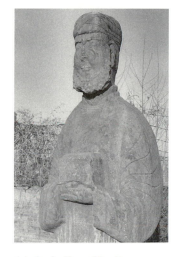

(5) Arab, Yong Houling (T5/E1).

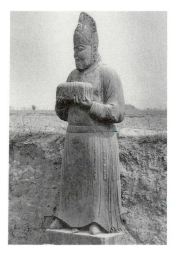

(6) Liao, Yong Yuling (T6/E3).

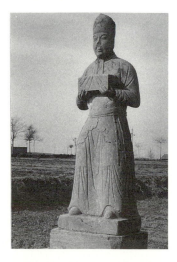

(7) Western Xia, Yong Yuling (T6/W3).

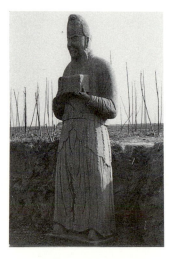

(8) Origin unknown, Yong Yuling (T6/E1).

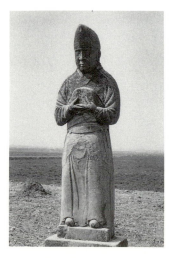

(9) Uighur? Yong Tailing (T7/W2).

positively identified as Liao, for example, it does not follow that earlier and later Liao figures will wear similar dress.

The most frequent embassies took place, as might be expected, with China's closest neighbours such as the Liao (Khitan), Xi Xia (Tangut), Koryo (Korea), Champa (southern Vietnam), and the Uighur kingdoms of Gaochang, Jiuzi, and Xizhou. Less frequent missions came from Tianzu (India), Dashi (Arabia), Jiaozhi (northern Vietnam), Tibet, Sanfuqi (Sumatra), and Persian-speaking centres such as Khotan. The Chinese dealt with these foreign envoys in three ranked departments. In the first were the Liao. By the Treaty of Shanyuan (1005) the empire of the Liao was accorded equality with the Chinese empire and Liao envoys were the responsibility of the "Department for Ingoing and Outgoing Credentials," which dealt with Chinese and Liao envoys exclusively; in the second rank were the Xi Xia (a Tangut kingdom established in 1038) and Koryo; in the third, the lesser kingdoms to the south and west and countries further afield.[4]

This indicates that the place of honour in the spirit road would, at least after 1005, be occupied by a Liao and that the next two places would probably be filled by Xi Xia and Korean envoys. (Although the Xi Xia kingdom only dates from the reign of the fourth emperor, Tangut envoys were among the first to pay respects to the Song dynasty when it was founded in 960.) The remaining three places would certainly have included representatives from one or more of the states in the Indo-Chinese peninsula, and these may well have been chosen and placed to give a reasonable geographical distribution.

Those statues which can definitely be identified by outside corroboration give some confirmation to these theories. The figures in the place of honour in the last two tombs (T6/E3 and T7/E3) wear a type of headdress almost identical to one found in a Liao tomb in the Beijing area and must therefore be Liao.[5] A Xi Xia, identified by illustrations of Xi Xia costume in Dr. Sheng Congwen's great work on ancient Chinese costume, holds second place in the sixth tomb (T6/W3).[6] A Korean, recognizable by his box, which resembles mother-of-pearl-inlaid lacquer boxes of the Koryo period, stands in the second row in the second tomb (T2/W2). The Southeast Asians are always in the second or third rows and almost always on the east side; the Arabs are always in the third row and, with one exception, stand on the west. A Khotanese, wearing a hat exactly like that shown in a Yuan picture of a Khotan horse and groom in the Freer Gallery in Washington, D.C., stands in the third row.[7] Sometimes a name gives a clue: the king of the Uighurs was known as the King of the Lions; several figures wear headdresses crowned with lions and are therefore likely to be Uighurs.

Finally, it is possible to deduce by elimination that certain figures should belong to a particular nationality. In the second tomb, for example, the fig-

294(6)

296(7)

197

294(2)

196

294(3),
295(6)

ures in the second row are Korean and Southeast Asian. If it is accepted that the place of honour is filled by the Liao, this makes it likely that the other figure carrying a bottle in the first row is Tangut. Two other figures standing in similar positions in the third and fourth tombs carry bottles and may thus be Tangut (or Xi Xia).

295(3),
295(5),
296(1)

APPENDIX C

HUANGLING AND ZULING

201–216
In 1369, the year after his accession, Hongwu visited his parents' grave near Linhao City, Anhui. He ordered their modest grave mound to be enlarged and appointed twenty local families as tomb guardians. During the same year he worked on the project for a new capital city, Zhongdu, and an ancestral mausoleum which would honour both his birthplace and his parents' grave. After being dissuaded from moving the latter to a more auspicious site because this might weaken the roots of the dynasty, he renamed the region Fengyang (south of the Phoenix Mountain).[1]

Chart 9

201
The city and tomb were designed as one complex based on research into Tang and Song plans. Yong Tailing, the last Northern Song tomb at Gongxian, was taken as a model for Huangling, but the customary orientation of the tomb was reversed to allow for an approach through the central southern gate of the city, and the spirit road leads from north to south.

Over one million workers were conscripted, including ninety thousand skilled artisans from all over the country and seventy thousand soldiers. The rest were impressed from peasantry in the Huai River valley, with catastrophic results for the region. In this previously prosperous area, the loss of agricultural manpower and the sudden burden of large numbers of officials with their families from Nanjing was more than the economy could bear. There is still a local ballad saying, "After Zhu Yuanzhang (Hongwu), nine out of ten years in Fengyang were famine years." When the emperor visited the nearly completed capital in 1375, there was a rising in which several workers were killed. Public opinion was against the emperor and although he bade forgiveness at one of the newly erected temples, the incident was considered so inauspicious that Zhongdu was abandoned and the capital moved back to Nanjing. As well as economic problems and difficulties of transport and communications, there was doubtless considerable hostility among official classes to the move from old-established centres of power to what would have been considered a backwater.

Part of the building material was taken to Nanjing; part was used to build the Longxing Temple, a grander copy of the Huangjue Temple in which Hongwu had been a monk for a time in his youth, and part was devoted to the construction of Huangling. The city walls are still standing and the site provides a rare example of a Chinese city built on previously unbuilt

224
ground which was later left undisturbed. Reliefs on the base of the main

southern gateway and numerous carved stones displayed in the Longxing Temple nearby are in Yuan style, with delicate landscapes and abundant use of plants, flowers, and natural animals as motifs.

The tomb was completed by 1379 and maintained as an imperial ancestral monument. An Office for Sacrificial Services was set up with four officials—"all state servants of great zeal and from the hereditary nobility." Twenty-four masters of ceremony were appointed and 3,342 families assigned as tomb guardians to water and sweep the grounds and provide lodgings for visitors to the tomb. Tomb security was entrusted to a garrison lodged in the southeast corner of the abandoned Zhongdu. The emperor visited the tomb several times and officials passing Fengyang on their way to the capital were ordered to pay respects at Huangling. Towards the end of the dynasty, in 1635, rebels burned the principal buildings, including the Sacrificial Hall, but the real destruction of the tomb dates from the early part of the Qing dynasty when an official, during time of hardship, gave the local population permission to remove building materials. "Huangling," it was recorded, "became nothing. Only two stelae and the [stone] men and horses remained."

In the centuries that followed, the only remnant which attracted interest was the western stele. (Owing to the unusual orientation of the tomb, this stele is on the right as you approach the tumulus. The stele on the left carries no inscription.) The inscription, 1,107 characters long, was written by Hongwu and describes the struggles involved in establishing the dynasty. Earlier, he had commissioned one Wei Su, a lecturer at the Imperial College, to write the text, but finding this version too bland, he rewrote the story himself.

Paradoxically, rediscovery of the tomb was an indirect result of the Cultural Revolution. Among others, Dr. Wang Jianying, a Beijing historian, was sent to the countryside in the Fengyang region. He spent his spare time exploring the ruins of the tomb and the abandoned capital and found, as has so often happened in Chinese history, that although the tomb buildings had all disappeared, the spirit road statuary, fallen, overgrown, and half-buried in the fields, had survived almost intact. In 1982 the tomb was declared a state monument; restoration of the spirit road followed, the tumulus was replanted, and in 1985 the tomb was opened to the public.

Whereas Huangling was a homogenous reconstruction of past tomb patterns, Zuling, was a blend of the old and the new. The original design was similar to that of Huangling but on a much smaller scale. (When it was finished, only 293 guardian families were appointed compared to the over three thousand at Huangling.) By the time work started, however, Hongwu's own mausoleum, Xiaoling, establishing the new Ming tomb pattern, was under way and the Zuling plans were already out of date. A comparison of

297

Chart 10

297. Huangling western stele. The inscription of 1,107 characters was written by Hongwu himself, describing his struggles to establish the dynasty. Owing to the unusual orientation, the stele is on the right as you approach the tomb.

the dates of Xiaoling and Zuling shows that whilst the main buildings of Xiaoling predate those of Zuling, the spirit road at Zuling is some twenty-three years earlier than that of Xiaoling. Work on Xiaoling began in 1381; the principal buildings were completed by 1383, when the empress Ma was buried and the first rites held; the gates and walls were finished in 1391, when the *xia ma fang,* an archway carrying an inscription ordering passers-by to dismount at the gates of the tomb, was erected. The spirit road statuary, like the memorial stele, could not be erected until after the emperor's death; they date from 1413.

At Zuling construction began in 1385; the Sacrificial Hall was finished in 1388; rites were performed in the following year and the spirit road statuary is believed to date from this period. Records of the exact date have not yet been found, but in this case there was no need to wait for the tomb occu-pant's death. The statuary is based on that of Huangling, with no influences from Xiaoling, and the costumes of the stone officials show that they be-

298

298. Xia Ma Fang, Xiaoling, tomb of Hongwu (d. 1398), Nanjing, Jiangsu. The inscription orders all those approaching the tomb to dismount from their horses.

long to a period before the Sumptuary Laws of 1391. In 1413, when the final work was being done at Xiaoling, an attempt was made to bring the Zuling complex into line with the new tomb pattern. A stele pavilion was added at the southern end and a Dragon and Phoenix Gate at the northern end of the spirit road; slaughterhouses, spirit ovens, and storerooms were put up in the southeast and southwest corners of the outer enclosure, corresponding to the buildings flanking the forecourts at Xiaoling. Ming accentuation of the approach and central axis was thus grafted onto Tang and Song concentricity.

The site on the banks of Lake Hongse was a notoriously swampy area. The lake, which was shallow and frequently clogged by silt brought from the Yellow River into the River Huai, had been created by irrigation works in the twelfth century. Dam works in the fifteenth and sixteenth centuries exacerbated the situation and local records are filled with accounts of serious flooding. In 1531 major repairs were undertaken at the tomb after a bad flood, and by 1678 the tomb and local county town, Sizhou, had disappeared completely beneath the lake surface.

Rediscovery followed the long drought of summer 1962 and winter 1963. In spring 1963, a group of local archaeologists, walking on the west bank of the lake, discerned, some fifteen metres from the shore, a collection of large stone figures. Wading out—there was an offshore wind blowing the water away from the coast—they found the two rows of the spirit road of Ming Zuling. Further exploration revealed the tomb's underground chamber. During the long years of immersion the tumulus had been washed away, but beneath the muddy lake floor, some fifty metres north of the

spirit road, were the remains of the *xuan gong*. Instead of the usual vaulted stone construction, this was built like a surface palace—a hall with three bays, using wooden beams and covered with a glazed tile roof. According to the records, the three bays, each dedicated to one generation of ancestors, housed three sets of imperial hats and robes to replace the long-vanished bodies and coffins. (The idea of replacing a body with robes was not new. The hat and robes of the legendary Yellow Emperor are said to have been buried in a tomb after his ascent to the land of the immortals.) Large numbers of black tiles were found as well as imperial yellow tiles; it is thought that the original hall, either from ignorance or economy, was roofed in black tiles, which were replaced during the major repairs of 1531. Unfortunately, during the Cultural Revolution the remains of this building were destroyed, and today there is only a small depression in the ground.

From 1976 to 1982 a major work of restoration was carried out. The site is now enclosed by a dyke 15.5 metres high and 27 kilometres long, with reinforced concrete along the 6 kilometres of the lakeside. The area within has been crisscrossed with underground drains and planted with evergreens. Excavation has established the tomb plan and revealed stone column bases of gateways and halls. The statues have been reerected and painstakingly reassembled. During the flooding they had fallen from their bases, but although some were badly broken, the weight of the stone prevented the fragments from being washed away, and it was not difficult to establish their original positions.

Despite the destruction of their surroundings, the spirit roads of both tombs are remarkably well preserved. As might be expected, those at Huangling are more worn, but even there, burial in the ground minimized the effect of weathering. At Zuling the soft lake floor acted as a preservative and these carvings are among the finest Ming tomb sculptures ever found.

The two spirit roads are similar in content and style but unlike any other known spirit roads. As has been seen, the subject matter appears to have been chosen more from a desire not to leave anything out than to express a particular idea. (At Huangling there are twenty-nine pairs of statues, compared with eighteen at Xiaoling and twenty in the Valley of the Thirteen Tombs.) Of particular interest are the columns, the human figures, and the heavenly horse.

211,212 There are no other known examples of a spirit road with two pairs of columns. The situation of these columns, halfway down the alley, is unusual: traditionally a single pair of columns marked, like the Han *que*, the entrance to an important site. Here they seem to divide the fabulous *qilin* and lions from the rest of the statues. The shape of the first pair is derived from Song columns, but has Yuan-style flower and plant engraving; examples of the second type, with a plain shaft and jewel-like top, can be found on some

minor tombs round Nanjing from the same period but are not known else-
where. Neither style survived: the columns at Xiaoling and in the Valley of
the Thirteen Tombs are carved in deep relief with clouds and dragons. At 237
Xiaoling a single pair mark a right-angled turn halfway down the avenue;
in the Valley of the Thirteen Tombs a single pair stand in the conventional
position at the start of the alley.

The inclusion of eunuchs gives yet another proof that both sets of statuary
were erected in the early years of the dynasty, presumably before Hongwu
had made the famous iron tablet, one metre high, saying that eunuchs must
have nothing to do with the administration. The military have precedence
over the civilians, a situation typical in the early years of a dynasty won by
the sword. At Xiaoling the civilians have regained their customary preemi-
nence. (The sculptors' attitude towards the two professions may be indicated
by the fact that at Huangling the civilians are taller than their military
counterparts.) The extraordinary realism of these figures and freedom from
some of the restraints governing human portraiture in stone have already
been noted.

The heavenly horse was inspired by the Tang winged horse but is inter- 208
preted in a very different way. Whereas the Tang creature was based on a
real horse to which wings had been added, the Ming version, little more
than a cartoon, was the physical representation of an idea. It forms a delib-
erate contrast to the rounded, well-composed, and lifelike statue of a horse Colour 15
and groom nearby. In later Ming tombs, when a coherent spirit road pattern
had been worked out, the heavenly horse disappeared.

TABLES AND CHARTS

TABLE 1. *Statuary on Imperial Tombs of the Southern Dynasties*

Emperor	Date of death	Tomb	Site	Statuary
Liu Song Dynasty (420–479)				
Song Wudi	422	Chuningling	Qilinpu, Nanjing	2 *qilin*
Song Wendi	453	Changningling	Shizichong, Ganjiaxiang, Nanjing	2 *qilin*
Qi Dynasty (479–502)				
Qi Xuandi (posthumously ennobled, 479)	447	Yonganling	Shiziwan, Huqiao. Nanjing	2 *qilin*
Qi Wudi	493	Jinganling	Qian'aimiao, Jianshan, Nanjing	2 *qilin*
Qi Jingdi (posthumously ennobled, 494)	Not known	Xiu'anling	Xiantang, Huqiao, Danyang	2 *qilin*
Qi Mingdi	498	Xinganling	Sanchengxiang, Jingling, Danyang	1 *qilin*
Liang Dynasty (502–559)				
Liang Wendi (posthumously ennobled, 502)	494	Jianling	Jinglin, Danyang	2 *qilin* 2 columns 2 stelae bases
Liang Wudi	549	Xiuling	Sanchengxian, Jingling, Danyang	1 *qilin*
Liang Jian Wendi	551	Zhuangling	Sanchengxian, Jingling, Danyang	1 *qilin*
Chen Dynasty (557–589)				
Chen Wudi	559	Wananling	Shimalu, Shanfangshi, Jiangningxian, Nanjing	2 *qilin*
Linkou, Liang or Qi Dynasty			Danyang	2 *qilin*

TABLE 2. *Statuary on Royal Tombs of the Southern Dynasties*

Name	Date of death	Site of tomb	Statuary
*Liang Dynasty Royal Tombs in Nanjing Area**			
Xiao Xiu	518	Ganjiaxiang Primary School, Nanjing	2 *bixie* 2 stelae bases 2 columns 2 stelae
Xiao Dan	522	Southwest of Ganjiaxiang, Nanjing	2 *bixie* 1 stele
Xiao Hui	526	East of Xiao Dan's tomb	2 *bixie*
Xiao Hong	526	Zhangkucun, Xianhemen, Nanjing	2 *bixie* 1 column, 1 column base 1 stele, 1 stele base
Xiao Jing	523	Shiyuecun, Ganjiaxiang, Nanjing	1 *bixie* 1 column
Xiao Ji	529	Shishicun, Jurong, Nanjing	2 *bixie*
Xiao Zhengli	548?	Lujiabian, Chunhuashi, Nanjing	2 *bixie* 2 columns
Xiao Ying	?	Dongjiabian, Ganjiaxiang, Nanjing	1 column
Unidentified Tombs in Danyang Area			
—	—	Lanshilong, Jianshan	1 *bixie*
—	—	Shuijingshan, Picheng	2 *bixie*
—	—	Jinwangchencun Jianshan	2 *qilin*

*There are several unidentified tombs in the Nanjing area with statuary appropriate for a royal tomb of the Six Dynasties period.

TABLE 3. *Tang Imperial and Other Tombs*

Emperor	Family name	Dates of reign	Tomb	Site
Imperial				
(Gaozu's grandfather)	Li Hu[1]		Yong Kangling	San Yuan County
(Gaozu's father)	Li Bing[1]		Xing Ningling	Xianyang
Gaozu	Li Yuan	618–626[2]	Xianling	San Yuan County
Taizong	Li Shimin	626–649	Zhaoling	Li Quan County
Gaozong	Li Zhi	649–683	Qianling	Qian County
Wu Zetian	Wu Zhao	690–705	Qianling	Qian County
Zhongzong	Li Xian	684, 705–710	Dingling	Fuping County
Ruizong	Li Dan	684–690, 710–712	Qiaoling	Pucheng County
Shaodi	Li Zhongmao	710[3]		
Xuanzong	Li Longji	712–756[4]	Tailing	Pucheng County
Suzong	Li Heng	756–762	Jianling	Li Quan County
Daizong	Li Yu	762–779	Yuanling	Fuping County
Dezong	Li Shi	779–805	Chongling	Jingyang County
Shunzong	Li Song	805	Fengling	Fuping County
Xianzong	Li Chun	805–820	Jingling	Pucheng County
Muzong	Li Heng	820–824	Guangling	Pucheng County
Jingzong	Li Zhan	824–827	Zhuangling	San Yuan County
Wenzong	Li Ang	827–840	Zhangling	Fuping County
Wuzong	Li Yan	840–846	Duanling	San Yuan County
Xuanzong	Li Chen	846–859	Zhenling	Jingyang County
Yizong	Li Cui	859–873	Jianling	Fuping County
Xizong	Li Xuan	873–888	Jingling	Qian County
Zhaozong	Li Jie	888–904[5]	Wenling	Henan Province
Zhaoxuan (Aidi)	Li Chu	904–907[6]	Heling	Shandong Province
Royal				
Wu Zetian's mother	Lady Yang	d. 670	Shunling	Pucheng County
Gaozong's crown prince	Li Hong	d. 675	Gongling	Yanshi County, Henan

Note: The tomb of Wang Jian (847–918) at Chengdu, Sichuan, is just post-Tang, but the sculpture belongs to the Tang period.

1. Posthumously ennobled by Gaozu
2. Abdicated, died A.D. 635
3. Reigned only two weeks, no mausoleum
4. Abdicated, died A.D. 761
5. Assassinated, no mausoleum
6. Deposed, no mausoleum

TABLE 4. *Surviving Statuary on Tang Imperial Tombs*

Tomb	Statuary
Xianling	1 tiger, 1 rhinoceros (buried), 1 *hua biao* column (1 tiger, 1 rhinoceros in Shaanxi Provincial Museum)
Zhaoling	4 stone bases (4 of the 6 reliefs of the six steeds, 1 lion, and lion with acrobat in the Shaanxi Provincial Museum)
Qianling	South gate: 2 *hua biao*, 2 winged horses, 2 ostriches, 10 horses (some badly damaged), 2 grooms, 20 officials, 61 foreigners, 2 lions. West gate: 2 lions. East gate: 2 lions. North gate: 2 horses
Dingling	1 pair lions (1 broken), 5 men (2 broken)
Qiaoling	1 *hua biao*, 2 *jiaoduan*, 2 ostriches, 5 pairs of horses, 15 officials (2 headless), 4 pairs of gate lions. North gate: 3 complete and 3 broken horses
Tailing	2 *hua biao* (1 broken), 2 winged horses, 2 ostriches, 9 pairs men (many in pieces), 5 horses, 6 gate lions. North gate: 2 horses
Jianling	4 pairs gate lions, 2 *hua biao* (1 fallen in ravine), 2 winged horses (1 half-buried), 2 ostriches, 10 pairs men, 9 horses (some broken), 1 small groom?
Yuanling	1 *hua biao* (fallen), 2 pairs lions in pieces, 3 pairs horses in pieces
Chongling	4 pairs gate lions, 1 *hua biao*, ostrich, winged horses, 1 standing figure, rest of men all broken, nine horses in pieces
Fengling	1 *hua biao* in pieces, 1 lion
Jingling	1 *hua biao*, 2 winged horses, 1 ostrich, 5 officials, 8 horses, 4 pairs gate lions. North gate: 4 small lions, 6 horses
Guangling	4 gate lions, 1 *hua biao* in pieces, 1 broken man, 3 horses, 2 winged horses, 1 broken ostrich
Zhuangling	4 pairs gate lions, 2 men, 2 horses in pieces, 2 *hua biao* (broken), 2 ostriches, 2 winged horses
Zhangling	1 *hua biao* (broken), 1 lion, 1 man (broken)
Duanling	2 pairs gate lions, 1 *hua biao*, 3 officials, 1 winged horse (fallen), 1 ostrich in pieces
Zhenling	2 *hua biao*, 2 winged horses, 1 ostrich, 4 horses in pieces, 13 men
Jianling	2 horses (broken), 1 winged horse, 2 men, 1 lion
Jingling	2 *hua biao* (fallen), 1 winged horse, 2 men, 1 lion

Source: Table given by He Zichang in " 'Guangzhong Tang Shibaling' diaocha" (An investigation into the Guanzhong Tang Eighteen Tombs), *Wenwu Ziliao Cong Kan* 1980/3, 150, updated by field research in 1986 and 1988.

TABLE 5. *Northern Song Imperial Tombs at Gongxian*

Family name	Reign name	Tomb name	Dates of reign	Site
Zhao Hongyin (Taizu's father, ennobled posthumously)		Yong Anling	963*	Chengfeng Village, Xicun Commune
Zhao Kuangyin	Taizu	Yong Changling	960–976	Chengfeng Village, 1 km west of Yong Anling
Zhao Guangyi	Taizong	Yong Xiling	976–997	Hutou Village, Xicun Commune
Zhao Heng	Zhenzong	Yong Dingling	998–1022	Zhuang Village, Zhitian Commune,
Zhao Zhen	Renzong	Yong Zhaoling	1023–1063	South of Gongxian City
Zhao Shu	Yingzong	Yong Houling	1064–1067	Southwest of Gongxian City, ½ km west of Yong Zhaoling
Zhao Xu	Shenzong	Yong Yuling	1068–1085	Eight Tombs Village, Zhitian Commune
Zhao Xu	Zhezong	Yong Tailing	1085–1100	Southwest of Eight Tombs Village, ½ km from Yong Yuling

*After raising his father posthumously to imperial rank, Taizu removed his coffin from Kaifeng and reburied him in the new imperial burial ground at Gongxian in 963.

Other Song Tomb Sites and Statuary. At Qufu, Shandong: Song statuary in the spirit road leading to Confucius's grave in the Kong family cemetery and on the gateposts of the Confucian family palace. At Hangzhou, Zhejiang: tomb of General Yue Fei (1103–1142). At Nanjing, Jiangsu: tomb of General Wang De (d.1154) at Xiao Miao, southeast of Yangziji.

TABLE 6. *Ming Imperial Tombs*

Family name	Reign name	Dates of reign	Tomb	Site
Zhu Shichen[1]	—	—	Huangling	Fengyang, Anhui
Zhu Chuyi[2]	—	—	Zuling	Lake Hongse, Jiangsu
Zhu Yuanzhang	Hongwu	1368–1398	Xiaoling	Nanjing
Zhu Yunwen	Jianwen	1398–1402	Unknown[3]	
Zhu Di	Yongle	1402–1424	Changling	Thirteen Tombs, Beijing
Zhu Gaozhi	Hongxi	1424–1425	Xianling	Thirteen Tombs
Zhu Zhanji	Xuande	1425–1435	Jingling	Thirteen Tombs
Zhu Qizhen	Zhengtong	1435–1449, 1457–1464	Yuling	Thirteen Tombs
Zhu Qiyu	Jingtai	1449–1457	—	Western Hills[4]
Zhu Jianshen	Chenghua	1464–1487	Maoling	Thirteen Tombs
Zhu Yutang	Hongzhi	1487–1505	Tailing	Thirteen Tombs
Zhu Houzhao	Zhengde	1505–1521	Kangling	Thirteen Tombs
Zhu Houcong	Jiajing	1521–1567	Yongling	Thirteen Tombs
Zhu Houcong's father, Zhu Youyuan		—	Xianling	Hubei[5]
Zhu Zaihou	Longqing	1567–1572	Zhaoling	Thirteen Tombs
Zhu Yizhun	Wanli	1572–1620	Dingling	Thirteen Tombs
Zhu Changle	Taichang	1620	Qingling	Thirteen Tombs
Zhu Yujiao	Tianqi	1620–1627	Deling	Thirteen Tombs
Zhu Yujian	Chongzhen	1627–1644	Siling	Thirteen Tombs

1. Zhu Yuanzhang's father, posthumously ennobled
2. Zhu Yuanzhang's grandfather, posthumously ennobled
3. Jianwen disappeared during the civil war of 1399–1402.
4. Jingtai assumed the throne in 1449 after his half-brother, the emperor Zhengtong, had been captured by northern invaders. When Zhengtong regained the throne in 1457, he refused Jingtai a burial in the dynastic grave area.
5. Jiajing was descended from a junior branch of the imperial family and awarded his father imperial rank posthumously.

TABLE 7. *Some Ming Royal Tombs and Tombs of Officials*

Guilin, Guanxi Autonomous Region

Tombs of the descendants of Prince Jing Jiang, Zhu Shouqian (r. 1370–1392),
great-nephew of Hongwu (Zhu Yuanzhang)

Zhu Zanyi (Dao Xi), d.1408
Zhu Zuojing (Zhang Jian), d.1469
Zhu Xiangcheng (Huai Shun), d.1458 (crowned after death)
Zhu Guiyu (Zhao He), d.1489
Zhu Yueqi (Li Yi), d.1516
Zhu Jingfu (An Su), d.1523
Zhu Bangning (Gong Hui), d.1572
Zhu Renchang (Kang Xi), d.1582
Zhu Ludao (Wen Yu), d.1590
Zhu Renshang (Xian Ding), d.1610
Zhu Luhu (Rongmu), d.1612

Hebei, Henan

Tombs of Prince Lu Jian (1568–1614) and his wife, Xinxiang
Tomb of an official, near Song Yong Dingling, Gongxian, 16th century?

*Jiangsu, Nanjing, and its suburbs**

Tombs of officials and generals who helped Hongwu establish the dynasty

Chang Yuchun, northeast of Taiping Men, 1369
Xu Da, northeast of Taiping Men, 1384
Li Wenzhong, northeast of Taiping Men, 1385
Two Wu Brothers, northeast of Taiping Men
Kang Maocai, north of Dongjingting bus stop, 1370
Yu Tonghai, north of Yuhuatai, 1367
Li Jie, east of Yuhuatai
Song Sheng, Ningwu Gonglu, 1407
Deng Yu, Ande Men, 1377
Xu Zhong, south of Ande Men
Mao Yuan, Jingming Si
Wang Yiqi, Zutang Shan, 1566
Tomb of the King of Borneo, south of Ande Men, 1408

Shandong

Tomb of the fifty-ninth descendant of Confucius, Kong family cemetery, Qufu

Anhui

Tomb of General Tang He, outskirts of Bengbu

*Sites taken from Barry Till's *In Search of Old Nanjing*, which includes list of tombs of
several unidentified Ming officials.

239

TABLE 8. *Comparison of Statuary on Ming Imperial Tombs*
(Numbers of Pairs)

Huangling	Zuling	Xiaoling	Thirteen Tombs
2 *qilin*	2 *qilin*	2 lions	2 columns
6 lions	6 lions	2 *xiezhai*	2 lions
2 columns	2 columns	2 camels	2 *xiezhai*
1 horse officer	1 horse officer	2 elephants	2 camels
1 horse and groom	1 horse and groom	2 *qilin*	2 elephants
1 horse officer	1 horse officer	2 horses	2 *qilin*
1 Heavenly Horse	1 Heavenly Horse	2 columns	2 horses
1 horse officer	1 horse officer	2 military officials	2 military officials
	2 civilian officials		
4 tigers	2 military officials	2 civilian officials	4 civilian officials
	2 eunuchs		
4 sheep	Dragon and	Dragon and	Dragon and
2 civilian officials	Phoenix Gate	Phoenix Gate	Phoenix Gate
2 military officials			
2 eunuchs			
1 pair of stelae	1 stele?	2 single stelae	2 single stelae

TABLE 9. *Qing Imperial Tombs*

Reign period	Temple name	Dates of reign	Tomb	Site
(Tianming's ancestors' tomb)	—	—	Yongling*	Northern
Tianming	Taizu	1616–1626	Fuling	Northern
Tianzhong	Taizong	1627–1643	Zhaoling	Northern
Shunzhi	Shizu	1644–1661	Xiaoling	Eastern
Kangxi	Shengzu	1662–1722	Jingling	Eastern
Yongzheng	Shizong	1723–1735	Tailing	Western
Qianlong	Gaozong	1736–1795	Yuling	Eastern
Jiaqing	Renzong	1796–1820	Changling	Western
Daoguang	Xuanzong	1821–1850	Muling*	Western
Xianfeng	Wenzong	1851–1861	Dingling	Eastern
Tongzhi	Muzong	1862–1874	Huiling*	Eastern
Guangxu	Dezong	1875–1908	Chongling*	Western
Xuantong (Puyi)†	—	1909–1911	—	—

*No spirit road
†The last emperor of China ended his life as a citizen of the Peoples' Republic and received a citizen's burial in Beijing in 1967.

CHART 1. Huo Qubing's tomb, showing the positions in which the animals were found. The orientation is indicated by arrows.

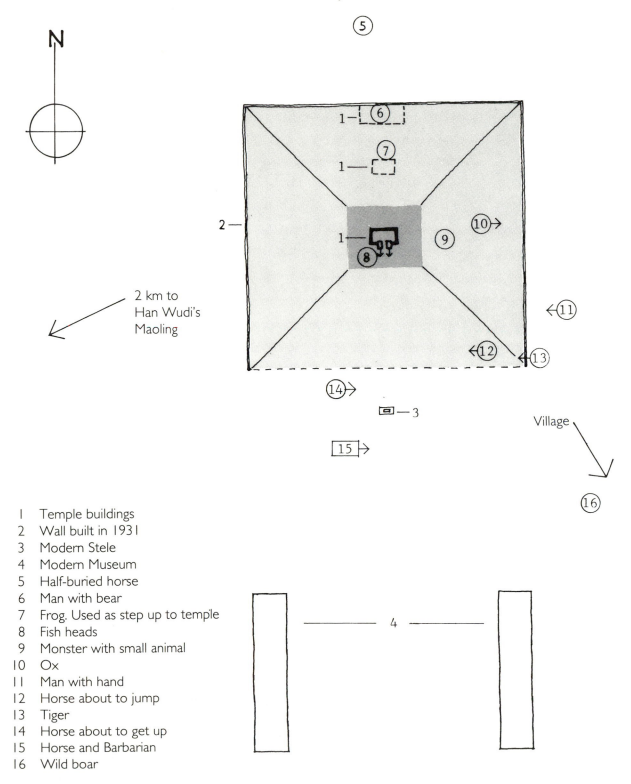

N

5

1— 6
1— 7
2—
1— 8 9 10→

←11
←12 ←13
14→

2 km to
Han Wudi's
Maoling

◫—3

15 →

Village

16

1 Temple buildings
2 Wall built in 1931
3 Modern Stele
4 Modern Museum
5 Half-buried horse
6 Man with bear
7 Frog. Used as step up to temple
8 Fish heads
9 Monster with small animal
10 Ox
11 Man with hand
12 Horse about to jump
13 Tiger
14 Horse about to get up
15 Horse and Barbarian
16 Wild boar

4

CHART 2. Comparison of Han and Six Dynasties spirit roads.

HAN

SIX DYNASTIES

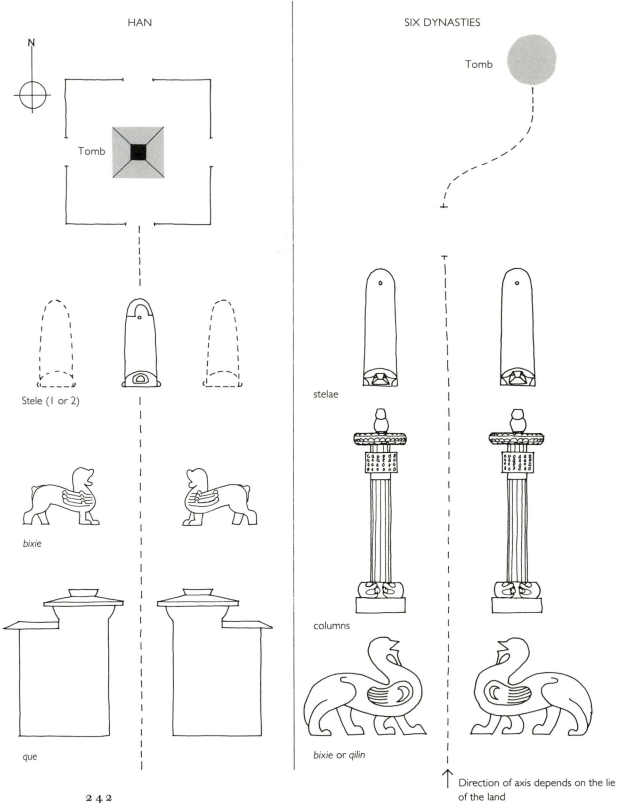

N

Tomb

Stele (1 or 2)

bixie

que

Tomb

stelae

columns

bixie or qilin

Direction of axis depends on the lie
of the land

0 50km

1	Xianling, tomb of Gaozu (618–26)	10	Fengling, tomb of Shunzong (805)
2	Zhaoling, tomb of Taizong (627–49)	11	Jingling, tomb of Xianzong (805–20)
3	Qianling, tomb of Gaozong (649–83) and Wu Zetian (690–705)	12	Guangling, tomb of Muzong (820–24)
4	Dingling, tomb of Zhonzong (684, 705–10)	13	Zhuangling, tomb of Jingzong (824–27)
5	Qiaoling, tomb of Ruizong (684–90, 710–12)	14	Zhangling, tomb of Wenzong (827–40)
6	Tailing, tomb of Xuanzong (712–56)	15	Duanling, tomb of Wuzong (840–46)
7	Jianling, tomb of Suzong (756–62)	16	Zhenling, tomb of Xuanzong (846–59)
8	Yuanling, tomb of Daizong (762–79)	17	Jianling, tomb of Yizong (859–73)
9	Chongling, tomb of Dezong (779–805)	18	Jingling, tomb of Xizong (873–88)

CHART 4. Tang Qianling. Based on map in "Notes on a Survey of Tang Qianling," *Wenwu* 1960/4, 59.

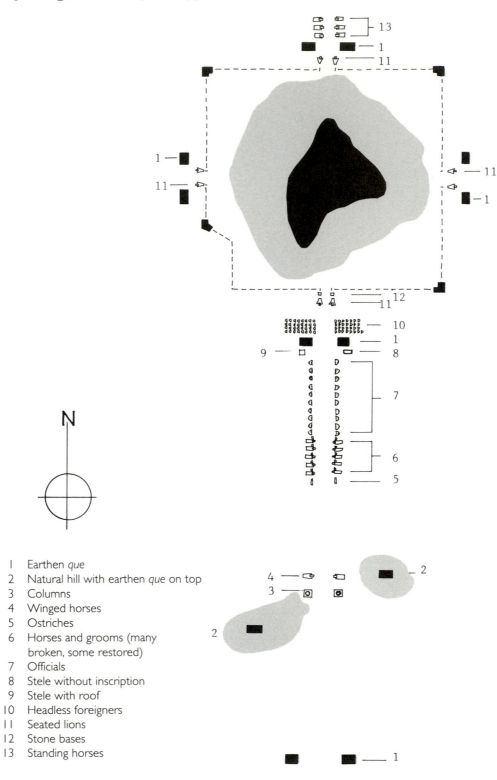

1 Earthen *que*
2 Natural hill with earthen *que* on top
3 Columns
4 Winged horses
5 Ostriches
6 Horses and grooms (many broken, some restored)
7 Officials
8 Stele without inscription
9 Stele with roof
10 Headless foreigners
11 Seated lions
12 Stone bases
13 Standing horses

CHART 5. Tang Shunling. Based on map in "Notes on Survey of Tang Shunling," *Wenwu* 1964/1, 35.

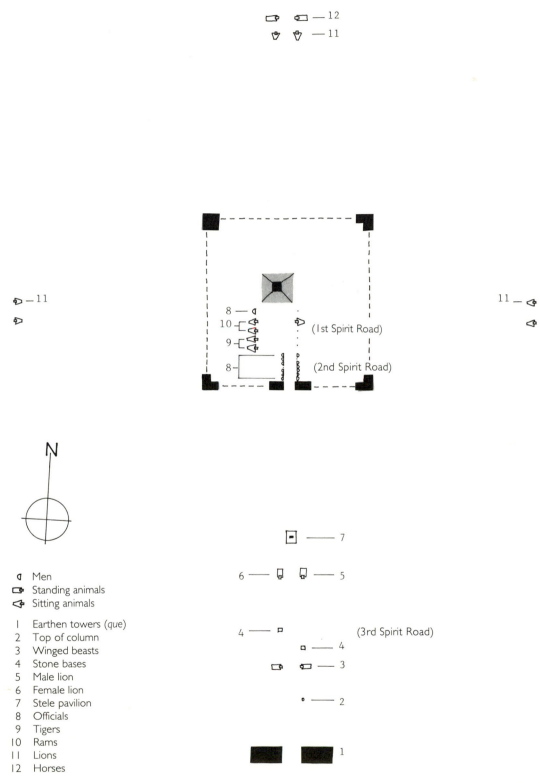

Men

Standing animals

Sitting animals

1 Earthen towers (*que*)
2 Top of column
3 Winged beasts
4 Stone bases
5 Male lion
6 Female lion
7 Stele pavilion
8 Officials
9 Tigers
10 Rams
11 Lions
12 Horses

CHART 6. Tang Gongling. Based on chart in *Kaogu Yu Wenwu* 1986/ 3, 33.

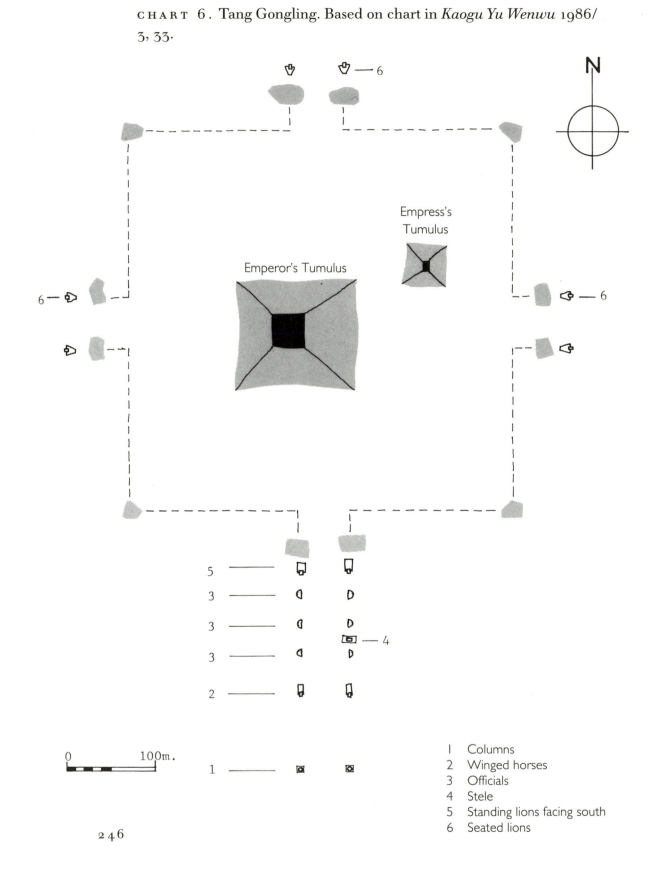

N

6

Empress's
Tumulus

Emperor's Tumulus

6 — 6

6 —

5 —

3 —

3 —

— 4

3 —

2 —

0 100m.

1 —

1 Columns
2 Winged horses
3 Officials
4 Stele
5 Standing lions facing south
6 Seated lions

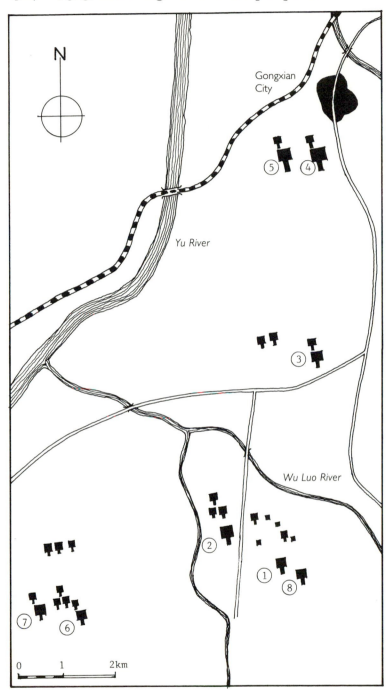

1 Yong Changling, tomb of Taizu (960–976)
2 Yong Xiling, tomb of Taizong (976–997)
3 Yong Dingling, tomb of Zhenzong (998–1022)
4 Yong Zhaoling, tomb of Renzong (1023–63)
5 Yong Houling, tomb of Yingzong (1064–67)
6 Yong Yuling, tomb of Shenzong (1068–85)
7 Yong Tailing, tomb of Zhezong (1085–1100)
8 Yong Anling, tomb of Taizu's father

CHART 8. Song Yong Dingling (not to scale). Based on chart of Yong Dingling in Guo Husheng et al., "An Investigation into the Song Tombs at Gongxian, Henan," *Kaogu* 1964/11, 568.

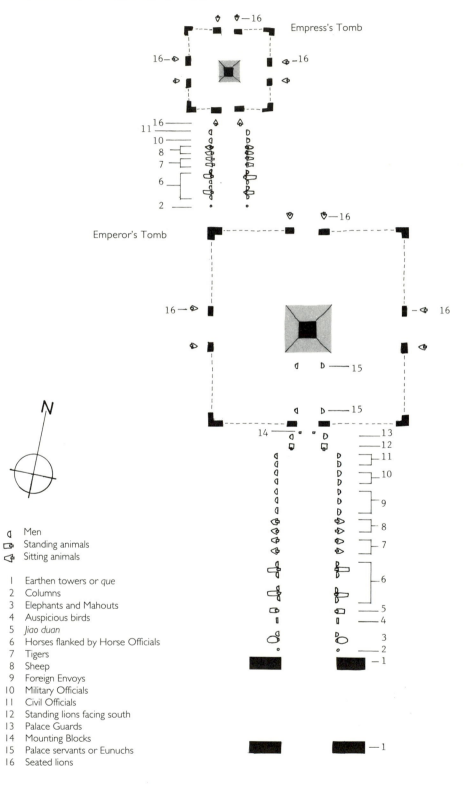

Empress's Tomb

Emperor's Tomb

N

◁ Men
☐⯈ Standing animals
◁⯇ Sitting animals

1 Earthen towers or *que*
2 Columns
3 Elephants and Mahouts
4 Auspicious birds
5 *Jiao duan*
6 Horses flanked by Horse Officials
7 Tigers
8 Sheep
9 Foreign Envoys
10 Military Officials
11 Civil Officials
12 Standing lions facing south
13 Palace Guards
14 Mounting Blocks
15 Palace servants or Eunuchs
16 Seated lions

CHART 9. Ming Huangling (not to scale).

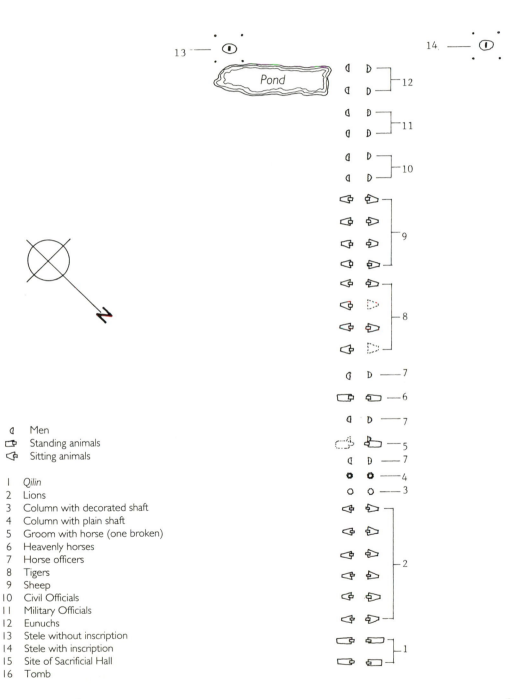

— 16

— 15

13 — ⊙ 14 — ⊙

Pond ⫶ ⫶ ── 12

⫶ ⫶ ── 11

⫶ ⫶ ── 10

── 9

── 8

── 7

── 6

── 7

── 5

── 7

── 4

── 3

── 2

── 1

⫶ Men
⊐ Standing animals
⊲ Sitting animals

1 Qilin
2 Lions
3 Column with decorated shaft
4 Column with plain shaft
5 Groom with horse (one broken)
6 Heavenly horses
7 Horse officers
8 Tigers
9 Sheep
10 Civil Officials
11 Military Officials
12 Eunuchs
13 Stele without inscription
14 Stele with inscription
15 Site of Sacrificial Hall
16 Tomb

CHART 10. Ming Zuling (not to scale).

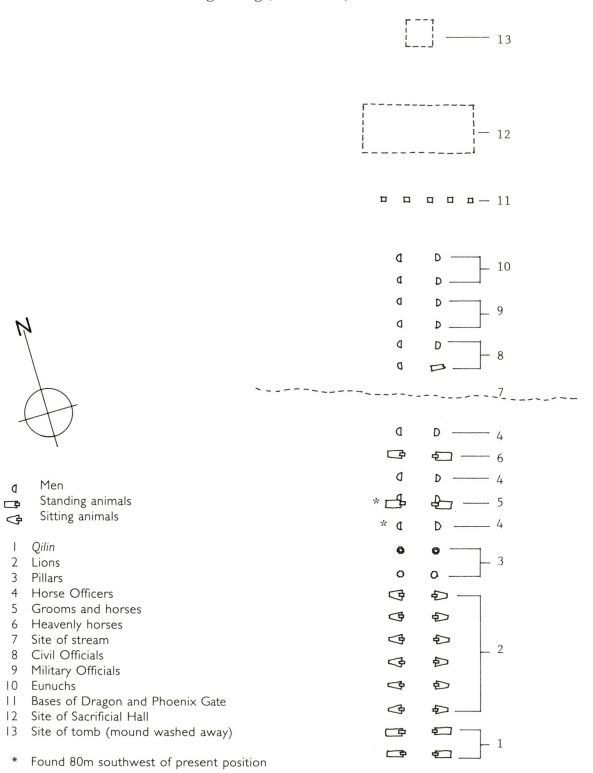

Men
Standing animals
Sitting animals

1 Qilin
2 Lions
3 Pillars
4 Horse Officers
5 Grooms and horses
6 Heavenly horses
7 Site of stream
8 Civil Officials
9 Military Officials
10 Eunuchs
11 Bases of Dragon and Phoenix Gate
12 Site of Sacrificial Hall
13 Site of tomb (mound washed away)

* Found 80m southwest of present position

CHART 11. Ming Xiaoling, Nanjing.

To Xiaoling

N

0 100 200m

1 Archway with order to dismount
2 Great Red Gate
3 Stele Pavilion
4 Lions
5 *Xiezhai*
6 Camels 1st pair sitting
7 Elephants 2nd pair standing
8 *Qilin*
9 Horses
10 Beacons
11 Military Officials
12 Civilian Officials
13 Site of Dragon and Phoenix Gate

Modern Road

2km

CHART 12. Valley of Ming Thirteen Tombs, Beijing. Taken from *Kaogu* 1986/6, 515.

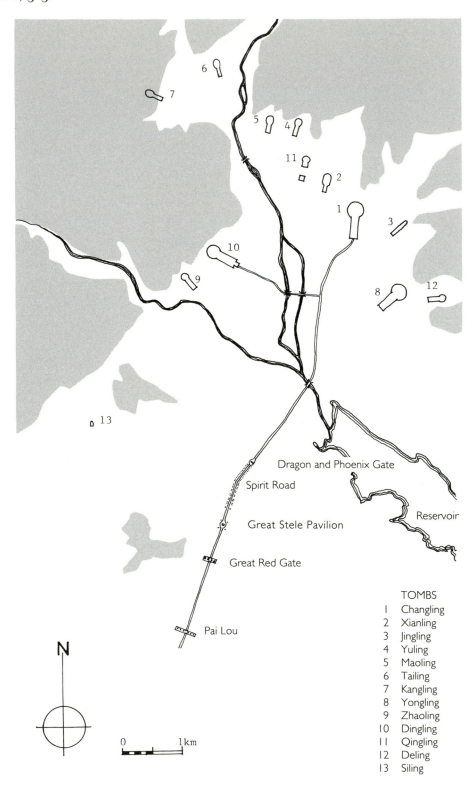

Dragon and Phoenix Gate

Spirit Road

Reservoir

Great Stele Pavilion

Great Red Gate

Pai Lou

N

0 1km

TOMBS
1 Changling
2 Xianling
3 Jingling
4 Yuling
5 Maoling
6 Tailing
7 Kangling
8 Yongling
9 Zhaoling
10 Dingling
11 Qingling
12 Deling
13 Siling

CHART 13. Ming Thirteen Tombs, Beijing.

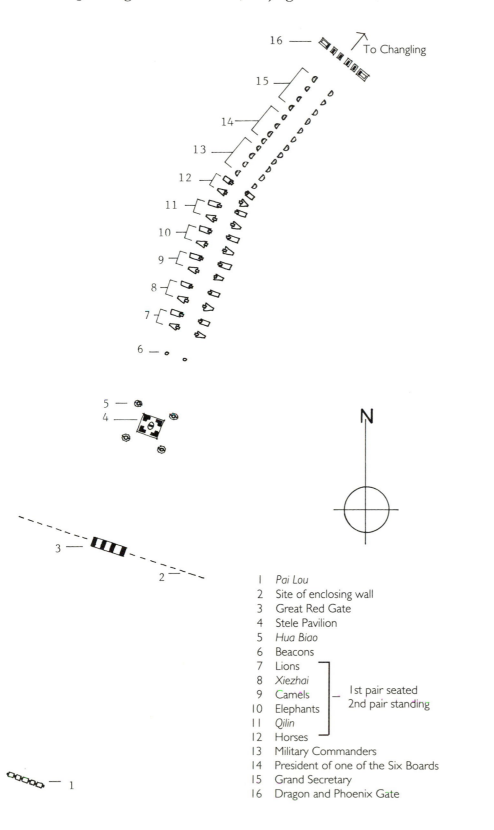

16 — To Changling

15

14

13

12

11

10

9

8

7

6

5

4

3

2

1 Pai Lou
2 Site of enclosing wall
3 Great Red Gate
4 Stele Pavilion
5 Hua Biao
6 Beacons
7 Lions
8 Xiezhai
9 Camels — 1st pair seated
10 Elephants 2nd pair standing
11 Qilin
12 Horses
13 Military Commanders
14 President of one of the Six Boards
15 Grand Secretary
16 Dragon and Phoenix Gate

N

CHART 14. Qing Northern Tombs (not to scale).

Fuling. Tomb of Tianming (1559–1626) Zhaoling. Tomb of Tianzhong (1592–1643)

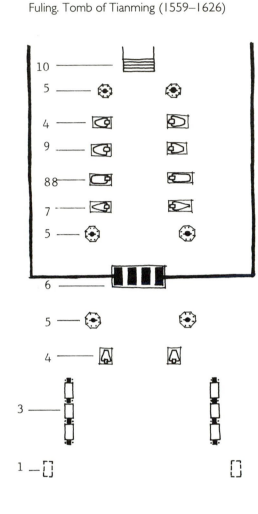

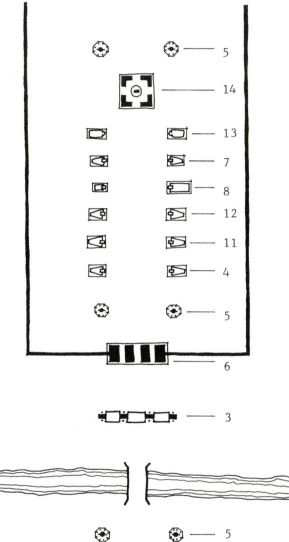

⌐⊐ Standing animals
⌐⊐ Sitting animals
 1 Site of Dismount Tablets
 2 Dismount Tablets
 3 *Pai Lou*
 4 Lions
 5 *Hua Biao*
 6 Great Red Gate
 7 Camels
 8 Horses
 9 Tigers
10 Steps leading to Stele Pavilion
11 *Qilin*
12 *Suanni*
13 Elephants
14 Stele Pavilion

CHART 15. Qing Eastern Tombs.

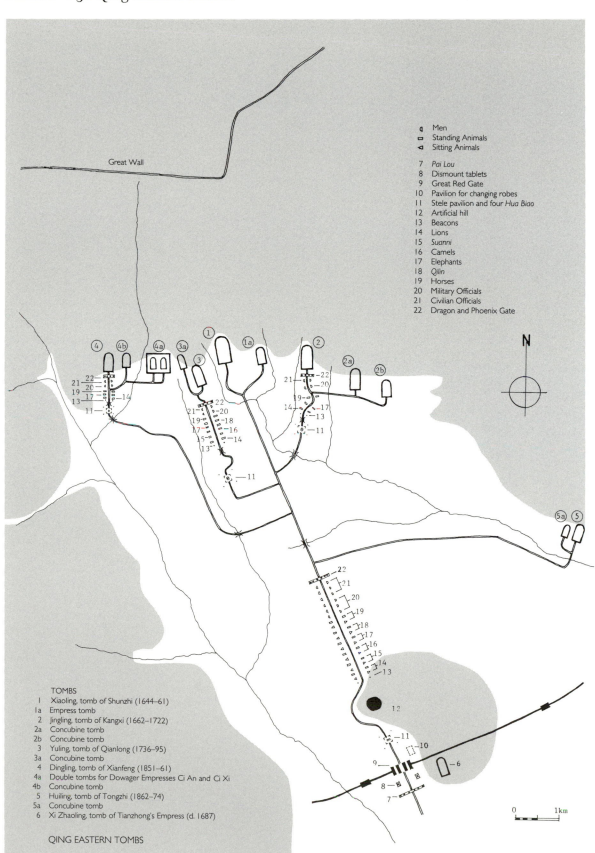

Men
Standing Animals
Sitting Animals

7 *Pai Lou*
8 Dismount tablets
9 Great Red Gate
10 Pavilion for changing robes
11 Stele pavilion and four *Hua Biao*
12 Artificial hill
13 Beacons
14 Lions
15 *Suanni*
16 Camels
17 Elephants
18 *Qilin*
19 Horses
20 Military Officials
21 Civilian Officials
22 Dragon and Phoenix Gate

Great Wall

TOMBS
1 Xiaoling, tomb of Shunzhi (1644–61)
1a Empress tomb
2 Jingling, tomb of Kangxi (1662–1722)
2a Concubine tomb
2b Concubine tomb
3 Yuling, tomb of Qianlong (1736–95)
3a Concubine tomb
4 Dingling, tomb of Xianfeng (1851–61)
4a Double tombs for Dowager Empresses Ci An and Ci Xi
4b Concubine tomb
5 Huiling, tomb of Tongzhi (1862–74)
5a Concubine tomb
6 Xi Zhaoling, tomb of Tianzhong's Empress (d. 1687)

QING EASTERN TOMBS

0 1km

CHART 16. Qing Western Tombs (not to scale).

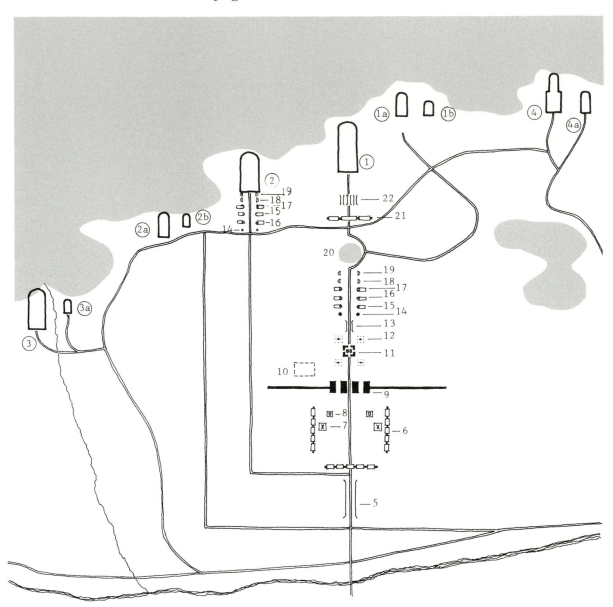

TOMBS

1	Tailing, tomb of Yongzheng (1723–35)
1a	Empress tomb
1b	Concubine tomb
2	Changling, Tomb of Jiaqing (1796–1820)
2a	Empress tomb
2b	Concubine tomb
3	Muling, tomb of Daoguang (1821–50)
3a	Empress tomb
4	Chongling, tomb of Guangxu (1875–1908)
4a	Concubine tomb

5	Seven-arched bridge
6	*Pai Lou*
7	Dismount tablets
8	*Qilin* on pedestals
9	Great Red Gate
10	Hall for changing robes
11	Stele pavilion
12	*Hua Biao*
13	Five-arched bridge
14	Beacons

15	Lions
16	Elephants
17	Horses
18	Military Officials
19	Civilian Officials
20	Artificial hill
21	Dragon and Phoenix Gate
22	Triple bridge

NOTES

Introduction

1. Edouard Chavannes, *La Sculpture sur pierre en Chine* (Paris: Leroux, 1893); *Mission archéologique dans la Chine septentrionale* (Paris: Leroux: 1909–15), two volumes of text, two of photographs divided by subject matter into non-Buddhist and Buddhist statuary. The results of the Segalen, de Voisins, and Lartigue expedition in 1914 were published after Segalen's death by Jean Lartigue in two volumes of photographs under the title *Mission archéologique en Chine (1914)* and one volume of text, *L'Art funéraire a l'époque des Han* (Paris: Geunther, 1923–35). *Chine: La Grande Statuaire* (Paris: Flammarion, 1972)—a study of the post-Buddhist development of the classical tradition of sculpture—was published by his daughter, Mme Joly-Segalen. A third great Western field-worker, Osvald Siren, concentrated on Buddhist statuary; he drew on his predecessors for some of his illustrations of non-Buddhist sites and included photographs of sculpture in museums outside China. He published many works, of which the most relevant here are *Chinese Sculpture from the Fifth to the Fourteenth Centuries*, 4 vols. (London: Benn, 1925) and "Chinese Sculpture of the Sung, Liao and Chin Dynasties," *Bulletin of the Museum of Far Eastern Antiquities* 14 (1942), 45–64. The great Japanese experts on Chinese sculpture, D. Tokiwa and I. Seikino, concentrated almost exclusively on Buddhist statuary.

2. Yang Kuan, *Zhongguo gudai lingqin zhidu shi yanjiu* (Research into the ancient mausoleum system of China) (Shanghai: Shanghai Classical Books Publishing House, 1985).

1. The Role of Sculpture and Sculptors in China

1. *Ying zao fa shi* gives six steps in the construction of stonework and four styles of engraving. Li Jie, *Ying zao fa shi*, 4 vols. (Shanghai: Commercial Press, 1953), vol. 1, 57.

2. Information given by Prof. Fu Tianchou on 3 April 1981; Prof. Jin Weinuo, 28 March 1983; and Prof. Tang Chi and Liu Xingzhen, 23 April 1986, all of the Central Institute of Fine Arts, Beijing; and by Prof. Yuan Xiaocun, president of the Yunnan Fine Arts Committee, 20 March 1986. These principles evolved by the sixth-century art critic Xie He still provide valid standards by which Chinese painting is judged. An analysis of the Six Principles is given in Michael Sullivan, *A Short History of Chinese Art* (London: Faber and Faber, 1967), 121–23.

3. I am grateful to Dr. Lawrence Sickman for drawing attention to one of the more subtle examples of this question of perspective. The Northern Wei frieze *Empress as Donor with Attendants* from the Pingyang Cave, Longmen, Henan (A.D. 523), now in the Kansas City Nelson-Atkins Museum of Art, shows a procession of figures approaching from the right. This would have been placed on one side of an entrance with a corresponding frieze on the left. The noses of all the figures have been tilted upwards and outwards to create a realistic impression on the viewer passing through the doorway on their left. The pleated robes have been given similar treatment.

4. Lu Xun describes the assimilation process in literature: Buddhist stories were first borrowed, then adapted to Chinese circumstances, and finally assimilated,

becoming fully Chinese. Lu Xun, *Brief History of Chinese Fiction* (Beijing: Foreign Languages Press, 1959), 59.

5. Wu Hung, "A Sanpan Shan Chariot Ornament and the *Xiangrui* Design in Western Han Art," *Archives of Asian Art* 37 (1984), 54.

6. There was a distinction between animals shown per se and those in Tang and post-Tang spirit roads which belonged to the human world, such as horses and elephants wearing ceremonial trappings and accompanied by grooms and mahouts. The latter, chosen for their role in a symbolic man-arranged ceremonial occasion, partake of the conventions governing human statuary.

7. Statuary on the tomb of the popular Song general Yue Fei (1103–1142) at Hangzhou, Zhejiang, includes statues of the four accomplices held responsible for his downfall. The four, placed just in front of the tomb, are kneeling with hands bound behind them and are cast in iron; officials on the spirit road leading to the tomb are carved in the customary stone.

8. Dr. Alexander Soper, in his analysis of Chinese references to the arts excluding painting, finds little mention of sculpture. In one place, however, there is a revealing remark: "His face is like a stone engraving." This was said in admiration, implying that the speaker had a clear idea of what a stone portrait of a man should be like and what it represented. In the West such a comment would be an objective observation; in China it was positive praise. A. Soper, "Textual Evidence for the Secular Arts of China in the Period from Liu Song through Sui (A.D. 240–618), Excluding Treatises on Painting," *Artibus Asiae*, supplement 24 (1967), 28.

9. *China Reconstructs* 1985/8, 62.

10. *Oriental Art*, Winter 1986–87, 427.

11. Typical examples are the fourth-century sculptor Dai Kui and his sons Dai Bo and Dai Yong; their reputation as sculptors was clearly linked to general abilities and high reputation at court. Dai Kui was a perfect Renaissance figure. Before turning to sculpture, he had an established position at court as a painter. Apart from his artistic skills he was known as a scholar, a composer of belles lettres, and a brilliant conversationalist. (Information given in a letter by Prof. Fu Tianchou, 3 April 1981.) A detailed study of named sculptors is given in Paul Pelliot, "Notes sur quelques artistes des Six Dynasties et des T'ang," *T'oung Pao* 22 (1923), 215–91. See also Jin Weinuo, "Wo guo gudai jiechude diaosujia Dai Kui he Dai Yong" (Dai Kui and Dai Yong: Outstanding sculptors in ancient China) and "Sui Tang shidai de diaosujia" (Sculptors of the Sui and Tang periods) in *Zhongguo meishu shi lun ji* (A collection of essays on the history of Chinese art) (Beijing: Peoples' Fine Arts Publishing House, 1981), 83–89, 113–16.

12. Names have been found on statues in the Dazu complex, Sichuan and the Longmen caves, Luoyang. The names of both the donors and sculptors are given in a stone inscription in the Eastern Han Wu family shrines in Shandong: "The filial sons Wu Shigong and his younger brothers Suizong, Jingxing and Kaiming, erected these pillars, made by the sculptor Li Dimao, styled Mengfu, at a cost of 150,000 pieces of money. Sunzong made the lions which cost 40,000 cash." C. P. FitzGerald, *China: A Short Cultural History* (London: Cresset, 1935; paperback reprint, 1965), 233. The tradition of anonymity persists among peasant sculptors in Shaanxi, who still reject the idea of carving their name on a figure, particularly one destined for a temple.

13. Modern sculptors in North Shaanxi carve small stone figures directly onto the stone block without any previous drawing or model. Reliefs on memorial archways are carved in a similarly direct fashion, and drawings are only used for exceptionally complicated designs.

14. A more recent example of the difficulties encountered in transporting blocks of stone was given by Mr. Rennie, staff surgeon to the British Legation in the 1860s, who wrote of

a large block of white marble, weighing sixty tons, which was at that time in course of passing through Peking on a large six-wheeled truck, drawn by six

hundred horses and mules. This mass of marble came from one of the quarries about sixty miles from Peking, and it was on its way to the Eastern Tombs, there to be cut into an elephant to form one of the decorations of the mausoleum of the late Hien Feng. Its dimensions were fifteen feet long, twelve feet thick and twelve feet broad. The horses and mules were harnessed to two immense hawsers, running parallel with one another from the truck; the length of each of them being nearly a quarter of a mile. On the block was hoisted the imperial flag, and on the truck a mandarin and some attendants were seated. One of the latter had a gong, which he sounded after each halt, when all was ready to start. Other gongs were then sounded along the line, and at a given signal the carters simultaneously cracked their whips, and off started the horses with their unwieldy load. (D. F. Rennie, *Peking and the Pekingese* [London: John Murray, 1865], 256–57)

15. This process can be seen clearly at Dazu, Sichuan, where work was interrupted by the Mongol invasion in 1271. The last section of the cliff carvings was left unfinished and shows the different stages of work: the upper sections are completed and polished; beneath this is a layer of semifinished carving; on the lower levels the stone is either in the process of being smoothed or carries a rough chiselled outline.

2. Western Han and the Emergence of Stone Tomb Statuary

1. Oral communication by Prof. Tong Enzheng, Sichuan University Museum, Chengdu, 16 March 1983.

2. Oral communication by Dong Jixian, Director of History, Chongjing Museum, Sichuan, 8 March 1983.

3. See K. C. Chang, *Shang Civilization* (New Haven: Yale University Press, 1980), 88, 115.

4. *Ci Hai*, 3 vols. (Shanghai: Shanghai Dictionary Publishing House, 1979), 676.

5. See chapter 3. Another recorded example of Qin use of stone statuary occurred during the reign of Qin Hui Wang. The Qin, wishing to capture a difficult mountain pass into the western Sichuan kingdom of Shu, placed five stone oxen on their side of the pass and behind them laid droppings of gold. The Shu were intrigued and accepted the oxen as gifts. In order to transport the oxen back to their capital, they had to cut a way down the mountain, which the Qin then used to invade and conquer their opponents. Liu Lin, ed., *Hua yang guozhi jiao zhu* (Chengdu: Ba Shu Shushe, 1948), 188; Wang Guowei, ed., *Shui jing zhu jiao Mian shui (shang)* (Shanghai, 1984), 881.

6. Wu Hung, "A Sanpan Shan Chariot Ornament," *Archives of Asian Art* 37 (1984), 45.

7. L. Ledderose, "The Earthly Paradise: Religious Elements in Chinese Landscape Art," in S. Bush and C. Murck, eds., *Theories of the Arts of China* (Princeton: Princeton University Press, 1983), 165–87.

8. According to the legend, the Queen of the Skies employed beautiful maidens to spin clouds for her; one escaped to earth where she fell in love with and married a poor cowherd. When the revengeful queen carried the girl back into the skies, the cowherd followed and had nearly caught his beloved when he felt his way blocked by an invisible wall—the Milky Way. The two lovers were transformed into stars on either side of this barrier, but once a year, on the seventh day of the seventh month, all the magpies in the world formed a bridge enabling the two to meet.

9. Wang Zhongshu, *Han Civilization* (New Haven: Yale University Press, 1982), 9.

10. Wang Zhongshu, *Han Civilization*, 6; Hei Guang: "Xian Han Taiyechi chutu yijian juxing shi yu" (A gigantic stone fish unearthed near Han dynasty Lake Taiye in Xi'an), *Wenwu* 1975/6, 91–92.

11. There are many descriptions of this tomb, of which the more important in English and French are: Victor Segalen,

Chine: La Grande Statuaire, 28–38, and "Feuilles de route, II," *Le Nouveau Commerce*, cahier 44 (1979), 63–67; Jean Lartigue, *L'Art funéraire*, 33–43, and "Au Tombeau de Huo K'iu-Ping," *Artibus Asiae* 1927/2, 85–94; Carl W. Bishop, "Notes on the Tomb of Huo Ch'u-ping," *Artibus Asiae* 1928/1, 34–46; Teng Ku, "A Few Notes on the Forms of Some Han Sculptures," *T'ien Hsia Monthly* (Shanghai) 1/5 (1935), 512–14; Wang Chongren, "Stone Sculptures of the Han and Tang Tombs," in *Recent Discoveries in Chinese Archeology*, trans. Zuo Boyang (Beijing: Foreign Languages Press, 1984), 27. In Chinese: Fu Tianchou, "Shaanxi Xingping xian Huo Qubing mu qiande Xi Han shidiao yishu" (The sculptural art of the Western Han stone sculptures at Huo Qubing's tomb, Xingping County, Shaanxi Province), *Wenwu* 1964/1, 40–44; Ma Ziyun, "Xi Han Huo Qubing mu shike ji" (Notes on the stone sculptures at the Western Han tomb of Huo Qubing), *Wenwu* 1964/1, 45–46; Xu Senyu, "Xi Han shike wenzi chutan" (A preliminary survey of Western Han stone inscriptions), *Wenwu* 1964/5, 2–3.

12. The characters on one block—*zuo si kong*—indicate that the carving was made by craftsmen from the official Works Department; the other, tailored on two sides, has ten characters noting that the carvers were Su Boya and Huo Jumeng from Lelong, Pingyuan. (Pingyuan in Shandong is known for its carvers.)

13. The importance of concentrating on the essence of the subject rather than its outward appearance is a recurrent theme among Chinese critics of painting and the subject of one of the Six Principles. For a reproduction of Liang Kai's portrait of Li Po, see Lawrence Sickman and Alexander Soper, *The Art and Architecture of China* (1956; Harmondsworth, Middlesex: Penguin Books, 1971), 264–65.

14. Prof. K. C. Chang suggests that in these statues and that of the horse and barbarian, the close physical contact between the two figures and, in particular, the proximity of their mouths symbolized communication with the spirit world. K. C.

Chang, *Art, Myth and Ritual* (Cambridge: Harvard University Press, 1983), 56–80.

15. In 1914 peasants showed Segalen the head of a horse, half-buried, in a corresponding position on the north side of the tumulus. This suggests that there may have been an official approach from both north and south. Lartigue was unable to find this head in 1923. Lartigue, *L'Art funéraire*, 42.

16. "Anyi xian Ducun chutude Xi Han shi hu" (A stone tiger excavated at Du village, Anyi County), *Wenwu* 1961/12, 48.

3. Eastern Han and the Establishment of the Spirit Road

1. Yang Kuan, *Zhongguo gudai lingqin*, 8–10.

2. Ibid., 210.

3. The inscription on one of the Wu family tombs in Shandong gives the relative cost of the stone *que* and stone lions as 150,000 to 40,000 pieces of money. Another text mentions that the price of a pair of *que* was ten times that of a stele, which cost 20,000 cash. Lartigue, *L'Art funéraire*, 189. Price comparisons are notoriously difficult at such a distance in time, but in rough equivalents it would have cost a contemporary high-ranking officer in northwest China his entire salary for four years to pay for a pair of *que*. For the same price he could have bought fifteen dwellings, forty farm horses, fifty yoke oxen, or eight adult female slaves. Michael Loewe, *Imperial China* (London: Allen and Unwin, 1966), 197.

4. "They are the most important sources for the history of Chinese sculpture yet to be studied." (Lartigue, *L'Art funéraire*, 47). See also Chen Mingda, "Han daide shi que" (Stone monumental towers of the Han dynasty), *Wenwu* 1961/12, 9–23; an analysis of the structure of *que* is given in the same author's article "Zhongguo fengjian shehui mu jiegou jianzhu jishude fazhan" (The technical development of wood framed buildings in Feudal China), in *Jianzhu lilun ji lishi yanjiu shibian*,

part 1 (Beijing: Chinese Architectural Science Research Institute, 1982), 56–95; Lu Pin, "Dengfeng Handai san que" (Three Han dynasty monumental towers at Dengfeng), *Wenwu* 1979/8, 90–92; Liu Xinjian and Zhang Wuxue, "Shandong Junan faxian Handai shi que" (Han dynasty stone monumental tower discovered at Junan, Shandong), *Wenwu* 1965/5, 16–19. The basic Western texts are Chavannes, *Mission archéologique*, vol. 1, part 1, on the Henan and Shandong *que*; Segalen, *La Grande Statuaire*, 59–85, and Lartigue, *L'Art funéraire*, 45–128, on the Sichuan *que*; Wilma Fairbanks, "The Offering Shrines of Wu Liang Tz'u" and "A Structural Key to Han Mural Art," in *Adventures in Retrieval*, Harvard-Yenching Institute Studies no. 28 (Cambridge, 1972), 41–86 and 87–140; and Wu Hung, *The Wu Liang Shrine* (Stanford: Stanford University Press, 1989), on the Wu family shrines, Shandong; Martin Powers, "An Archaic Bas-Relief and the Chinese Moral Cosmos in the First Century A.D.," *Ars Orientalis* 12 (1981), 25–40, on the Nanwuyang *que*, Shandong.

5. These were known as the "2,000 *da*"—those whose salary equalled or exceeded 2,000 *da* or 50 kg of grain.

6. The original meaning of *que* is said to be a character with a similar sound which means "to lack something, a gap"; *que* were thus built in pairs to frame an opening—an entrance. The character *que* was sometimes used for certain halls such as an entrance hall (Lartigue, *L'Art funéraire*, 190). It was also used to denote the pairs of stone pillars set at the four cardinal points round the altar during the great *Feng* ceremonies held by Han Wudi at Taishan, Shandong. Edouard Chavannes, *Le T'ai-chan* (Paris: Leroux, 1910), 179.

7. Chen Mingda, "Han daide shi que," 22.

8. For rubbings of *que* on stone coffins see Lucy Lim, ed., *Stories from China's Past* (San Francisco: Chinese Culture Foundation, 1987), 106–07, 156.

9. Comparing these constructions with rubbings of wooden *que* on Han tomb bricks, Chen Mingda has reconstructed the

building techniques of Han and pre-Han earthen and wooden towers and suggests that the two styles of ceremonial architecture known by the Song as *dian ge* and *ting tang* and by the Qing as *da mu shi* and *da mu xiao shi* were already developed under the Han. One of these is exemplified by the *que* construction, the other in the very different construction shown in the majority of Han tomb pottery figurines of dwellings. Chen Mingda, "Han daide shi que," 22, and "Zhongguo fengjian shehui," 84.

10. Lu Pin, "Dengfeng Handai san que," 90.

11. Chen Mingda, "Han daide shi que," 17.

12. Jean-Pierre Diény, *Annuaire, Ecole Practique des Hautes Etudes*, section 4 (1977–78), 1,149–53.

13. Some inscriptions refer to the *mu dao* (tomb road), an expression more commonly used for the tunnel-passage leading from the south to the underground tomb chamber. One inscription speaks of the "stone tomb *que*" but in others "*que*" stands alone, indicating that it was not necessary to specify further.

14. Martin Powers, "The Shapes of Power in Han Pictorial Art," Ph.D. thesis (University of Chicago, 1978), 95.

15. Such a figure can be seen on Eastern Han stone coffins in Chongjing Museum, Sichuan, and on the Eastern Han Wang Hui coffin, Lushan, Sichuan. See also Lim, *Stories from China's Past*, 128. The theme reappears on stone coffins of later dynasties.

16. Information given by Dr. Edward Schafer in letters dated 9 April and 16 May 1985.

17. These earthen *que* were made of rammed earth with brick facing. Remnants of these facings can be seen on the two sets of *que* marking the entrances to the middle and inner enclosures at Tang Qianling, Qian County, Shaanxi.

18. Powers, *The Shapes of Power*, 11–13.

19. This list, given by Wang Zhongshu, director of the Institute of Archaeology, Beijing, is largely based on information given by Li Daoyuan of the late North-

ern Wei (c. A.D. 500) in the *Shui jing zhu* (The waterways classic). This is an annotated and greatly expanded version of the *Shui jing*, written in the Three Kingdoms period (third century). The author of the latter was a geographer who travelled extensively, making a detailed record of all he saw. Most of his observations concern geographical features but he also mentions cities, large buildings, and tombs, and much of our knowledge about Han dynasty spirit roads is derived from his work.

20. Florance Waterbury, *Early Chinese Symbols and Literature* (New York: Weye, 1942), 103.

21. The king of Yuezhi sent lions as tribute in A.D. 87 when he asked for the hand of a Chinese princess; in 101 the Parthians sent a lion or lions; in 133 a lion was sent from Sule (Kashgar). Berthold Laufer, *Chinese Pottery of the Han Dynasty* (Leiden: E. J. Brill, 1909), 236–39. In one Eastern Han story, a lion brought by Westerners was tethered to a tree by the posting house on the western road into the capital, Changan. When the restless lion began to roar, it called forth a dragon from a nearby well. Here the lion clearly replaces the tiger as a counterpart to the dragon. Edward Schafer, *Golden Peaches of Samarkand* (Berkeley: University of California Press, 1963), 84–85.

22. A pair of beasts from the tomb of Zong Zi (died c. A.D. 167), now in the museum at Nanyang, have the characters *tian lu* and *bixie* carved on their shoulders.

23. The situation was complicated by the occasional use of a different but homonymous character for *lu* which gave the meaning "heavenly blessings" or "good fortune from heaven." Another meaning for this character is "imperial salary derived from an official position." (To hold high office was almost synonymous with good fortune.)

24. John Goodall, *Heaven and Earth* (London: Lund Humphries, 1979), 58.

25. *Hou Han shu: Yu fu zhi* (Books of the Later Han dynasty: Memoir on vehicles and dress), 3,676–77.

26. A seated tiger photographed by Segalen in Quxian in 1914 can no longer be found. Segalen, *La Grande Statuaire*, fig. 5.

27. Yang Kuan, *Zhongguo gudai lingqin*, 211.

28. Wang Wencai, "Dong Han Li Bing shixiang yu Dujiang Yan 'shuize'" (The Eastern Han stone statue of Li Bing at Dujiang Weir as a "water gauge"), *Wenwu* 1974/7, 29–32; Sichuan Province Guanxian Cultural Bureau, "Dujiang Yan chutu Dong Han Li Bing shixiang" (The excavation of the Eastern Han stone statue of Li Bing at Dujiang Weir), *Wenwu* 1974/7, 27–28; Sichuan Museum, "Dujiang Yan you chutu yi qu Handai shixiang" (Another Han dynasty stone statue excavated at Dujiang Weir), *Wenwu* 1975/8, 89–90.

29. The inscription is still legible. On the right and left sleeves are: "On the twenty-fifth day of the intercalary month of the third moon, the first year of the Qian Ning period in the reign of the Ling Di emperor of the Eastern Han dynasty, Zhen Yi and his assistant Yin Long built the statues of three gods to perpetually guard and preserve the waters." On the front of the statue is inscribed: "The late prefect of Shu, Li Bing."

30. The rhinoceros, like the water buffalo and ox, was associated with water spirits and statues of these beasts were often placed on the banks of lakes and rivers to prevent floods. The inscription on the graceful bronze ox on the banks of the lake at the Summer Palace, Beijing (from 1755), recalls how the legendary Yu regulated the courses of rivers and overcame serious floods.

31. Yang Kuan, *Zhongguo gudai lingqin*, 155.

32. "The dragon begat nine sons. . . . *Ba xia* throughout his life enjoyed carrying heavy objects, and the bases of stone stelae of today are handed down in his image." Xu Yingqiu, *Yu yi tang tanhui* (Gathering of talents at the Hall of the Jade Arts), citing Li Dongyang, *Huai lu tang ti*.

4. The Period of Disunion

1. *San guo zhi: Wei zhi*, chap. 1, 53, and chap. 2, 81 (Shanghai: Zhonghua Shu Ju, 1962).

2. Jan Jakob Maria de Groot, *The Religious System of China* (Leiden, 1892–1910; reprint, Taipeh: Ch'eng-wen Publishing Co., 1967), vol. 2, 813.

3. Oral communication by Wang Zhong-shu, director of the Institute of Archaeology, Beijing, 29 March 1983.

4. "Each year the green of spring covers the *qilin*"—the Tang poet Li Shangyin, writing about the tomb of the Eastern Jin emperor Yuan.

5. Chun-shu Chang and Joan Smythe: *South China in the Twelfth Century: A Translation of Lu Yu's Travel Diaries, July 3–December 6, 1170* (Hong Kong: Chinese University Press, 1981), 86.

6. Records have been found of seventy-four imperial and royal tombs; thirty-three sites with surface remains have been located, twenty-five closely corresponding to literary records and nineteen positively identified. The great work of identification was begun by Dr. Zhi Xizu and his son Zhu Xie in the 1930s; since 1949 further progress has been made and much statuary has been painstakingly repaired and reerected in situ.

7. Luo Zongzhen, "Liu Chao lingmu jiju shike" (The tombs of the Six Dynasties and their stone sculptures), *Nanjing Museum Publications*, March 1979, 91.

8. Herbert A. Giles, *A Chinese Biographical Dictionary* (London: Quaritch, 1898), 821–22.

9. For a more detailed analysis of the layout of Southern Dynasties tombs, see Luo Zongzhen, "Liu Chao lingmu jiju shike," 79–98; Xu Pingfang, "Zhongguo Qin Han Wei Jin Nan Bei Chao shidai de lingyuan he yingchang" (The tomb enclosure and grave city in the Qin, Han, Wei, Jin, and Northern and Southern Dynasties of China), *Kaogu* 1981/6, 521–30.

10. Luo Zongzhen, "Liu Chao lingmu jiju shike," 81.

11. Long, carefully constructed drains lead underground from the tombs to the plain. Luo Zongzhen, "Liu Chao lingmu jiju shike," 90–91.

12. Although the only columns and memorial stelae to have survived are on Liang tombs, it is clear that this complement obtained for all the later four Southern Dynasties. The Song traveller Lu Yu described the tomb of Song Wendi (424–453) in 1170: "The road seemed very wide. There were stone pillars, bowls for receiving dew, and (stone statues of such fabulous animals as) unicorns (*qilin*) and 'two-horn' lions (*pi-hsieh*). On a pillar were cut the eight characters 'Avenue leading to the tomb of the great ancestor, Emperor Wen'." Chang and Smythe, *South China in the Twelfth Century*, 47.

13. Imperial beasts could be further divided into *qilin*, with one horn, on the left seen from the tomb, and *tianlu*, with two horns, on the right. The former were always male; the latter were sometimes but by no means always female. The distinction between beasts with horns and those without was important. Two very young Qi emperors were deposed and then killed by their uncle, who usurped the throne in A.D. 494. Their graves were marked by small winged lions without horns because the new emperor, Qi Mingdi, did not consider them to have been real emperors.

14. A. Salmony, "Antler and Tongue," *Artibus Asiae*, supplement 13 (1954), 37, 42; Carl Hentze, *Die Sakalbronzen und ihre Bedeutung in den Frühchinesischen Kulturen* (Antwerp: De Sikkel Nijhoff, 1941), 53, figs. 1–6. Small Han stone figures with outstretched tongues can be seen in Lushan Cultural House, Ya-an, Sichuan. Amongst elderly Tibetans and Greenlanders, it is still considered a sign of politeness to stick out your tongue.

15. Sickman and Soper, *The Art and Architecture of China*, 62.

16. Jiangsu Province Cultural Relics Management Committee, *Jiangsu Xuzhou Han huaxiang shi* (Beijing: Scientific Publications, 1959), pl. 23.

17. Cheng Te-k'un, "Ch'in-Han Archeological Remains," *Journal of the Institute of Chinese Studies of the Chinese University of Hong Kong* 9/2 (1978), 577, and

Beijing City Cultural Working Team, "Bei-jing xijiao faxian Handai shi que qingli jianbao" (A brief clarification of questions about a Han dynasty monumental tower found in the western suburbs of Beijing), *Wenwu* 1964/11, 13–24.

18. In the Liang royal tombs, the size of the characters on the column varied according to the degree of affinity with the dynastic founder's father, Liang Wendi. His characters are 22 cm high; those of his sons, Xiao Hong and Xiao Jing, are 10 cm high whilst those of his grandson, Xiao Ji, are only 6 cm high and look curiously lost on the otherwise blank tablet.

19. Oral communication by Luo Zong-zhen, 26 March 1981.

20. The Fan Min stele is 1.16 m high; that of Xiao Xiu, 2.85 m high.

21. This only applies to surface decoration; inside the tomb, figurines and other small objects continued to reflect the former daily life of the deceased.

22. In 454, the Northern Wei emperor commissioned for a principal temple five standing images of Sakyamuni "on behalf of the five emperors from Tai Tsu on" (i.e., the founder of the dynasty and his successors). Soper refers to a southern prince, the ninth son of Song Wendi, who fled to the north after the fall of the Song dynasty and is said to have opened two caves at Yungang in honour of his parents. Soper, "South Chinese Influence on the Buddhist Art of the Six Dynasties Period," *Bulletin of the Museum of Far Eastern Antiquities* 32 (1960), 70–71.

23. Yong Guling, near Datong, tomb of the Northern Wei dowager empress Xiao, shows a most unusual combination of traditional Han tomb buildings with Buddhist temples incorporated into the tomb complex. This was probably the furthest point of Buddhist infiltration into the Chinese tomb system. Xu Pingfang, "Zhongguo Qin Han Wei Jin Nan Bei," 525.

5. Sui and Tang Dynasties

1. *Cambridge History of China*, vol. 3, part 1, ed. J. Fairbanks and D. Twitchett (Cambridge: Cambridge University Press, 1979), 112.

2. According to the records, there were sixty-seven "accompanying tombs" at Xianling (tomb 1); over two hundred have been found at Zhaoling (tomb 2); twenty-three at Qianling (tomb 3); and fifteen are recorded for each of the subsequent two tombs. From then on, the system was virtually dropped, and six mausolea have none at all. Howard J. Wechsler, *Offerings of Jade and Silk* (New Haven: Yale University Press, 1985), 142–60.

3. *Jiu Tang shu* (Old Tang history), 16 vols. (Beijing: Zhongguo Shuju, 1975), vol. 8, chap. 72, 2568.

4. The last two emperors, having fled from the capital during the break-up of the dynasty, were buried in Henan and Shandong, respectively.

5. He Zichang, "'Guangzhong Tang Shibaling' diaocha," *Wenwu Ziliao Cong Kan* 1980/3, 141. With two exceptions—Tailing, 38 km, and Zhenling, 60 km—all the later tombs had a circumference of 28 km.

6. *Xin Wudai shi* (New history of the Five Dynasties), *Si bu bei yao* edition (Shanghai, 1936), vol. 93, chap. 40, 6b.

7. On the whole it is probable that the inevitable progress in mechanization of agriculture and problems of pollution pose greater threats to the preservation of spirit road statuary than any yet encountered.

8. At Qianling, as well as the statues of sixty-one foreigners outside the southern gate to the inner enclosure, remnants of a pair of stone figures—possibly guardians or palace servants similar to those at the Song tombs—have been found just inside this gate. Unexplained additional figures have also been found at Qiaoling. Shaanxi Provincial Cultural Relics Management Committee, "Tang Qianling kancha ji" (Notes on a survey of Tang Qianling), *Wenwu* 1960/4, 54, and "Tang Qiaoling diaocha jianbao" (Report on the investigation of Tang Qiaoling), *Wenwu* 1966/1, 45.

9. There was a direct correspondence between the political fortunes of the empire and these spirit roads: the tombs of the six Tang emperors before the rebel-

lion spanned 129 years; after 755 the rate doubled, with twelve mausolea being built in 124 years. Not surprisingly, standards in the latter period declined.

10. *Cambridge History of China*, vol. 3, part 1, 189; Wechsler, *Offerings of Jade and Silk*, 60.

11. The officials are first differentiated at Tailing, tomb of Xuanzong (d. 761). This ranking of civilian and military officials was noted by the Japanese traveller Ennin, who described a national anniversary ceremony at a Buddhist monastery in Yangzhou in 838 in which the minister of state entered from and presided over the east side of the courtyard whilst a general did the same on the west. *Ennin's Travels in T'ang China*, ed. Edwin O. Reischuaer (New York: Ronald Press, 1955), 131–33. Records of an imperial audience eight hundred years later in the seventeenth century refer to military officials on the right, civilian on the left, and to "ten led horses with saddles and bridles complete." (Right and left refer to their position in relation to the emperor: right means east.) C. A. S. Williams, *Outlines of Chinese Symbolism and Art Motives*, 3d ed. (New York: Dover, 1976), 139.

12. Nonreligious use of this type of feline appears to have originated in the north, where sculptors would have been familiar with the Buddhist guardian lion since the fifth century in the Yungang grottoes, near Datong, Shanxi. Judging from a fine seated lion of this type, found on the site of a Sui palace, in the Shaanxi Provincial Museum, the Sui as northerners seem to have adopted this form of door guardian (see fig. 99).

13. The Tang lion never replaced the tiger as a symbol of highest authority: the all-important signs of legitimacy, the imperial seals, were carved with coiled dragons and tigers, never lions. Tigers and sheep, symbolizing martial valour and filial piety, were placed on the tombs of senior Tang officials. These seated tigers are gentle creatures not visibly related to either the Han tiger/lion or the Buddhist lion. Usually, like the Cheshire Cat in *Alice in Wonderland*, they are smiling.

14. De Groot, *Religious System of China*, vol. 2, 826.

15. In 668 Gaozong, after his victories in Korea, brought the captive king of Korea and his companions to Zhaoling to be presented to the deceased emperor; later they were paraded in triumph through the streets of Chang'an, then pardoned and given titles. C. P. FitzGerald, 2d ed. *The Empress Wu* (London: Cresset Press, 1968), 74.

16. For a full discussion of these figures, see Chen Guocan, "Tang Qianling shiren xiang ji qi xian mingde yanjiu" (A study of the rank and name of the stone figures at Tang Qianling), *Wenwu Ji Kan* 2 (1980), 189–203, and "Empress Wu's Tomb and Its Sixty-one Mystery Figures" by the same author in *China Reconstructs* 1983/8, 66–69. By the eleventh century the inscriptions on the back of these figures were already difficult to decipher. Between 1086 and 1093 a zealous Song official, You Shixing, collected rubbings made earlier by the local inhabitants and recorded his findings on four tablets placed near the figures. The tablets are now lost, but a thirteenth-century book, *Records and Drawings of Chang'an*, gives a list of thirty-six names, many historically identifiable, which is based on the tablet inscriptions. These provide striking proof of the multinational character of the Tang empire and include sixteen leaders of Western Turk, Uighur, and other border nations who were made generals or marshalls by the Tang court; others held high military office or were appointed as governors in military outposts in Central Asia and regions today part of the Soviet Union and Mongolia north of Ulan Bator.

6. Northern Song Dynasty

1. The first half of the Song dynasty is referred to as Northern Song to distinguish it from the second half, after 1127, when the Song were forced to retreat south and establish their capital at Linan (Hangzhou). Although referred to as "the sixteen provinces," these units were not much

larger than prefectures; the total area, less than the size of a modern province, was, however, mountainous and of great strategic value.

2. Shiba Yoshinobu, "Sung Foreign Trade" in *China among Equals*, ed. Morris Rossabi (Berkeley: University of California Press, 1983), 98, 101. The total tribute paid to the Liao and the Xi Xia eventually reached 755,000 units a year, but at most these payments never amounted to as much as 2 percent of Song revenues. Edwin Reischauer and Jonathan Fairbank, *A History of East Asian Civilization* (Boston: Houghton Mifflin, 1958), vol. 1, 205.

3. The last two emperors of the Northern Song were captured by the Jin during the defeat of the dynasty and died as prisoners in the northeast. In the following discussion of Song mausolea and sculpture, Yong Anling (963), tomb of the first emperor's father, is excluded since the site is so badly silted up that it is difficult to see details. Generally speaking, however, it looks similar to the other seven mausolea, indicating that the Song imperial tomb plan was worked out at the outset of the dynasty.

4. The "five sounds theory" evolved from the habit of classifying things in categories of five which followed Zou Yan's (370–270 B.C.) development of the "five elements" (*wu xing*) theory. Mentioned by the Han writer Wang Cun in his *Discussion of Balance*, this interpretation of *fengshui* was occasionally used for determining the site of a Northern Dynasties or Tang tomb, but the Song are the only dynasty to apply it to imperial tombs. Oral communications by Fu Yongguei, director of the Cultural Bureau, Gongxian, 19 March 1981 and 7 March 1983; and by Prof. Guo Hushang, Department of Architecture, Nanjing Institute of Technology, Nanjing, Jiangsu, 28 February 1983 and 8 April 1986.

5. Oral communication by Fu Yonggui, 23 February 1983.

6. Guo Husheng et al., "Henan Gongxian Songling diaocha," *Kaogu* 1964/11, 565.

7. Gongxian lies strategically on the main route between the capital, Kaifeng, and Luoyang; the River Luo, running east-west, provided easy transport from the quarries in Wang An Mountains, Yanshi County, to the west. It was important that the site be near the capital since the mere passage of the cortège was a lengthy affair. Over twelve thousand troops lined the route when the fourth Song emperor's coffin was brought from Kaifeng to Gongxian. The coffin was pulled by "car-drawers" who dragged the heavy hearse with thick ropes of white silk; they were gagged to transform the customary singing into a monotonous hum considered more suitable for a funeral procession. De Groot, *Religious System of China*, vol. 1, 188–89; vol. 3, 1128.

8. The inner enclosure of Tang Gongling, in the adjoining Yanshi County, Henan, is 470 m from north to south; the corresponding distance at Song Yong Changling is 232 m.

9. An imperial spirit road consisted of one pair each of columns, elephants with mahouts, auspicious birds, fabulous creatures (*jiao duan*), two pairs of ceremonial horses each with two attendant officers, two pairs of sheep and tigers, three pairs of foreign ambassadors, two pairs of military and civilian officials, one pair of palace guards, two mounting blocks, two pairs of palace servants, and a pair of lions at each gateway into the inner enclosure. Empresses were entitled to one pair of columns, two pairs of horses, each with an attendant, two pairs each of sheep and tigers, and one pair each of military and civilian officials and palace servants. If space allowed, they could also have a pair of *que* at the southern end of the spirit road. Statuary for lower ranks was strictly regulated: the highest three ranks of officials were allowed one pair of stone men; lower ranks were theoretically limited to sheep, tigers, and columns; there are, however, also a pair of horses on the tomb of the Song general Wang De (d. 1154) near Nanjing, Jiangsu.

10. Seven elephants with silk and gold decorations in their harness led the procession for the Song sacrifices to heaven held at the altar south of the city on the winter

solstice. Oral communication by Professor Guo, 8 April 1986.

11. Oral communication by Dr. Sheng Congwen, Academy of History, Beijing, 29 March 1986.

12. Even if such figures appeared on some Tang tombs, it cannot have been the general practice. The tumuli and statuary at Tang Gongling are unusually well preserved and have been the subject of two archaeological surveys. No trace of any statuary within the inner enclosure has been found.

13. I am grateful to Prof. Guo Husheng for this suggestion. The practice of sending and receiving embassies was highly developed under the Song. Embassies were exchanged with the Liao, for example, on certain ritual occasions: there were fixed-date embassies at the New Year and on the birthdays of the emperor and empress; embassies were also sent and received on the death of the Chinese or Liao ruler, on the occasion of a new Chinese or Liao ruler, and on the assumption by a Liao empress of the regency for a junior crown prince. In all cases the ambassador was appointed for a single occasion from among senior officials or members of the imperial family. These exchanges were on the face of it courtesy visits; letters expressing sympathy, felicitations, or merely goodwill were always exchanged along with substantial gifts. See Herbert Franke, "Sung Embassies," in *China among Equals*, 118–19.

14. It is recorded that a Song director of rites, one Zhu-ke-lang-zhong, was asked to draw a portrait of a newly arrived foreign envoy; he was also to note the mountains and rivers of the envoy's country and the folk customs of his people. *Song Shi*, vol. 163 (Department of Rites), (Shanghai: Zhonghua Shu Ju, 1977), 3854. The realism of the stone ambassadors suggests that they were based on such drawings. Although wood-block printing had been discovered in the ninth century and was in common use by the tenth, these drawings are unlikely to have been transferred to woodblocks since they were not for general circulation.

15. *Gongxian wenwu jianjie* (Gongxian: Gongxian Cultural Preservation Bureau, 1979), 15.

16. These arrangements were not the result of economic factors: the state income of the Southern Song was greater than that of any previous dynasty. For further details about the Southern Song tombs, see Paul Demiéville, "Les Tombeaux des Song méridionaux," *Bulletin de l'Ecole Française de l'Extrême-Orient* 25 (1925), 458–67.

7. Ming and Qing Dynasties

1. For a history of Zhongdu, see Wang Jianying, " 'Ming Zhongdu' ti yao" ("Ming Zhongdu": A summary) in *Jianzhu lishi yu lilun* (Corpus of architectural history and theory) (Jiangsu: Peoples' Publishing House, 1981), 162–71; and "Ming chu yingjian Zhongdu ji qi dui gaijian Nanjing he yingjian Beijingde yingxian" (The building of Zhongdu in the early Ming period and its effect on the switch to build Nanjing and the building of Beijing) in *Lishi di li* 3, 86–97 (Shanghai: Shanghai Peoples' Publishing House, 1984), and "Lost Ming City was Model for Beijing," *China Reconstructs* 1982/9, 56–59.

2. Letter from Wang Jianying, Peoples' Educational Publishing House, Beijing, 7 July 1985.

3. Margaret Medley gives the following definition of a *qilin*: "It may be leonine, with scales and horns, or it may be an elegant cloven-footed beast, with or without scales, with a bushy mane and tail, and a horn, or a pair of horns. Variations are extremely numerous and impossible to classify satisfactorily as the Chinese have, in the past, given this name to many animals, including the giraffe." *A Handbook of Chinese Art*, 3d ed. (London: Bell, 1977), 91.

4. Ruan Rongchun, "Lun Mingdai Zuling, Xiaoling shendao shike zhi shidai" (A discussion of the dating of the stone sculpture in the spirit roads of Ming Zuling and Xiaoling), *Kaogu Yu Wenwu* 1986/2, 90–91. The suggestion in this article that Zuling predated Huangling is disputed and in the author's view is not borne out by an examination of the statuary.

5. Although the central approach and Changling, the first tomb in the valley, are on a north-south axis, the site of later, smaller tombs was determined by the lie of the land and some are on an almost east-west axis.

6. Yang Kuan, *Zhongguo gudai ling-qin*, 62.

7. The Hall of Heavenly Favours at Changling is 219 m by 96 m. According to Liang Sicheng, former professor of architecture at Qinghua University, Beijing, the surface area of the Hall of Supreme Harmony in the Forbidden City is very slightly larger than that of the Changling hall, but the roof of the latter contains the longest *ang* in existence.

8. The memorial stelae at Xiaoling and in the Ming Valley are the two largest in China, but the embryo of a much larger stele can be seen in the Yangshan quarry outside Nanjing. When Hongwu died, his son, Yongle, ordered a gigantic stele for Xiaoling. For eight years, over two thousand men worked on two stones—one for the shaft and the other for the headpiece. Finally it was realised that even if the work could be completed the blocks were too heavy to move: the larger stone is reckoned to weigh fifty thousand tons. The present stele at Xiaoling took eleven years to carve.

9. The seventh Ming emperor, Jingtai, is buried in a princely tomb in the Western Hills. When, in 1449, his older half-brother, the emperor Zhengtong, was taken prisoner by northern invaders, Jingtai assumed the throne. After Zhengtong's release, Jingtai kept him a virtual captive and Zhengtong did not regain the throne until a palace coup in 1457. When Jingtai died, Zhengtong refused him a burial place in the imperial cemetery.

10. The *xiezhai* originated in classical mythology and was very popular in third and fourth centuries, when it was embroidered on the caps of all judges; during the Ming dynasty it appeared on the badges of imperial censors. Said to be white, it roared when it saw injustice.

11. Johannes Prip-Møller, *Kina før og nu* (Copenhagen: Gads Forlag, 1944), 34–35.

12. The *makara* was of Indian origin, a mythical serpent-god associated with water and hibernation and symbolizing growth and fertility. Fine examples of *makara* can be seen on the Yuan archway at Juyongguan near Beijing.

13. Nine of Hongwu's twenty-four sons were appointed provincial governors with the title of prince (*wang*). This is usually translated as "king," but these provinces were not kingdoms. "Duke" is probably the closest analogy, but I have used "prince" because of its clear family connection. There were four degrees of *wang*, depending on the original degree of relationship to the emperor. Information given by Wang Zhongshu and Xu Pingfang, Institute of Archaeology, Beijing, 27 February 1983.

14. Lu Jian was a full younger brother of the thirteenth Ming emperor, Wanli (1572–1620), whose tomb, Dingling, was excavated under the direction of Dr. Xia Nai between 1956 and 1958. Lu Jian designed his own tomb on the scale of Dingling. There were protests at court, but the emperor supported his brother. For further details of Lu Jian's tomb, see Xinxiang City Museum, *Lu Jian wang mu jianji* (A brief account of the tomb of Prince Lu Jian) (Henan, 1986).

15. The first Manchu emperor, Nurhachi, transferred the bodies of his parents, grandparents, and wife to a tomb near his capital, Yandu. The second Manchu emperor, acting on the advice of Chinese counsellors, ennobled these ancestors posthumously in the Chinese manner and transformed their tomb into a mausoleum, Yongling, dedicated to Nurhachi's father, grandfather, great-grandfather, a remote ancestor, and two uncles. The only Chinese elements in this tomb are the memorial stelae erected on Shunzhi's orders in 1661.

16. Gisbert Combaz, *Sépultures impériales de la Chine* (Brussels: Presses de Vromant, 1907), 22.

17. This kind of necklace, a *chaozhu*, is described by Verity Wilson in *Chinese Dress* (London: Victoria and Albert Museum, 1986), 29.

18. Three tombs do not have spirit roads: Daoguang's Muling; Tongzhi's Huiling, and Guangxu's Chongling. Daoguang

(1821–50) specifically refused a spirit road on grounds of economy; it is not clear why Tongzhi (1862–1874) did not have one. When Guangxu (1875–1908) died, his tomb was not yet built and his grave, Chongling, in the Western Tombs, was financed by grants from the Republican government after 1911.

19. It was rumoured that Yongzheng (1723–1735) had altered his father's will by which the fourteenth son rather than he, the fourth son, should have inherited the throne. One of his first imperial acts was to have his younger brothers and various other members of the family assassinated, and for this reason he may not have wished to lie close to his father's grave.

20. These tombs were given the same name as the emperor's mausoleum, with the prefix west or east. The widow of the second Manchu emperor, who survived him by forty-four years, died in Beijing in 1687. Her grandson, Kangxi, wished to build her a tomb in Shenyang next to her husband's Zhaoling, but she left written instructions that she preferred to remain in the south next to her son and grandson. Her tomb in the Eastern Tombs is thus named West Zhaoling, being to the west of the distant Zhaoling in the north.

21. The largest empresses' tombs are the joint tombs of the two widows of the emperor Xianfeng (1851–61): the notorious dowager empress Ci Xi and her fellow dowager empress Ci An. These were unusually extravagant constructions, taking eight years to build and costing over six million taels. When the work was finished, Ci Xi was dissatisfied and ordered the main and side halls to be rebuilt and gilded at a cost equivalent to more than 160 kg of pure silver. Ci Xi's underground chamber is now open to the public.

22. The longest bridge, over the River Weijia in the Eastern Tombs, has seven arches and is known as the "five-tone bridge" because you can obtain the tones of the pentatonic scale by tapping any one of the 110 stone panels.

23. De Groot, *Religious System of China*, vol. 3, 1295.

Appendix A: Shunling

1. Shaanxi Provincial Archeological Research Institute, "Tang Shunling kanchaji" (Notes on a survey of Tang Shunling), *Wenwu* 1964/1, 34–39.

2. *Cambridge History of China*, vol. 3, part 1, 304–05.

Appendix B: Foreigners in the Northern Song Spirit Roads at Gongxian

1. I am particularly grateful to Prof. Guo Husheng of the Nanjing Institute of Technology, Dr. Craig Clunas of the Victoria and Albert Museum, and the late Dr. Sheng Congwen of the Academy of Sciences, Historical Section, for their help with this section.

2. The practice of sending messages in fine boxes continued until the Qing dynasty. In the late seventeenth century, in the Kangxi period, high-ranking officials sent New Year messages in brocade-covered boxes as tokens of respect. *China Reconstructs* 1985/12, 12.

3. Oral communication by Professor Guo, 28 February 1983.

4. Franke, "Sung Embassies" in *China among Equals*, 120. A description in the *Dong jing men Hua Lu* (Reminiscences of the flourishing eastern capital) gives a slightly different distribution for the last period of the Northern Song just before the fall of Kaifeng. All sources agree, however, in placing the Liao in the first and the Xi Xia in the second places.

5. Jan Fontein and Wu Tung, *Unearthing China's Past* (Boston: Museum of Fine Arts, 1973), 186. It is suggested that such headdresses were originally made in China for the Khitans.

6. Sheng Congwen, *Zhongguo gudai fushi yanjiu* (A study of ancient Chinese dress) (Hong Kong: Commercial Press, 1985), 359.

7. The horse and groom are details in a Yuan dynasty painting in the Freer Gallery, Washington, D.C., by Chao Yung. Its date corresponds to 1347.

Appendix C: Huangling and Zuling

1. For further details of Huangling and Zuling, see *Huangling bei* (Huangling stele) (Fengyang: Fengyang County Cultural Relics Management Bureau, 1981); Zhang Zhengxiang, "Ming Zuling," *Kaogu* 1963/8, 437–41; Liu Yucai et al., "Ming Zuling shike xiufu" (Restoration of the stone sculptures at Ming Zuling), *Jiangsu Kaogu Xuehui* 1982/5, 11–15; and Liu Yucai and Liu Xin, "Ming Zuling shulue" (A brief account of Ming Zuling), *Kaogu Yu Wenwu* 1984/2, 70–75.

BIBLIOGRAPHY

Non-Chinese Sources

Acker, William Reynolds Beal. *Some T'ang and Pre-T'ang Texts on Chinese Painting.* 2 vols. Leiden: E. J. Brill, 1954, 1975.

Adams, Edward B. *Through Gates of Seoul: Trails and Tales of Yi Dynasty.* Seoul: Taewon Publishing Co., 1974.

Allan, Sarah. "Sons of Suns: Myth and Totemism in Early China." Reprint from *Bulletin of the School of Oriental and African Studies* 44, part 2. London: University of London, 1981.

Armstrong, Alex. *Shantung.* Shanghai: Shanghai Mercury Office, 1891.

Ashton, Leigh. *An Introduction to the Study of Chinese Sculpture.* London: Benn, 1924.

Baber, E. Colborne. "Travels and Researches in Western China." *Royal Geographical Society Supplementary Papers* 1, part 1. London: John Murray, 1886.

Bedouin, Jean-Louis. *Victor Segalen.* Paris: Seghers, 1963.

Beurdeley, C. and M. *Giuseppe Castiglione.* London: Lund Humphries, 1972.

Bishop, Carl W. "Notes on the Tomb of Ho Ch'u-ping." *Artibus Asiae* 1928/1, 34–46.

Bodde, Derk. "Myths of Ancient China." In Samuel N. Kramer, ed. *Mythologies of the Ancient World.* New York: Doubleday, 1961.

Bouillard, Georges. *Les Tombeaux impériaux Ming et Ts'ing.* Beijing: Nachbauer, 1931.

Bouillard, Georges, and Commandant Vaudescal. "Les Sepultures impériales des Ming (Che-San Ling)." *Bulletin de l'Ecole Française de l'Extrême-Orient* (Hanoi) 20/3 (1920).

Bourne, Frederick S. A. "Notes of a Journey to the Imperial Mausolea, East of Peking." *Proceedings of the Royal Geographical Society* 5 (1883), 23–31.

Boyd, Andrew. *Chinese Architecture and Town Planning, 1500 B.C.–A.D. 1911.* London: Tiranti, 1962.

Bush, Susan, and C. Murck. *Theories of the Arts in China.* Princeton: Princeton University Press, 1983.

Cambridge History of China. Ed. Denis Twitchett and John K. Fairbank. Cambridge: Cambridge University Press, 1978–.

Cammann, Schuyler. "Types of Symbols in Chinese Art." In A. J. Wright, ed. *Studies in Chinese Thought.* Chicago: University of Chicago Press, 1953.

———. "Some Strange Ming Beasts." *Oriental Art*, n.s. 2 (1956), 94–102.

Capon, Edward. "Chinese Tomb Figures of the Six Dynasties." *Transactions of the Oriental Ceramic Society* 41 (1975–77), 279–91.

Chang, Chun-shu, and Joan Smythe. *South China in the Twelfth Century: A Translation of Lu Yu's Travel Diaries, July 3–December 6, 1170.* Institute of Chinese Studies, Monograph Series no. 4. Hong Kong: Chinese University Press, 1981.

Chang, Kwang-chih. *The Archeology of Ancient China.* New Haven: Yale University Press, 1963; 3d ed., 1977.

———. *Shang Civilization.* New Haven: Yale University Press, 1980.

———. *Art, Myth, and Ritual.* Cambridge: Harvard University Press, 1983.

Chavannes, Edouard. *La Sculpture sur pierre en Chine au temps des deux dynasties Han.* Paris: Leroux, 1893.

———. *Mission archéologique dans la Chine septentrionale.* 3 vols. Paris: Ernest Leroux, 1909–15.

———. *Le T'ai Chan.* Vol. 21 of *Annales du Musée Guimet.* Paris: Leroux, 1910.

Chaves, Jonathan. "A Han Painted Tomb at Loyang." *Artibus Asiae* 30 (1968), 5–27.

Chen Guocan. "Empress Wu's Tomb and Its Sixty-one Mystery Figures." *China Reconstructs* 1983/8, 66–69.

Ch'en, Kenneth K. *Buddhism in China: A Historical Survey.* Princeton: Princeton University Press, 1964.

Ch'en Yuan. *Westerners and Central Asians in China under the Mongols.* Trans. Ch'ien Hsing-hai and L. Carrington-Goodrich. Monumenta Serica, Monograph 15. Los Angeles, 1966.

Cheng Te-k'un. *Archeological Studies in Szechwan.* Cambridge: Cambridge University Press, 1976.

———. "Ch'in-Han Architectural Remains." *Journal of the Institute of Chinese Studies of the Chinese University of Hong Kong* 9/2, (1978), 503–83.

———. "Ch'in Han Mortuary Architecture." *Journal of the Institute of Chinese Studies of the Chinese University of Hong Kong* 11 (1980), 193–269.

———. *Studies in Chinese Archeology.* Hong Kong: Chinese University Press, 1982.

Combaz, Gisbert. *Sépultures impériales de la Chine.* Brussels: Presses de Vromant, 1907.

Couling, Samuel. *The Encyclopaedia Sinica.* Shanghai: Kelly and Walsh, 1917. Repr. Hong Kong: Oxford University Press, 1967.

D'Ardenne de Tizac. *La Sculpture chinoise.* Paris: Van Oest, 1931.

De Groot, Jan Jakob Maria. *The Religious System of China.* 6 vols. Leiden, 1892–1910. Repr. Taipeh: Ch'eng-wen Publishing Co., 1967.

Demiéville, Paul. "Les Tombeaux des Song Méridionaux." *Bulletin de l'Ecole Française de l'Extrême-Orient* 25 (1925), 458–67.

De Voisins, Gilbert. *Ecrit en Chine.* 2 vols. Paris: Cres, 1923.

De Woskin, K. J. *Doctors, Divines and Magicians of Ancient China (Biographies of Fang-shih).* New York: Columbia University Press, 1983.

Diény, Jean-Pierre. *Annuaire.* Ecole Practique des Hautes Etudes, section 4, Sciences Historiques et Philologiques (1976–77), 1015–25; (1977–8), 1149–61.

Eberhard, Wolfram. *Dictionnaire des symboles chinois.* Trans. Helen Belletto. Paris: Seghers, 1984.

Eitel, Rev. E. J. *Feng Shui.* London: Trubner, 1873. Repr. Bristol: Pentacle Books, 1979.

Elisseeff, Danielle and Vadime. *New Discoveries in China.* London and New York: Alpine Fine Arts Collection, 1985.

Elvin, Mark. *The Pattern of the Chinese Past.* London: Methuen, 1973.

Fairbanks, Wilma. "The Offering Shrines of Wu Liang Tz'u" and "A Structural Key to Han Mural Art." *Adventures in Retrieval.* Harvard-Yenching Institute Studies no. 28 (Cambridge, 1972), 41–86 and 87–140.

Ferguson, John C. "The Six Horses of Tang Taizong." *Journal of the North China Branch of the Royal Asiatic Society* (Shanghai) 67 (1936), 1–6.

Fernald, Helen E. *Chinese Court Costumes.* Toronto: Royal Ontario Museum of Archeology, 1946.

Feuchtwang, Stephan. *An Anthropological Analysis of Chinese Geomancy.* Vientiane: Vithagna, 1974.

Finsterbusch, Kate. *Verzeichnis und Motivindex der Han-Darstellungen.* 2 vols. Wiesbaden: Otto Harrassowitz, 1966, 1971.

Fisher, E. S. "A Journey to the Tungling and a Visit to the Desecrated Eastern Mausolea of the Ta Tsing Dynasty in 1929." *Journal of the North China Branch of the Royal Asiatic Society* (Shanghai) 61 (1930), 20–39.

FitzGerald, Charles Patrick. *China: A Short Cultural History.* London: Cressett Press, 1935. Paperback reprint, 1965.

———. *The Empress Wu.* London: Cressett Press, 1956. 2d ed., 1968.

———. *A Concise History of Asia.* London: Pelican Books, 1974.

Fong, Mary H. "Tang Tomb Murals Reviewed in the Light of Tang Texts on Painting." Reprint from *Artibus Asiae* 45/1 (1984), 35–72.

Fonssagrives, E. *Si-ling: Etude sur les tombeaux de l'ouest de la dynastie des Ts'ing.* Paris: Leroux, 1907.

Fontein, Jan, and Wu Tung. *Unearthing*

China's Past. Boston: Museum of Fine Arts, 1973.

———. *Han and T'ang Murals.* Boston: Museum of Fine Arts, 1976.

Giles, Herbert A. *A Chinese Biographical Dictionary.* London: Quaritch, 1898.

Glahn, Else. "Some Chou and Han Architectural Terms." *Bulletin of the Museum of Far Eastern Antiquities* 50 (1978), 105–25.

Goodall, John A. *Heaven and Earth: 120 Album Leaves from a Ming Encyclopedia.* London: Lund Humphries, 1979.

Goodrich, L. Carrington. *A Short History of the Chinese People.* New York: Harper, 1943. Paperback reprint. London: Allen and Unwin, 1972.

Granet, Marcel. *La Civilisation chinoise.* Paris: Albin Michel, 1929.

Hackin, Joseph. *Studies in Chinese Art and Some Indian Influences.* London: India Society, 1937.

Hawkes, David. *Ch'u-Tz'u: The Songs of the South: An Ancient Anthology.* London: Oxford University Press, 1959.

Hay, John. *Ancient China.* London: Bodley Head, 1973.

Hentze, Carl. *Chinese Tomb Figures.* London: Goldston, 1928.

———. *Die Sakalbronzen und ihre Bedeutung in den Frühchinesischen Kulturen.* 2 vols. Antwerp: De Sikkel/ Nijhoff, 1941.

Hucker, Charles O. *A Dictionary of Official Titles in Imperial China.* Stanford: Stanford University Press, 1985.

Imbault-Huart, Camille. "Tombeaux des Ming près de Pekin." *T'oung Pao* (Leiden) 4 (1893), 391–401.

James, Jean M. "Bridges and Cavalcades in East Han Funerary Art." *Oriental Art,* n.s. 28/3 (1982), 165–71.

Juliano, Annette. *Art of the Six Dynasties.* New York: China Institute in America, 1975.

———. "Teng-Hsien: An Important Six Dynasties Tomb." *Artibus Asiae,* supplement 37 (1980).

Laing, Ellen Johnston. "Neo-Taoism and the 'Seven Sages of the Bamboo Grove' in Chinese Painting." *Artibus Asiae* 36/1–2 (1974), 5–54.

Lartigue, Jean. "Au Tombeau de Huo K'iu-Ping." *Artibus Asiae* 2 (1927), 85–94.

Laufer, Berthold. *Chinese Pottery of the Han Dynasty.* Leiden: E. J. Brill, 1909.

———. "Chinese Clay Figures." Chicago Natural History Museum, Anthropological Series 13/2 (1914).

Lee, Sherman E., and Wai-Kam Ho. *Chinese Art under the Mongols: The Yuan Dynasty (1279–1363).* Cleveland: Cleveland Museum of Art, 1968.

Lim, Lucy, ed. *Stories from China's Past: Han Dynasty Pictorial Tomb Reliefs and Archaeological Objects from Sichuan Province, Peoples' Republic of China.* San Francisco: Chinese Culture Foundation, 1987.

Liu Yucai. "Ming Statues Raised from a Watery Grave." *China Reconstructs* 1983/5, 42–43.

Loewe, Michael A. N. *Imperial China.* London: Allen and Unwin, 1966.

———. *Everyday Life in Early Imperial China during the Han Period.* London: Batsford, 1968.

———. *Crisis and Conflict in Han China.* London: Allen and Unwin, 1974.

———. "Man and Beast: The Hybrid in Early Chinese Art and Literature." *Numen* 25, fasc. 2 (Leiden: E. J. Brill, 1978), 97–117.

———. *Chinese Ideas of Life and Death.* London: Allen and Unwin, 1982.

Lu Xun. *A Brief History of Chinese Fiction.* Beijing: Foreign Languages Press, 1959.

Mahler, Jane Gaston. *Westerners among the Figurines of the T'ang Dynasty of China.* Serie Oriental Roma no. 20. Rome: Instituto Italiano per il Medio ed Estremo Oriente, 1959.

March, Andrew L. "The Changing Landscape of the Chinese Geomancy." *Journal of Asian Studies* 27 (Feb. 1968), 253–67.

Maspero, Henri. *Le Taoisme et les religions chinoises.* Paris: Gallimard, 1971.

Medley, Margaret. *A Handbook of Chinese Art.* London: Bell and Sons, 1964. 3d. ed. 1977.

Mizuno, Seiichi. *Chinese Stone Sculpture.* Tokyo: Mayuyama, 1950.

———. *Bronze and Stone Sculpture of China from the Yin to the T'ang Dynasty*. Tokyo: The Nihon Keizai, 1960.

Munsterberg, Hugo. *The Art of the Chinese Sculptor*. Rutland, Vt.: Tuttle, 1960.

Needham, Joseph. *Science and Civilisation in China*. Cambridge: Cambridge University Press, 1954–.

Paludan, Ann. *The Imperial Ming Tombs*. New Haven: Yale University Press, 1981.

———. "Two early Ming mausolea." *Orientations* 1988/1: 28–37.

———. "The Chinese spirit road." *Orientations* 1988/9, 56–65; 1989/4, 64–73; and 1990/3, 56–66.

Pelliot, Paul. "Notes sur quelques artistes des Six Dynasties et des T'ang." *T'oung Pao* (Leiden) 22 (1923), 215–91.

Pirazzoli t'Serstevens, Michele. *Chine: Architecture universelle*. Friburg: Office du Livre, 1970.

———. *The Han Civilization of China*. Oxford: Phaidon, 1982.

Powers, Martin J. "The Shapes of Power in Han Pictorial Art." D.Phil. thesis. University of Chicago, 1978.

———. "An Archaic Bas-relief and the Chinese Moral Cosmos in the First Century A.D." *Ars Orientalis* 12 (1981), 25–40.

Priest, Alan. *Imperial Robes and Textiles of the Chinese Court*. Minneapolis: Minneapolis Institute of Arts, 1943.

Priest, Alan, and Pauline Simmons. *Chinese Textiles*. New York: Metropolitan Museum of Art, 1931.

Prip-Møller, Johannes. *Kina før og nu*. Copenhagen: G. E. C. Gads Forlag, 1944.

Qian Hao et al. *Out of China's Earth: Archeological Discoveries in the Peoples' Republic of China*. London: Frederick Muller; Beijing: China Pictorial, 1981.

Rawson, Jessica. *Ancient China*. London: British Museum Publications, 1980.

———. *The Lotus and the Dragon*. London: British Museum Publications, 1984.

Reischauer, Edwin O. *Ennin's Travels in T'ang China*. New York: Ronald Press, 1955.

Reischauer, Edwin O., and Jonathan K. Fairbank. *A History of East Asian Civilization*. 2 vols. Boston: Houghton Mifflin, 1958, 1960.

Rennie, David Field. *Peking and the Pekingese*. 2 vols. London: John Murray, 1865.

Rossabi, Morris, ed. *China among Equals*. Berkeley: University of California Press, 1983.

Rose, Sir Francis. *Art Seen through Chinese and Western Eyes*. London: China Society, 1946.

Rudolph, Richard C. *Han Tomb Art of West China*. Berkeley: University of California Press, 1951.

Salmony, Alfred. *Chinese Sculpture*. New York: Morrill Press, 1944.

———. "Antler and Tongue." *Artibus Asiae*, supplement 13 (1954).

Schafer, Edward. *Golden Peaches of Samarkand*. Berkeley: University of California Press, 1963.

———. *Pacing the Void*. Berkeley: University of California Press, 1977.

Schloss, Ezekiel. *Foreigners in Ancient Chinese Art*. New York: China Institute in America, 1969.

———. *Art of the Han*. New York: China Institute in America, 1975.

Segalen, Victor. "Recent Discoveries in Ancient Chinese Sculpture." *Journal of the North China Branch of the Royal Asiatic Society* (Shanghai) 48 (1917).

———. *Lettres de Chine*. Ed. Jean-Louis Bedouin. Paris: Plon, 1967.

———. *Chine: La Grande Statuaire*. Paris: Flammarion, 1972. Trans. by Eleanor Levieux as *The Great Statuary of China*. Chicago: University of Chicago Press, 1978.

———. *Les Origines de la statuaire de Chine*. Ed. A. Joly-Segalen. Paris: Editions de la Différence, 1976.

———. "Feuilles de route, I." *Le Nouveau Commerce*, cahier 41 (1978).

———. "Feuilles de route, II." *Le Nouveau Commerce*, cahier 44 (1979).

Segalen, Victor, Gilbert de Voisins, and Jean Lartigue. *Mission archéologique en Chine (1914)*. 3 vols. Paris: Paul Geunther, 1923–35.

Sickman, Lawrence, and Alexander Soper. *The Art and Architecture of China.* Harmondsworth, Middlesex: Penguin, 1956. Paperback ed. based on 3d hardback ed., 1971.

Siren, Osvald. *Chinese Sculpture from the Fifth to the Fourteenth Centuries.* 4 vols. London: Ernest Benn, 1925.

——. *History of Early Chinese Art.* 4 vols. London: Ernest Benn, 1929–30.

——. *The Chinese on the Art of Painting.* Beijing: Henri Vetch, 1936.

——. "Chinese Sculpture of the Sung, Liao and Chin Dynasties." *Bulletin of the Museum of Far Eastern Antiquities* 14 (1942), 45–64.

Soper, Alexander. "Literary Evidence for Early Buddhist Art in China. I. Foreign Images and Artists." *Oriental Art* 2/1 (1949), 28–35.

——. "South Chinese Influence on the Buddhist Art of the Six Dynasty Period." *Bulletin of the Museum of Far Eastern Antiquities* 32, part 1 (1960), 47–112.

——. "Imperial Cave-chapels of the Northern Dynasties: Donors, Beneficiaries, Dates." *Artibus Asiae* 28/4 (1966), 241–70.

——. "The Purpose and Date of the Hsiao-T'ang Shan Offering Shrines: A Modest Proposal." *Artibus Asiae* 36/4 (1974), 249–66.

——. "Textual Evidence for the Secular Arts of China in the Period from Liu Song through Sui (A.D. 420–618) Excluding Treatises on Painting." *Artibus Asiae*, supplement 24 (1967).

Sullivan, Michael. *A Short History of Chinese Art.* London: Faber and Faber, 1967.

——. "A Western China Discovery of Immense Importance." *The Illustrated London News*, 20 April 1946, 429–31.

Swann, Peter. *Chinese Monumental Art.* New York: Viking Press, 1963.

Tchang, P. Mathias. *Tombeaux des Liang.* Shanghai: Imprimerie de la Mission Catholique, 1912.

Teng Ku. "A Few Notes on the Forms of Some Han Sculptures." *T'ien Hsia Monthly* (Shanghai) 1/5 (1935).

Thorp, Robert L. "The Mortuary Art and Architecture of early Imperial China." Ph.D. thesis. University of Kansas, 1979.

Till, Barry. "Some Observations on Stone Winged Chimeras at Ancient Chinese Tomb Sites." *Artibus Asiae* 42/4 (1980).

——. *In Search of Old Nanking.* Hong Kong: Joint Publishing Co., 1982.

Vandermeersch, Leon. "*Wangdao* ou la voie royale." *Publications de l'Ecole Française de l'Extrême-Orient* (Paris) 112 and 113 (1977 and 1980).

Vogel, J. Ph. "Le Makara dans la sculpture de l'Inde." *Revue des arts asiatiques* 6 (1929–30), 133–46.

Wang Chongren. "Stone Sculptures of the Han and Tang Tombs." *Recent Discoveries in Chinese Archeology.* Trans. Zuo Boyang. Beijing: Foreign Languages Press, 1984.

Wang Jianying. "Lost Ming City Was Model for Beijing." *China Reconstructs* 1982/9, 56–59.

Wang Zhongshu. *Han Civilization.* New Haven: Yale University Press, 1982.

Waterbury, Florance. *Early Chinese Symbols and Literature.* New York: Weye, 1942.

Watson, William. *The Genius of China* [Catalogue of the Chinese Exhibition, Royal Academy]. London: Times Newspapers, 1973.

——. *Style in the Arts of China.* Harmondsworth, Middlesex: Penguin Books, 1974.

Weber, Charles D. "The Spirit Road in Chinese Funerary Practice." *Oriental Art*, n.s. 24/2 (1978).

Wechsler, Howard J. *Offerings of Jade and Silk.* New Haven: Yale University Press, 1985.

Wen Fong, ed. *The Great Bronze Age of China.* New York: Metropolitan Museum of Art/Alfred A. Knopf, 1980.

Wenley, Archibald G. "The Grand Empress Dowager Wen Ming and the Northern Wei Necropolis." *Freer Gallery of Art Occasional Papers* no. 1 (Washington, D.C., 1947), 1–22.

Werner, Edward Theodore Chalmers. *A Dictionary of Chinese Mythology.* Shanghai: Kelly and Walsh, 1932.

White, William Charles. *Tomb Tile*

Pictures of Ancient China. Toronto: University of Toronto Press, 1939.

Williams, Charles Alfred Speed. *Outlines of Chinese Symbolism and Art Motives*. 1932; 3d ed. New York: Dover Publications, 1976.

Wilson, Verity. *Chinese Dress*. London: Victoria and Albert Museum Publications, 1986.

Wittkower, Rudolph. *Sculpture*. Harmondsworth, Middlesex: Penguin Books, 1977.

Wright, Arthur. *Studies in Chinese Thought*. Chicago: University of Chicago Press, 1953. 3d ed. 1967.

——. *Buddhism in Chinese History*. Stanford: Stanford University Press, 1979.

Wu Hung. "A Sanpan Shan Chariot Ornament and the *Xiangrui* Design in Western Han Art." Reprint from *Archives of Asian Art* 37 (1984).

——. "Buddhist Elements in Early Chinese Art." *Artibus Asiae* 47/3–4 (1986), 263–352.

——. *The Wu Liang Shrine*. Stanford: Stanford University Press, 1989.

Wu, Nelson I. *Chinese and Indian Architecture*. New York: Braziller, 1963. London: Prentice-Hall, 1963.

Yetts, Walter Percival. *Symbolism in Chinese Art*. Leiden: The China Society, 1912.

Xia Nai. "Opening an Imperial Tomb." *China Reconstructs* 1959/3, 16–21.

Chinese Sources

This is a list of some books and articles dealing with or mentioning spirit road sculptures and tomb planning; it is not a list of all Chinese articles on tombs. The list is arranged chronologically in each section.

GENERAL

Li Jie. *Ying zao fa shi* (Manual on architecture. 4 vols. Shanghai: Commercial Press, 1953.

Jin Weinuo. *Zhongguo meishu shi lun ji* (A collection of essays on the history of Chinese art). Beijing: Peoples' Fine Arts Publishing House, 1981.

"Jiantan Zhongguo gudai jianzhu shigong gongju" (A brief discussion of constructional tools in ancient Chinese building). *Keji shi wenji* 1984/11, 153–64. Shanghai: Shanghai Science and Technology Publishing House.

Zhonguo meishu quan ji (The great treasury of Chinese fine arts). Shanghai: Peoples' Fine Arts Publishing House. *Sculpture*. Vol. 2. *Qin Han diaosu* (Qin Han sculpture) (1985). Vol. 5. *Wudai Song diaosu* (Five Dynasties and Song sculpture) (1988). Vol. 6. *Yuan Ming Qing diaosu* (Yuan, Ming, and Qing sculpture) (1988).

Sheng Congwen. *Zhongguo gudai fushi yanjiu* (A study of ancient Chinese dress). Hong Kong: Commercial Press, 1985.

Yang Kuan. *Zhongguo gudai lingqin zhidu shi yanjiu* (Research into the ancient mausoleum system of China). Shanghai: Shanghai Classical Books Publishing House, 1985.

Sun Zhongjie et al. *Zhongguo diwang lingqin* (The Chinese royal and imperial mausoleum system). Heilongjian: Peoples' Publishing House, 1987.

Wang Ziyun. *Zhongguo diaosu yishu shi* (A history of Chinese sculptural art). 2 vols. Beijing: Peoples' Fine Arts Publishing House, 1988.

HAN DYNASTY

Jen Naiqiang. "Lushan xinchu Han shike kao" (On the Han stone sculpture recently discovered at Lushan). *K'ang Tao Yueh K'an* 1942/4, 6–7.

Wang Ziyun. "Xi Han Huo Qubing mu shike" (Western Han stone carvings at Huo Qubing's tomb). *Wenwu Cankao Ziliao* 1955/11, 12–18.

Tao Mingguan et al. "Lushan xiande Dong Han shike" (East Han stone sculpture in Lushan County). *Wenwu Cankao Ziliao* 1957/10, 41–42.

Jiangsu Province Cultural Relics Management Committee. *Jiangsu*

Xuzhou Han huaxiang shi (Han dynasty relief stone carvings at Xuzhou, Jiangsu). Beijing: Scientific Publications, 1959.

Chen Mingda. "Han daide shi que" (Stone monumental towers of the Han dynasty). *Wenwu* 1961/12, 9–23.

Shaanxi Provincial Museum Bureau. "Anyi xian Ducun chutude Xi Han shi hu" (A stone tiger excavated at Du village, Anyi County). *Wenwu* 1961/12, 48.

Fu Tianchou. "Shaanxi Xingping xian Huo Qubing mu qiande Xi Han shidiao yishu" (The sculptural art of the Western Han stone sculptures at Huo Qubing's tomb, Xingping County, Shaanxi Province). *Wenwu* 1964/1, 40–44.

Kong Ciqing. "Shandong Qufu Konglin faxian Handai shishou" (Han dynasty stone animals found in the Kong cemetery at Qufu, Shandong). *Kaogu* 1964/4, 209.

Ma Ziyun. "Xi Han Huo Qubing mu shike ji" (Notes on the stone sculptures at the Western Han tomb of Huo Qubing). *Wenwu* 1964/1, 45–46.

Xu Senyu. "Xi Han shike wenzi chutan" (A preliminary survey of Western Han stone inscriptions). *Wenwu* 1964/5, 1–9.

Beijing City Cultural Working Team. "Beijing xijiao faxian Handai shi que qingli jianbao" (A brief clarification of questions about a Han dynasty monumental tower found in the western suburbs of Beijing). *Wenwu* 1964/11, 13–24.

Liu Xinjian and Zhang Wuxue. "Shandong Junan faxian Handai shi que" (Han dynasty stone monumental tower discovered at Junan, Shandong). *Wenwu* 1965/5, 16–19.

Wang Wencai. "Dong Han Li Bing shixiang yu Dujiang Yan 'shuize'" (The Eastern Han stone statue of Li Bing at Dujiang Weir as a "water gauge"). *Wenwu* 1974/7, 29–32.

Sichuan Province Guanxian Cultural Bureau. "Dujiang Yan chutu Dong Han Li Bing shixiang" (The excavation of the Eastern Han stone statue of Li Bing at Dujiang Weir). *Wenwu* 1974/7, 27–28.

Hei Guang. "Xian Han Taiyechi chutu yijian juxing shi yu" (A gigantic stone fish unearthed near Han dynasty Lake Taiye in Xian). *Wenwu* 1975/6, 91–92.

Sichuan Museum. "Dujiang Yan you chutu yi qu Handai shixiang" (Another Han dynasty stone statue excavated at Dujiang Weir). *Wenwu* 1975/8, 89–90.

Lu Pin. "Dengfeng Handai san que" (Three Han dynasty monumental towers at Dengfeng). *Wenwu* 1979/8, 90–92.

Xu Pingfang. "Zhongguo Qin Han Wei Jin Nan Bei Chao shidaide lingyuan he yingchang" (The tomb enclosure and grave city in the Chinese Qin, Han, Wei, Jin and Northern and Southern Dynasties of China). *Kaogu* 1981/6, 521–30.

Chen Mingda. "Zhongguo fengjian shehui mu jiegou jianzhu jishude fazhan" (The technical development of wood-framed buildings in feudal China). *Jianzhu lilun ji lishi yanjiu shi bian* (Studies in the theory and history of architecture) 1, 56–95. Beijing: Chinese Architectural Science Research Institute, 1982.

Yang Kuan et al. "Qin Han lingmu kaocha" (An investigation into Qin Han tombs). *Fudan Xuebao (Shehui Kexui Pian)* 1982/6, 46–52.

Nanyang Cultural Bureau. *Nanyang Handai huaxiang shi* (Han dynasty stone reliefs in Nanyang). Beijing: Peoples' Publishing House, 1985.

Liu Fengqun. "Dong Han Nan Chao lingmu qian shi shou zaoxing chutan" (A preliminary research into the style of Eastern Han and Southern Dynasties stone animals). *Kaogu Yu Wenwu* 1986/3, 86–90.

Yan Wenru. "Guanzhong Han Tang lingmu shike ticai ji qi fengge" (Concerning questions of style in the Guanzhong Han and Tang tomb sculptures). *Kaogu Yu Wenwu* 1986/3, 91–95.

Ding Zuchun. "Sichuande Han Jin shi que" (Han Jin monumental towers in Sichuan). *Kaogu Yu Wenwu* 1987/6, 46–52.

THE PERIOD OF DISUNION

Chu Hsi-tsu (Zhu Xizu) et al. *Liu Chao lingmu diaocha baogao* (Report on investigations into the tombs of the Six Dynasties) Nanjing: Monumenta Sinica, 1935.

Lin Shuzhong. "Jiangsu Danyang Nan Qi lingmu zhuan yin bihua tantao" (A study of the impressed bricks and wall paintings of the Southern Qi tombs at Danyang, Jiangsu). *Wenwu* 1977/1, 64–73.

Luo Zongzhen. "Liu Chao lingmu jiju shike" (The tombs of the Six Dynasties and their stone sculptures). *Nanjing Museum Publications*, March 1979, 79–98.

———. "Nan Chao Song Wendi ling he Chen Wendi ling kao" (An investigation into the tombs of Song Wendi and Chen Wendi of the Southern Dynasties). *Nanjing Museum Publications* July 1984, 77–80.

Yao Qian, Gu Bing, et al. *Liu Chao yishu* (Art of the Six Dynasties). Beijing: Wenwu Publishing House, 1981.

———. *Nan Chao lingmu shike* (Stone carvings of the tombs of the Southern Dynasties). Beijing: Wenwu Publishing House, 1981.

Guan Yuchun, "Shilun Nanjing Liu Chao lingmu shike yishu" (A discussion on the art of the stone sculptures of the Six Dynasties tombs at Nanjing). *Wenwu* 1981/8, 61–64.

Lin Shuzhong. *Nan Chao lingmu diaoke* (Tomb carvings of the Six Dynasties). Beijing: Peoples' Fine Arts Books, 1984.

Chen Changan. "Jianshu diwang lingmu de xunzang, yong keng yu shike" (A simple description of live burial, tomb figurine pits and stone sculptures in imperial and royal tombs). *Zhong Yuan Wenwu* 1985/4, 72–77.

Yuan Rongqun. "Liangdai 'qing hua bi qu tu' yu Zhang Senyu huafeng" (Liang dynasty 'qing hua bi qu tu' and the painting style of Zhang Senyu). *Kaogu Yu Wenwu* 1988/4, 71–73.

SUI AND TANG DYNASTIES

Shaanxi Provincial Cultural Relics Management Committee. "Tang Qianling kancha ji" (Notes on a survey of Tang Qianling). *Wenwu* 1960/4, 53–60.

Shaanxi Provincial Museum. "Shike shuan shi he xiniu" (Two stone lions and a rhinoceros). *Wenwu* 1961/12, 48–50.

Shaanxi Province Archeological Research Institute. "Tang Shunling kancha ji" (Notes on a survey of Tang Shunling). *Wenwu* 1964/1, 34–39.

He Zhenghuang. "Jieshao Shaanxi Bowuguan xin jiande shike yishu chenlie shi" (Introduction to the new Shaanxi Museum stone sculpture exhibition hall). *Wenwu* 1964/1, 47–8.

Shaanxi Province Cultural Relics Management Committee. "Tang Jianling caice gongzuo jianbao" (Working report of a survey of Tang Jianling). *Wenwu* 1965/7, 31–34.

———. "Tang Qiaoling diaocha jianbao" (Report on the investigation of Tang Qiaoling). *Wenwu* 1966/1, 43–45.

Zhaoling Cultural Relics Management Bureau. "Zhaoling peizang mu diaocha ji" (Notes on an investigation into accompanying burials at Zhaoling). *Wenwu* 1977/10, 33–40, 49.

Chen Guocan. "Tang Qianling shiren xiang ji qi xian mingde yanjiu" (A study of the rank and name of the stone figures at Tang Qianling). *Wenwu Ji Kan* 2 (1980), 189–203.

He Zichang. "'Guanzhong Tang Shibaling' diaocha" (An investigation into the Guanzhong Tang "Eighteen Tombs"). *Wenwu Ziliao Cong Kan* 1980/3, 139–53.

Wang Shihe and Lou Yudong. "Tang Qiaoling kancha ji" (Notes on a survey of Tang Qiaoling). *Kaogu Yu Wenwu* 1980/4, 54–61, 69.

Wang Pizhong et al. "Tang Xingningling diaocha ji" (Notes on an investigation of Tang Xingningling). *Wenwu* 1985/3, 46–47.

Ruo Shi. "Tang Gongling diaocha jiyao" (Summary of investigations into Tang Gongling). *Wenwu* 1985/3, 43–47.

Luo Xizhang. "Sui Wendi ling ci kancha ji" (Notes on a survey of the mausoleum and hall of Sui Wendi). *Kaogu Yu Wenwu* 1985/6, 25–28.

Li Hui. *Tang Shibaling shike* (Stone carvings of the Tang "Eighteen Tombs"). Shaanxi: Peoples' Fine Arts Publishing House, 1988.

Chen Changan. "Tang Gongling ji qi shike" (The stone sculptures of Tang Gongling). *Kaogu Yu Wenwu* 1986/3, 32–36.

Yan Wenru. "Guanzhong Han Tang lingmu shike ticai ji qi fengge" (Concerning the style of the Guanzhong Han and Tang Tomb sculptures). *Kaogu Yu Wenwu* 1986/3, 91–95.

Henan Province Yanshi County Cultural Relics Management Committee. "Tang Gongling shice jiyao" (A summary of the actual measurements of Tang Gongling). *Kaogu* 1986/5, 458–62.

Wang Ziyun. *Shaanxi gudai diaoke* (Ancient stone sculpture of Shaanxi). Shaanxi: Peoples' Fine Arts Publishing House, 1985.

Zhang Chongde. "Tangdai Jianling jiqi shike" (The stone sculptures of Tang dynasty Jianling). *Kaogu Yu Wenwu* 1988/3, 41–44.

Li Lanke. "Longyao Tang ling 'Guangyesi bei' yu Li Tang zuji" (The Tang mausoleum, Guangyesi stele, and the native place of the Tang Li family ancestors). *Wenwu* 1988/4, 55–65.

FIVE DYNASTIES AND
SONG DYNASTY

Nanjing Museum. *Nan Tang er ling* (Two tombs of the Southern Tang). Nanjing: Wenwu Publishing House, 1957.

Songling (Song Tombs). Beijing: Wenwu Publishing House, n.d.

Guo Husheng et al. "Henan Gongxian Songling diaocha" (An investigation into the Song Tombs at Gongxian, Henan). *Kaogu* 1964/11, 564–77.

Gongxian wenwu jianjie (A brief introduction to the cultural relics of Gongxian). Gongxian: Gongxian Cultural Preservation Bureau, 1979.

Fu Yongguei. "Henan Gongxian Songling shike" (The stone sculptures of the Song tombs at Gongxian, Henan). *Kaogu Xue Jikan* 2 (1982), 134–62.

Lin Shuzhong. *Songling shidiao* (The sculptures of the Song mausolea). Beijing: Xinhua Book Shops, 1984.

Sichuan Province and Cultural Centre of Pengxian County. "Nan Song Yu Gongzhu fufu hezang mu" (The Southern Song joint burial of Yu Gongzhu and his wife). *Kaogu Xuebao* 1985/3, 383–402.

YUAN DYNASTY

"Yuan Cha Han Jie Mu Er mu qian faxian shi wengzhong" (Discovery of a stone guardian in front of the tomb of Yuan dynasty Cha Han Jie Mu Er). *Kaogu Yu Wenwu* 1987/5, 110.

MING DYNASTY

Zhang Zhengxian. "Ming Zuling." *Kaogu* 1963/8, 437–41.

Dingling. Beijing: Beijing Publishing House, 1973.

Ming Shisanling (The Ming "Thirteen Tombs"). Beijing: Beijing Publishing House, 1978.

Henan Provincial Museum and Xinxiang City Museum. "Xinxiang shijiao Ming Lu Jian Wang mu ji qi shike" (The Ming dynasty tomb of Prince Lujian in the suburbs of Xinxiang). *Wenwu* 1979/5, 7–13.

Nanjing Museum Publications. *Ming Xiaoling*. Beijing: Wenwu Publishing House, 1981.

Huangling bei (Huangling stele). Fengyang: Fengyang County Cultural Relics Management Bureau, 1981.

Wang Jianying. " 'Ming Zhongdu' ti yao" ("Ming Zhongdu": A summary). *Jianzhu lishi yu lilun* (Corpus of architectural history and theory). Jiangsu: Peoples' Publishing House, 1981, 162–71.

———. "Ming chu yingjian Zhongdu ji qi dui gaijian Nanjing he yingjian Beijingde yingxian" (The building of Zhongdu in the early Ming period and

its effect on the switch to build Nanjing and the building of Beijing). *Lishi di li* 3, 86–97. Shanghai: Shanghai Peoples' Publishing House, 1984.

Xinxiang City Museum. *Lujian Wang mu jianji* (A brief account of the tomb of Prince Lu Jian). Henan, 1986.

Liu Yucai et al. "Ming Zuling shike xiufu" (Restoration of the stone sculptures at Ming Zuling). *Jiangsu Kaogu Xuehui* 1982/5, 11–15.

Wang Yan. "Ming Shisanling bianqiang shankou chakan ji" (Notes on an investigation into the perimeter, walls and mountain passes of the Ming "Thirteen Tombs"). *Kaogu* 1983/9, 810–16.

Liu Yucai et al. "Ming Zuling shike xiufu" (Restoration of the stone sculptures at Ming Zuling). *Jiangsu Kaogu Xuehui* 1982/5, 11–15.

Ruan Rongchun. "Lun Mingdai Zuling, Xiaoling shendao shike zhi shidai" (A discussion of the dating of the stone sculpture in the spirit roads of Ming Zuling and Xiaoling). *Kaogu Yu Wenwu* 1986/2, 88–92.

Wang Yan. *Dingling Duo Ying* (The royal treasury of Dingling—imperial Ming tomb). 2 vols. Beijing: Cultural Relics Publishing House, 1989.

QING DYNASTY

Cultural Bureau of Preservation of the Western Tombs. *Qing Xiling* (Qing Western Tombs). Beijing: Beijing Publishing House, n.d.

Qingdai diwang lingmu (The imperial mausolea of the Qing dynasty). Beijing: Dangan Archives Publishing House, 1982.

Shenyang City Cultural Bureau. *Qing chu sanling* (Three imperial mausolea of the early Qing dynasty). Shenyang: Wenwu Publishing House, 1982.

Wang Qiheng. "Qingdai lingqin digong qin jing kao" (Research into the underground palaces and burial pits in the Qing mausoleum system). *Wenwu* 1986/7, 67–75.

INDEX

Page numbers are set in Roman type; plates, figures, and charts in italics at the end of each entry or subentry; minor references, prefixed by m., are at the end of an entry.

"Accompanying tombs," 84, 86, 119, 122, 264n2, *130*

Africa, 175

Ambassadors. *See* Foreign, foreigners

Anhui province, 156, 224. *See also* Fengyang; Huangling; Zhongdu

Animals: and spirit world, 9, 40–41, 51, 262n30; supernatural qualities, 9, 40

Animals, stone: and spirit world, 9, 19, 40–41, 51, 61–70, 99, 260n14; conventions governing carving of, 9, 21–22, 41–42, 44, 61–70, 83, 99, 101, 120, 134–35, 194, 258n6; role of, 9, 40–43, 60, 70, 78, 129, 169, 202; fabulous attributes, 9, 41–42, 65, 101, 129, 181; symbolism of, 40–41, 98, 126, 202; banned, 52. *See also* Fabulous beasts

Animals, winged. *See* Fabulous beasts

Ancestor worship: and tombs, 1, 28, 82–83, 156, 163; and sculpture, 9, 53; and state, 84, 175, 193; and Buddhism, 82–83, 264n22

An Lushan rebellion, 98

Anyang, Henan, 15

Arabia, Arabs, 84, 133, 218, 222, *194*, *295(7)*, *296(5)*

Archaism, archaistic, 121–22

Archaeology, archaeological: discoveries, 1, 15, 17, 46, 73, 156–57, 222, 225, 227; Song interest in, 8, 121; excavations, 199, 228, 268n14; m. 32, 60, 83

Architecture, architectural: and statuary, 1, 3, 5, 21, 28, 32, 34–35, 44, 156, 202; civic, 5, 34, 73, 76, 165; and *fengshui*, 164, 189; wood vs. stone, 165, 207, 210; stonework, 165, 194, 202. *See also* Pai lou; *Que*; Techniques

Archway, 73, 162, 194. *See also* Pai lou; *Xia ma fang*

Asia. *See* Southeast Asia

Atlas, atlantean, 76, *26*

Attendants, of animals, 101, 129, 162, 169, *163*. *See also* Grooms; Mahouts

Auspicious bird. *See* Vermilion Bird of the South

Ba xia. See Tortoise

Bayeux tapestry, 38

Beacons, Ming, 180

Beads (*Chaozhu*), 198, 268n17, *269*

Bear, 22, 43, *18, 19*

Beards, 42, 61, 65, 163, *79, 202–03*

Bei. See Stelae, stone

Beijing, Hebei province, 12, 73, 164, 193, 195, 198, 268n12. *See also* Forbidden City; Ming Tombs

Belted bamboo dynasties, 75

Bi, 21

Bixie, 42–44, 61–65, 262n22, 263n12, *51, 54–57, 80–82, 91, pl. 4*

Black Tortoise and Snake of the North, 37

Blessed Isles of the East, 16

Boar, stone, *19*

Book of Rites, Zhou, 122

Borneo, tomb of king of, 181, *250, 252*

Bricks, Han tomb, 14, 29, 31, 34, 35, 73

Bridges, 194, 202, 207, 269n22, *286*

Bronze: figurines, 9, 15, 42, 65; statues, 15, 34, 262n30; reuse of, 16

Buddhism, Buddhist: sculptural traditions, 1–3, 46; statuary, 2, 76, 82–83, 264n22, 264n23; sinicization of, 3, 82–83, 257n4; influences, 9, 46, 52, 58, 59, 75, 76, 77, 85, 264n23; and Confucianism, 57, 121; and Daoism, 57; lion, 101. *See also* Motifs

Calligraphy, 8, 58, 217; mirror writing, 73, 75, *84*

Camel, camels, 40, 169, *259*

Cao Cao. *See* Wudi; Wei

Captives, at tombs, 84, 117, 265n15

Censers, hill, *19*

Central Asia, Asian, 58, 84, 99, 265n16

Officials, stone: Han, 45, 46, *41, 42;* distinctions between military and civil, 46, 99–101, 138, 229, 265*n*11; Tang, 86, 93, 98, 99–101, 120, 216, *121–23, 129, 141–46, 293;* Song, 126, 129, 134–38, *165–69, 200;* Ming, 162, 163, 169, 226, 229, *202–04, 213, 214, 227–31, 232, 233, 242, 247, 250, 251, 253, 255;* Qing, 188, 195–98, 202, *267–69, 279–85, pl. 16;* post-imperial, 210–13, 292. *See also* Costumes; Portraiture, stone

Orientation: of statuary, 6, 8, 44, 45; Han tomb, 31, 37, 59, 60, 260*n*15; Southern Dynasties tomb, 59; Tang tomb, 85, 86; Song tomb, 122; Ming tomb, 157, 164, 224, 225, 268*n*5. See also *Fengshui*

Ostriches, 93, 99, 126, *118, 139, 140*

Oxen, stone, 19, 40, 259*n*5, 262*n*30, *11*

Pai lou, 5, 167, 176, 195, 207, 220–21, 243, 260–61, 264–65, 286–90, *pl. 17*

Painting: and sculpture, 3, 5, 8, 12, 92, 101; Six Principles of, 57–58, 257*n*2, 260*n*13. *See also* Drawings; Models

Palace servants, 123, 129, 181, 264*n*8, *238*

Paradise gardens, 16–17, 19, 29

Persians, 84, 222

Perspective, 5–8, 22–25, 257*n*3

Philosophy: and statuary, 3, 44, 51, 60, 82, 157, 193, 213; *Yin-yang,* 23. *See also* Confucianism; Daoism

Phoenix, 34, 99

Phoenix Mountain, Anhui, 224

Pillars. *See* Columns; *Que*

Pingyang *que,* Sichuan, 22–24, *29(1–3)*

Pointing, use of, 13

Portraiture, stone: conventions governing, 9–11, 48–49, 83, 135–38, 163, 194, 229, 258*n*6, 258*n*8; abstraction in, 11, 169; of non-Han, 11, 138, 181, 194, 267*n*14. *See also* Costumes; Foreign, foreigners

Pottery, 4, 9, 15, 35, 65, 99, 261*n*9

Pucheng county, Shaanxi, 12

Qianling, Tang mausoleum, 2, 85–118 *passim,* 123, 129, 261*n*17, 264*n*2, 264*n*8, 265*n*16, *115–27, pls. 5, 10, chart 4*

Qianlong (Gaozong), (r. 1736–95), Qing emperor, 198

Qiaoling, Tang mausoleum, 87, 264*n*8, *100, 136, 139, 141, 148, 149, pl. 11*

Qilin, 42–43, 61–65, 159, 169, 176, 202,

228, 263*n*4, 263*n*12, 263*n*13, 267*n*3, *2, 47–50, 52–53, 58–72, 74–79, 206, 220, 224, 234, 275, pls. 2,3. See also* Fabulous beasts; Felines

Qin dynasty (221–206 B.C.), statuary, 16

Qin Shihuang (d. 210 B.C.), first emperor of China, 4, 15, 16, 34, 37, 83, *29(4)*

Qin Shihuangdi. *See* Qin Shihuang

Quarry, quarries, 14, 122, 144, 194, 266*n*7, 268*n*8

Que, earthen, 34, 38, 86, 122, 123, 216, 261*n*17, 266*n*9

Que, stone: Han, 5, 31–38, 40, 52, 73, 76, 228, 261*n*8, 261*n*9, 261*n*13, *22–30, pl. 1;* as historical material, 5, 32, 34–35, 260*n*4, 261*n*9; cost of, 32, 258*n*12, 260*n*3; entitlement to, 33–34, 261*n*5; temple, 33, 34

Que, wooden, 5, 33, 34, 40, 50, 261*n*9

Queen Mother of the West, 9, 16, *29(3)*

Qufu, Shandong, statuary, 1, 46, 135, 185, 210, *41, 42, 198–200, 255, 256, 291, 292*

Quxian, Sichuan, 262*n*26

Rams. *See* Sheep

Reliefs, stone, 8, 13, 31, 77, 229, 258*n*13. *See also* Engravings; Friezes; Rubbings; "Six steeds" reliefs

Renzong (Zhao Zhen, d. 1063), Song emperor, 146

Republican government and tombs, 268*n*18

Restoration, 225, 228, 263*n*6

Rhinoceros, 47, 88–89, 133, 218, 262*n*30, *103*

Rites, rituals, 3, 6, 9, 28, 37, 46, 84–85, 86, 129, 166, 226

River Huai, Jiangsu, 224, 227

River Min, Sichuan, 46, 48

River Wei, Shaanxi, 86, 217

Roofs, 34, 37, 76, 228, *26, 288*

Ruan Wengzhong, 16, 83

Rubbings, 34, 35, 119, 121, 261*n*8, 261*n*9, 265*n*16, *19, 21, 28, 29*

Ruizong (Li Dan, d. 712), Tang emperor, 87

Sacrifices, 28, 29, 165, 266*n*10

Sacrificial hall, 28, 29, 31, 60, 86, 166, 225, 226

Saddles, saddlecloths, 129, 181, 185, 202, 216, 218, *181, 209, 247, 276*

Sanfuqi. *See* Sumatra

Sculptural style. *See* Style

Sculptural techniques. *See* Techniques

Sculptors: status of, 5, 11; and architecture, 5, 21, 194; aims of, 5, 21, 229; villages of, 11; named, 12, 19, 260*n*12; influences on, 76, 162. *See also* Architecture; Painting; Portraiture; Style

Sculpture, stone: survival of, 1, 2, 3, 29, 31, 40, 55, 83, 87, 123, 156, 157, 225, 228; and state, 1, 8–9, 37, 117–19; entitlement to, 1, 8, 29, 34, 55, 93, 98, 216; Buddhist and non-Buddhist, 2, 3, 46, 83; attitudes to, 3, 4, 5, 8, 148, 258*n*7, 258*n*8; and painting, 3, 5, 8, 12, 21, 92, 101, 257*n*2; and architecture, 3, 5, 21, 28, 32–38, 44, 156; and supernatural, 3, 8, 15, 16, 17, 29, 40, 51, 78, 99, 213, 260*n*14; purposes of, 3, 8, 15, 17, 21, 23, 29, 37, 46, 47–48, 51, 88–89, 115, 117–19, 126, 259*n*5; as historical evidence, 3, 32, 34, 35–37, 99, 101, 129, 162; dating of, 3, 45; angle of viewing, 5, 6, 8, 21, 22–23, 25, 44, 257*n*3; and calligraphy, 8; choice of subjects, 8; and immortality, 8, 9, 16; powers of, 8, 9, 15, 16, 32, 37, 48, 51, 70, 99, 213; unfinished, 14, *6*; as status symbol, 29, 35, 40, 42, 51, 60–61; banned, 52. *See also* Cost; Megalithic settlements; Orientation; Portraiture

Segalen, Victor, 2, 18, 21, 34, 260*n*15, 262*n*26

Seven months rule, 122, 144

Shaanxi province, 11, 12, 42. *See also* Qianling; Shunling; Xian; Xianyang

Shaanxi Provincial Museum, Xian, 17, 83, 88, 91

Shandong province, 2, 33, 34, 37, 42, 61. *See also* Qufu

Shang dynasty, 9, 15

Shanxi province, 11. *See also* Datong; Yungang

Shanyuan, Treaty of, 222

Sheep, 9, 40–41, 98, 126, 134, 162, 185, 216, *130*, *175*, *176*

Shendao (spirit road), 35, 99

Sheng Congwen, Dr., 222

Shenyang, Liaoning, 193

Shu, kingdom of, 15, 52, 259*n*5

Shunling, Tang mausoleum, 93, 216–17, *137*, *138*, *153*, *154*, *293*, *chart 5*

Shunzhi (Shizu, d. 1661), Qing emperor, 194

Sichuan province, 2, 11, 15, 16, 33, 34, 37, 38, 42, 46, 50, 52, 61, 75, 263*n*14. *See also* Chengdu; Chongjing; Dazu

Sickman, Dr. Lawrence, 257*n*3

Sino-Japanese War, 2

Six Principles for Painters, 5, 57, 257*n*2, 260*n*13

"Six steeds" reliefs, 8, 12, 92, *109–14*

"Sixteen Provinces," 121, 265*n*1

Sizhou, Jiangsu, 227

Song Mountains, Henan, 122

Song Wudi. *See* Wudi, Liu Song

Southeast Asia, Southeast Asian, 129, 133, 218–23, *193*, *195*, *294(2)*

Southern Qi (479–502) statuary, *62–70*, *79(3–7)*

Spade. *See* "Man with a spade"

Spinning Maiden. *See* Cowherd

Spirits: helpers, 9, 16; on statuary, 37, 75, 77, 78. *See also* Immortals

Spirit world, links with, 9, 16, 17, 19, 23, 29, 35, 38, 40, 41, 61–65, 99, 260*n*14. *See also* Immortals; Animals, stone

Stelae, stone: inscriptions on, 8, 50, 77, 78, 199, 217, 225, 263*n*12; cost of, 32, 260*n*3; crown, 50; hole in, 50, 76; base, 50, 262*n*32; banned on tombs, 52; m. 31, 55, 60, 86, 93, 98, 163, 167, 226, 264*n*20, 268*n*8, 268*n*15, *45*, *46*, *88*, *92–94*, *124*, *125*, *217–19*, *238*, *271*, *297*. *See also* Tablets

Stelae, wooden, 31, 49–50, 76

Stele pavilion, 167–69, 195, 217, 227

Stone: as a medium, 15, 29–31, 138, 210; associated with immortality, 8, 9, 16; in architecture, 165, 194, 202

Style, sculptural: influences on, 9, 44, 75, 134; Han, 21, 25, 37, 42; movement in, 21–22, 44, 61, 70, 78, 101, 120, 176; use in dating, 45; Southern Dynasties, 61–65, 78; Northern Dynasties, 83, 89; Tang, 89, 92, 98, 99, 101, 120, 264*n*9; realism in, 89, 92, 99, 101, 120, 163, 176, 229; Song, 123, 134–44; Ming, 159, 162–63, 169, 175–76, 228–29; Yuan, 162, 225, 228; Qing, 194–95, 202. *See also* Portraiture; Techniques

Suanni, 202, *278*

Su Boya, Han sculptor, 260*n*12

Suide, Shaanxi, 11

Sumatra (Sanfuqi), 222

Sumptuary Laws, 227